Praise for *Femina*

'Beautifully written, wonderfully free-ranging and gloriously original, *Femina* makes us look into the mists of history in new, exciting and provocative ways. A joyous read'

— Peter Frankopan, bestselling author of *The Silk Roads*

'Janina Ramirez is a born storyteller, and in *Femina* she is at the peak of her powers. This is bravura narrative history underpinned by passionate advocacy for the women whom medieval history has too often ignored or overlooked. *Femina* is essential reading for anyone who is interested in the Middle Ages and its place in the modern mind'

— Dan Jones, bestselling author of *The Plantagenets* and *Powers and Thrones*

'The women of the Middle Ages, so often silent and inconspicuous in our histories, find voice, agency and justice in this brilliant book'

— Alice Roberts, bestselling author of *Ancestors: A Prehistory of Britain in Seven Burialss*

'*Femina* is an important addition to our understanding of a period still – mistakenly – thought to have excluded women from positions of power and significance. *Femina* skillfully brings out from the shadows the lives of women who ruled, fought, traded, created, and inspired'

— Cat Jarman, bestselling author of *River Kings: A New History of Vikings from Scandinavia to the Silk Roads*

'Spellbinding, passionate, gripping and magnificently fresh in tone, boldly wide in range, elegantly written, deeply researched, *Femina* is a ground-breaking history of Middle Ages. It brings the world to life with women at its very heart, centre stage where they belong. What a delight'

— Simon Sebag Montefiore, bestselling author of *Jerusalem: The Biography*

'This is a passionate, energetic, hugely enjoyable and brilliantly observed book. Both a plea for a new way of thinking about history and a commitment to putting women's lives back at the heart of things, I read it in one sitting. Magnificent'

— Kate Mosse, bestselling author of *Labyrinth*

'Janina Ramirez is a passionate voice for women in history. With this bold and masterful book, she salvages women's stories from the dark corners into which they have been pushed, and brilliantly restores them to the centre of the historical narrative where they have always belonged'
– Hallie Rubenhold, bestselling author of *The Five: The Untold Lives of the Women Killed by Jack the Ripper*

'A compelling and breathtaking account of the women whose stories have been lost, ignored, or silenced in history. As important as it is remarkable'
– Susie Dent, bestselling author of *Word Perfect*

'Passionate, provocative and brilliant, this book is a firecracker somehow captured between two covers'
– Lucy Worsley, author of *Jane Austen at Home*

'Challenging, inclusive and riveting, Janina Ramirez's book is breaking new grounds. This is a history as you've never read before. A unique page turner'
– Olivette Otele, author of *African Europeans: An Untold History*

'Inventive, informative, surprising – this book is a revelation! Seeing so many remarkable women creating so much powerful history rewrites our entire sense of the medieval past'
– Waldemar Januszczak, Chief Art Critic, *Sunday Times*

'As both writer and broadcaster, Dr Janina Ramirez radiates tremendous passion for her subject. To spend time in her company is to soon find yourself intoxicated by the vast drama of human history, with all its far-off wonders, frustrating mysteries, and tantalising echoes that still resonate in our modern world'
– Greg Jenner, author of *Ask a Historian* and *Dead Famous: An Unexpected History of Celebrity*

'Gripping, incisive, brilliant, Janina Ramirez opens a door into hidden worlds, the secrets of women's lives. She is a detective and guide on this, an eye-opening, wonderful journey into the power, beauty and reality of early women's experiences'
– Kate Williams, author of *England's Mistress: The Infamous Life of Emma Hamilton*

About the Author

Dr Janina Ramirez is a *Sunday Times* bestselling author, BBC broadcaster, researcher and Oxford University lecturer, based at Harris Manchester College. She has a passion for communicating ideas about the past, presenting her ideas widely at conferences, public speaking and outreach events, and publishing her research in journals and magazines. She has presented and written over 30 hours of BBC history documentaries and series on TV and radio, and written seven books for children and adults, including *The Private Lives of the Saints*, *Riddle of the Runes* and *Goddess*. She lives in Oxfordshire with her young family.

FEMINA

A New History of the
Middle Ages, Through
the Women Written
Out of It

Janina
Ramirez

WH ALLEN

OOI

WH Allen, an imprint of Ebury Publishing,
20 Vauxhall Bridge Road,
London SW1V 2SA

WH Allen is part of the Penguin Random House group of companies
whose addresses can be found at global.penguinrandomhouse.com

Penguin Random House UK

First published in the United Kingdom by WH Allen in 2022
This edition published by WH Allen in 2023

Maps © Helen Stirling 2022

www.penguin.co.uk

A CIP catalogue record for this book is available from the British Library

ISBN 9780753558263

Typeset in 10.32/12.05pt Bembo MT Pro by Jouve (UK), Milton Keynes

Printed and bound in Great Britain by Clays Ltd, Elcograf S.p.A.

The authorised representative in the EEA is Penguin Random House Ireland,
Morrison Chambers, 32 Nassau Street, Dublin D02 YH68

Penguin Random House is committed to a sustainable future
for our business, our readers and our planet. This book is made
from Forest Stewardship Council® certified paper.

To the women lost to time, those that look for them,
and those who told me about them.

For D, K and K.

'I am the fiery life of divine substance, I blaze above the beauty of the fields, I shine in the waters, I burn in sun, moon and stars.'

Hildegard of Bingen

CONTENTS

Preface

This book comes with no apology. I am not here to convince you that it is high time we put women back at the centre of history. Many have done this before me. I'm also not here to draw a dividing line between male and female, to stress the importance of each in opposition to the other. Instead, I want to show you that there are so many more ways to approach history now. Far from being 'unrecoverable',[1] developments in archaeology, advancements in technology and an openness to new angles have made medieval women ripe for rediscovery.

I am not rewriting history. I'm using the same facts, figures, events and evidence as we've always had access to, combined with recent advances and discoveries. The difference is that I'm shifting the focus. The frame is now on female rather than male characters. Both perform in the narratives, and we can only truly understand one in relation to the other. This book is about individuals, rich in their complexity and fascinating in their variety. It is also about societies – groups of individuals working together and against one another, alongside a backdrop of shifting politics, economics, beliefs and power. Approaching the past through women's lives and stories offers a unique prism through which to find new and overlooked perspectives.

Women have always made up roughly half the global population. Why then should they not inform the way we perceive the past? We know so much about the rich and powerful few, but what about the poor and impoverished many? The very old and the very young are often ignored too. Disabilities are not a modern phenomenon, and neither are issues surrounding sexuality and gender. Yet we read so little about these areas in history books. Great progress has been made to understand the historical aspects of race and immigration recently, but there is still a long way to go. The medieval world was fluid, cosmopolitan, mobile and outward-looking. Every major city would have been full of individuals of different skin colours, ages, backgrounds, religions and heritage. Let's put them back into the history books too.

There are so many overlooked periods, groups and individuals that can enrich our relationship with the past, and it is in this spirit that I offer up this work. It is the start of a conversation, and I encourage every one of you reading to join in. There are numerous unexplored avenues and tantalising roads less trodden. History is organic and the way we engage with it grows and changes. But how individuals have written history reflects the time in which they write, as much as the time they are writing about. Repackaging the past can influence the present. In times of colonial expansion, when support for the slave trade was required, the historian fed readers tales of explorers and conquerors. When soldiers were needed, ready to die for king and country, the historian gave them heroes and warriors. When society favoured male dominance and female subservience, the historian provided male-orientated history.

What about writing history now, at a time when so many are striving for greater equality? Can looking backward impact how we look forward? Finding empowered women with agency from the medieval period is my way of shifting gear, providing new narratives for readers today. I know it carries bias, as all history is by its very nature subjective, no matter how objective we try to

be. But through these remarkable women, I hope to show how we can effectively scrutinise historical evidence in more inclusive ways and engage with the past through fresh eyes. You cannot be what you cannot see. So, let's find ourselves in what has gone before, and reframe what we value going forward.

Introduction

Wednesday, 4 June 1913 – Epsom Derby

Half a million people have swarmed through the gates of Epsom racecourse on this sultry summer afternoon. Derby Day has captivated the nation; normal life is suspended. Bookies scream over the noise of the vast crowd, while tipsters perched precariously on scaffolds wave their arms above a sea of bodies. The people gathered here represent every part of Edwardian society. They arrive on foot, by bike or train, in horse-drawn carriages or by motorcar. Members of the nobility stand alongside farmers, and boot cleaners rub shoulders with bankers. All have travelled to this otherwise sleepy village in Surrey for a chance to experience a few seconds of pounding hooves thundering past in a cloud of dust, sweat and noise.

The king and queen of Britain sit above them all in the royal box. King George V's horse Anmer is running but the favourite is Craganour, decked out in violet and primrose. As 3pm draws closer tensions rise. Horses and jockeys tussle along the starting line, the king's rider Herbert Jones distinguished by the red and blue of his royal shirt. A prize of more than £6,000 (equivalent to £1.5 million today), as well as a place in history, awaits the first to hurtle past the finishing post beneath the heaving stands. Most will watch the race not from the tiered seating areas but pressed up against the white barriers that run at chest height both sides of the track. Tattenham Corner is a particularly advantageous spot for a good view on the mile-and-a-half course. Here the horses curve around the sharpest part of the bend, before accelerating up the

final stretch. Traditionally, once all the horses have passed, the crowds clamber under the barriers and flood onto the course to follow the race to the winning post.

It's not just those lining the edges who will watch this Derby. Film cameras are also situated along the track. They will burn the action onto silver nitrate so cinema audiences across the Commonwealth can soak up the atmosphere at the world's most famous horse race. Three cameras all have their lenses trained on Tattenham Corner, positioned at angles to catch every movement. As the starting pistol cracks, jockeys dig their heels hard into the horses' sides and push forward. Spittle foams at the beasts' mouths and riders lean close to their sleek bodies, whipping their flanks as they accelerate to nearly 70 kilometres an hour. Slowing to round the top of the bend, the horses have split into two groups, a gap building between those with a chance at gold and a cluster lagging behind. The king's horse, Anmer, is in the latter group.

Then the cameras pick up something unexpected. A figure has dipped under the guard rail as the first wave of storming hooves screech past and around the bend. They move a few metres further into the track with determination, then face towards the last few riders, singling out Anmer, the king's horse. It appears as though they are trying to present the jockey with an object gripped in their hand. The horse, seeing someone in its path, begins to jump, but as it lifts its hooves high the figure crashes to the ground. Beast and rider tumble too, the horses behind just narrowly avoiding a collision. After a few seconds Anmer climbs to his feet and staggers on to complete the race rider-less. Jockey Herbert Jones has concussion, and is injured but alive. The mysterious stranger lies unconscious and bleeding.

They are instantly swept up in a wave of bodies as some rush to help, while the majority charge down the track towards the finish line. Amidst the chaos a man stops to pick up something lying close to the inert figure. It is a scarf, with stripes of purple, white and green running along its length, and the words 'Votes for Women' emblazoned on each end:[1] the sash of a suffragette. News would spread quickly that a 'crazy woman' had thrown herself in

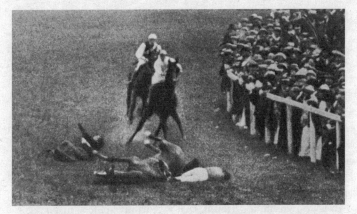

Photograph from 1913 Epsom Derby.

front of the king's horse and disrupted the most important race of the year. As she lies in hospital fighting for life, hate mail builds up on her bedside table. One letter, signed simply 'An Englishman', is characteristic of the vitriol levelled against her: 'I hope you suffer torture til you die, you idiot. I should like the opportunity of starving and beating you to a pulp.'[2] But the woman will never read these words; four days after the incident she succumbs to her injuries. The jockey will recover to ride again two weeks later, but he is never able to forget what happened and eventually takes his own life. As a political gesture, the horse Anmer is exiled to Canada, scapegoated for his part in a death over which he had no control.

The woman who seared the 1913 Derby into the history books was the young activist Emily Wilding Davison. The previous evening, she had been 17 miles north of Epsom, in Kensington, preparing for the Suffragette Fair. There she stood before the huge statue of Joan of Arc that greeted visitors to the fair: the fourteenth-century hero holding her sword high above her head, the words 'Fight on and God will give the victory' emblazoned on the plinth below. Emily was supposed to be volunteering at this fair, not disrupting the Derby, the very next day. She had mentioned the

possibility of 'making a protest on the racecourse', but only Alice Green, whose house Emily was staying at, knew that she was travelling to Epsom. She purchased a train ticket and pinned two flags inside her coat, their green, white and purple bands a testament to a cause she would dedicate her life to: women's suffrage through 'deeds not words'.[3]

Had she planned to die by suicide – a martyr to the cause – or simply to pin a sash to the horse? Was the incident premeditated or she was acting spontaneously? It's impossible to know for sure – she left no note behind. But by walking in front of the king's horse in full view of 500,000 people and three film cameras, Emily had performed the ultimate deed for her cause. As she herself wrote: 'To lay down life for friends, that is glorious, selfless, inspiring . . . the last consummate sacrifice of the Militant.'[4]

Emily had enrolled in the Women's Social and Political Union in November 1906, and over the seven years leading up to her death she had become increasingly militant. She was arrested nine times, went on hunger strike seven times and was force-fed 49 times; a painful, terrifying and brutal process that left many women with long-term mental and physical scars. She threw herself from a prison railing to protect another inmate and engaged in acts of vandalism, particularly the burning of postboxes. Described by Emmeline Pankhurst's daughter Sylvia as 'one of the most daring and reckless of the militants', Emily was treated as a martyr after her death. Twenty thousand people attended her funeral, making it the single biggest ceremony for a non-royal in British history. Her death and her activism are what Emily Wilding Davison is remembered for. But there is another aspect of her life that underpins this book; one that is rarely mentioned in the huge body of literature on her. She was a medievalist.[5]

Medieval Women: Modern Women

A highly educated woman, Emily had achieved first-class honours in English Literature having sat her finals at St Hugh's College,

Oxford. She could not graduate because Oxford University degrees were closed to women until 1920.[6] Instead she continued to undertake research and to publish, particularly on medieval literature. She produced a swathe of articles, each of which explored how the past she was fascinated by could shape her present. It's a widely held view that women's empowerment began in the twentieth century, when the 'votes for women' movement finally gave a voice to the 'second sex'. The lives of men, women and children would be improved as human tyranny and outdated traditions were finally replaced by something closer to equality. The centenary of women's suffrage in 2018 was accompanied by repeated exhortations that women had once and for all emerged from the shadows.

But Emily Wilding Davison didn't think the suffragettes were breaking new ground. For her, they were attacking a recent phenomenon of oppression. She wanted to return to an earlier time which she believed was populated by powerful women. In the medieval period she saw a model that challenged the pattern of misogyny embedded in the modern age.[7] In fact, her view of the medieval world was one rich in diversity, with men and women as equals. In an essay published just one month before her death called 'A Militant May Day', she describes a crowd in an idealised medieval setting. It is international and multicultural, with English, Scots, French, Russians, old, young, male and female celebrating together, and a 'little Saxon' holding hands with a 'little Jewess'. Instead of 'God Save the King', she claims the May Day motto is 'God Save the People'.[8] In the women of the medieval world, she found inspiring voices that had since been suppressed. Through this book we will similarly see that many of the modes of discrimination we vigorously challenge today are not always products of the medieval or pre-medieval periods, but of the last few centuries.

For the suffragette movement, one medieval woman in particular represented the notion of a determined female triumphing against all the odds: Joan of Arc.[9] Her active militarism and mode of dress made her an androgenous hero who embodied the motto,

'Deeds not Words'. Emily and the suffragettes were not alone in finding medievalism a source of inspiration for nineteenth- and early twentieth-century challenges. William Morris sought to combat the rise in industrial consumerism by embracing the handmade mediums of the medieval period. Augustus Pugin saw a national purity in Gothic architecture absent in the classical tradition, so used the medieval style as inspiration for the Houses of Parliament. John Ruskin encouraged a return to the romance of the medieval as a means of gaining 'truth to nature'. For the suffragettes, however, the women they foregrounded displayed two essential medieval attributes: they were challenging societal norms by achieving power and influence despite their sex, and they were deeply religious.

The modern leaning towards science and reason over religion and spirituality has meant the deeply devout nature of the suffragette movement is often overlooked. For many today they are seen as political rather than pious. But the majority of women who took part in militant activity saw themselves as soldiers of Christ, promoting social change framed within religious terms. A saint of the Catholic church, Joan of Arc's slogan 'Fight on and God will

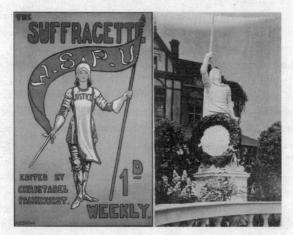

Suffragette poster with Joan of Arc figure, Hilda Dallas (left). Postcard showing statue of Joan of Arc from 1913, Suffragette Fair, Kensington (right).

give the Victory' was emblazoned on banners alongside her medieval image. Joan was everything Emily Wilding Davison aspired to. Her inexplicable rise from teenage peasant to leader of the French army during the Hundred Years War presented an image of quasi-military female empowerment, but she was historically distant enough to appear unthreatening to early twentieth-century gender norms. While twentieth-century women would be criticised for dressing in male clothing, this warrior cloaked in the veil of the past could do so openly.[10] What's more, her actions were sanctioned by God, Mary and the saints. She was a holy warrior.

As the suffragette movement spread across the ocean, women in the US also found inspiration in Joan of Arc. The image of Inez Milholland astride a huge white horse leading a pageant through the streets of Washington DC on 3 March 1913 has become iconic. Her version of Joan of Arc was dreamy and romantic, her hair long and loose and topped with a crown. Like Emily, Inez's costume design was inspired by the many years she had spent studying medieval literature. Very few scholars have discussed these suffragettes who were fascinated by the medieval period. But

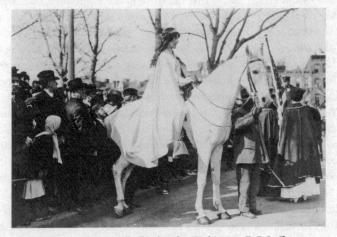

Photograph of Inez Milholland at the Washington DC Suffragette pageant, 3 March 1913.

understanding their medievalism subverts the general consensus that these twentieth-century women were fighting for agency in a vacuum, blazing a trail like never before. Rather than accept the misconstructions of the medieval period that had accrued over the intervening centuries, these suffragettes recognised a time when women had agency – and they wanted to return to it.

Emily's medievalism underlines her identity as a suffragette. A classmate recalled how Emily took the name 'Fair Emelye' after reading Chaucer's *Canterbury Tales* at school:

> Her chief friend at the time had no recollection of discussing women's rights with her or any public question. Far more interesting to them both was Chaucer's *Knight's Tale*, which they were both studying and from which Emily derived another of her names. 'The Faire Emelye' she was always called from that time on by this friend and a few others, her hair, which was fair and very pretty, making the name appropriate.[11]

'The Knight's Tale' is the first full story in the *Canterbury Tales*, and describes how Emelye was captured along with her sister Queen Hippolyta when Theseus laid siege to Scythia, home of the powerful Amazon women. She is taken to Athens, where she becomes the object of desire for two knights being held captive in a tower. To this end, she is idealised and objectified, but in many ways Emelye contradicts expectations of women in romance. First, the 'Amazon' women of Scythia were military-trained, and said to be able to ride horses, wield weapons and fight as equals to men.[12] Second, Emelye expresses her desire to remain dedicated to the goddess of the hunt, Diana: 'I Desire to be a maiden all my life, / Nor never would I be no lover nor wife.' She tells the goddess that she prefers hunting and woodcraft to marriage and childbirth. Emelye is eventually married off against her will, but her emboldened speech to Diana acts as a timeless rallying cry to women who want to determine their own destinies.

While Emelye may at first have appealed to the young Wilding

Davison on account of her fair hair and beauty, her imprisonment would have only strengthened Emily's connection to her. References to Emelye are full of suggestions that her freedom is limited, and her fate governed by forces beyond her control. Signing letters as 'Emelye', the young suffragette was identifying with the female warrior, and in her essay 'The Price of Liberty' Emily suggests that the militancy of suffragettes ties them back to strong women of the past: 'The perfect Amazon is she who will sacrifice all even unto this last.'[13] But her actions at the Epsom Derby are the strongest indicator that Emily was profoundly influenced by Emelye and 'The Knight's Tale'.

After her death, fellow suffragettes argued that Emily had not intended to be a martyr, but instead was trying to call on the king for justice. Immediately after the incident, the newspaper in her hometown of Morpeth reported that she 'offered up her life as a Petition to the King . . . Her petition will not fail, for she herself has carried it to that High Tribunal where men and women, rich and poor, stand equal.'[14] By this point in 1913 the suffragette movement had felt it had exhausted routes of communication through members of parliament, and instead forged plans to appeal directly to the monarch. This idea has its roots in the medieval custom of the king as the ultimate arbiter of justice, who could be approached by his subjects as he travelled around the kingdom and asked for his intervention in their matters.

'The Knight's Tale' provided Emily with the perfect source of inspiration for how to achieve such a petition. In the opening verses, the triumphant lord Theseus arrives at the city of Thebes. Rows of ladies clothed in black kneel before him in the street, crying, wailing and lamenting. These women are widows, victims of the tyrant Creon's attack on the city, desperate for the bodies of their loved ones to be retrieved and laid to rest. Theseus, expecting a hero's welcome, is shocked by their behaviour and goes to dismiss them. But then one of the women 'caught the reigns of his bridle'. His horse subdued, Theseus is compelled to hear the women's grievances. This woman's actions changed the course of history. Theseus wages war against Creon, the bones are

recovered, and the ruler fulfils his oath to the women. It is possible that the example of the Theban widows may have determined Emily's final act of reaching towards the king's horse, recasting herself as one of her heroines through her death. By emulating the actions of women from the past, Emily Wilding Davison carved her name onto history as a martyr for her cause.

Women Writing Women

Emily was not the only woman to find inspiration for suffrage by looking to the medieval period. The less militant but no less significant Grace Warrack drew on her passion for medieval literature to bring a lost woman's work to a huge new readership. Over a decade before Emily ran out at the Derby, this middle-aged Scottish Presbyterian arrived in London and made her way to the British Library's reading room. She had come in search of a fourteenth-century Catholic English mystic. Wading through the catalogue for the 50,000 books, manuscripts and prints left by Hans Sloane to the library in the eighteenth century, Grace found an interesting entry. Under the heading 'Magic and Witchcraft' a manuscript was labelled 'Revelations to One Who Could Not Read a Letter, 1373'.[15] She had found what she was looking for – the earliest surviving copy of Julian of Norwich's *Revelations of Divine Love*. Over the course of one month Grace transcribed the full text and translated it from medieval to modern English. She then returned to Edinburgh and managed to persuade the publisher Methuen to print the first complete printed text of Julian's work in 1901. It has never been out of print since, and generations of scholars have discovered the medieval masterpiece thanks to Grace's translation.

Grace was determined that Julian's quiet, contemplative yet revolutionary views on spirituality should be made available to a wide audience. By publishing *Revelations of Divine Love*, Grace provided twentieth-century women with one of their most impressive medieval foremothers. Julian was born in the city of Norwich around 1343. She was 30 years old when, paralysed and resigned to death,

she received a set of visions or 'revelations'. She would go on to make a full recovery, but her life had been changed forever. When she returned to health, she chose to be enclosed as an anchoress, and received the last rites before being holed up in a single room for the rest of her life. She spent another three decades or more in her cell, contemplating the visions she had received and writing her remarkable book, which is the first known text by a woman in English.

Revelations of Divine Love is a sublime book; the work of a steady gaze applied to spiritual matters. Julian doesn't tell us anything about the turbulent fourteenth-century world she inhabited: the plagues, heresy trials, wars and schisms.[16] She is barely present in her text. Instead, she describes in almost cinematic detail the sufferings of Christ and repeatedly asserts that the motherly love of God for his creation lies at the core of all existence. Her famous phrase – 'all shall be well, all shall be well and all manner of things shall be well' – is not a trite piece of consolation, but rather a meaningful and considered statement of divine intent.[17] Even so, it's remarkable that we know of Julian today, and that her name did not go the same way as so many other medieval women.

From the Reformation onwards, libraries were scoured for controversial texts. Various shorthand terms were used in catalogues to indicate which should be considered and potentially destroyed. Books were recorded as containing 'witchcraft', 'heresy' and 'Catholic' subject matter; the destiny of many of these texts is unknown, with the lists the only record of their existence. The title of this book – *Femina* – was the label scribbled alongside texts known to be written by a woman, so less worthy of preservation. We can only wonder how many other texts were dismissed or destroyed as the work of 'femina'. *Revelations of Divine Love* should have gone the same way and fallen victim to the book burnings of generations of reformers. Tracing the rare survival of Julian of Norwich's work can shed light on why so few medieval women have been recorded down the centuries.

The sixteenth-century Reformation caused an ideological crack through the heart of England. Under Henry VIII's son Edward, Catholics were rounded up and killed, while under his

daughter Mary, the tables turned, and Protestants were burned. A major casualty of this embittered religious turmoil was books. Catholics destroyed Protestant books and vice versa. The burning, destruction or removal of books carries with it two purposes: to destroy the physical objects, and to remove their contents from people's memories.[18] Thousands of medieval manuscripts, the repositories of generations of knowledge and art, were declared heretical and destroyed. Those that survived were either accepted as orthodox, so almost exclusively written by educated men, or were hidden away. While Julian's book wasn't heretical, it did sail close to the wind. She referred to Christ as a woman, suggested that sin was 'behovely' ('necessary'), and she saw God as entirely forgiving no matter what a person did during their lives.[19] She would have kept her writings secret while inside her anchoress cell, but they eventually made their way out into the world.

The book remained hidden until the sixteenth century, when it travelled to France to be met by nine young women escaping Protestant England to set up a Catholic convent in Cambrai, France. All were aged between 17 and 22, and among them was Gertrude More, great-great-granddaughter of famous Tudor Catholic and writer Thomas More. As well as hiding priests, religious objects and medieval texts in their stately home, the More family took an unconventional attitude towards educating women. Thomas insisted his many daughters received the same classical education as his only son, with their intellectual capabilities impressing even King Henry VIII. The king was amazed to find a woman's signature at the end of an 'extremely erudite' letter written in perfect Latin by Thomas's daughter Margaret.[20] This educational environment permeated through the generations, and Gertrude was encouraged to enter a convent to further her studies. The nuns at Cambrai were sent a collection of medieval manuscripts to help them in their contemplative life, and among these was Julian's *Revelations*. They made multiple copies of her text and the community preserved it through times of hardship, until the French Revolution when the convent was disbanded and the nuns, fearing execution, escaped to Stanbrook Abbey in Yorkshire. They took Julian with them.

These copies gave Julian of Norwich a platform, and from here a sequence of male scholars chose to either embrace or reject her writings. She was hijacked by writers on both sides of the religious divide in the seventeenth century. Catholic convert and Benedictine monk Serenus Crecy copied and printed her work, while his Protestant counterpart, Bishop Edward Stillingfleet, declared her 'everything that is wrong with the Roman church' and her writings the 'fantastic revelations of a distempered brain'.[21] To him, Julian's femininity wasn't so much a problem in itself. But it represented the 'alien' and 'other' of Catholicism, which was a threat to the unity of the Church of England.[22] Stillingfleet embraced deism, the idea that empirical reason and observation of the natural world provide enough evidence of a supreme being and that, therefore, revelations cannot be divine in origin.[23] As women were excluded from universities and theological discourse, their texts were not empirical, instead dealing with spiritual matters through their lived experience of revelations. They also tended to write in the vernacular rather than in the Latin learned by male scribes. The works of medieval 'feminae' were the perfect target for the reformers of the later generations.

Always the Second Sex?

The Reformation impacted women significantly. As convents were closed, opportunities available to women narrowed to being a wife and being a mother. Nuns were returned to their families or made to marry, and educational opportunities were increasingly restricted throughout the sixteenth and seventeenth centuries.[24] The relegation of women to the role of the second sex was firmly embedded in Protestant communities, with Martin Luther stating 'the wife should stay at home and look after the affairs of the household as one who has been deprived of the ability of administering those affairs that are outside and concern the state', while John Calvin agreed that 'the woman's place is in the home'.[25]

The situation worsened further for women as eighteenth- and

nineteenth-century writers crafted ever more elaborate social divides between the sexes. Despite having a female monarch in Victoria, women did not have the right to vote, sue or own property if they were married, ceding all possessions to their husband.[26] Educational opportunities were virtually non-existent until Cheltenham Ladies College opened its doors in 1853. The divide was gender specific, with women increasingly confined to domestic activities and restrictive clothing. But there was also a class-based rift.[27] What was acceptable for an upper-class lady was dictated by matters of taste, while men and women suffered similar degradation through poverty in industrial Britain. There was an idea of the perfect lady, as expressed by medical doctor William Acton, who specialised in masturbation. Women were supposed to be, 'The best mothers, wives, and managers of households, know little or nothing of sexual indulgences. Love of home, children, and domestic duties are the only passions they feel.'

Acton goes on to describe a woman he interviewed who was, in his opinion, the 'perfect' English lady:

> I believe this lady is a perfect ideal of an English wife and mother, kind, considerate, self-sacrificing, and sensible, so pure-hearted as to be utterly ignorant of and averse to any sensual indulgence, but so unselfishly attached to the man she loves, as to be willing to give up her own wishes and feelings for his sake.[28]

Pseudo-scientific treatises like Acton's did not help women's emancipation, but much of the blame for the exclusion of women from eighteenth- to nineteenth-century histories lies at the feet of exponents for the so-called 'great men' theory during the height of the British Empire. As Britain competed with other European powers to expand its reach, absorbing entire cultures through the exploits of privileged Western men, so history was recorded in a way which placed them centre stage. The loudest voice among many in this movement was Thomas Carlyle (1795–1881). He wore many different hats throughout his long and successful life:

philosopher, mathematician, historian, satirist and teacher. But he is mainly remembered for the bold statements in his work *On Heroes, Hero Worship and the Heroic in History*, including, 'the History of the World is but the biography of Great Men'.[29] Reading Carlyle's text today is an unsettling experience as he disregards entire sections of society:

> The great man, with his free force direct out of God's own hand, is the lightning. His word is the wise healing word which all can believe in. All blazes round him now, when he has once struck on it, into fire like his own. The dry mouldering sticks are thought to have called him forth! Those are critics in small vision, I think, who cry: 'See, is it not the sticks that made the fire?' No sadder proof can be given by a man of his own littleness than disbelief in great men.[30]

Here, everybody but a 'great man' suffers the indignity of being deemed insignificant. Women make up a significant portion of those dismissed of course, but also included are those Carlyle perceives as 'little men'. This was the dominant approach of historians, and we still feel the pull of the so-called Great Man theory today. Those who didn't fit the moral code of Victorian England, or sat outside the narrative of conquest, were repackaged or removed from the record. Individuals like Alfred the Great fared well, preserved for posterity by Victorian historians as a great military leader. But his daughter Æthelflæd was overlooked. A military strategist and social reformer of a kind that almost eclipsed her father in her lifetime, she didn't fit with Victorian notions of a woman's place in society. Women of the past were recast as reflections of what Victorian society wanted them to be.

While seemingly engaging with the medieval period, Pre-Raphaelite and Victorian artists created sensual representations of the few medieval women they could access, once again filtering them through Victorian sensibilities. They are cast as virgin, victim, mother, whore or hag, with the image of an unobtainable maiden trapped in a tower repeated ad nauseum. Millais's *Ophelia*

is the desperate, hysterical woman, who according to Shakespeare was driven mad and through her watery death forever subsumed within nature. The way Millais has painted her parted lips is a tantalising invitation to stare lasciviously upon her downfall. Other medieval women are shown looking out from towers, working on their embroideries and pining for strong knights away on exciting God-given missions. The truth is that the foundations of Victorian-era medievalism lay on shaky ground. The texts preserved and copied down the centuries had already suffered from multiple stages of editing and erasure. The versions read in the nineteenth century had been repeatedly revisited, with women cast in socially acceptable ways for ever-changing audiences.

Not all blame lies at the feet of nineteenth-century historians. There are myriad reasons why so many women have been lost to the sands of time. Some originated during the medieval period itself. While there were certainly places of education in the convents of medieval Europe, educated men outnumbered educated women, and they had fewer opportunities to learn to read and write and make their mark. Over-writing – the practice whereby male writers would take the visions, words and ideas of female

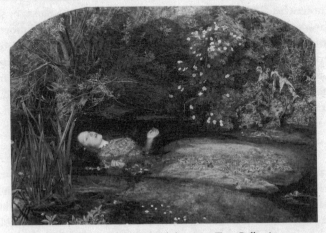

Sir John Everett Millais, *Ophelia*, 1852, Tate Collection.

intellectuals and rewrite them for a largely male audience – was also common throughout the period.[31] This meant that both oral and written accounts by women were subsumed into those of later authors and remain unacknowledged. The erasure of many literate women from the records is more a case of poor referencing than deliberate exclusion. But as the centuries wore on, the lives of medieval women simply didn't interest later generations of male readers and writers. The acts of brilliant officers, bold leaders and reasoned male intellectuals were of more value.

Teaching children about 'great men' enforced a sense of a great nation, a version of history which could be distributed along the length and breadth of vast empires. Controlling access to the past controls populations in the present, and determining who writes history can affect thought and behaviour. Famously the Nazis created a version of German history which cherry-picked and repackaged information so as to benefit the regime's agenda. But historical manipulation is everywhere, and trickles through to each of us in similar ways. At the time of writing this book there is a dangerous undercurrent to medieval studies, as the period is increasingly hijacked by the far right to promote extreme ideologies on race, ethnicity and immigration.[32] Among the individuals who stormed the US Capitol in January 2020, the 'Q-Shaman', as he's come to be known, was covered with Norse tattoos. The perpetrator of the Christchurch terrorist attack in 2019, who killed 51 and injured 40, had covered his weapons with medieval symbols of a crusader knight renowned for killing Muslims.[33] And the so-called 'War on Terror' has exacerbated relations between East and West, with politicians like President George W. Bush drawing parallels with the Crusades.[34]

Misappropriation of the medieval period is rife, from comedic parodies to conspiracy theories. By casting the light back on medieval women and turning many lenses – from osteoarchaeology to art historical analysis – on the evidence, I want to illuminate a different version of the Middle Ages. All historical accounts are the products of the human concerns of their time and I freely acknowledge that I am focusing on a group I sympathise with, interpreting

the evidence with my own interests at the fore. Yet it is ultimately an attempt to open up different ways of engaging with history. This quote by the medievalist Kolve is my concession:

> We have little choice but to acknowledge our modernity, admit that our interest in the past is always (and by no means illegitimately) born of present concerns.[35]

Whether forgotten, ignored or deliberately written out, it is a wonder than any female voices survive at all. But the discipline of history has undergone its greatest shake up in the last few decades because of developments in the connecting areas of social history, archaeology, DNA research and statistical analysis. While texts tend to favour the few, these approaches search for the many. It is in this realm of cross-disciplinary collaboration that medieval women begin to emerge. The digital revolution has made our search somewhat easier. We can now find our own histories by searching family records and accessing archives. Other types of stories are starting to emerge, populated by a new cast of characters who lived on our streets, in our homes and shared aspects of our lives.

In this book the women fight as brave warriors, physically crossing the taboo of the 'weaker sex'; they rule with the power of kings and emperors; they write their own stories and determine their histories; they reach, and sometimes exceed, the intellectual achievements of contemporary male scholars, making exceptional discoveries in the areas of the sciences and the arts; they hold the purse strings, amassing unthinkable wealth, and do all this while often performing the traditional female tasks of child-rearing and housekeeping.

Many of the women featured in this book chose an alternative way of life – one that deliberately removed them from established female realms of the kitchen, nursery and bedchamber. They thrived in monasteries and workshops, stepping away from domestic interiors and embracing new challenges. That they could do this is testament not only to how formidable they were as individuals, but also to the fact that the medieval period was perhaps

more accommodating than we think. Our view of this time has been skewed by the historical writers that have come before us. It was a 'dark age', a time of 'barbarians': to be 'medieval' is short-hand for backwards, superstitious, reactionary, volatile. By digging into mistruths and truths, I want to show how the historical divide can be crossed to create as authentic a picture as possible of these women and the time in which they lived.

This journey to discover lost or ignored women starts in the very north of England, before sweeping down through the midlands and into the south. It then crosses the North Sea to Scandinavia, passes over to Normandy, across to Germany, and then to the south of France. From there it moves to the mega-state at the heart of Europe, Poland, before following the route of the Hanseatic League back to East Anglia and the cosmopolitan city of London. This

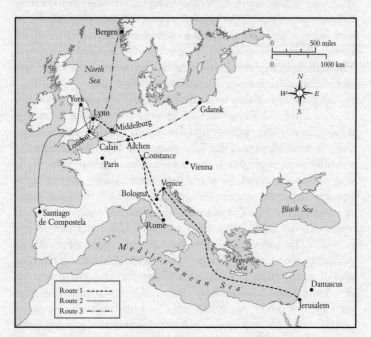

Map showing the pilgrimages of Margery Kempe from King's Lynn, 1413–33.

scope is intentional: the medieval world was not a small, parochial one where everyone lived and died within view of their local church. Some people travelled vast distances in their lives, via boat, on foot and by horse. The route covered by this book is very similar to the journeys taken by medieval women in their own lifetimes. The English woman examined towards the end of the book – Margery Kempe – visited all these kingdoms and more.

As the book moves across a wide geographical area, so it shifts across disciplinary boundaries. The early chapters focus on archaeological discoveries, drawing in textual evidence. Later chapters shift between art historical, theological, historical and literary evidence, and throughout the approach is deliberately interdisciplinary. While I have focused on a selection of women that can be reconstructed relatively well through a combination of evidence from a range of sources, there are still so many others who remain frustratingly out of reach. But even 90 years ago Grace Warrack would have been amazed that I could include the Loftus Princess or the Birka Warrior Woman in a discussion of medieval women. Through dedicated research and further advancements, it may just be a matter of time before others appear more fully.

'What thing is it that women most desire?' So speaks Chaucer's Wife of Bath. The response she gives is that women want sex, money, land, independence and fun. Emily Wilding Davison and Grace Warrack had read the Wife's words, and they became part of a century-long fight for women to have the right to fulfil those wishes. Some parts of the world have taken positive steps towards equality. But most women across the globe can still fulfil few, if any, of those desires. Equality is a frail veneer pinned precariously over some societies, and completely ignored or deliberately suppressed in others. Yet a new thrust foregrounding the needs of women is gathering momentum. If sources are to continually reinforce an idea of a past where women haven't contributed, women will feel they have always been invisible. We need a new relationship with the past, one which we can all feel a part of. Finding these extraordinary medieval women is a first step, but there are so many other silenced voices waiting to have their stories heard.

1

Movers and Shakers

Discovery!

2006 – Loftus, Redcar and Cleveland, England

S treet House Farm sits on a crossroads at the northernmost edge of the North Yorkshire Moors – a wild terrain lashed by the winds. Beyond the farm's furthest field the sea crashes against the sheer rocks of the coast. The town of Loftus, in the borough of Redcar and Cleveland, sits just a mile or so to the south and east of the farm. We're in the territory of Wordsworth, Dracula and the largest concentration of ancient trees in northern England.[1] If these trees could talk, they would tell countless stories of the events that have played out on this landscape. The present story concerns Steve Sherlock, an archaeological detective (his surname is a happy accident). For four decades Steve has investigated local mysteries that stretch back thousands of years.[2]

Steve knows this land intimately, having grown up in the nearby town of Redcar, and has spent a lifetime sifting through the soil in search of both treasures and answers. From 1979 to 1981 he was part of a team that discovered Neolithic cairns and Iron Age settlements on this unassuming crop of land surrounding Street House Farm. One discovery in particular set this site apart: a unique structure, radiocarbon-dated to around 2200 BC. While it survives as a set of post-holes – echoes in the soil of once-great wooden monuments – originally it was a circular enclosure, roughly eight metres across, composed of 56 upright roughly-cut

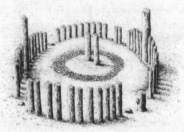

Reconstruction of the Street House 'Wossit', Loftus, Late Neolithic, c. 2200 BC.

timbers with a curious D–shaped raised section in the centre.[3] The spacing of the posts suggest that people moved between them in a processional or ceremonial way. In the absence of any other convincing suggestions, it was declared a 'ritual site', where unknown ancient ceremonies took place, and named the 'Wossit' (from 'what–is–it').[4] It acts as a reminder that when we look backwards through time our investigations are tentative and we must keep asking the question 'what is it?'

What's clear is that at Loftus, the now seemingly remote and isolated hilltop farm was once an ancient hub of people, noise, movement and life. The remnants of structures going back millennia pepper the fields, including Teesside's official 'Oldest House', which predates Stonehenge. Decades after he saw the postholes of the Wossit emerge from the soil, the outline of a rectangular enclosure in a nearby field, picked up in an aerial photograph, caught Steve's attention. Inside an Iron Age ditch were the traces of buildings, including a number of roundhouses. While Steve had come here to discover a pre-Roman world, an unassuming mound near the centre suggested there was something else worth exploring.[5]

Cutting through the outlines of older Iron Age houses, yet systematically arranged within the parameters of the enclosure, were 109 graves. Each one was carefully dug into the ground to allow enough room for a body to be laid in a foetal position on its side. There were no bones – the acidic soil having claimed anything organic – but certain clues began to emerge as the team peeled

back layers of earth. Beads, scraps of metal, parts of eroded weapons all suggested that these burials were not Iron Age, but more recent. These were early medieval, and more excitingly still, they seemed to date from a period when this part of the north of England was undergoing an ideological revolution. They dated from the time when Christianity was putting its first roots down along the Northumbrian coastline.

The most significant find, however, was hiding within the mound right in the heart of the cemetery. While other graves stretched along the parameters of the enclosure, this area of raised earth provided a focal point for the burials. Opening the central grave Steve found the mother lode; beautiful, symbolic early medieval jewellery of the very highest status. Reaching up above all the other graves, the individual in this barrow of earth was clearly important, both to those carefully burying their loved ones around them, and for the archaeological team digging them up 1,400 years later. This was the grave of a leader, someone treasured by their community, someone with power, wealth and influence. There are scant clues as to the meaning behind this burial ground. To understand it we need to insert ourselves among the people of seventh-century Loftus and take a close look at the objects they placed in the ground. Through them, a picture emerges of a northern English society rocked by change yet clinging to the past.

Welcome to Seventh-Century Loftus

The salt air bites your skin as you look out over the choppy waters of the North Sea. The waves before you connect rather than divide, linking this outcrop of northern English cliff face to Scandinavia, Germany and onwards to exotic lands in the south and east. Ships moored in the bay below are the horses of the sea, allowing international travel and promising riches. Turning your back on the water and looking inland, a strange terrain unfolds. There are lumps and bumps across the earth, the echo of great buildings many centuries old. Stones from old Roman structures

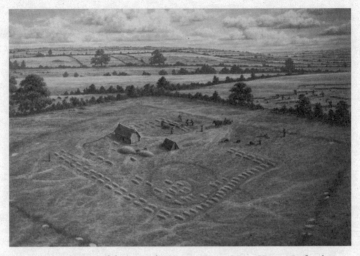

Reconstruction of the seventh-century site at Street House, Loftus by
Andrew Hutchinson; © Andrew Hutchinson and Stephen Sherlock.

are scattered around, and a couple of new wooden edifices rise up
between burial mounds and raised ditches.

A ceremony is taking place. People process through a series of
wide openings in the centuries-old Iron Age enclosures, then into
a square area about the size of half a football pitch. Congregating,
they move towards one of the new wooden buildings. It's a simple
structure, just one entrance onto a small, dark space. Inside, some-
one is laid out on their back, dressed in luxurious robes with gold
glittering on their chest. They are still and peaceful, quite clearly
dead. To the left of this little building a hole has been dug in the
ground, a large pile of freshly turned soil by its side. Peer down
into the hole and something surprising lies inside – a beautifully
carved and ornately decorated bed. It is covered in furs and sump-
tuous materials, and a soft pillow rests beneath a solid ash-wood
headboard.

Behind the mound of earth another wooden building rises up.
The doors are open and from inside comes the soft glow of candle-

light. Standing on a raised circular platform next to the hole in the ground, leaders from the community are dressed in their finest clothes, red, green and yellow dyed wool edged with exotic fabrics like silk, imported from over the seas. Gold buttons and ornate buckles glitter among folds of material worn by the men, while the women wear beaded necklaces in layers down their chests. They observe solemnly as people move towards them, gradually filling up the enclosure. The illustrious and industrious, the great and the many, are all here to pay their respects to one person. Soon the deceased will be placed in their bed, to sleep for all eternity surrounded by ancestors from millennia ago. They will become one with the landscape. These people are here to remember them, but the burial rites are also a strong reminder of how they will all one day merge with a place whose history stretches back to the mythic past.

The Secrets of Grave 42

The early medieval burial ground at Loftus is unusual. More than 100 graves are arranged in a rectangle, forming a clear outline. They're all oriented east to west, common in Christian burials, with the head placed in the direction of the rising sun.[6] At the heart of the site are three graves, which Steve Sherlock labelled 41, 42 and 43. Of these, one was given more elaborate treatment than the others. Grave 42 had a burial mound raised up over it so that it could be seen from a distance. Although the bone, wood and fabric had vanished, the remaining metal objects indicated how the original burial would have looked. Eroded iron cleats and scrolled headboard fittings were all that was left of a very fine wooden bed. This was by no means the only bed burial found in England, but it was the only one this far north.[7]

Inside the bed, close to where the deceased's chest would have been, a set of glittering finds emerged from the soil. Two pendants, set with highly polished cabochon red gemstones, large and exotic in design. Three beads – two of them blue and one made

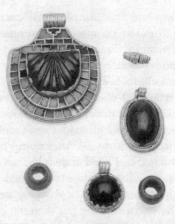

Garnet and gold pendants from grave 42, Street House, Loftus
© Stephen Sherlock.

from gold wire, which would once have been strung on a necklace – lie beside them. But the most exceptional find was the central ornament, a shield-shaped golden pendant with rows of cloisonné gemstones around a scallop-shaped garnet nearly two centimetres across. The first of its kind to have been found, it suggests that the person honoured in grave 42 was very important – most probably a member of royalty or nobility. It also suggested that she was a woman.[8]

Without bones to analyse, the gendering of the graves at Street House was based on the finds. Weapons and paired blades were considered male objects, while beads, keys and jewellery were female. This, of course, is not exact. When examining other sites with skeletal remains, the gendering of objects is sometimes reversed. For example, at the nearby cemetery of Norton, Cleveland, a man was found buried with a bead as well as weapons, and women have been interred with knives or swords.[9] There have also been discoveries across the North Sea where the finds are gendered male, while the bones are female. However, it is generally accepted that women were more likely to be buried with jewellery.

The pendant offers fascinating insights into its owner and the

world she was a part of. Now known as the Loftus Princess, only someone important would be buried with such honour and with such beautiful treasures. This sort of cloisonné jewellery was ubiquitous among elite burials of the time, with similar pieces found at the Sutton Hoo ship burial, the most exuberant celebration of burial with grave goods ever discovered in England. And in the same year as the Loftus Princess was discovered, metal-detectorist Terry Herbert dug up a staggering 3,500 pieces of cloisonné jewellery in the largest collection of Anglo-Saxon gold and silver metalwork ever found – the Staffordshire Hoard.[10]

The pieces from the Staffordshire field, however, differ from the jewel at Loftus in a striking way. They were all fittings from weapons or were associated with a male military elite. Ripped from swords and scabbards or torn from their owners' bodies, they were the treasures of men at arms who battled and died in the kingdom known as Mercia. The Loftus jewel is no such battle trophy. It was placed in the ground as part of a burial; presumably the personal possession of the Northumbrian woman who wore it. By making such a statement through her burial, she and her community have left behind insights into their world which we can finally unearth.

Sorcery of the Smith

The discovery of gold and garnet jewellery across the length and breadth of the country not only reveals that it was fashionable in the early Middle Ages, but that it had symbolic meaning too. As groups of Angles, Saxons and Jutes crossed the seas and settled across England in the centuries after the Fall of Rome, so they brought their clothes and cultures with them. The many surviving pieces of cloisonné jewellery tied their owners back to an earlier Germanic world. They were symbols of identity as well of power and wealth.

While we have very little physical evidence to help us understand how the workshops that produced these beautiful items would have operated, the skills required to make an object as intricate as the Loftus pendant opens up new windows onto

seventh-century England. Given that workshops had no running water and jewellers had to rely on simple tools and natural light, it is quite remarkable that this kind of jewellery was made at all. One grave found in Tattershall Thorpe, Lincolnshire – the Smith's Hoard – contained tools which suggest the deceased worked with metal.[11] It was a lone burial, which reflects the respect in which smiths were held. He may have been an itinerant tradesman who died while travelling and was granted this honour by the community. Finds from his grave include an iron bell, which he would have rung to drum up trade, his tools – snips, hammerheads, tongs and punches – and scraps of metal, probably stored together in a bag. By placing these items in the ground, the community were revering him, laying his status symbols alongside his body and providing him with what he might need in the afterlife.

In the seventh century smiths were seen as powerful and important members of society. This was a hangover from the Germanic pagan religion practised across England before the arrival of

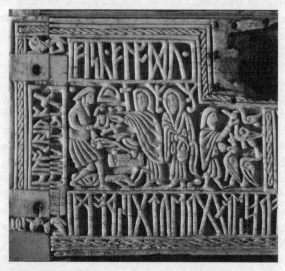

Image of Wayland the Smith from the front of the Franks Casket, British Museum.

Christian missionaries. One celebrated mythical figure was the smith Wayland. The *Poetic Edda* tells his story. Wayland was such an impressive worker of jewellery that King Niðhad wanted him enslaved so no one else could have the pieces he created. He ordered Wayland be crippled by cutting his hamstring tendons and trapped the smith on an island to produce treasures for him exclusively. But Wayland plotted his escape. He slew the king's two sons and fashioned goblets out of their skulls, a brooch from their teeth and jewels from their eyes. He then lured the king's daughter to his workshop. Here he drugged and raped her, impregnating her with his own child who would eventually succeed her cruel father as king. Wayland's vicious revenge complete, he escaped with a flying machine he'd made from birds' feathers.

Episodes from this tale were carved into the side of a whale-bone box, known as the Franks Casket, around the same time that the Loftus burial ground was in use.[12] Wayland's bent leg reveals how he was hamstrung, while he holds tongs above an anvil like those found in the Smith's Hoard. The decapitated son lies below him, while feathers are plucked from birds in preparation for his airborne get away. For a society organised around a warrior elite often on the move, small, personal, portable pieces of art – namely jewellery – were more valuable than large-scale paintings, sculpture or architecture. These jewels were the masterpieces of their time and the people who made them displayed an almost god-like ability to work metals; turning rough rocks into liquid form, then back to solid, preserved as a glittering, eternal piece of alchemical wizardry.

The Loftus jewel is a spectacular example of the smith's sorcery But it's not just the golden jewellery itself which helps us understand early medieval England; Old English literature tells us much about the symbolism of prized possessions too.[13] The epic poem *Beowulf* frequently mentions gold, given from lords to secure the loyalty of followers, with ancient heirlooms used to secure treaties and oaths. Hrothgar says he gained trust from Beowulf's father by sending 'old treasures to the Wylfings over the sea's spine; he swore oaths to me'. More relevant to our exploration of the Loftus Princess, gold is placed in the ground and protected by both a terrifying

Coins such as these were collected and prized for their material worth, and for the status of the exotic, powerful people of the past they connected back to. These were the tools of emperors, kings and rulers who controlled vast empires. The collection of 37 Merovingian coins found at Sutton Hoo were worthy of being placed in a royal burial, perhaps to provide payment to the ferryman for the crossing of the deceased's soul.[16] Using antique or imported coins to make a new piece of jewellery would capture some of that power in the very medium of gold.

The use of a backplate was a particularly innovative technique: it turned a flat, dark red stone into something magnificent by refracting light back behind it, creating a sparkling effect. The craftsmanship required to produce these punched gold leaves is astonishing. They are approximately 0.03 millimetres thick, with a stamped checkerboard pattern to produce a regular system of lines that are difficult to see with the naked eye. There are between three and five straight lines per millimetre.[17] When royal jewellers Garrard were asked in 2009 about creating a piece like the Sutton Hoo shoulder clasps – the most exceptional examples of early medieval jewellery to survive – they estimated that, with electricity, running water and 24-hour lighting, it would take a month of continuous work and £200,000 to produce just one. While the shoulder clasps showcase the highest standard of cloisonné jewellery ever discovered, the Loftus pendant is also a high-status piece. Intriguingly, it has a unique feature that sets it apart from the Sutton Hoo treasure.

The jeweller's clever techniques created a tiered effect on the Loftus pendant, so each row rises above the next. But there is a slight asymmetry between the levels, due to the irregular sizes of the garnets. This wasn't the result of a craftsman's sloppy work; instead, like the coins, the gems were taken from an earlier piece and reused in this woman's jewellery. The recycled garnets would have had to be cut to size. This was no mean feat. Garnets are hard, rating about 7.5 on Moh's scale, where talc is 1 and diamond is 10. Shaping, cutting and polishing garnet is still time-consuming today, as it requires a harder substance to rub down the surface.

Individual gems would be attached to a dop stick (a piece of wood with adhesive to hold the gem in place) and then held against a turning mechanism kept in motion by an apprentice; this created an abrasive surface. Water would need to flow across the gems as they turned to stop them overheating and cracking. The garnets were then polished until they were less than a millimetre thick.[18] To get them thin enough and perfectly cut so they fitted within their cells required delicate hands and keen eyes, not to mention decades of experience. Were these gems originally an heirloom, something precious to a family member and reset in a new context? Or was the war gear of an ancestor broken up, their memory preserved through the gems in this pendant? The fact that this woman chose to have a new piece designed incorporating second-hand stones is another example of a pattern seen across the Loftus site, where the artefacts and structures of previous generations could be reused and reappropriated.

The Symbolic Arrival of Christianity

The early medieval graves themselves were deliberately cut into a landscape that already had an ancient history by the seventh century. The site for the cemetery was not accidental – this community wanted to tie itself to the land and to the past. Close to the Loftus Princess is another woman, buried with a bead which was already about 500 years old when it was reused, set in a triangular golden fitting. And on the northern edge of the cemetery, in grave 21, two first-century coins were found alongside a string of beads. Both coins have galloping horses on one side and were carefully arranged on either side of the neck so that the horses appear to run across the chest and away from the body.

While anyone looking at the buried woman would have seen a necklace with two horses, the obverse of these coins reveals different symbolism altogether. Abstracted crosses were stamped on the faces pressing against the body. They would not necessarily have been displayed publicly but these hidden Christian symbols would

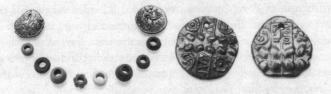

Necklace beads and two coin pendants from grave 70, Street House, Loftus
© Stephen Sherlock.

be known to the wearer. In this way they recall other objects from the so-called 'conversion period' of the seventh century, like the Eccles buckle.[19] This unassuming piece has knotted snakes and a double-headed serpent on the front – symbols commonly found on earlier metalwork. But hidden on the inside, pressed up against the wearer, is a fish. A Christian symbol, which visually represents the phrase 'Jesus Christ Son of God Saviour' (the first letters of which in Greek spell ICHTHYS/Fish), this creature only starts to appear in English jewellery at the beginning of the seventh century.[20]

The other symbol most often associated with Christianity – the cross – began to form the basis of patterns in brooches at this time too, emerging from circular designs like a Magic Eye picture. Styles were changing. Symbols were changing. And the ideological landscape of England was changing. The princess's jewel only gains its full significance when understood against the backdrop of such radical ideological, political, cultural and social transformations.

The period from the fifth to eighth centuries in England has been called a 'Dark Age' because of the lack of surviving textual evidence.[21] It's true that when the Romans left at the beginning of the fifth century, they took with them their meticulous record keeping, although some writers such as Gildas continued to record events into the sixth century.[22] We're taught that Christianity disappeared with the Romans, only to return on that date drummed into English schoolchildren; the 'arrival of Christianity' in AD 597. This was when St Augustine led a conversion mission on the

instruction of Pope Gregory the Great and landed on the Isle of Thanet in Kent. But rarely does widespread change occur on a single date or in a single moment, and the term 'arrival of Christianity' is misleading. The whole country didn't suddenly realise they had a new religion; Woden was out, and Jesus was in. History is much more fluid and organic.

Christianity had been practised throughout the British Isles since the reign of Constantine the Great (AD 272–337). Some of the most important pieces of Christian art – including the earliest depiction of Christ, the first representation of the crucifixion and the oldest liturgical items – have been found in England, suggesting the new religion was firmly embedded in the third and fourth centuries.

In AD 412, when Roman governance was withdrawn so the Empire could take care of issues closer to home, a power vacuum opened up. Over the centuries we've filled this void with legends of King Arthur and Merlin the wizard, but the historian Bede gives a version of accounts which archaeology largely supports. He describes how, following the upheaval from the collapse of Roman rule, groups from territories now roughly coinciding with Denmark and Northern Germany arrived in England and brought about wholesale change. Certainly, the language transformed. Before the fifth century, Romano-British people would have spoken a form of Celtic dialect. This practice continued in Ireland, Northern Ireland, Scotland, Wales and Cornwall, but in England, Old English became the vernacular. The impact of the incomers from German lands was huge, affecting the very language used by people in their day-to-day lives. The immigrants assumed positions of power and influence, sliding into roles left vacant when the command structures of the Roman Empire disintegrated.

They also brought their religion. Evidence for Christianity and earlier Romano-British worship disappears from the archaeological record in the fifth century, only continuing in the so-called 'Celtic fringes'. In England, new place names dominated, celebrating Germanic gods.[23] Woden, Thor and Freyja exerted a significant influence on the landscape, even influencing the names of the days

of the week to the present day (Woden's day, Thor's day, Freyja's or Frigg's day). Because this religion endorsed an active afterlife where warriors would feast and fight for all eternity in Valhalla, or live alongside the goddess Freyja in the 'people's field' Folkvangr, they started to bury their dead with grave goods. This has left modern-day archaeologists tantalising insights into the world views of the German incomers, which are only now shining new lights on forgotten individuals like the Loftus Princess.

As well as radical changes to language and religion, society transformed during the sixth century. In place of Romano-British

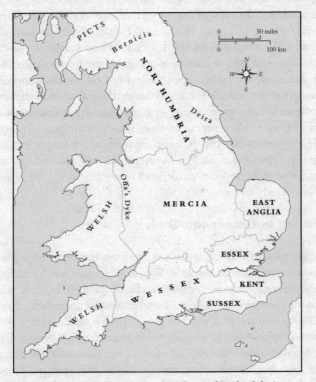

Map showing the seven major kingdoms of England during the seventh century.

infrastructure, a warrior-elite assumed rulership and distinctive king-doms emerged. At first these were small, with one leader securing the loyalty of followers and centring their control on great halls.[24] As individual rulers gained more prestige and greater armies, they extended the boundaries of their territories through war and subjugation until, by the end of the century, there were seven major kingdoms: Northumbria, Mercia, East Anglia, Essex, Wessex, Sussex and Kent. The ruler of each kingdom jostled for overall power, with Bede describing the position of 'bretwalda' or 'overlordship' shifting between individuals.[25] When Augustine, then just a frightened Roman monk, pulled up on the shores of Thanet in AD 597, the bretwalda was the ruler of that very kingdom – Æthelberht of Kent.

The choice to send a Roman mission to Kent was not acci-dental. The king was married to a Frankish Christian woman named Bertha and, thanks to its location, the heathen people of this kingdom had been interacting with the Christian continent through trade and diplomacy. Rather than a divinely inspired attempt to 'save pagan souls' as Bede would have us see it, St Augustine's sixth-century mission was a strategic attempt to bring a part of the old Roman Empire into a new 'Christian' Empire centred on the Papacy. Kent, Æthelberht and his wife Bertha were all key to the mission's success.

Women as Conversion Tools

We are used to reading about women from history as addendums to their families and husbands. We know about Queen Bertha of Kent because she was married to King Æthelberht. But while some wives barely get a mention in that most important of early medieval historical sources – Bede's *Ecclesiastical History of the English People* – Bertha features more prominently. Through Bede we learn that she was not only of royal, but also of saintly, lineage. Her grandparents were the founder of the Merovingian dynasty, Clovis I, and the celebrated Burgundian Princess, Saint Clotilde. Meaning 'famous in battle', Clotilde's name reflects the idea that

early medieval rulers – male or female – primarily held power through military might.

Like her granddaughter, Clotilde wielded considerable influence. When her sons – heirs to the Merovingian dynasty – were deciding whether to overthrow the young heirs of Burgundy and take their lands under their control, they placed the decision in their mother's hands. They sent her a pair of scissors and a sword, with the following instructions: if she felt they should peacefully back down she should choose the scissors and cut off their long hair, which represented their royal power. If she felt they should assert their power, she should choose the sword. She famously replied, 'It is better for me to see them dead rather than shorn.'[26] Clotilde was true to her name. She chose the sword. This decision brought about the murder of two young princes, aged seven and ten, killed by Clotilde's older sons on their mother's instructions. But she remained 'honoured by all' and celebrated for her humility and grace. She also influenced the Franks in the way Bertha would influence the people of Kent, persuading her husband to convert to Christianity and establishing a new Christian dynasty which would rule for over two centuries. She is still celebrated as a Roman Catholic saint.

Bertha's parents, Ingoberga and the Frankish king Charibert I, were equally influential. The sixth-century historian Gregory of Tours describes their complex marriage, explaining that they separated after Ingoberga discovered her husband was in love with the daughters of a poor wool worker. He would later go on to marry one of them, making her Queen of the Franks in Ingoberga's place. Bertha came from the broken marriage of her parents to the distant land of England, inhabited by people thought to be dangerous heathens. But she was not being cast into a void; she had a role to play, and her husband-to-be knew it.

Just over Æthelberht's Kentish border, in East Anglia a powerful pagan ruler was celebrating his links to Scandinavia and Germanic paganism to support his claim to the 'overlordship' of the English kingdoms. It has been claimed that King Rædwald may even be the individual commemorated in the Sutton Hoo ship burial.[27]

Bede emphasised Rædwald's Germanic heritage, saying he was descended from Wuffa, founder of the Wuffingas dynasty, whose family is at the centre of the English epic poem *Beowulf*. He also wrote that Rædwald had dabbled with Christianity, seeing its potential for providing new links with the continent. But rather than convert fully, he simply added an image of Christ alongside his collection of pagan deities.[28]

The finds from Sutton Hoo support this dualism. Silver bowls with incised crosses and two baptismal spoons were discovered alongside an ancestral helmet and shield. These weapons were produced across the North Sea and sent to East Anglia as heirlooms. But the overwhelming symbolism was of double-headed serpents, dragons and boars which covered the individual's head, while the ravens of Woden (complete with a tiny depiction of the god himself in garnets) protected his body. The items from Sutton Hoo are predominantly pagan with a nod to Christianity. While clearly hedging his bets, the individual buried at Sutton Hoo chose to ride aboard an enormous ship to an afterlife in Valhalla with Woden. Across the border, however, Æthelberht of Kent was aligning himself more fully with another sacred ally.

Religion has long been used as the tool of the powerful through periods of change. When the Emperor Constantine emerged victorious from the civil wars of the early third century, he launched his reign by pinning his success on a new religion – Christianity. It was the sign of Christ, the chi-rho (after the first two letters of his name in Greek), that Constantine had emblazoned on his soldiers' shields, which, in his opinion, secured his victory over Maxentius at the Battle of Milvian Bridge.[29] During his 'vision' on the eve of battle, Constantine described seeing the sign of the cross above the sun, with the words 'through this sign you shall conquer' stretching across the sky. He set a precedent. After him rulers would reinvent their dynasties through their ties with Christianity. Pope Gregory wrote to King Æthelberht about the 'fame' Constantine secured by accepting Christianity, and even compared Bertha to Helen, the Emperor's mother, who was dedicated to supporting the newly empowered religion.[30] From Æthelberht's

point of view, the church brought all sorts of additional benefits: international trade links, shared military concerns and powerful bureaucracy that could bolster a ruler's administrative power. It brought books, law codes, ancient concepts of regal potency and a new set of allies. Christianity brought power, and Æthelberht of Kent knew that.

His new wife, Bertha, was a pawn in a game of international politics, married off to create a bond between pagan Kent and Christian Frankia. In AD 580, almost two decades before Gregory the Great would send Augustine on his mission, Bertha was sailing across the English Channel with a Christian bishop by her side. But she wasn't simply a puppet on a string; she seems to have controlled her destiny to a certain extent. Bede says that Bertha insisted on being allowed to practice her Christian religion. She brought her chaplain, the Frankish Bishop Liudhard, with her and stated that Æthelberht had to provide her retinue with a church in which to worship.[31] An older Romano-British building in Kent's capital of Canterbury was reappropriated. Roman tiles, a tomb and sections of wall were built into a new structure, with most of the nave added around the time of Bertha's arrival in Kent. Like the cemetery at Street House, sixth-century English people were deliberately bringing the past into their narratives of change. Earlier Roman stones were symbolically incorporated into the first Christian church in pagan Kent.

The connection between stone and Rome seems to have carried resonance through to the early medieval period, despite centuries of incoming Germanic settlers living in wooden halls rather than brick-built villas.[32] Bertha's church was dedicated to St Martin. Bertha was raised in Tours, where the saint had been bishop and where he was celebrated as 'hammer of the heretics'. In selecting a saint honoured as a military bishop dedicated to destroying pagan practices, Bertha and Æthelberht were sending a clear message to the other rulers of the English kingdoms; Christianity was taking hold in Kent and heathens should watch out, as change was coming. St Martin's remains the oldest parish church in the English-speaking world.

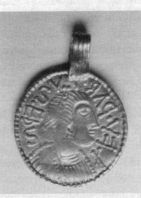

Pendant made from a gold coin showing the Bishop Liudhard, seventh
century, discovered at St Martin's Church, Canterbury.

Remarkably, the arrival of Bertha and Liudhard stamped its
mark not just through the words of Bede and the bricks of St
Martin's church, but also through a hoard of treasure. In April
1844 the antiquarian Charles Roach Smith presented a handful of
early medieval curiosities to the Numismatic Society. He explained
they had been found 'a few years hence' and were discovered
together near the churchyard of St Martin's, Canterbury.[33] Among
the pieces was a coin adapted to be worn as a pendant. It would
once have formed part of a necklace like the one the Loftus Prin-
cess was buried wearing, and it is a rare survival: the only piece of
early seventh-century jewellery found in a church graveyard. Per-
haps a member of Bertha's retinue wore this necklace to the grave,
expressing her religion through her jewellery.

The name of Bertha's bishop, Liudhard, is inscribed backwards
on the pendant, probably because the individual striking the coin,
unable to read Latin script, made the cast by copying an original.
This was then inverted when the coin was struck, and the metal-
worker did not notice the error. The pendant has been used as
evidence to show how ignorant and illiterate the early medieval
world was. But this was a simple mistake to make, especially in
England where coinage was not being regularly minted. Today the

word 'illiterate' is associated with a lack of education. But the methods of passing down information in the non-literate communities of early medieval England were incredibly sophisticated.[34] Individuals could recite poems from memory over the course of many hours, if not days. They had to retain information on bloodlines, land possession, law codes, as well as a vast body of stories, myths and history. To be illiterate was not to be ignorant, but rather to utilise more of the memory actively. It was Christianity that brought literacy and Latin to a people who had depended for three centuries on oral tradition and memory. It could be argued that with writing came complacency, bureaucracy and rigidity.

Writing and Christianity also brought control. A letter from Pope Gregory to Bertha indicates that she was already 'learned in letters'. She was clearly a powerful and influential woman with an international reputation when he wrote to her in AD 601. He praised her 'good deeds [which] have become known not only to the Romans, who have prayed fervently for your life, but also in various places and up to the most serene prince of Constantinople.' Bertha had brought about change and a new way of life to the English kingdoms; one which slowly saw the rejection of a pantheon of Germanic gods and treasure-laden burials. In the wake of Christianity came a swathe of customised buildings: churches, cathedrals and monasteries. A new way of perceiving the afterlife was also developing, where precious goods no longer needed to go with their owners into the ground. For historians, a new flush of textual evidence begins to appear after the seventh century, as scribes started recording information in manuscripts. But for archaeologists, a previously rich source of information on people from the past begins to dry up. This was a pivotal moment in history and the Loftus Princess is our window onto this time of great change.

Women Up North

Unlike Bertha, we don't know exactly who the Loftus Princess was. Her jewellery is nearly all that remains to provide insights

into her life and death. But we do know she was wealthy, influential and most probably had converted to Christianity. The clue lies at the very centre of her necklace; the main jewel carved in the shape of a scallop shell. There are no surviving comparison pieces to this gemstone, but in other contexts the shell, like the cross and the fish, carried Christian symbolism. By the ninth century it had become associated with St James, peppering the route of pilgrimage to Santiago de Compostela. But the symbol's associations can be traced back even earlier. In the classical Roman religion shells were connected to Venus, goddess of love and fertility.[35] She emerged from the sea fully formed when the titan Chronos castrated his father Uranus and tossed the genitals into the sea. Venus was not born from a woman but was miraculously incarnated in the waters. As is common in early Christian symbolism, an older meaning is replaced with a new one. The shell Venus rode on became a symbol of baptism, new and eternal life.[36]

In the mid-sixth century, just before Bertha crossed the sea to Kent, many thousands of miles away the Emperor Justinian was using Christian symbolism to bolster his power. He restored the Western Roman Empire by taking Ostrogothic- and Vandal-held lands in Northern Africa, Spain and Italy. In fact, Justinian's career could be seen as the inspiration for Gregory the Great's mission to England just a few decades after the emperor's death. Both men wanted the furthest reaches of the old Roman Empire to come under the influence of the church and the papacy.[37]

Justinian's impact on Christian art is still evident in the beautiful mosaics which survive in the churches of Ravenna in Italy – a focal point for his control of the Western Empire. In the church of Sant'Apollinare Nuovo, saints are displayed with a shell canopy above them, signifying their eternal life. The famous portraits of Justinian and his wife Theodora at the Basilica of San Vitale also feature a scallop shell, this time above the empress's head. She had probably died by the time this mosaic was completed, with the shell signifying her resurrection and new life in heaven. And while the living Justinian doesn't appear under a shell, the mosaic shows that he ordered the chi-rho to be emblazoned on his soldiers'

shields, like Constantine before him. He too was forging a strong and enormous empire. Watching from the other side of Europe, English rulers like Æthelberht of Kent would have seen in Justinian the imperial power possible when a ruler throws his support behind the Christian church.

Although these mosaics in Italy are far from the windswept cliffs of Cleveland, and Justinian and Theodora's centre of power in Byzantium is further away still, the impact of their Christian court was felt in late sixth- and early seventh-century England. A necklace found in Desborough, Kent, dating to almost the exact same time as the Loftus pendant, is similar to that worn by Theodora in the Ravenna mosaic. A taste for the empress's cabochon – i.e. shaped and polished – gemstones and Byzantine jewellery spread far, and both the owner of the Desborough necklace and the Loftus Princess were following this fashion with their own cabochon jewels. On the Kentish piece there is a cross at the centre of the necklace. On the Northumbrian necklace there is a shell. Still subtle enough to straddle both non-Christian and Christian symbolism, the wearer of the Loftus pendant had one foot in the past and one in the future.

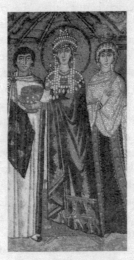

Mosaic of Empress Theodora, San Vitale, Ravenna, c. AD 548.

The Desborough necklace, made up of gold and garnet cabochon with
a central cross, late-seventh century, British Museum.

She was living through a period of religious and cultural transform-
ation when links to the Christian world were getting ever stronger.

The period between Bertha arriving in Kent and the Loftus
Princess being buried with a Christian symbol around her neck
was relatively short – a decade or two. Just as the religion travelled
to England with a woman, it was women who aided the quick and
effective spread of Christianity across the country. The role of
women in the early church is consistently underplayed, but when
it came to the conversion of the English, wives and mothers were
the ultimate tools of influence. The reason the archbishop of Can-
terbury is the head prelate of the church of England today is largely
down to Bertha. Originally Gregory the Great had intended his
mission to establish a centre in the north, at York, and one in
the south, in London. This would mirror the Roman capitals of
Britannia Superior and Inferior.[38] But the goodwill shown to
Augustine and his missionaries in Kent under Bertha's influence
seemingly affected the decision to found a major monastery and
the cathedral in Canterbury.

Bertha's son, Eadbald, was problematic. He didn't continue his
father's support for the church, instead reverting the kingdom
back to the Germanic religion when he succeeded Æthelberht.
Eventually he did accept Christianity, but it took a second papal
mission, hot on the heels of the first, to embed the religion more

thoroughly in Kent. The new faith was constantly gaining and losing ground through the first half of the seventh century as individual rulers accepted it, only for their children to reject it once they died. But while her son didn't follow her grand plan, Bertha's daughter Æthelburg did.

Like her great-grandmother and mother before her, Æthelburg was sent away in marriage to a pagan king. In AD 625 she travelled north, past the firmly pagan territory of East Anglia, into Northumbria. Here she married Edwin, whose successful reign saw him unite the two kingdoms of Deira and Bernicia into one large and dominant northern powerhouse. Æthelburg also brought a bishop with her as part of her marriage arrangements. Edwin had to accommodate the Roman missionary Paulinus, and Bede describes how this fervent individual set about converting the women of the Northumbrian court. Æthelburg's daughter, Eanflæd, was the first person baptised by the Roman mission in Northumbria. Eanflæd would go on to play an important role in the newly emerging northern church, marrying her father's successor and then becoming the first abbess of the freshly founded double monastery at Whitby. This princess's baptism set a precedent that other noblewomen of the north would follow.

Buried in a Bed

At the moment of the Loftus Princess's burial, Christianity was spreading across the country as Paulinus converted royals in the north and new monasteries sprang up throughout the land. We know that Christian burials don't tend to include grave goods, but it takes time for dearly held practices to be replaced. If someone has spent their life thinking about death and the afterlife one way, then are expected to bury their own loved ones in a different way, there will be periods of transition with older traditions still persisting.[39] The earlier burials with weapons, buckets of food, and fine clothing slowly gave way to simple Christian burials, with bodies wrapped in just a shroud. The idea of an afterlife where material

wealth was needed, was replaced by systems of inheritance, whereby beautiful and prized possessions would be left to the next generation rather than buried in the ground to serve the dead. The cemetery at Loftus is a final flicker of the old ways; a moment in time captured in the earth.[40]

Described as a 'Final Phase' burial, grave 42 at Street House has Christian symbolism, continental fashion, and Germanic goods all wrapped up together. Most significantly, however, is the fact the woman was buried in a bed. Even today, a bed is one of our biggest expenses when furnishing a house. To put such a well-made piece into the ground, rather than reuse it, was a commitment by the people of Loftus to honour this important woman. It would have taken physical exertion to dig a large enough hole and lower down the bed. This sort of dedication to burial reaches its peak in the spectacular ship burial of Sutton Hoo, where alongside the cloisonné jewellery and Merovingian coins, a whole ocean-ready boat 27 metres long was put in the ground. But the Loftus Princess is not sailing on the eternal seas like the royal buried in East Anglia. Rather she is laid out to sleep for all eternity. The word 'leger' in Old English meant both 'bed' and the grave – 'a place where one lies' – so a bed burial would give an individual the ritual and ceremony of a Germanic burial with grave goods, while honouring the new beliefs introduced by Christianity.

It only seems to be noblewomen in the seventh century who were given the honour of a bed burial. Over a dozen have been found across England, with Loftus as the most northern example. All fit the cast of 'Final Phase' burials which include both pre-Christian and Christian elements. At Shrublands Quarry in Suffolk, a woman was buried in a bed wearing a necklace which had a reused Frankish coin complete with cross symbol, as well as three amethyst cabochons. Some bed burials show a complex array of objects placed around the woman, such as the grave from Edix Hill in Cambridgeshire. This young woman, who was between 17 and 25 years old and had leprosy, was buried with a collection of curiosities, including swords, knives, a spindle whorl, a sea-urchin fossil and some sheep anklebones.[41] A more explicit

association between Christianity and female bed burials is found in the delicate pectoral cross discovered alongside iron cleats in Ixworth. One of the most stunning pieces in the Ashmolean Museum's early medieval collection, this cross displays all the technical mastery of finds from Sutton Hoo and the Staffordshire Hoard, but couldn't be clearer in its Christian symbolism. This is an equal-armed cross, and the woman was buried with it around her neck to show how she aligned herself explicitly with the new religion.

An exciting excavation in 2011 at the village of Trumpington, Cambridge, brought another gold and garnet cross out of the ground. Yet again it was in the bed burial of a seventh-century noblewoman. Alison Dickens led the team of archaeologists from the University of Cambridge; the team originally expected a site with prehistoric remains and instead uncovered an early medieval settlement. Among the outlines of seventh-century buildings were four graves and, like at Loftus, the landscape at Trumpington showed centuries of use for living, ritual activities and burial. The team first discovered iron cleats, before uncovering the human remains of a woman around 16 years old. Nestled on her chest was an exquisite gold and garnet pectoral cross. It was a huge discovery and added another layer to our understanding of Final Phase burials.

Moving back up north, both the Ixworth and Trumpington crosses have many similarities with another secreted grave goods, buried with one of England's most celebrated saints. Few individuals received such adulation in Bede's *Ecclesiastical History* as St Cuthbert (c. 634–687). In fact, the historian wrote two separate works, one in prose and one in poetry, on the life of this famous Northumbrian bishop. For Bede, Cuthbert brought together the most important elements of Christianity in the north during the tumultuous seventh century. The two men are now buried together in Durham Cathedral, the remains of early medieval Northumbria's most famous bishop and historian huddled together in the grave.[42] It was Cuthbert's commitment to converting the English that Bede most admired:

For he [Cuthbert] not only provided an example to his brethren of the monastery, but also sought to lead the minds of the neighbouring people to the love of heavenly things. Many of them, indeed, disgraced the faith which they professed by unholy deeds; and some of them, in the time of mortality, neglecting the sacrament of their creed, had recourse to idolatrous remedies, as if by charms or amulets, or any other mysteries of the magical art, they were able to avert a stroke inflicted upon them by the Lord.[43]

Bede's caution against 'amulets' is ironic, since nestled within Cuthbert's coffin, under many layers of burial shrouds, one such talismanic object was discovered. In the ninth century his body, hidden inside his wooden coffin covered with Christian carvings, Latin inscriptions and runes, was carried from Cuthbert's heartland – the monastery of Lindisfarne – via Chester-le-Street, to escape the attacks of Viking raiders.[44] When Chester-le-Street was also under threat of Danish invaders at the start of the eleventh century, the coffin was firmly entrenched at Durham, where it has remained ever since. The huge Norman cathedral that grew up around his shrine testifies to the veneration in which he was still held after the Conquest, and many pilgrims visited the saint. Little

Pectoral cross of St Cuthbert, buried in his coffin,
c. AD 687 Durham Cathedral.

did these tens of thousands of visitors know, but Cuthbert had a secret object with him all along.

In 1827 the coffin, by then enclosed like a Russian doll inside generations of subsequent wooden layers, was finally removed, opened and analysed. The best surviving early English medieval textiles in existence were found inside, as well as the Stonyhurst Gospel Book and a sacred comb. This may well have been the one used by the priest Alfred Westou, who during the early eleventh century repeatedly combed the hair of Cuthbert's incredibly well-preserved corpse.[45] The coffin had clearly been opened many times, with the incorruption of the saint's body noted as a sign of his divinity. But on each occasion they seemed to have missed the little lump of gold hung around his neck. Only when the bones were taken from their shrouds did it appear. Already old and repaired when it went into the ground, Cuthbert's pectoral cross sits well alongside those buried with women in Ixworth and Trumpington. The first wave of English converts to Christianity expressed their new-found faith through these personal possessions. As with the antique coins found in the other woman's grave at Loftus and the princess's own pendant, it seems these objects could both conceal and reveal. Cuthbert lived as a hermit and a monk but hid this high-status piece of Germanic jewellery inside his robes.

Northumbria was a particularly interesting melting pot in terms of Christianity. Paulinus's mission attempted to bring Roman Christianity to the royal house of Northumbria through the conversion of Edwin. But some time before this, Irish missionaries had been working their way across the northern borders, establishing Celtic institutions and exerting considerable influence over individual rulers. Cuthbert's own monastery of Lindisfarne was founded as a west-coast satellite of Iona. This important Celtic monastery had been established by St Columba in AD 563 – decades before Augustine arrived in Kent. All along the northern part of England, Irish missionaries were making inroads and setting up monasteries that were different to the Benedictine ones spread by the papacy. They were unique powder kegs of seemingly unorthodox practices, even differing in how they calculated the date of Easter.

Born from the earlier wave of Christianity which took hold in the Celtic fringes when the Romans left in the fifth century, the power of Celtic influence in the north explains why Edwin, his Kentish wife Æthelburg and Bishop Paulinus went in hard with converting the region to Roman Christianity. The different worlds reconciled in the person of Cuthbert. He combined a Germanic warrior youth with an early religious career in the Celtic monastery of Melrose, then later a commitment to Roman Christianity during his time as Bishop of Lindisfarne. But it would take a woman – Hild of Whitby – to finally embed Roman Christianity in the north.

Hild and Mentoring

Like that great converting queen of the Franks, Clotilde, Hild of Whitby's name means 'battler'. She was born around AD 614 into the royal family of Northumbria. Her great-uncle and aunt were King Edwin and Æthelburg, Bertha's daughter, and she was brought up at their court. She was a princess and would have been a useful pawn in the marriage plans of the Northumbrian royal houses. To understand the world Hild grew up in, we can explore the site of Yeavering in Northumberland. Only discovered in 1949 when a particularly harsh summer had scorched the fields and revealed the outlines of an early medieval complex, it is most likely the site of Ad Geferin, the royal palace where Bede describes Paulinus preaching and baptising in AD 627.[46] Two huge wooden halls form the centre of the site, with a large walled enclosure to the east (probably for collecting cattle for food and taxes), and a platform with raised seating to the west. It appears to be some sort of auditorium for Paulinus himself to preach Christianity to the people of the north, the archaeological evidence supporting Bede's written account. Yeavering is close to the river Glen, where Bede says Paulinus baptised many, so once again text and archaeology come together to illuminate this tantalising moment of mass conversion.

The site at Yeavering, like Loftus, made use of older Mesolithic,

Neolithic, Bronze and Iron Age remains on the landscape. On the peak at Yeavering Bell, a large hillfort revealed a settlement with over a hundred roundhouses by the first century AD.[47] This was a place in the Northumbrian landscape where an English leader with Germanic roots, like Edwin, would encounter people from different ethnic backgrounds.[48] He could hear the concerns and gather the taxes of the people of his kingdom, including those who tied themselves back to Romano-British relatives, and further still, to Celtic tribes. The buildings that formed Edwin's court, however, were firmly those of Anglo-Saxon kings and queens, and the largest hall would have been reminiscent of Hrothgar's hall, Heorot, described in *Beowulf:* 'The building in which that powerful man held court was the foremost of halls under heaven; its radiance shone over many lands.'[49] Four buildings in the complex had floor areas of up to 300 square metres. These were labelled 'Great Halls', and with their lofty vaulted wooden ceilings they would have been huge, impressive spaces.

Here the warrior class would live, dine, travel and fight together, the loyal retainers sleeping around the mead benches while the king, queen and royal family retired to the smaller hall. The royal court would move between centres like that at Yeavering, stopping to receive taxes in livestock and supplies from the local people, on a cycle of visits that kept the king connected to his subjects. As a member of their court, Hild may well have travelled with them. She would have been brought up listening to the boasts of warriors, the tales of heroes and the myths of Woden, Freyja and Thor. She was a warrior princess. However, Bede states that at 33 – the age at which Christ died and halfway through her own life – Hild embraced Christianity. She had wanted to travel abroad to a monastery in Gaul, but she was seen as an asset to the conversion efforts in northern England and made abbess in Hartlepool. She was following in great footsteps, as her predecessor, Heui, was the first woman in Northumbria to become a nun and found a monastery in AD 640.[50] Hartlepool was the centre of a network of convents which spread across the landscape, all headed by strong-willed noblewomen of Northumbria.[51]

Excavations at Hartlepool have revealed interesting details of how these early converts in the north commemorated their dead. There were four cemeteries in use simultaneously at Hartlepool, serving different functions and communities. The Church Walk cemetery contained the graves of men, women and children, indicating this was for the local population. In a time of great change, it is understandable that communities would be made of a mixture of people, some who wanted to be buried according to older traditions, while others wanted to embrace the new. There was also an influx of people from outside the kingdom: foreigners like missionaries and members of monastic communities who could move hundreds of miles to take up religious positions across the country. The complex burials at Hartlepool reflect complex communities, with people of different backgrounds, classes and beliefs each wanting something different in their eternal rest.

Nearer to the sheer cliff face, a collection of female graves was discovered. This was most probably the earliest cemetery space for the nuns, called Cross Close. Like the Loftus Princess, the newly converted noblewomen at Hartlepool were buried on a windswept headland, surrounded by the sea, and were also laid out as if in eternal sleep. Some had pillow stones beneath their heads. Significantly, though, these nuns were part of a literate community, as eight of the graves had headstones inscribed with women's names. Stone and Rome. Literacy and The Church. The symbolic connections are clear.

Other finds from Hartlepool suggest that this early monastery, founded by a woman in the seventh century, was a place of wealth, privilege, power and learning. A gilded hairpin may have belonged to one of the nuns. Its imagery is not Christian, but more reminiscent of the interlacing biting beasts found on the Sutton Hoo treasures. This was an expensive item, designed to display the owner's status. Despite Bede's claims that no one at Hild's monasteries was rich or poor, holding 'all things in common', early English medieval convents were not places of simple living and modesty. These first-generation converts did not have to give up all the luxuries of their secular lives, and as wealthy noblewomen,

they brought their finery with them. This pattern continues 40 miles down the coast at Whitby.

Hild moved from Hartlepool to the site known then as Strenae-shalch and now as Whitby, in AD 657. Here she was granted land to build a double monastery where both men and women could learn the scriptures and dedicate themselves to a monastic life. An engraved stone slab commemorates her successor as abbess, Ælf-flæd, and the use of the Latin script and alphabet supports Bede's suggestion that Whitby was a centre of learning and literacy. But like at Hartlepool, finds from Hild's abbacy include many luxuries such as decorative hairpins, golden book covers and even a comb with a runic inscription.[52] Runes were the alphabet of the pre-Christian English, but the inscription is clearly Christian: 'My God. May God Almighty help Cy . . .' Again, we find an object which links the Germanic warrior world to the new Christian one. Like Hild herself it straddles ideologies and a time of transition.

Hild was at the top of the tree in terms of influence in seventh-century Northumbria. Bede states that 'even kings and princes sought and received her counsel', and she acted as mentor to the daughter of Oswui, King of the Northumbrians from 642–670. What's more, it was under her rule, in the monastery she founded herself, that the leaders of the English church gathered for the famous Synod of Whitby in AD 664. With Hild in charge of pro-ceedings, the good and the great, representatives of Rome and Ireland, argued which traditions the Northumbrian church should follow.[53] The result went the way of Rome. The variety and uniqueness of Celtic monasteries was lost to the rigour and rou-tine of the Benedictine Rule, and monasticism in the north was transformed forever. For a woman to be involved in such high-level synodal processes is something extraordinary even today. It is also significant that five men who trained under Hild were all made bishops; if there were king-makers in the medieval world, then she was the bishop-maker. Whitby was the training ground for a new, Roman Christian, learned and respected English church. From Hild's northern headland, educated men and women would stretch out the length and breadth of the country,

assuming the very highest positions within churches and monasteries, including the archbishop of York.[54] Hild's influence would permeate the fabric of Christianity in this part of the world and its effects were felt down the centuries.

Hild's influence brings us back to the Loftus Princess and the status represented by her gleaming pendant. Bede records how Hild's importance within the church was told to her mother in a dream of a brightly shining necklace:

> She found a most precious necklace under her garment, and whilst she was looking on it very attentively, it seemed to shine forth with such a blaze of light that it filled all Britain with the glory of its brilliance. This dream was doubtless fulfilled in her daughter that we speak of, whose life was an example of the works of light, not only blessed to herself, but to many who desired to live aright.[55]

That a necklace connects Hild and the Loftus Princess is a happy coincidence. The Loftus burial site is just 18 kilometres from Whitby along the ancient Cleveland Street. The village of Easington, just a kilometre south of Street House, may be the site named by Bede as 'Osingadun'.[56] An important meeting took place here between St Cuthbert of Lindisfarne and Hild's successor, Abbess Ælfflæd of Whitby. The two feasted on land which was described as 'a possession of her minster'. Loftus could very well have been part of the Whitby monastery's estate.

It's highly unlikely that we will ever know for sure whether the satellite community ruled over by the Loftus Princess was tied to Hild and Whitby. But what these seventh-century northern women do reveal is that joining the Roman church in the first flush of conversions was a way of gaining power and influence. These noblewomen could bypass marriages arranged for the purposes of securing allegiances and creating heirs, and instead form their own centres of learning where they could be rich, respected and remembered, with the same opportunities as the men around them. They could shape their future and those of their communities. This was

a singularly positive time for women in the church and the Loftus Princess, Hild, Ælfflæd and others reaped the rewards of the new faith.

Legacy of the Loftus Princess

The Loftus Princess's grave was deliberately placed as a focal point of the cemetery. She was buried in a designated 'shrine' area, with a processional route leading mourners and pilgrims past her burial mound and out the back – a form of early medieval crowd control. Her burial would have involved various rituals and ceremonies, as first the bed, then the woman, was lowered into the ground. Shards of pottery and glass were then placed around her head, and finally, a mound designed to be seen from afar was raised up over her. It's clear her community venerated her. As later pilgrims would visit sacred sites and leave votives to a saint, so it seems the people visiting the burial at Loftus left scraps of heirlooms around the head of the princess.[57]

But the fields at Loftus, cultivated by humans for over 4,000 years, were abandoned shortly after the princess and her community were buried there. As we've established, the period she lived and died in was one of religious, cultural and social change. The 'old gods' were under threat as a new belief system from the continent was edging further into the landscape. Burying newly converted Christians within and alongside older prehistoric and Roman monuments was not accidental;[58] this act deliberately ties this woman and her community to the landscape. Both permanence and change are in evidence at Loftus. Although we are not afforded much written evidence, the woman at the heart of this site is the gateway through which, centuries later, we can glimpse this transitional moment.

But written evidence does allow us to say for sure that where people were buried was important. Bede describes a community of seventh-century nuns choosing their cemetery after being guided by a miraculous light:

But that resplendent light, in comparison wherewith the sun at noon-day might seem dark, soon after, rising from that place, removed to the south side of the monastery, that is, to the westward of the chapel, and having continued there some time, and rested upon those parts, in the sight of them all withdrew itself again to heaven, leaving no doubt in the minds of all, but that the same light, which was to lead or to receive the souls of those handmaids of Christ into Heaven, also showed the place in which their bodies were to rest and await the day of the resurrection.[59]

The Venerable Bede has been quoted throughout this chapter as the primary source of events for the seventh century in Britain. He is a singularly important writer and many of his claims have later been substantiated by other discoveries, both in archaeology and further documents. He was a monk, a scholar and a teacher. Traditionally his *Ecclesiastical History* has been seen as concerned with the lives of 'great men' – bishops, warriors, kings. But it does, in fact, feature powerful, influential, significant and important women throughout. If, when reading Bede, we ignore these medieval women we lose an important layer of detail, as his world is one in which they mattered.

He includes hymns to Queen Ethelthryth, ascribes miracles to the nun Eadgyth, and declares Hild 'the most religious handmaid of Christ'. The women in his world were worthy of note and some changed the course of history. Combining Bede's texts with the rich archaeological discoveries from seventh-century sites like Loftus, Hartlepool and Whitby makes clear that the seventh century was even an empowering time for women. While so much has been lost, looted, or still remains under layers of soil, archaeological evidence gives voices and an identity to the many women who have been overlooked. While men have been searched for in the archaeological record, women have not. Now we are finding them we can build a new picture of this period and present a host of literate, influential and important women who had an impact on the communities around them.

Women like Hild chose to join monasteries, rising to positions of great power as abbesses, gaining wisdom and influencing decision-making within the newly emerging church. They had a choice and they embraced lives that brought them in touch with the Christian continent, with new ideas, beautiful art and architecture, and a world of stories, saints and sinners that would change the ideological landscape of Britain long-term. Not until the last decades have women been able to assume such roles within the modern church, but for a short time in the seventh century they were the movers and shakers. Despite not being recorded in history, the Loftus Princess was another one of these powerful women, and through her we gain a surprising view on life in seventh-century northern England. While some women have not left their mark on the written record, their truth is still there waiting to be discovered. We just have to dig for it.

2

Decision Makers

Discovery!

August 2021 – Cookham, Berkshire, England

On the leafy banks of a particularly picturesque stretch of the River Thames in the sleepy village of Cookham, a team of archaeologists, supported by willing locals, sift through barrow-loads of soil, working against the clock. Dr Gabor Thomas, who instigated and now leads the dig, is following a hunch. Medieval texts report that one of the most influential women of the eighth century, Cynethryth, became abbess of a monastery somewhere along the river by the contested border between the kingdoms of Mercia and Wessex. It's where she lived out her final years and was most likely buried. But the monastery is thought to be 'lost'. Now Dr Thomas wants to 'solve this mystery once and for all'.[1] They only have two weeks to dig and return the site to its original state. They need to move fast.

After two days the machines have done their work, pulling back the turf and top layers of soil. Now it's the turn of brushes and trowels. Finds are emerging thick and fast from the rectangular trenches scattered across a field overlooked by the tower of Holy Trinity Church, just 50 metres away from the largest trench. It is this building which brought the team to Cookham. A wall behind the altar is made up of reused Saxon stones, and it is clear the site had served a religious function for over a thousand years. But as the large postholes appearing like black stains on the soil suggest,

the earliest buildings here were not stone, but timber. The meticulous process of scraping and brushing continues, and the outlines of long-lost wooden buildings start to emerge. There are also treasures, not in the sense of sparkling gold and cloisonné jewels, but rather archaeological treasures that build a picture of a real eighth-century environment.

One archaeologist prises up a delicate copper alloy bracelet that once would have gripped the wrist of a high-born lady at the monastery, or perhaps even a child, before falling to the ground to be hidden for over a millennium. A dress pin, now bent out of shape, would have fastened the cape of another woman, her colourful gowns a sharp contrast to the plain habits of later medieval nuns. Broken pottery shards give a fragmentary impression of elaborate jugs and goblets that would once have held food and drink, shared by guests around a table. The bones of large animals, including cows and sheep, are an echo of great feasts once held in the hall, and small green flecks on otherwise unimpressive lumps of material are evidence of slag for copperworking. Another important find, a small iron axe head, suggests this was not simply the peaceful retreat of devoted religious men and women, but rather a site of industry, of political and militarily strategic importance.

As the jigsaw puzzle of trenches is mapped carefully onto laptops and finds are gathered into plastic bags, it becomes clear that by the eighth century a complex of buildings had spread across the now-empty field. In the centre a large wooden hall presided over the site, with a lofty oaken roof and space inside to feast, sleep and pray. Around this hall smaller timber structures are picked out, each separated from the other by ditches. Some of the smaller buildings contain evidence of hearths and may have been used to smelt metal, while others may have been scriptoria for writing, huts for working leather or weaving, wards for treating the sick, or housing for guests. This is a town in miniature revealing the full industrial capabilities of an early medieval monastery.

Monasteries, convents and double monasteries like the one at Cookham, where men and women lived and prayed together,

were political, social, artistic and cultural hubs. They were run by the most powerful people in the country, and were the nexus of education, medicine, science, technology, writing and both secular and religious influence. This establishment, overseen by Abbess Cynethryth at the end of the eighth century, would have rivalled the royal court in terms of luxury and wealth.

As the short dig ends and volunteers hurry to replace turf to give the impression they were never there, metal-detectorist Jim Mather makes a final discovery: a tiny Anglo-Saxon coin, called a sceat.[2] Minted between AD 680 and 760 as some of the first coinage issued in the early medieval period, the sceat gives the team a 'terminus post quem' – a starting date. This is just an initial investigation, but Thomas is confident about what they have discovered. 'We are thrilled to find physical evidence of the monastery Cynethryth presided over, which is also very likely to be her final resting place.' A tantalising thought. Somewhere on this site may lie the bones of one of England's most influential eighth-century women. If discovered, DNA analysis could be conducted to reveal information about her diet, health and lifestyle. It might even be possible to reconstruct her appearance. But all these 'what-ifs' must wait. Further digs will take place in the coming years. A clearer picture of Cynethryth's monastery will emerge and with it, a view of the early medieval world that could further challenge assumptions. This is just the beginning.[3]

Welcome to Eighth-Century Mercia

An island, built on layers of gravel, rises out of the river at a curve in the Thames. On the banks people rinse out clothing, gather water in buckets and load goods onto small boats. Smoke drifts up from fires across the site, while the thrash of anvil on metal pounds out from behind wattle and daub walls. The wooden hall that dominates the landscape is decorated with interlacing beasts carved into the oak ridges. The building resembles those sung of by poets. Like Heorot, Hrothgar's legendary hall from *Beowulf*, this is:

> A great mead-hall, mightier than any ever heard of on earth . . . craftsmen came from far and wide from many tribes to work on the hall.

Walking towards the wide doors, the promise of a lord to his retainers entices visitors to the warm light within:

> There, as he had promised, he held feasts for his people, gave out gold rings and other gifts. Poets sang to the sound of the harp. The hall-roof was high over the heads of the feasters.

This hall on the edges of the kingdoms of Mercia and Wessex also resounds with the noise of feasting and the song of poets. But rather than the plights of knights and battles against dragons, the words shared around this burning hearth tell of a different lord – the lord of heaven. Instead of battles with enemies, stories of saints against demons entertain those within. Rather than the berserker Beowulf tearing Grendel's arm from its socket, the audience listen in raptures to St Judith's beheading of Holofernes. For this is a monastery, not a mead-hall.

The walls are plastered and painted in bold colours, with angels holding banderols and saints bearing their symbols. St Catherine clings to her wheel, Helena holds the true cross, and Margaret of Antioch suppresses the devil. Their miracles and martyrdoms spread onto embroidered panels that insulate the hall and sparkle with golden thread in the flickering light. These saintly super-heroes have taken the place of warriors, and a surprising number of women feature in this new spiritual universe.[4] In the centre of the hall a finely dressed lady presides. Jewels glisten on her chest and rich fabrics of many colours cling to her elderly frame.

Attention is focused on her. Men in tunics present swathes of vellum which she carefully reads before signing in black gall ink with a feathered quill: 'Cynethryth, by the Grace of God, Queen of the Mercians'. Messengers roll the parchments ready to take to their horses and ride west along the river, towards the other monasteries that pepper the edges of the Thames. Cynethryth is

approaching her fifties and her decades as co-ruler to the powerful Offa of Mercia have etched their lines on her face. Now a widow, she owns this micro-town of Cookham outright and coordinates everything from religious worship to the trade up and down this stretch of the river.[5]

Called 'Abbess' by the men and women around her, she has double power in this double monastery. She is both spiritual leader and lady of the land. Although drawing to the end of her life, she still has work to do, decisions to make and lives to influence. Her echo will pass down the centuries in just a clutch of coins, a handful of references and the imprint on the earth of her great hall. But from these fragments we can uncover not just this one woman, but those women of Mercia who determined the shape of nations.

Women of Mercia

One of the few scholars to pay sustained attention to Cynethryth says: 'If the political women of the Early Middle Ages demand our attention everywhere, they certainly should receive it in the history of the Mercian kingdom.'[6] The greatest of the four Anglo-Saxon kingdoms in the eighth century, Mercia had a different approach to women in power than the neighbouring kingdoms of Wessex, Northumbria and East Anglia. In the huge region stretching from the Humber in the north, down the Welsh border to the Thames, women could sign charters, own land in their own right, and co-rule with their husbands. What's more, through the increasing reach of monasteries founded by female members of the royal family, Mercian women could navigate their way into politically expedient positions as prominent decision makers.

While she was hugely influential in her lifetime, Cynethryth is relatively unknown today. Remembered as the wife of Offa (still famous for the enormous earthwork raised in his name along the English–Welsh border) she ruled jointly with him for over 25 years. Offa's legacy as ruler is recorded in the sophisticated coins

Silver penny of Queen Cynethryth, c. AD 790.

that survive from his reign. His wife Cynethryth is the only early medieval woman in the West to have her own coinage minted. On these incredibly rare artefacts found across England, her profile portrait gives a stylised view of what she looked like, rather than a faithful reproduction. Nevertheless, they remain the earliest depictions of an English queen.

Next to her image, Latin letters spell out 'Eoba', the name of the moneyer who minted the coin. He was based in Canterbury, Kent, which had only recently been annexed to Mercia in 764. Her influence had reached these new corners of the kingdom fast. It is possible the coins were minted for her own use, although the fact that they are found across the country in every kingdom suggests they had wide circulation. More likely, the choice to feature Cynethryth rather than Offa was a strategic move to distance the newly subjugated people from the individual responsible for their subservience. Depicting the queen rather than the king on coinage was one way to placate a newly conquered kingdom. 'Cynethryth Regina M.' appears on the reverse – the same title she used to sign charters: 'Cynethryth Queen of the Mercians.'

Two thousand miles away, another powerful woman was also minting coins with her image pressed into metal. In Constantinople (now Istanbul) the Empress Irene had, over a period of thirty years from 775 to 802, progressed from queen consort, to regent for her son, and finally to sole ruler. Offa and Cynethryth, at the

Gold solidus of Empress Irene, c. AD 800.

edges of the known world, were well aware that there was a woman at the very heart of power in the East. Irene's supporters had gouged out her own son's eyes to secure her position as sole ruler, and with her rivals out of the way Irene demanded she rule not as empress, but as emperor. She signed her letters with this title and even had coins minted referring to the ruler as 'Emperor of Rome'.[7]

On Irene's coins her forthright frontal pose, jewelled crown, orb and sceptre are distinctly Byzantine. But Cynethryth and Offa modelled their coins on a different image – the Roman imperial rulers of the West.[8] Although this idea of 'Romanitas' – tying a dynasty back to the imagery and power of Rome – was a technique employed by many early medieval rulers, the elegance and artistic quality of the portraits on Cynethryth and Offa's coins set them apart.[9]

The view from Rome itself was unambiguous; this controversial Byzantine woman by no means represented the Roman Empire nor the new power holders of Rome, the popes of the Vatican. Threatened by her influence, Pope Leo III threw his support behind Charlemagne as Emperor of the West and on Christmas Day AD 800, declared him Holy Roman Emperor. The threat of this powerful woman in the East had to be subdued at all costs.

Like Mercia, the new Carolingian Empire under Charlemagne

defined itself in relation to the old Roman Empire.[10] Classical texts, artworks and architecture were all embraced and emulated during this eighth-century Renaissance. To strengthen resistance to Irene, Charlemagne reached out to Offa and Cynethryth through letters, even offering his son Charles in marriage to their daughter. In an act of brazen one-upmanship, Offa displayed his arrogance on the world stage by suggesting his son Ecgfrith should also marry Charlemagne's daughter Bertha. This led to a break in friendly relations between the Holy Roman Empire and Mercia, although Charlemagne's right-hand man, Alcuin, continued to show affection and respect for Cynethryth, describing her as 'controller of the royal household' and referring to her as 'dear lady'.[11] He even suggests that she was so busy 'about the king's business' that she barely had time to read his letters.[12] Cynethryth commanded respect on an international scale.

Coins don't just tell us about someone's influence: they are among the most fascinating and useful of all historical artefacts. If discovered in an archaeological site they provide dating evidence, and the materials and alloys used reveal information on metalworking and systems of exchange. Their imagery is an art-historical goldmine, with symbols and styles indicating cultural links. And the combination of text and image can reveal ideological issues of importance to kingdoms, states and nations. One coin minted during Offa and Cynethryth's time as rulers reveals more than most. Struck in 774, the template is that of the golden dinars produced under the powerful Abbasid caliph Al-Mansur at the same time.

This coin indicates that the Mercian court was in contact with Islamic lands and sought to directly copy their style of inscription, even if the English version indicates little knowledge of written Arabic. The text has minor errors, with 'Offa Rex' inserted upside down in relation to the script. First recorded in a salesroom in Rome, it could have been minted to trade with Islamic Spain, or perhaps as part of an offering to the pope from the overtly Christian Offa. Like Charlemagne, Offa wanted the support of the papacy for his reign and kingdom. This little object opens a

Umayyad gold dinar of King Offa, c. AD 790.

window onto an eighth-century world which was interconnected across religious divides and boasted trade links thousands of miles long.[13]

While Cynethryth's court had far-reaching connections, closer to home it represents an important moment in the founding of an English nation.[14] Cynethryth's name is revealing in itself: the first element 'Cyne' means 'royal' or 'ruler'. Her standing was different to that of the wife and daughters of the last pagan king of Mercia, Penda, who ruled from AD 626–55.[15] He maintained his paganism at a time when other kingdoms, including Northumbria, were converting to Christianity. This has meant his treatment by written sources, particularly Christian writers like Bede, is condemnatory.[16] Nevertheless, his defeat of King Oswald of Northumbria created the uber-kingdom of Mercia. Like his wife, Offa also claimed descent from Penda, so to marry someone with ties to the Mercian royal house would have reinforced his position. What's more, by consistently raising up his wife and allowing her power in her own right, Offa was creating a Mercian dynasty. To empower her was to strengthen his own position.

Cynethryth's role as mother was also pivotal to her increasing influence. With the birth of an heir – her son Ecgfrith – she entered the political sphere, co-signing and witnessing documents as queen. Although Ecgfrith would go on to succeed his father as king of

Mercia, he died after just five months of rule, and Cynethryth would outlive both husband and son. Arguably it was her daughters who became the more important nation-builders. Cynethryth negotiated marriages and positions as monastic leaders for all four of her daughters. By doing so she tied her family to rulers of the separate kingdoms and secured their status as saintly queens. Æthelburh became abbess of Fladbury, continuing her mother's example of holding land and running a religious community. Eadburh was married to the king of Wessex, while another daughter became queen of Northumbria through her union. These women were the glue that helped hold together ever-fractious regional relations.

It is a sign of how highly women were valued in Mercia that all four of Cynethryth's daughters were also listed at witnesses to charters – something almost unheard of across early medieval England. Cynethryrth's role was unparalleled at the time, and her signature – 'Queen of the Mercians by the Grace of God' – suggests divine rulership, an idea that was still embryonic in the West at this time. No other non-Byzantine woman from the rule of Emperor Constantine in the fourth century to the ninth century carried this title.[17] The royal couple worked together, founding monasteries to exploit the new opportunities open to them. They established religious communities, which they dedicated to St Peter, across many territories. These included sites in Bedford, Bath, Northampton, Westminster, Peterborough and more.[18] The spread of monasteries across Mercia in the eighth century was not simply a pious and religious act, but a financially and politically expedient one too. During Cynethryrth's life Mercia was expanding to become not just the most dominant kingdom in Britain, but a serious player on a world stage.

Mercian Overlordship

It may seem like a simple point, but the way we conceive of nations is a relatively recent concept. The accurate mapping of the globe was not possible until after the Age of Discovery in the sixteenth century.[19] Then maps were developed to depict the

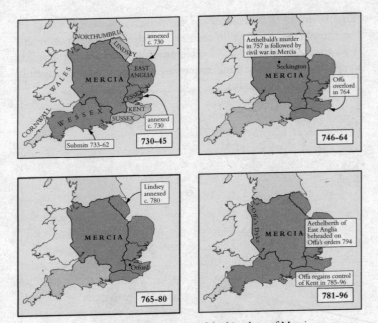

Maps showing the expansion of the kingdom of Mercia
during the eighth century.

geography, borders and boundaries of countries pictorially from
an aerial view. Before this, national identities were forged along
different lines.[20] Factors like language, religion, natural features
and shared history then, as now, were ways of developing a shared
sense of nationhood. But in the early medieval period loyalty was
to a ruler rather than to a country, and kingdoms would shift their
borders regularly. What we refer to as the United Kingdom was,
in the sixth century, a cluster of many groups each defining them-
selves in opposition to those on their borders. These had coalesced
into the major kingdoms of Northumbria, Mercia, East Anglia,
Kent, Essex, Sussex and Wessex by the time Bertha drew up on
Bretwalda Æthelberht's shores of Thanet in 580.

Over a century after Bertha's arrival, the historian Bede paints
a picture of 'overlordship' following the path of Christianity, with

Æthelberht in Kent ceding to the newly converted kings of Northumbria.[21] He had his reasons for pushing this narrative; he was, after all, writing an 'Ecclesiastical History of the English People' focused on the influence of the church. Under this agenda

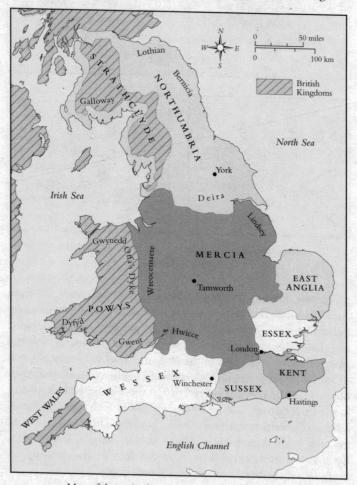

Map of the major kingdoms in England at the time of Bertha's arrival around c. AD 580.

the hugely powerful Penda of Mercia's dominance was down-played, since he was a pagan who killed Christians. But other sources of archaeological and art-historical evidence suggest that Mercia was in fact the most powerful kingdom in Britain from the time of Penda until the ninth century.

The Staffordshire Hoard gives a clear picture of the military prowess of the Mercian kingdom in the seventh century. The 4,600 pieces, which add up to over 5 kilograms of gold and 1.5 kilograms of silver, are all martial in character and include the fittings for weapons. Just one helmet alone was composed of over 1,000 pieces from the hoard and a recent reconstruction reveals a hybrid object. The panels on the sides are distinctly Scandinavian, but the ridge at the top, which may have included horse's hair raised upwards, recalls Roman helmets.[22] The military elite of Mercia were clearly rich and regularly involved in battles, no matter what Bede's version of history insisted. Their high-status objects echo the power of Rome and signal the wealth of their kingdom. During the eighth century Offa and Cynethryth would continue the process, begun by Penda, of enriching and enlarging Mercia.

The capital of Mercia, Tamworth, had grown from a small settlement to a thriving town by the time Offa and Cynethryth built their palace there. Although royal duties meant the king and queen were constantly travelling their kingdom – defending territories, receiving taxes, seeing to the needs of communities and staying at royal properties – they spent more time at Tamworth than anywhere else.[23] Most of the Mercian charters were signed there, and the annals record the royal family regularly celebrating Easter and Christmas at a timber-framed palace in the centre of the well-defended town.[24] At its heart was the earliest known watermill in Britain since Roman times. This would have served an important function for the inhabitants of Tamworth, who brought their grain to the mill to have it ground to flour. The huge mill stones also held symbolic significance; they were a gift from Emperor Charlemagne in return for a set of desirable English woollen cloaks.[25] The wool of English sheep and the weavers who worked it were the envy of Europe.

While Tamworth was the royal hub of the kingdom, nearby Lichfield was its spiritual centre. Until Offa brought Kent under his control, he resented the fact that the archbishopric was based in Canterbury. With the consent of the pope, he elevated Lichfield to the highest church in England. The new archbishop, Higbert, received the pallium – a strip of wool worn over the chasuble – directly from Pope Adrian. In return Offa promised to send him a gold coin for every day of the year. It has been suggested that the Islamic-style coins struck in 774 could have been part of this offering, which was used to buy candles to light St Peter's – the main church of the papacy in the Vatican. The English influence on the church stretched to the very heart of Western Europe. Lichfield only held the archbishopric for 16 years before it returned to Canterbury. But in that time Offa and Cynethryth enriched the church substantially, filling it with art and relics that would make it worthy of being the central ecclesiastical building in the country.[26] The St Chad's Gospel Book, which remains in the cathedral it was made for, is one of the many riches of the Mercian church.

Written in the mid-eighth century, so not actually from the lifetime of St Chad (*c.* 634–72), the manuscript has 236 pages. Eight of these are illuminated, and their style reveals a good deal about the emergence of the Christian church in the kingdom of Mercia.[27] The church in Northumbria, which in the seventh century could already boast a number of monasteries and a bishopric at York, made attempts to send priests and bishops into pagan Mercia. However, the kingdom under Penda remained a hostile place for missionaries. Bede reports that many were unsuccessful before Chad, who had been bishop in Northumbria and was since retired. An old man in search of a quiet life, he was recalled to his duties and sent to Lichfield in 669, charged with the unenviable task of rooting Christianity into pagan Mercia.

A plague had decimated the English church, leaving a dearth of priests, so Chad's time in Mercia was spent travelling the vast kingdom to ordain new ministers.[28] He died after just two years, but his burial at Lichfield and his reputation as an outstanding Christian meant the church could boast the relics of their own Mercian

Chi-rho page from the Lichfield Gospel book, eighth century (left)
and incipit page from the Lindisfarne Gospels, c. AD 720 (right).

saint. Details of Chad's life mainly survive in the writings of Bede,
but the St Chad Gospels support some of his biographical infor-
mation.[29] Bede said Chad had trained under Aidan at Lindisfarne,
and it is clear that the scribes responsible for the St Chad Gospel
were influenced by the Northumbrian monastery's illumination
style. The chi-rho pages from both the Lindisfarne and St Chad
Gospels are remarkably similar, featuring whorls and spirals, ani-
mal heads and the same diminuendo of the script, as large initials
gradually reduce in size to smaller text.

Whether such similarities indicate the manuscript now held in
Lichfield Cathedral was originally made in Lindisfarne, or whether
the individual responsible for it trained there is impossible to
determine. But it shows that in the eighth century, Christianity
was still struggling to bed down in certain regions, and it was the
missionary activity of a few from the north that brought it to the
region of Mercia. The shared style mirrors how Chad himself left
Northumbria to bring Christianity to Mercia. With few priests
and bishops, the early church was vulnerable to disasters like the

plague, and the safest way for the church to expand was to find powerful secular rulers to support it. Offa and Cynethryth seized this opportunity.

With the relics of their very own Mercian saint in Chad, the royal couple endowed Lichfield richly and a new church was dedicated to St Peter. Here, Chad's bones were displayed in what Bede describes as 'a wooden monument, made like a little house, covered, having a little hole in the wall'.[30] Visitors could put their hand through this hole and grab a handful of the saint's miracle-working dust, which they mixed with water and gave to the sick to drink. Little evidence of the eighth-century church survives, but a 2003 discovery opened a window onto this lost cathedral. A new platform was due to be installed in the existing cathedral, so archaeologist Warwick Rodwell took the opportunity to explore underneath the present nave.[31] He found evidence for the outline of the eighth-century church alongside cobbles from the foundations. A sunken area and a column base suggested this may have been the original eastern end of the church and the site where Chad's burial was displayed. Most exciting of all were three fragments of sculpted limestone that likely formed part of the original tomb cover over the saint's coffin. Now known as the Lichfield Angel, this bas-relief carving reveals how sophisticated the art of Cynethryth's Mercia was, and how far the interaction with the Carolingian world extended.

What remains of the Lichfield Angel is just half of what would originally have been a depiction of the angel Gabriel announcing news of Jesus's incarnation to the Virgin Mary. Only Gabriel remains, but the sculpture is almost unparalleled in its preservation, since the slabs had spent the centuries 'indoors', in favourable conditions. It is now recognised as one of the most important pieces of early medieval English sculpture to survive.[32] Two things make it unique. First, evidence of paint remains across the sculpture, so we know the original slab would have been brightly coloured. The background was white, the halo gilded, and the feathers show delicate painting with areas of red, outlined in black, grading down to pink. Tiny diagonal strokes of red run the length

The Lichfield Angel carved in stone and painted,
late-eighth or early-ninth century.

of the individual feathers. The Lichfield Angel reminds us that so much of the art and architecture of the medieval period survives without its colour. We see just the bones, rather than the finished piece.

Second, the style is distinctly Carolingian. The angel is beautifully modelled, and the curls of the hair, drapery of the clothing and delicacy of the facial features are all recognisably classical.[33] In Carolingian depictions of the Annunciation, like an ivory from Aachen dating to around AD 800, the flowing drapery and lift of the back foot give drama and movement to the event, as if the angel is rushing towards Mary.[34] Offa and Cynethryth were at pains to compete with Charlemagne, and survivals like the Lichfield Angel suggest that both courts prized classical models to reinforce their association with the Roman Empire of antiquity.[35] Cynethryth was queen of a powerful kingdom, characterised by the finest art and a greatly enriched church.

Mercia's Demise: Vikings on the Rise

The kingdom of Mercia reached its zenith during Cynethryth and Offa's reign. But just a few years before Offa's death in AD 793, over the Northumbrian border a new threat had arrived in England. Viking longships were drawing up to the shores of Lindisfarne and a hoard of Norsemen raided the rich and historic monastery. News of the attack reached Alcuin in the heart of the Carolingian Empire at Aachen, and he wrote emotively how:

> heathens desecrated God's sanctuaries and poured the blood of saints within the compass of the altar, destroyed the house of our hope, trampled the bodies of saints in God's temple like animal dung in the street.[36]

The event also seems to have been captured in stone. On a sculptured grave marker, a group of men are shown running, their front legs raised to indicate motion. They wear chain mail and are wielding swords and axes above their heads. The reverse of the stone could not be more emphatic of how the Lindisfarne monks viewed the Viking attack. Here two monks bow down before a cross, accompanied by the sun and the moon. It's Judgement Day and the implications are clear. New battle lines have been drawn between blood-thirsty pagans from over the seas and God-fearing Christians. The attack on Lindisfarne was just the beginning, and the kingdom of Mercia would become a casualty of decades of Viking incursions.

In an unassuming mound in the garden of the vicarage at St Wystan's Church, Repton, archaeologists Martin Biddle and Birthe Kjølbye-Biddle discovered evidence of the traumas England faced throughout the ninth century, which challenged the Mercian queens in new and devastating ways.[37] Forming a triangle with Tamworth to the west and Lichfield to the south, the Mercian town of Repton was of equal importance for its double monastery, local saint and royal burial crypt. While Tamworth was the secular centre,

Grave marker stone showing Viking attacks (left) and the Day
of Judgement, Lindisfarne, c. AD 793 (right).

focused on the royal palace, and Lichfield was the bishopric, Repton combined religious and secular functions. Founded in the early seventh century, the double monastery at Repton was headed by an abbess, who was usually a member of the Mercian royal family. It had served as the bishop's seat in Mercia until Chad moved it to Lichfield in 669. Repton was famous for St Guthlac, who had entered the monastery there but abandoned his life as a monk to become a hermit. He lived the rest of his years in the fens covered only by animal skins, battling with demons which he said constantly assailed him. Today we might consider Guthlac troubled by mental health issues, but to the eighth-century Mercians he was seen as a saint and was visited, even by royalty, for his advice and guidance.[38]

A natural spring ran beneath the original abbey at Repton and a baptistry was constructed on top of it in the mid-eighth century. This was then transformed into a crypt and functioned as a royal mausoleum. The first Mercian king to be buried there was Æthelbald, who had ruled for over fifty years from 716–57. His leadership established the foundations for Mercia's rise to the most powerful kingdom in England during the eighth century, before his successor Offa took over. It is surprising, therefore, that Offa was not laid to rest alongside his influential predecessor at Repton. We can assume it was Cynethryth herself who chose Bedford as his burial place, since she held lands there.[39] Was she trying to develop a cult around her husband in this strategic location north of London?

Perhaps she hoped that creating a site of Mercian royal power away from the kingdom's heart on its further eastern edge would cement her son's legacy as the new ruler to this extended border.

Offa's tomb in Bedford was lost, reputedly carried away by the river, and the burial place of his son Ecgfrith is unknown, yet we know plenty of other Mercian rulers chose to be buried at Repton. King Wiglaf (827–9) and his grandson, who became known as St Wigstan, were both placed in the crypt, turning the church into a pilgrimage site.[40] Like Lindisfarne, the monastery at Repton was full of treasures, right next to water and poorly defended. It was easy pickings for Viking raiders.

However, while the initial years after the sack of Lindisfarne were characterised by rapid attacks – longships coming in on the tide, grabbing booty, and leaving on the tide – a key change took place in AD 865. A coalition of Scandinavian troops launched a concerted effort to occupy and conquer the major kingdoms of England. The fleet of ships, which may have carried many thousands of warriors, first landed in East Anglia where they negotiated the acquisition of horses in return for peace.[41] With the ability to move faster across land, the army then began its assault on Northumbria. Over the next few years, the Vikings did not leave the country but 'overwintered' at camps, consolidating their troops with new arrivals and taking advantage of local resources to support their soldiers.[42] It was a traumatic invasion that would impact all the English kingdoms and everyone from royalty to the impoverished. The sites of these 'overwinter' camps are mentioned in written sources, but no physical evidence for them had been discovered until the Biddles started their excavations at Repton during the 1970s and 1980s. What they found was 'one of the most significant Viking sites in England for more than forty years'.[43]

Repton was a tantalising opportunity to uncover a Viking camp, since the *Anglo-Saxon Chronicle*, which recorded events of national and local importance from the eighth century onwards, mentions that the army overwintered there from AD 873 to 874. Early trenches revealed evidence of a ditch running from the River Trent

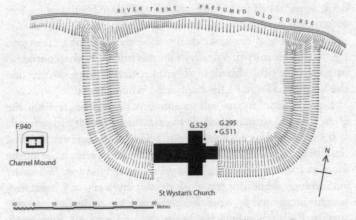

Plan of the Viking enclosure with the church at the centre, Repton.

in an arc, with the church intersecting it at its centre. This layout transformed the purpose of this stone building from church to gatehouse and suggests the area inside the fortifications was intended as a last defensive retreat. Rather than simply raid the monastery at Repton, the incoming troops took over the church building and adapted the space to their needs. Further excavations revealed evidence for a larger camp outside of the ringed enclosure. Here the army would have lived and trained. A recent dig at the Viking winter camp in Torksey suggests that these camps would have served many functions, with craftspeople and workshops providing all that an army in the thousands might need.

As burials started to emerge from the dig at Repton, further evidence for a Viking winter camp came to light.[44] One grave contained five coins, conveniently providing a date in the years when the Viking army was said to be at Repton, from 872–4. A double grave to the east end of the church was also interesting, as one of the two bodies showed signs of excessive violence. The male skeleton was blinded and castrated, as shown by lacerations on the skull and hip bone. He was then buried next to a close relative (most probably his son), a Thor's hammer tied around his

neck, a sword by his side and a boar's tusk placed between his legs to stand in for his missing penis. The burial has ritualistic elements, suggesting the individual was being prepared to feast and fight for all eternity in Valhalla. This was not a Christian burial, so its presence by the church in Repton is convincing evidence that the Biddles had discovered the Viking winter camp.

But the clincher was still to come. A short distance from the church, in the vicarage garden, was a low mound that had reputedly been opened by a gardener in the nineteenth century. Finding 'hundreds of bodies' inside, he was instructed by the wife of the vicar to cover it over and plant a sycamore tree on top. When the archaeological team began work on the site a century later, they sought out the trunk of the tree and dug down to discover an early medieval stone building. Inside the two stone rooms, now partly demolished, piles of bones were arranged around a single burial in a separate chamber – most likely that of a particularly important Viking war leader. It has been suggested that the remains might have belonged to Ivar the Boneless, son of the legendary Ragnar Lothbrok, who certainly played a role in the Great Heathen Army and died around AD 873. But the collection of bones around him would prove even more revealing.

Isotope analysis on the mass grave was conducted by the archaeologist Dr Cat Jarman across five years, and her discoveries have shed new light on the people who made up the Great Heathen Army.[45] The primary bones (skulls and femurs) of 264 individuals had been stacked as in an ossuary, suggesting they were brought from another location, most likely a Mercian battlefield. The majority of the skeletons were male and between the ages of 18 and 45, in keeping with what we might expect of a Viking army. The bones reveal that they also ate a foreign diet, suggesting they originated from Scandinavia. However, a surprising 20 per cent of the bones were female. We can gather from this that women travelled with the army and lived with them at the camp. This reinforces the idea that the aim of the Great Heathen Army was not just to raid and pillage, but to conquer and settle. These women may have been wives, slaves, servants, relatives or even

female warriors, but in their fragmentary state it's hard to know more of the role they played.

The finds from Repton paint a dramatic picture. The very heart of Mercia had been occupied by hostile forces and its church repurposed for use by an invading army. The grandeur of Mercia under Offa and Cynethryth was to become a distant echo; the years 865 to 879 were some of the most tumultuous in English history as kingdom after kingdom fell to Viking forces. Crucially, an important decision was made by the Viking army at Repton: half would go north to consolidate rule there, while the other half would press south to take the only remaining independent kingdom of Wessex. If the troops had not divided at this point the history books may tell a very different story. England may have become a Danish-held territory. As it is, there was one individual who did more than any other to push back the complete conquest of England by Vikings, and by understanding his dominance, our eyes are opened to a remarkable woman, too.

Alfred the Great and the Game of Thrones

It is the nature of early medieval history that reframing narratives to include women often means situating them against backdrops that are largely dominated by men. One of the most overlooked rulers of the tenth century only has a dim echo in the historical record, overshadowed by the male relatives that came before and after her. To understand the significance of Æthelflæd, Lady of the Mercians, she must be positioned alongside the men of her time, who are far better documented. Only then can her achievements come into focus. And one man overshadows all others: her father Alfred, the only English ruler to have been given the title 'Great'.

Alfred ruled as king of the West Saxons from 871–86 and king of the Anglo-Saxons until his death in 899. His long reign was punctuated by some of the most hostile social and military pressures of the medieval period in England. With four older brothers,

he was never even intended for the throne – but each died until only Alfred was left. The fortunes of his kingdom of Wessex were constantly unstable as, unlike in Mercia, the potential to secure influence through marriage had not been exploited to the same extent. Across the previous two centuries the crown had not passed from father to son (or indeed to daughter), but rather was fought over by three powerful rival families.[46] With Alfred's grandfather, Ecgberht, a new dynasty emerged, but it remained on shifting sands.

Viking forces swept across England, defeating each kingdom in turn. Rulers were removed and puppet kings, loyal to Danish overlords, put in their place. In Mercia, the army that overwintered in Repton drove the king, Burgred, into exile. He had ruled successfully from 852 to 874 and had brought relative stability to the kingdom, but he was replaced by Ceolwulf, who would become the last independent ruler of Cynethryth's once powerful kingdom. Mercia now belonged to the Vikings. By AD 875 only Wessex survived as a force to halt the complete conquest of the Great Heathen Army. When the troops split at Repton, the southern half was led by the Danish ruler Guthrum.[47] They were diminished in numbers but continued to secure victories across the south.

Alfred's older brother died in 871 and left him the throne. Viking troops initially took advantage of this moment of change, attacking Alfred while he was preparing his brother's funeral. Unable to fight, he made arrangements with the Viking army for them to cease their attacks, establishing payment of a 'Danegeld'. Hoards of coins minted in Wessex have been discovered at Croydon, Gravesend and Waterloo Bridge, which hints at the huge sum the Danes demanded. The early years of Alfred's reign were characterised by crisis management and battle. When Guthrum's army surprised him after Christmas 878 and attacked his royal stronghold of Cippenham he became a hunted man, attempting to outrun the enemy through guerrilla warfare and the support of a small troop of loyal followers. His family were also under threat and his first-born child, his daughter Æthelflæd, was certainly old

enough to be affected by this period of life on the run. They were pushed to the very edges of Wessex and forced to create a fort in the Somerset marshes at Athelney. Alfred and Æthelflæd's worlds were getting ever smaller as town by town, village by village, the Great Army crept through the kingdom.

The best known story about Alfred is of how he burned the cakes.[48] A peasant woman supposedly asked him to watch her oven while she went to the well. Distracted by matters of state, he neglected the job. This legend doesn't date from Alfred's lifetime, and is most likely a later invention designed to highlight both the king's humility and his commitment to saving the nation. While fantastical, it supported this idea of a great man with his mind on important things. Alfred watched the way Viking forces behaved and changed his tactics accordingly. Rather than the traditional shield wall, where English soldiers would press together to form a defensive barrier, he experimented with small attacks from secure bases. This would eventually lead to the creation of burhs – fortified towns – across Wessex, which would protect populations against future attacks.[49] The cities of Winchester, Worcester and Malmesbury all owe their footprint to Alfred's burghal system.

Having rallied English soldiers from the adjoining counties to Athelney, Alfred finally achieved a victory at the Battle of Edington. The Danes retreated to safety, but Alfred's troops were able to starve them into submission. A truce was agreed and Guthrum took the additional step of agreeing to be baptised, with Alfred as his sponsor. Their settlement effectively separated England into two kingdoms running along a line from the Thames to the Humber. The area to the north was the Danelaw, while the south was English and governed by Wessex. The divide was ideological too, with Wessex defining itself as a Christian powerhouse opposed to the pagans ruling north of the border. Relative peace allowed Alfred to build on his military successes and secure the future of his kingdom.[50]

He is celebrated for his many victories in battle, but perhaps as important as his military successes were his investments in art, culture and education. While he spent half the kingdom's income

on governance and social renewal, the other half went to the church. This is not to say he was simply propping up the establishment. It was in monasteries, churches and cathedrals that most of the learning, knowledge gathering, and administration of Wessex took place. Decades of Viking attacks had destroyed centuries of Christian achievements and wiped out a generation of teachers. In his own words:

> Then when I remembered all this, then I also remembered how I saw, before it had all been ravaged and burnt, how the churches throughout all England stood filled with treasures and books, and there were also a great many of God's servants. And they had very little benefit from those books, for they could not understand anything in them, because they were not written in their own language.[51]

He dedicated himself to translating those books he thought 'most needful for all to know' from Latin into Old English – a remarkable achievement given how many challenges he faced during his reign – and arranged for copies of the texts to be distributed across the country.[52] Alongside the manuscripts he ordered aestels (pointers used for following the text while reading), to be sent out with each set of books. Handles from six of these aestels survive, reflecting how widespread and ultimately successful he was in this endeavour. The most famous is known as the Alfred Jewel and around its edge is the inscription: 'Aelfred mec heht gewyrcan', or, 'Alfred ordered me to be made'. Beneath a large piece of clear quartz crystal an individual stares out from an enamelled backplate, grasping two floriate sceptres. There are similarities with the ninth-century Fuller Brooch, which shows the five senses and sight in the centre. The Alfred Jewel, meant to accompany books that spread wisdom, may depict not sight, as in eyesight, but rather insight; the pursuit of knowledge.[53]

Alfred was given the title 'Great' not by his contemporaries but by writers from the sixteenth century onwards. Because he encouraged the translation of religious texts from Latin into English, he was (erroneously) held up by post-Reformation theologians

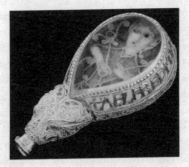

The Alfred Jewel, made up of gold, enamel and rock crystal,
Ashmolean Museum, c. AD 871–99.

The Fuller Brooch, hammered sheet metal with neillo,
British Museum, late-ninth century.

as the originator of the break with Rome.[54] The epithet 'Great'
was further reinforced by later writers, who saw in Alfred's resist-
ance to Viking incursions the creation of a Christian English

nation. With the evolution of a navy to defend against the Danes, he was a hero worthy of celebration by an empire committed to 'ruling the waves'. One eighteenth-century historian declared him 'the most perfect character in history'.[55] By the nineteenth century Alfred's life had become 'the favourite story in English nurseries'.[56] For the (wrongly calculated) millennial celebrations of his death in 1901, a four-day event was held in Winchester, organised by a committee which included Thomas Hardy, Rudyard Kipling and Arthur Conan Doyle. A seventeen-feet-high bronze statue of Alfred was unveiled on the eastern end of the Broadway. Rather than a faithful representation, he is shown with full curly beard – a Victorian impression of an Arthurian hero.

The portrayal of Alfred as one of history's 'great men' is hard to avoid. The biography written by his friend, Asser, presented him as saint-like, divinely assuming the role of king only after all his older brothers died, as if he were destined for it. Another 'great' of history, Charlemagne, also realised the importance of a good biographer, commissioning his dedicated servant Einhard to write his life. His reign was plighted by genocide, dictatorial rule and infighting. But he knew that with the support of the church and those that hold the quill, history would remember him well. Even in 2021 a bestselling book on the Anglo-Saxons determined Alfred was chief among England's kings, bishops and warlords: 'courageous, clever, innovative, pious, resolute, and far-sighted.'[57]

Alfred is one of the few individuals from the medieval period to have been reimagined and made relevant for the modern age. But as his light grew ever brighter, the flames of those around him receded or were snuffed out. There is one woman in particular, however, who deserves to be recognised alongside him – his daughter Æthelflæd.

Last Lady of the Mercians

Of course, Æthelflæd is part of Alfred's legacy, but to paint the fullest picture we can, she must also be viewed alongside the strong

women of Mercia who came before her. Æthelflæd's mother, Ealhswith, was a Mercian noblewoman descended from the royal line through her mother. However, in Wessex she was not referred to as queen, despite the fact she was married to the king. The reason has its roots in the reign of another important Mercian woman – the daughter of Offa and Cynethryth, Eadburh.

Like her mother, Eadburh had become an incredibly powerful and influential ruler through her marriage to Beorhtric of Wessex. She signed two charters in 801 as 'Regina' (queen). But her life is recorded by Alfred's biographer Asser as a cautionary tale. Her 'headstrong and malevolent' ways are explained as the reason why, in the ninth century, no subsequent wives of the king of Wessex were allowed to use the title 'queen', or even sit beside their husbands.[58] According to Asser, Eadburh was so influential she took 'whole power of the realm and began to rule tyrannically'. Eadburh controlled the men of the court, and if she wished to remove them, would either deprive them of their roles or their lives. Asser says she used poison, but that this technique backfired when she accidently killed her own husband. Cast out of Wessex for regicide, she took refuge with Charlemagne. But when she rejected his advances, he too banished her. Like her mother, she was given a large monastery in Frankia to control as abbess.

Asser's account heaps further shame on Eadburh, suggesting her fall from grace on being exiled by Charlemagne was not yet complete. Instead, she was reported to have been caught having sex with an English man and expelled from her monastery:

> Henceforward she lived a life of shame in poverty and misery until her death; so that at last, accompanied only by one slave, as I have heard from many who saw her, she begged her bread daily at Pavia, and so wretchedly died.

This account may contain exaggerations and untruths, despite the fact Asser assures readers it was the king himself who told this story many times. But its inclusion in Alfred's 'Life' is tactical, to explain why the court in Wessex held such strict traditions in

relation to the king's wife. Asser himself laments that his court in Winchester continued the 'perverse and detestable custom' of demeaning the wife of the king, but this story lays the blame with the strong women of Mercia themselves. It is testament to how different the role of women was in these two kingdoms that, despite the fact Alfred's wife was a Mercian royal, she didn't sign a single charter and was not even named in his biography.

Æthelflæd was brought up in the court in Wessex, was daughter to its king and educated by its finest minds. But through her mother she was also half Mercian. Knowing how different the role of royal women had been north of the Thames, and seeing her own parent having to assume a subservient role, may have increased her desire to take up a position in her mother's kingdom where she could rule as an equal to men. Her marriage to the much older Æthelred of Mercia was politically expedient for her father, but possibly an attractive proposition for Æthelflæd too. The kingdom of Mercia had allied with Wessex after the Battle of Elledun in AD 825, ending the supremacy of Offa and Cynethryth.[59] Æthelred was known as 'Lord of the Mercians' and he ruled over a reduced territory, as half of Mercia lay in what was now the Danelaw. He had also acknowledged the lordship of Alfred, and marrying his daughter was a way of cementing his loyalty.[60] In return Alfred gave his son-in-law London, as it had traditionally been a Mercian town, and extended his system of burhs, providing Æthelred with strong power bases through the kingdom.[61]

Æthelflæd was probably still in her teens when she married Æthelred in AD 886.[62] He had been a successful warrior and ruler of Mercia for some years by this time, suggesting he was at least a decade her senior. While her father was still alive, Æthelflæd was largely invisible in the records, as her husband signed charters with the support of the king. But she was to emerge as a ruler in her own right as first Alfred died in 899, and then her husband's health began to fail a few years later. By 902 she was making important decisions on behalf of the kingdom of Mercia. The routing of the Norse from Dublin had left a displaced group of Vikings without somewhere to settle. They appealed to Æthelflæd for permission

to set up a place to farm near Chester. Her response reveals a clear head for diplomacy and forward-planning, even while still a young woman.

She gave them land in the Wirral and for a time they lived peacefully. But at the same time, strategically she began to fortify the city of Chester in case they decided to raid it. She was following the example of her father, reinforcing Roman walls and creating a defensive burh.[63] The Irish Annals give details of how Æthelflæd protected the city when in 907 the Wirral Vikings joined with Danish troops and attacked Chester. She 'gathered a large army about her from the adjoining regions'. After an initial battle Æthelflæd sent messengers to the enemy troops. She stated she was 'queen who holds all authority over the Saxons'. Through requests of loyalty and the promise of rewards, she convinced the Wirral Vikings she had treated so generously to switch their allegiances and join her forces and together they pushed back their attackers. The people of Chester used every means possible to defeat the Danes, including pouring boiling ale onto the men below, and even throwing 'all the beehives there were in town on top of the besiegers.'[64] Æthelflæd was now more than just a wife and lady; she was a military strategist, diplomat and defender of Mercia.

Rival of Kings

While so much evidence survives to flesh out the rule of her father Alfred, comparatively little information on Æthelflæd remains. The situation worsened during the rule of her brother, Edward, who actively suppressed her reputation in order to bolster his position as king of Wessex. It was important for the Wessex court to stress that Mercia was not an independent kingdom ruled by a strong woman, but rather part of the expanded domain which under King Edward constituted England. Æthelflæd's history was rewritten, and her name removed from records to prop up the legacies of her male relatives.

But there is one important source which reverses the pattern of so many historical documents: a text in which she is mentioned repeatedly while her husband is named only twice (on his death and on the birth of their daughter).[65] The primary source for events covering her life is the *Anglo-Saxon Chronicle*. The name suggests one book, but it was in fact a set of annals, each kept by scribes at the most important monasteries across the country. The original text, tracing the history of England back to AD 60, was probably instigated by King Alfred. This was then added to as further 'memos' were sent to the different chroniclers to include in their copies. Alfred no doubt intended it as a way of documenting an authorised national history of England. But as monks continued to add to their versions, local issues came to the fore in different areas. A specific set of annals added somewhere in Mercia (probably Worcester) covers the years 909 to 927. It is possible that Æthelflæd, seeing the importance her father placed on the *Chronicles* in his reign, had a hand in commissioning the Mercian version, now known as the Annals of Æthelflæd. This source gives insights into her reign that are not included in the other versions of the *Chronicle*, which emphasise Edward's achievements over those of his sister.[66]

She is mentioned in other sources too, particularly by Norman chroniclers, who were surprisingly favourable about her in later accounts. In the twelfth century, Henry of Huntingdon declared her to be 'so powerful that in praise and exaltation of her wonderful gifts, some call her not only lady but even king'. In a poem, he praised her as 'worthy of a man's name' and 'more illustrious than Caesar'. Sources from the Celtic west show Æthelflæd was recognised as queen and ruler.[67] The Annals of Ulster refer to her as 'famosissima regina saxonum' (most famous queen of the Saxons). Even in Wessex, where she remained consistently subservient to her brother, the king, they describe how she witnessed charters under an elevated title: 'Lady of the Mercians by the virtue of divine grace.' Lady was the title her mother had, so could be considered equivalent to queen. And even if she wasn't openly referred to as 'regina', her actions reveal she was behaving as one.

Æthelflæd knew the importance of bolstering her reign through patronage of the church. She also understood the power of saints. When her brother Edward invaded the Danelaw and raided Bardney Abbey, she managed to acquire the relics of the Anglo-Saxon saint-king Oswald, intending them for a new minster she was building in Gloucester. She was establishing this city as the new heart of her Mercia, with the church functioning as a royal mausoleum to replace Viking-ravaged Repton.[68] Putting the relics of saints in newly founded burhs was a common tactic of Æthelflæd's. In 907, having rebuilt the town of Chester, she translated the relics of the Mercian princess Werburgh from Hanbury in Staffordshire to a newly founded minster.[69] The famous saint of the marshes, Guthlac, had also been relocated from Crowland to Hereford. The great Mercian saints were being gathered up and their bones redistributed to imbue their regional potency to Æthelflæd's new burhs.[70]

Saint Oswald was particularly important.[71] King of Northumbria from AD 634 to 642, he was killed by the great Mercian lord Penda in the seventh century at the Battle of Maserfield. As an additional insult, the king's head and arms were hacked off and displayed on wooden stakes. Oswald was a Christian king, while Penda was a pagan. His death was seen as a form of martyrdom and his body parts were protected as relics. His skull still sits inside a coffin in Durham Cathedral alongside that of the famous northern saint Cuthbert of Lindisfarne (although there are four other relics that also profess to be the 'Head of Oswald' in churches across Europe). His body was claimed by his niece Osthryth who, although a Northumbrian, was married to the king of Mercia. She brought it to Bardney Abbey in Lindsey, in her new kingdom of Mercia, and over the following decades the community there reported many miracles.

Bede wrote extensively of the miracles associated with Oswald's relics. To the eighth-century Northumbrian historian, Oswald was a Christian hero like the Emperor Constantine, bringing Christianity to his nation. When Æthelflæd had entered the Viking-held parts of Mercia and retrieved the body from Lindsey,

she was not only acting as powerful Mercian queens had done before her. She was also echoing Constantine's mother, Saint Helena, who travelled to the Holy Land and brought back the True Cross. To Æthelflæd the rescue of these relics was a symbol of her divine rule, and placing this Christian English saint-king at the heart of her new minster in Gloucester was an important symbolic act.

Gloucester had been damaged when the Great Heathen Army overwintered there in AD 877. Their camp, which may have been protected by an arced fortification from the river like at Repton, was the site that Æthelflæd chose for her new church. There is evidence of Viking destruction around the city, and churches appear to have come under particular attack. Stone crosses, the advertising billboards of the early Christian church in England, had been broken up and their fragments scattered. Æthelflæd's church was a phoenix rising from the ashes of war, and she based its design on that at Repton.[72] Excavations revealed an eastern chapel with a sunken crypt, and the use of four pillars to support the floor exactly replicates the royal mausoleum at Repton. Æthelflæd was intending this church in Gloucester as her dynastic burial place. There she and her husband would lie alongside one of England's greatest saints.

Seizing the relics was provocation to the Vikings across the border with the Danelaw. In 910 they moved into Mercia, raiding and grabbing plunder, pushing deep into Shropshire until Æthelflæd led a force against them. Joined by troops sent from her brother in Wessex, the Mercians won a staggering victory at the Battle of Tettenhall. While Æthelflæd probably did not take up arms herself, it is likely she provided strategic leadership. Three Viking kings were killed in the battle and Æthelflæd had proved that she could head up an army.

The following year her husband died. Æthelflæd had already been the primary decision maker in Mercia for nearly a decade, following the example of influential Mercian queens, but in an unprecedented move, the noblemen of Mercia elected her as ruler – a rare occurence indeed in early medieval history.[73] Their

choice was wise, as she continued to be a shrewd ruler who set about extending the work of her father, particularly with regards to burh building. She strengthened the old royal capital of Tamworth, and laid the groundwork for Stafford, Hereford, Shrewsbury and Warwick. Many of these cities owe their existence to Æthelflæd's efforts.

It is difficult to know if, like her father, she invested in education – after all, she didn't have an old friend like Asser recording and rhetorically shaping her life for posterity. Æthelflæd herself was well educated, having been taught at the court school in Winchester, and it is clear that throughout her reign she was enriching a knowledge hub at Worcester. Four prayer books dating from the ninth century were written by and for women here, with one containing a gynaecological prayer. But there isn't the same evidence surviving from her lifetime as there is from Alfred's. It is her military exploits, recorded by chroniclers, which have left an impression. With the support of her brother, she secured some of the most significant victories in battle of the early tenth century. In AD 917 she led troops to reconquer the Viking city of Derby, one of the 'Five Boroughs of the Danelaw'. She clearly led with the same sense of 'commitatus' (loyalty to one's lord) as male warriors, as the Mercian Chronicle records how she lost four of her thegns at Derby 'who she particularly loved.'

The next year she secured Leicester and made her way towards the prestigious Viking-held city of York. The kingdom of East Anglia had already submitted to Edward, so taking York would have meant the English territories were once more united. She had even managed to secure an alliance with the Scots and the largest territories in Wales were under her 'lordship', so the United Kingdom as we know it today was forming through her diplomacy.[74] The Danes were ready to offer their submission to her, not to her brother. But she died on 12 June and was taken to be buried with her husband at St Oswald's Priory in Gloucester. Securing the fealty of the Danes of York would have been her ultimate achievement, and had she succeeded she would have been remembered as the unifier of Britain.

Instead, the next generation took up the mantle. Æthelflæd gave birth to just one daughter. This was unusual in a period when the provision of a male heir was a primary role of a royal wife. The twelfth-century historian William of Malmesbury records that she declined to have sex after bearing a daughter because it was 'unbecoming of the daughter of a king to give way to a delight which, after a time, produced such painful consequences'. He also suggests that she shied away from 'marital obligations' because of the risks it posed her life. It may be that Æthelflæd had suffered physical difficulties through the birth and pregnancy. True to the Mercian queens that had gone before her, however, she believed a female heir was as capable of ruling as a male one. She put in place insurances, securing the promises of the Mercians lords that her daughter, Ælfwynn, would succeed her.

Ælfwynn was probably well educated and prepared for leadership. Like the Mercian women before her, she witnessed charters and owned land. Her achievement is notable, as her ascension as ruler of Mercia after Æthelflæd's death is the only time rule passed from one woman to another in early medieval England. But she was not destined to follow her mother's successes as Lady of the Mercians. After a few months her uncle, King Edward, removed her from Mercia and, like Queen Cynethryth, she probably lived the rest of her life in a monastery. Whether she lacked her mother's strength of character or was simply a victim of Edward's scheme to expand his kingdom of Wessex, Ælfwynn did not manage to rule like her mother.

This honour was to fall on her cousin, Athelstan, who had been brought up alongside Ælfwynn. After being declared 'King of the English' at his coronation in AD 925, he went on to conquer Scotland and unite all the kingdoms of England under one ruler. But as the saying goes, behind every great man is a great woman. Edward had sent his son Athelstan to be raised in Æthelflæd's court, perhaps as a way of preparing for his succession and acceptance by Mercia in the future. He gained his education and his military training in Mercia and didn't forget this, giving a charter of privileges to St Oswald's church in Gloucester as soon as he gained the throne. Æthelflæd's legacy continued in her nephew.

What would England be today if Mercian queens had not wielded such power as decision makers? Cynethryth had more influence than almost all other women from the sixth to ninth centuries, and this mantle was carried over by the Lady of the Mercians, Æthelflæd. In the knowledge that women had achieved so much in their own right before her, Æthelflæd was able to rule with 'strength of character' for two decades at the turn of the tenth century, a pivotal point in English history. The story of how, in the space of just two generations, England went from a single marshy island in Athelney under Alfred to what it is today has been repeated down the centuries. It is also at the heart of an imperialist historical narrative where England became Master of the Seas. But the men of this period have always overshadowed the influence of Æthelflæd. She was wife, daughter, sister and aunt to the most important men of the ninth and tenth centuries, but she was also a ruler herself, whose decisions shaped the fortunes of kingdoms. She deserves recognition, not just as Alfred's daughter and Athelstan's aunt, but in her own right

She gained respect in Mercia during her lifetime, even if the Wessex version of history was the one that spread most widely. A Worcester chronicler records she was 'merciorum domina, insignis prudentiae, et iustitiae virtutique eximiae femina' (a woman of prudence, justice and extraordinary strength of character). This reputation carried down the centuries immediately following, with this twelfth-century poem a testament to how she was perceived a quarter of a millennium after her death:

Heroic Æthelflæd! Great in martial fame,
A man in valour, though a woman in your name:
Your warlike hosts by nature you obeyed,
Conquered over both, though born by sex a maid.

To later Norman writers she was like an English Joan of Arc, a warrior woman who deserved fame. But when her story no longer served the dominant narrative, her reputation was eclipsed. Over the last three centuries, it is her father, Alfred, who has become a

3

Warriors and Leaders

Discovery!

2017 – Stockholm University, Stockholm, Sweden

Inside the Archaeological Research Laboratory of Stockholm University, a scientist wearing magnifying glasses and latex gloves delicately holds a fragile piece of ancient tooth in one hand. With the other, they carefully apply pressure on the tooth with a vibrating drill and the whirring metal grinds into the aged enamel.[1] The tiny shards are carefully deposited into a vial along with measured drops of phenol–chloroform. Then, once ethanol is added, the little plastic tube is placed in a centrifuge incubator.[2] The process of extracting ancient DNA is laborious, meticulous, sterile and slow.

Information emerges on a computer screen as lines and dots, but there are pieces missing. The DNA extracted from this tooth has spent more than a millennium in the ground, resulting in incomplete genome coverage.[3] It doesn't show the individual's eye colour or provide information on their appearance. However, while the minute sequences of the DNA prove difficult to decipher, the chromosomes are clear. The team members search repeatedly, yet across every sample they find no evidence of a Y chromosome anywhere. Instead, there is a clear pattern of two X chromosomes.

Osteoarchaeologist Anna Kjellström has finally been proved right. A year earlier she laid out the full set of 42 surviving bones,

each marked 'Bj 581' in Indian ink. Following the example of Berit Vilkens, another female specialist who examined the bones in the 1970s, she had noted problems with the original assignment of this skeleton as male. She agreed that the tibia was long, suggesting the individual was about 170 centimetres tall, the average height for an early medieval man. But the bones of the forearm were slender and more typical of a female skeleton. The pelvic bone also held clues: in women, the inlet is broader and more circular to allow for childbirth, and the ilium (the curved arch of the pelvic bone) is wider. What remained of this skeleton's pelvis followed these traits. But for over a century this individual has been known as the 'Birka Warrior'. Found with an axe, quiver of arrows, spears and a sword, the skeleton was surrounded by 'masculine' objects, so archaeologists assumed the bones had to be male too. Now the XX chromosomes overturned these assumptions. The warrior was a woman.

For the first time since its discovery in the nineteenth century, one of the best-known Viking graves ever uncovered in Sweden was revealing new secrets. The University of Stockholm published its findings in September 2017, and within days the discovery had gone viral. More than 130 global news articles and over 2,000 online accounts spread the findings like wildfire.[4] The overriding response was incredulity. How could this person, buried with all the trappings of war, raiding and pillaging, be female? This didn't fit the traditional view of Vikings, and the reaction highlighted patriarchal assumptions that, frustratingly, still linger. Women could do many things, but to imagine them in the cut and thrust of early medieval warrior culture was a step too far.

The Swedish team who made the discovery faced immediate pushback, with scholars picking apart every aspect of the investigation. It was argued that the bones may not even have belonged to the individual found in grave Bj 581, as they could have been mislabelled or mislaid. The team refuted this, showing how each bone had been inscribed with the burial's reference when they were excavated, but every glimmer of doubt was cast. They were

Remaining bones from grave Bj 581, Birka.

criticised for not consulting textual specialists, with the suggestion that a largely scientific team had passed over details of historical, literary and cultural evidence in their search for a female warrior.[5] So the following year they expanded their original findings to include evidence from other disciplinary areas supporting the idea that a Viking woman could be buried as a warrior.[6] Yet specialists and sceptics alike have continued to cast aspersions. And worse still, the largely female team of experts have been on the receiving end of threats and online abuse.

What is beyond doubt is that the 2017 discovery has led to a reassessment of what we thought we knew about Viking culture. The fact a woman could be buried in such a way – as a leader and a warrior – flew in the face of how Vikings had been presented from the Victorian age onwards. Examining the finds alongside the archaeological site and broader evidence for Viking women, a more nuanced view appears. Far from a rigid patriarchal society, the tenth-century world of Birka was a place where gender was more fluid than we might imagine, and women could assume a wide spectrum of roles. Perhaps a warrior, and certainly important and influential, the individual buried in grave number Bj 581 gives us a glimpse of Viking-age women in all their variety and complexity.

Welcome to Tenth-Century Birka

Lake Mälaren stretches westward from modern-day Stockholm, a 120-mile expanse of freshwater studded with islands. Navigating around these by boat takes you in and out of the Baltic Sea, then along a riverine loop through the heart of Sweden. Emerging from the huddle of islands, you can travel south towards Constantinople and the Islamic caliphate, west around France and Spain to the Mediterranean, or north to Britain and across the Arctic Circle. In the tenth century, this is the epicentre of Sweden; the heart of a Viking spiderweb of international travel and trading. The island of Björkö is one among many, only distinguished by its name – from the Swedish for 'birch' – suggesting it has a plentiful supply of wood. For most of its history it has been sparsely inhabited, the earliest settlers leaving their mark on the landscape in just a few dozen Iron Age burials in the north-east. But something dramatic happened here in the middle of the eighth century. In the manner of Dubai springing upwards and outwards in the 1990s, a huge settlement appeared and spread suddenly across the southern part of the island. This was Birka.

The town of Birka is diverse and energetic, with a bustling port. The prows of dozens of boats cling to enormous wooden posts driven into the water, small river crafts moored alongside seafaring, dragon-prowed longships. The harbour wraps around the coastline and reaches out across the water. This is a floating market square, connected by bridges more than a hundred metres long. Traders shift bulky goods from carrier ships, while nets full of fish are hauled out of the water onto a shoreline thronged with people and buildings. Wooden houses sit cheek by jowl, tight wooden boardwalks weaving between busy yards, workshops and latrines. This is a sensory experience, as the smell of excrement battles with the rich scents of cooking pots filled with fresh produce and seasoned with exotic spices. The rhythmic clink of carpentry, loud calls of sailors and the noise of farm animals assault the ears. This is Sweden's first city, and it is alive with sights, sounds and sensations.

Around a thousand people live in this lively town, with many more coming and going along trade routes from Moscow to Finland.[7] As ideas, cultures and people move through these waters, so goods from the end of the Silk Road, like barrels of wine, glassware and Arabic silver coins, are exchanged for Scandinavian jewellery or animal furs.[8] Wheat, wool and tin are shifted in bulk onto flatbed cargo ships called knarrs, their narrow keels and broad hulls allowing them to navigate shallow waters but also cover vast distances by sea. The huge sails of these ships could cover 70 miles per day carrying 20 tons of goods as well as livestock and a 20-strong crew. One of four major maritime trading centres in tenth-century Scandinavia, Birka was an essential port of call for all those interested in increasing their wealth.

All manner of traders ply their wares along the waterfront. Individuals haggle over the value of metal, checking its quality on touchstones hung around the neck and weighing it on scales of different sizes.[9] Vikings make the 'prima signatio', or sign of the cross, to indicate to Christian traders that they are free to do business.[10] As was the case in sixth-century England, Christianity is exerting an influence on this Viking town, with a small ninth-century church tucked away to the south. Men and women wear pendants around their necks, alternating between Thor's hammers and individually shaped crosses. The Muslim world is evident in Birka too, with Islamic coins providing a rich source of silver. Delegates from the caliphate arrive with exotic textiles and leave with armloads of Swedish materials. Ideologies as well as items pass through this island.

Birka already benefits from natural defences, a 30-metre-high mass of rock rising above the town to the west.[11] This has been extended by a man-made rampart of stone and earth rising to heights of 12 metres and arcing around the town from north to east. Newly erected wooden barricades protect the central zone, with palisaded walkways and a series of watchtowers providing the perfect position for launching defensive assaults. The huge amount of portable wealth moving in and out of the town, combined with its waterfront location, makes Birka vulnerable. Such a rich port is

a sitting duck for piratical smash-and-grab raids, and protections are essential for ensuring the town continues to thrive and trade. Warriors bearing shining weapons, with bows slung over their shoulders and quivers of arrows on their backs, walk up and down the ramparts, looking down on the inhabitants they guard.

Just outside the southern edge of the town, the warriors reside in their own barracks building. Inside this vaulted oaken hall, the highly skilled soldiers eat, drink and sleep together. Outside they train and hone their physiques, practising hand-to-hand combat using an armoury of axes, spears, swords and knives. Stretching away from the barracks is a series of mounds, each a reminder of a Birka inhabitant who has gone before. In this cemetery the burials huddle together in death, save for one, which sits apart from the rest. Overlooking the sea, high on the hillside with an enormous boulder rising above it, this burial is new. It is a memorial to a great leader, revered by the warriors who train nearby. The inhabitant will sleep quietly for more than 800 years, but when they re-emerge from the ground, they will make history for a second time.

Lost and Found

The site of Birka is a singular resource for Viking-age archaeologists. Occupied by a population of roughly 1,000 people for just 200 years (AD 750–950) before being abandoned, it provides a window into two centuries of life, trade, death and memorial across the high point of Viking expansion. The tooth and bone analysed in 2017 were part of a skeleton first discovered during excavations conducted in 1878 by ethnographer and archaeologist Knut Hjalmar Stolpe, who was drawn to the unique nature of the area.[12] He excavated across the island for more than 20 years and uncovered more than 1,000 burials. Thankfully he employed forward-thinking archaeological techniques, like plotting finds on graph paper and meticulously recording his work in a series of notebooks. He was not simply a gentleman overseer of the dig,

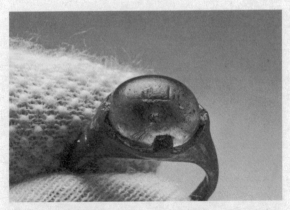

Ring discovered at Birka, made up of silver and coloured glass,
engraved with an Arabic inscription, tenth century.

but was dedicated to the site, returning year after year to develop
his understanding of the town of Viking Birka.

His digs uncovered many remarkable finds, including a silver
ring from a female burial, with a large stone. Stolpe thought was
amethyst, but recent analysis has discovered was the rarer material
of coloured glass; a substance produced in the eastern world in the
tenth century. Carved into the glass in ancient Arabic script are
the words 'for Allah' or 'to Allah'. It is impossible now to say
with any certainty why this woman was buried wearing it. Had
the ring been acquired while travelling in the Islamic world?
Was it bought in Birka or given as a gift? Was the woman a Mus-
lim herself? The fact it was chosen to accompany her to the
afterlife suggests it meant something to her and to those burying
her, and also indicates how cosmopolitan and international this
medieval town was.[13] But the rest remains tantalisingly out of
reach.

The burials at Birka offer glimpses into a more balanced Viking
world than the male-dominated society we often imagine. Female
graves outnumber those of males, and people of all ages, classes
and backgrounds cluster among the burials.[14] But one in particular
was 'perhaps the most remarkable of all the graves in the field', as

Stolpe's excavation drawing of grave Bj 581, 1870s (left),
and reconstruction of the grave (right).

Stolpe scrawled in a Royal Academy report. It stood out to him because of the wealth of finds accompanying the skeleton, and he called it Bj 581. Stolpe's drawings show the position of items arranged around a body that was originally seated, either on a chair, stool or saddle. Two horses, a mare and a stallion, one with a complete riding set, were also placed in the grave on a ledge. The figure, sitting upright, faced towards them inside the wooden chamber and was surrounded by an arsenal of weapons arranged on the floor and walls. These included an axe, two shields, a spear and a sword. A bow and quiver of arrows suggest that the individual may have been an elite warrior, able to fight and shoot from horseback. From more than a thousand graves that Stolpe excavated, only 75 contained weapons, and just two had a full set.

Bj 581 was also deemed extraordinary at the time of discovery for another reason. Something unusual was found placed on the

deceased's lap: a full set of elk-horn gaming pieces.[15] Rules for the Scandinavian game of hnefatafl have not survived but marked boards and poems referring to the game help to reconstruct it. Hnefatafl involves two armies: one defensive and one aggressive. A king piece is centrally placed, and the aim is to safely reach the edge of the board. Meaning 'game of the fist', it involves concentration and forward planning.

From shipwrecks to Jorvik (modern day York), gaming pieces have been discovered across the Viking world. They served a variety of roles, relieving boredom, allowing social bonding and encouraging diplomacy.[16] Two men playing a tafl game while drinking from horns are painted on the Swedish Ockelbo Runestone, suggesting it was a common pastime. Rich ship burials, like that at the royal sites of Vendel and Välsgarde, also contained board games with the pieces laid out as if still in play, deliberately placed into the grave to project something symbolic about the deceased.[17] If these individuals had the luxury to partake in a non-productive activity, it follows that board games in burials could indicate high status, wealth and leisure time.

But gaming pieces placed in warrior burials may symbolise something other than high status. They may also reflect the strategic skills needed by the individual in life to coordinate battles and organise armies. While gaming boards are often found in elite male graves, Bj 581 is the only Viking-age female burial to include one. Placed on the Birka Warrior Woman's lap, the gaming pieces positioned alongside such a large array of weapons could suggest she was seen as a military strategist. Buried so close to the garrison buildings, it is possible she was involved in the sort of tactical military endeavours usually attributed to men. This woman presents a view of the Viking world which calls into question our more recent gender norms.[18] But this time and these people have been misunderstood for too long. The comic-book version of Vikings as wild, ignorant barbarians has its roots not in the facts of the distant past, but in the propaganda of the last century and a half.

Rewriting 'Vikings'

There are many falsehoods that permeate and shape our understanding of history. Alfred the Great burned the cakes. Cnut – he turned back the sea.[19] And the Vikings were bearded men who wore horned helmets and killed indiscriminately. All these statements are based on inaccuracies. It is still the case that if you enter a fancy-dress shop and ask for a Viking outfit, you'll be handed a horned helmet.[20] But no horned Viking helmets have ever been discovered.[21] There are many reasons why it's not pragmatic to have horns on a helmet, not least because they provide a visual target, are cumbersome and would be a hindrance in battle. It's true that early accounts of Gaulish headdresses, like that of Diodorus Siculus's *Universal History* of the first century BC, indicate they wore 'bronze helmets with high protrusions' (Book 5, 30.2). Yet there are some seven centuries and thousands of miles between this account and the Vikings. Only metal skullcaps have ever been found in Viking contexts.

Admittedly it has been suggested that helmet plaques, like those found both in England on the Sutton Hoo helmet and on the Torslunda plates from Sweden, show warriors with horns on their helmets. But closer investigation reveals that these 'horns' have hooked beaks. This is a feature found throughout early medieval art and it is much more likely that the 'horns' represent two birds; a symbolic rendering of Odin's ravens Huginn and Muninn (Thought and Memory). There is a big difference between a

Warrior figures from the plaques on the Sutton Hoo Helmet, seventh century.

helmet worn for protection during battle and a ceremonial head-dress donned for symbolic purposes.

Far from ancient, the Viking horned helmet is only 150 years old. In 1876, German designer Carl Emil Doepler created the stage costumes for a production of Wagner's *Ring* cycle. Wanting the Viking-age characters to appear more impressive on stage, he put horns on the headdresses of the evil characters, while the heroes wore headdresses with wings. The popularity of this visual image – ancestors harnessing the strength of animals in a form of supernatural shapeshifting – meant it became a way of celebrating all things 'Germanic'. The hijacking of Viking culture by German nationalists was a deliberate strategy, and in just twenty years the horned helmet was reproduced on everything from cruise menus to children's books. Tying Germany to a perceived Viking ancestry only intensified under the Nazis.[22] The runic Sowilo symbol inspired the SS lightning bolt insignia, and the Ahnenerbe, Heinrich Himmler's think tank, searched for proof of the racial superiority of Germans through Aryan and Nordic links.[23] The 'horned helmet' version of Viking history is not simply something

Frank Bernard Dicksee, *The Funeral of a Viking*, Manchester Art Gallery, 1893.

to be laughed off or ignored; it has been misappropriated and misused in the most damaging ways.

The Germans were not alone in creating a mythic version of the Vikings to suit their ideological agendas. As the twentieth century loomed, the British and Germans raced to gain control of the seas and to lay claim to their most famous historical seafarers. The painting by English painter Frank Dicksee from 1893, called *The Funeral of a Viking*, presents a view that is still firmly embedded in modern consciousness. Two of the brutishly strong individuals are wearing horned helmets, one even valiantly keeping his on his head as he pushes the ship out to sea. As texts of the Scandinavian sagas were rapidly being translated into English and devoured by a public keen for adventure and tales of conquest, an image of unbeatable, unfettered warriors emerged. The British Empire was still 'master of the seas' and there was a symbolic potency in harking back to Viking origins. Archaeologists, linguists and place-name specialists all added fuel to the fire, uncovering evidence that the history of the British Isles led back to the Vikings. They were not wrong, but the tenor of this nationalistic misappropriation is clear from Dicksee's painting.

Here we see physically strong men, their muscles rippling in exertion, in an elemental battle against water and fire. The image is framed by water, flames and mountains, suggesting that the Viking forefathers had an intimate connection to the natural world. Weapons and bodies stretch across the painting in diagonals, giving it a dynamic thrust and vigorous energy. There is an unrestrained romantic otherness about the men – these are not dignified Victorian gentlemen; these are their pagan forefathers. We're led to believe that inside the refined and sophisticated Victorian man lies the passion and power of earlier ancestors. But this is empire-fuelled fantasy. The real world of the Vikings was very different, as was the idea that nineteenth-century men were restrained and upstanding.

Dicksee's vision, Doepler's creation of the horned helmet, and later comic strips like *Hägar the Horrible* from the 1970s, represent a more modern nationalistic view of Viking culture.[24] A view that

removes women from the narrative. The DNA discovery of 2017 is finally painting them back into the picture, and also shedding light on how many other false Viking myths have their origins in the last two centuries. The 'Vikings' were not simply a race of barbaric warriors who raided, raped and robbed their way across the known world. They were not pagan, ignorant, unhygienic bearded men. These assumptions need to be challenged for us to get a truer sense of the world the Birka Warrior Woman inhabited.

Truth or Lies?

The very idea of the Vikings being a unified race, or even a distinctive group, is problematic. The term 'Viking Age' is only used from 1873 onwards. In early medieval texts, the Old Norse word 'víking' describes an activity a group of 'víkingr' (explorers, merchants, travellers) would carry out as they took to the seas on expeditions. These could include raiding, trading, diplomacy, settlement and intermarriage. And when their violent attacks were recorded, their victims never called them 'Vikings'. Instead, they were Norse, Swedes or Danes. If written about in a damning way they were 'pagans', 'heathens' or 'wolves'.[25]

Far from a unified race, the Vikings originated in distinct Scandinavian regions and warred as much between themselves as they did with outside groups. Certain characteristics bound the Viking world together. Their religion was polytheistic, with the greatest gods and goddess displaying vices and virtues aligned to a warrior society. Their language, social structure and legal codes were loosely related, and their legacy in material culture – zoomorphic art, metalwork and armoury – can be seen as a unifying factor. But they were not a distinctive race and their movements from as far afield as Newfoundland to the edges of the Silk Road were on the whole not part of a coordinated mission, but rather the result of travel, settlement and integration.

Our impression of Vikings has been partly conditioned by quotations that have been repeated down the centuries. There is the

assumption that Vikings were bearded, dirty barbarians. The evidence remarkably comes down to a single, and distinctly unfavourable, account by the tenth-century Arabian writer Ahmad ibn Fadlan. He describes the 'Rus' (Vikings who settled along the river routes between the Baltic and Black Seas) as being 'the dirtiest creatures of God'. Then he relishes in the extent of their hideous hygiene: 'They have no shame in voiding their bowels and bladder, nor do they wash themselves when polluted by emission of semen, nor do they wash their hands after eating'. He continues, describing how the Rus all spit and blow their noses into one communal washing bowl. Ibn Fadlan's account was designed to shock his civilised Arabic readers and his writing is full of flamboyant 'tales of adventure' likely exaggerated for his intended audience. Travel writers are known to sensationalise what they encounter for entertainment purposes. Yet these accounts have been isolated and repeated by historians down the centuries, shaping our perceptions of all the Scandinavian groups of the Viking Age.

Other sources were plundered by historians from the seventeenth century onwards to uncover evidence of Viking atrocities. Accounts of barbarism were exaggerated, with one suggesting that they drank from human skulls. This now-infamous claim was again the result of one account; a mistranslation of an Old Norse kenning (a poetic term for the combination of two words which creates new, metaphorical meanings) in the 1630s. King Magnus Ólafsson translated the phrase: 'drekkum bjór af bragði / ór bjúgviðum hausa' as 'we shall soon drink beer out of the skulls of those they killed'. However, it should have read 'we shall soon drink beer from the curved trees of skulls', alluding to a wooden drinking horn.[26]

That said, it is possible that the Vikings may have witnessed such practices through their interactions with nomadic tribes in Central Asia who did practise drinking from skulls. (My thanks to Peter Frankopan for his insight on this point!)

A similar misunderstanding underlies the legendary 'blood-eagle' – long thought to be a form of Viking execution. It is mentioned in two sources, and Ivar the Boneless reputedly used it to punish the king of Northumbria: 'They caused the bloody eagle

to be carved on the back of Ælla, and they cut away all of the ribs from the spine, and then they ripped out his lungs.' However, the sagas in which these references are made were written after the twelfth century in a Christian society. The Scandinavian countries had accepted Christianity, along with its myriad martyrs. As St Sebastian was shot through with arrows until his organs were displayed, so the blood-eagle seems a later literary elaboration designed to chime with a newly Christianised audience.[27] It's a misreading, but the legacy of historical mistakes can last for centuries.

Even the more seemingly authentic contemporary accounts were largely penned by monks who had an agenda: their monasteries had been attacked and plundered. These were written to incite widespread condemnation, for example Alcuin of York said about the early raids on Lindisfarne: 'The church of St Cuthbert is spattered with the blood of the priests of God, stripped of all its furnishings, exposed to the plunderings of pagans.' These 'pagans' who conducted the first recorded Viking raid were a group of Norse sailors, and Alcuin's version of their attack on the island of Lindisfarne in AD 793 has been regularly cited by historians as heralding the start of the Viking Age.

It is clear that the Anglo-Saxon monastery suffered terribly at their hands. As a tidal island, undefended and used as a safe house for much of the wealth of the Northumbrian Kingdom, Lindisfarne was an easy target for Norsemen out 'a-viking'.[28] They needed to bring home enough wealth during the clement sailing months to see them and their communities through the harsh winters. A relatively short journey across the North Sea to attack an unfortified site with a glut of portable wealth was tempting. The fact the inhabitants were monks would not have been an issue, as the eighth-century Norsemen did not share the Christian moral framework which designated monasteries as sacred spaces. At this event two world views collided, and history has recorded it by tarring all 'Vikings' as savage, opportunistic, pagan and bloodthirsty.

Although the saying goes that history is written by the victors, in the case of the historical reputation of the Vikings, history was written by the victims. British monks could record their accounts

of the raids, but the Vikings were an orally literate society and didn't write down their own histories, stories, traditions, laws and ideas. They did have runic script, but this was only used for inscriptions rather than for extensive passages of texts. It was not until the start of the second millennium, when Christianity was spreading through Denmark, Sweden, Norway and up to Iceland, that the Scandinavian people began using writing as a means of documenting and recording. Preserving older accounts of their eighth-, ninth- and tenth-century predecessors has left behind a version of their past filtered through the moral prism of Christianity. The twelfth- and thirteenth-century authors like Snorri Sturluson, who provided the earliest surviving account of Viking mythology, would have had different religious views to the ancestors they wrote about.

Texts can prove unreliable when trying to access historical facts about the Viking Age, but archaeology paints a different picture. Rather than dirty, violent and barbaric, finds from burials consistently show that Viking people were fastidious about their appearance. Tweezers, combs and ear scoops for removing wax were frequently placed in graves.[29] The importance of washing regularly is even preserved in the Old Norse term for Saturday – 'laugardagr' or 'bathing day'. When Viking individuals arrived in new locations or met with people from other cultures, to most they would have appeared well-groomed, well-travelled and exotic. This was reinforced by the fashions both men and women favoured.

Grave goods indicate that men and women decked themselves in beads and jewels from across the known world. Finds such as a bronze Buddha made in Kashmir and an Egyptian baptismal spoon were transported to and buried in the cosmopolitan trading hub of Helgo, near Stockholm. We can deduce that the foreign materials and ideas they encountered on their travels were prized, displayed and treasured. These archaeological discoveries present a Viking world which was curious, wide-reaching and powerful.

Bronze Buddha, most likely made in Kashmir, buried in Helgo, sixth century.

Viking Women

The 2017 DNA discovery has led to a surge of interest in Viking women. Even the most outspoken critics of the geneticists concluded 'the emotional lure of the woman warrior, especially in the Viking Age, is too strong for reasoned argument'.[30] Surrounded by weapons, with a pair of horses at her feet and an enormous boulder raised over her grave, the Birka Warrior Woman feeds a growing fascination for fantastical females that defy stereotypes.[31] From Wonder Woman to Lagertha in the History Channel's *Vikings* series, the shattering of the taboo of women as the weaker sex, through a combination of archaeology and forensic investigation, is a distinctly twenty-first century phenomenon.[32] Recently scholars have returned to sources like the sagas, scrutinised myths and scoured historical records to find evidence for the daily life of women in early medieval Scandinavia.[33] But this is as reductive as defining what life is like for 'a British woman' in the twenty-first century. The picture that emerges is as varied, unique and dependant on individual circumstances as it is today. All manner of factors affected how women lived in the Viking Age, and experiences were not universal, but rather subject to class, age, background, family, health and wealth.

In many respects, life for Viking women was beset by the same issues that have affected women across time.[34] They were used as diplomatic pawns through arranged marriages, had to endure the trials of childbirth, were responsible for the upbringing of children and were in charge of caring for the home. They also could be a burden on their families, as they required a dowry upon marriage. It has been suggested that female infanticide, to avoid the need to provide for too many daughters, was practised in some parts of early medieval Scandinavia.[35] Unwanted babies could be 'bera út' (carried out) and left to die exposed to the elements.[36] When Norway converted to Christianity, laws were frequently passed preventing infanticide, which suggests it was indeed a problem that needed eradicating. But it was both male and female babies that were 'carried out'. Given the life-threatening harsh winter conditions endured by many in Scandinavia, an additional unwanted baby could have meant the difference between survival and death for a family. Infanticide is a dark reflection of a harsh existence, not just a result of a gender imbalance.

Recent studies have found that the movement and settlement so characteristic of the Viking Age may have been a necessity due to a disparity between the male and female population.[37] Men were able to take more than one wife, leaving many single men with not enough women to marry them. It is possible that competition for wives led young men to travel, prove their military prowess and gain wealth which could elevate their status. While this evidence all seems to support an image of women in Viking society as disenfranchised, oppressed and controlled, dealing with life inside the threshold of the home while men handled the world outside, there is evidence that points in the opposite direction.[38]

Frequent discoveries of keys in female burials suggest that women had responsibility for household property, could be involved in trade and were able to run businesses. Surviving law codes, designed to provide moral and legal guidance, also indicate that many Viking women could live well and arguably had more rights than their southern European counterparts. They could own property, divorce their partners if treated badly, and run their

own estates. If her husband hit her, a woman could demand payment of a fine. If he did this in front of witnesses, she would receive payment and could divorce him after the third blow. There are also cases where women requested a divorce because their husbands dressed 'in a feminine manner', as in *Laxdaela Saga*, where Guthrum makes Thorvaldr a wide-necked shirt to obtain half his estate and her freedom.[39] In more loving relationships, husbands would also celebrate their wives. The Odendisa Runestone, from Hassmyra in Sweden, includes an inscription where the husband laments: 'No better wife will come to Hassmrya to run the estate.' The woman's name – Odendisa – is very rare and translates as 'Goddess of Odin'.

Indeed, it is in the realm of the Viking gods that the role of women is even more prominent. A woman – Freyja – arguably holds the second-most important position in the pantheon of the gods, after the All-Father Odin. She's known commonly as a goddess of love, death, sex, beauty and war, and was entitled to take half the dead to her realm, Folkvangr, while Odin received the other half in Valhalla. Her hall is seen as a suitable resting place for women who had lived an exemplary life, but also for male warriors killed in battle. Alongside Freyja, the Norns, who spun the threads of fate, and the winged Valkyries play an essential role in the spiritual life of the Viking Age. These supernatural women were woven into mythological tales of war and battle throughout the Viking sagas. In a ninth-century poem attributed to Thórbiorn Hornklofi, a Valkyrie talks with a raven about the act of taking the slain warriors from the battlefield:

A maiden high-minded speaking, golden-haired, white-armed, with a glossy-beaked raven. Wise thought her the valkyrie; men were never welcome to the bright-eyed one, her who birds' speech knew well. [40]

Kennings describing the Valkyries emphasise their bloodthirstiness, and one describes them as 'the desiring goddess of the excessively drying veins.'[41] They are women thirsting to feed from

the ruins of war; they swoop over the battlefield like the carrion beasts of Odin, pecking over their spoils. These stories were not for the faint-hearted, and they position female spiritual beings at the vanguard of warfare. It's important to note that our very notion of modern warfare is at odds with the Viking Age. Today we envisage war as a moment when two distinct forces engage in battle. Warrior culture for the Vikings was a way of life that fed into, and was fed by, their spiritual practices. Instead of thinking in terms of our modern religions, the Vikings had a belief system that was bound to, and adapted to, their social and cultural practices. As warfare was an essential component, it is unsurprising to find men and women reflecting warrior aspects in their rituals and attitudes towards the supernatural world.[42]

Women played an essential part in the spiritual life of Viking communities. Texts record that some women acted as seers, known as 'völva' (which means 'holder of the magic staff'). Völvas would strive for 'seiðr', which was a form of magic connected to Freyja and Odin (the female and male deities) that could foretell and shape the future.[43] Once again, archaeology supports the textual evidence, with the discovery of graves containing objects which could have been used in the practice of seiðr. Most common is the distaff, used for spinning, which may have emulated the act of the Norns spinning the strands of fate.[44] *The Saga of Erik the Red* describes a völva called Thorbjórg, which means 'protected by Thor'. She was buried with: 'a staff in her hand, with a knob on the top; it was ornamented with brass and inlaid with gems round about the knob.'

A wand fitting this description was found in a Viking Age grave in Fyrkat, Denmark. A woman was buried in blue and red clothes adorned in gold thread. After being placed inside a carriage, items were arranged around her, including rare silver toe rings and bronze bowls from central Asia. Seeds from the poisonous henbane were included in the burial, placed inside a purse. When added to a fire, they produce a smoke with hallucinogenic results so may have been used in ritual practices to induce shamanic trances. A box was placed at her feet which also contained unusual

objects: owl pellets along with the bones of small birds and mammals. This woman could have been a völva, and she was certainly honoured after death with a burial containing objects that suggest she performed ritual acts.

As the mythological world of the Viking Age was one in which women played powerful and active roles in all areas, including warfare, it stands to reason that they could have performed such actions in life. In Scandinavian communities, where family groups (who may not have had physically strong trained young men to protect them) were isolated from one another, it is perfectly feasible to imagine that a woman could have picked up a weapon and have been trained to use it. When winters were brutal and entire villages could be decimated by illness or famine, every individual counted and to designate roles as 'male' or 'female' would have been detrimental. Women would have to do everything men did. This was also the case with travelling and settling groups – every person had to contribute. We already know women travelled with men on Viking expeditions, particularly when settling in new areas, as revealed by the large number of female skeletons in the burial pit at Repton.[45] When fighting for survival, women were (and still are) as adept as men, and they could certainly defend themselves and their community.

Mistresses of the Seas

There are identifiable, named Viking women whose feats are celebrated and recorded in the sagas and in runic monuments. They achieved great things and have been remembered for them. The thirteenth-century Icelandic text *Laxdaela Saga* describes the ninth-century settler of Iceland, Unn the Deep-Minded. Wife to the self-professed 'King of Dublin' Olaf the White, she travelled extensively with her family, following her son to live with him in the Hebrides.[46] When he died, she secretly commissioned a large knarr ship, which she captained to Orkney. In control of a crew of 20, Unn was acting as a commander. She married off her young

granddaughter to a stranger and carried prisoners and slaves across the waters.

When she arrived in western Iceland, claiming the land as her own, she established a community and gave the slaves free status and land. She knew that after the death of her son, her social position going forward would be threatened. Her decision to act as a leader, gathering together family, slaves and possessions in search of a place for her to live out her old age, was one of survival.[47] Her life is retold in many sagas; a foundation story centred on a powerful woman was celebrated and remembered down the centuries. Recent DNA studies in Iceland show that the early settlers were indeed from Ireland, Scotland and Scandinavia, so Unn's legacy continues today.[48]

The accounts from victims of the Viking armies suggest that women were among the warriors. The twelfth-century text *Cogadh Gaedhel re Gallaibh* ('the War of the Irish with the Foreigners') states that during an attack on Munster in the mid-tenth century one of the 16 flotillas was commanded by 'the fleet of the Inghen Ruaidh', translating as the 'Red Girl'. This casual reference infers a woman was capable of being a fleet commander.[49] The grave at Birka suddenly seems less of an anomaly, and instead reveals a tantalising window onto a select group of Viking women who could fight and lead.

So why, then, are we still so shocked to find archaeological evidence of women warriors? Turning to Norway, the country's largest ship was discovered in Gokstad in 1880. Intended for warfare, trade and the transportation of both people and goods, it could carry 32 oarsmen and had a mast that could be raised to support a sail of 110 square metres. Its design is ingenious, but the execution is simple, with little in the way of carvings or decorations. Buried beneath a huge mound, the ship contained the body of a man. He was about 40 years old, six feet tall and powerfully built; a true 'Viking'.

Just over two decades later, in 1904, Gabriel Gustafson led a team in uncovering another enormous ship, this time in Tønsberg, on the Swedish–Norwegian border. Known as the Oseberg ship,

it now stands alongside its predecessor in the Viking Ship Museum and the differences are notable. Slightly smaller than the Gokstad ship, it has elaborate carving on the prow and stern, and the range of goods placed inside at burial is simply staggering. From enamelled buckets to dog collars, fragments of tapestries to the only surviving Viking Age chair, the finds from the Oseberg ship provide a microcosm of ninth-century life inside the most lavish and powerful Viking households.

There is another major difference between the ships. The Oseberg ship was a commemoration of two individuals, not one. And the discovery that the bones of both skeletons were female led to great confusion. While the Gokstad skeleton fitted preconceived notions of a Viking warrior, scholars searched valiantly for an explanation as to why an elderly and a middle-aged woman would be worthy of a burial as extraordinary as the Oseberg ship. There was even the suggestion that a third, male body must have been interred as the focus for such an elaborate funerary monument – with the women sacrificed to accompany a much more important man to the afterlife.[50] But nothing of the sort has ever been discovered. Instead, the boat burial, complete with four sleighs, a large carriage, furniture, household objects and textiles, was focused on these two women alone, aged roughly 50 and 80.[51] Attempts have been made to determine who they were, with a popular suggestion that one was Queen Åsa, grandmother to Norway's first king. Whether or not we will ever confirm their identities, the scale of their burials suggest they were of the very highest status and were honoured by their community.

Furthermore, the bones in the Oseberg ship show clear signs of being disturbed some centuries after they were originally interred. This is not an uncommon feature of Viking burial mounds; it seems that often, at some point after burial, shafts were driven into the ground at the point where the body was located, and some of the skeleton removed. It's hard to imagine the purpose of this. One suggestion is that the bones could have been ground down and used to make weapons that preserved the memory and strength of great ancestors in their manufacture.[52] The process of forging

weapons required iron to be burned with carbon, and as bones have been found in cooking pots at cemeteries, it seems human remains could have been used to create bone-coal for the hardening process. 'Born' out of the furnace, the weapons were then given names like Gram, Bastard and Tyrving. Through forging the metal with human bones, the life experiences of great predecessors could be magically subsumed into the objects.

Another theory about the disturbance of the Oseberg skeletons centres on the spread of Christianity in Scandinavia. Among the Rus, there are records of rulers disinterring the bones of relatives to have them baptised. In the mid-eleventh century Yaroslav the Wise had his two pagan uncles, Olaf and Yaropolk, exhumed, blessed and reburied in his newly established church. Harald Bluetooth, the first Christian ruler of Denmark, ordered his pagan parents to be reburied in a chamber beneath the floor of his church at Jellinge. Churches in Scandinavia were often built near or on top of pre-Christian burial grounds, and the famous thirteenth-century *Laxdaela Saga* describes how a pagan witch buried beneath one of Iceland's first churches appears in a dream and asks to be reinterred somewhere away from Christian tears and prayers.[53]

The skeletons of the women buried at Oseberg are incomplete, and it is clear that some bones were removed via shafts. Whether these missing bones were reburied or used to imbue weapons with the protection of ancient ancestors is impossible to determine. But the disruption of their burial suggests that its location was remembered for centuries, and their names, reputations and importance were passed down the generations. They prove that women could be honoured long after death as bold, strong Viking warriors.

Gender norms?

The overturning of our assumptions about the social order of Vikings extends beyond the afterlife and into other areas of the living, for example, trade. Today we still speak of 'tradesmen' and

assume the travel, negotiation and labour involved in moving goods is a largely male sphere. However, in Birka the weights and scales usually associated with traders are found in 32 per cent of female graves, compared with only 28 per cent of male burials.[54] Birka is a place where gender assumptions are continually challenged, and assessment of similar finds across Norway show a similar pattern. Trade was not the exclusive preserve of men.

Unsurprisingly perhaps, throughout the written evidence, the ideal individual celebrated by Viking society and the gods displays characteristics that would be described as 'masculine'.[18] The warrior class made up the social elite, destined to be celebrated in the afterlife, so physical strength and skills at arms were prized. But these characteristics are not a definitive marker of biological sex. Fluidity could exist in both directions – towards and away from this ideal.

Gender ambiguity, based on clothing, hair, attributes and behaviour, is commonly expressed in Viking Age art and literature. And through religion, which often holds up a mirror to wider social and cultural issues, we gain an even greater insight.[55] The famous account of Thor's wedding survives in *Þrymskviða*, one of the best-known poems from the anonymous series of accounts known as the *Poetic Edda*.[56] Thor's magical hammer, Mjolnir, is stolen by the king of the giant-folk Þrymr. So Loki, god of mischief, borrows Freyja's flying cloak and learns that Þrymr will only give back the hammer in return for the goddess's hand in marriage. The brothers Thor and Loki ask Freyja to dress for the wedding, but she flies into a fury and categorically refuses. This woman will not be married off against her will, so the gods meet and determine that Thor should go in her place.

They make specific arrangements – the god of thunder should wear a dress down to the knee, a bridal veil and the goddess's precious and recognisable necklace, Brísingamen. Loki also dresses as Thor's handmaid. The two reach the court of the giants and when the feast is presented, Thor begins to behave in ways that Þrymr finds suspicious, consuming animals whole and drinking three barrels of mead. Loki explains this away by claiming Freyja hadn't

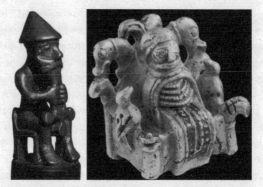

The Eyrarland Statue of Thor, bronze, National Museum of Iceland,
c. AD 1000 (left) and Odin from Lejre, cast silver,
National Museum of Denmark, c. AD 900.

eaten for eight days, so even this seemingly 'masculine' behaviour is
accepted. Ready to cement their marriage, Þrymr presents the bride
with her wedding gift – the hammer Mjolnir. His magical weapon
returned, Thor throws off his disguise and kills all around him.

Because this account was recorded in the thirteenth century,
doubt has been cast on whether it is a very early story, or a later
parody meant to show the pagan gods in an unflattering light.
However, the Eyrarland Statue, a tenth-century sculpture found
in Iceland and dated firmly to the Viking Age, seems to show the
moment Thor was presented with the hammer on his lap. This
suggests the story is an old and established one.

Another depiction of divine genderfluidity was uncovered by
an amateur archaeologist in 2009 and is now known as Odin from
Lejre, Denmark.[57] It dates to around AD 900 and, in cast silver at
just 18 millimetres high, it appears to portray the chief of the gods.
The tiny sculpture includes all of Odin's recognisable attributes.
He is seated on his high throne, Hliðskjálf, from which he can see
the nine realms. His two ravens, Huginn and Muninn, are depicted
on the arms of the throne, while his wolves, Geri and Freki, sit
behind. The ambiguity, however, comes from the clothing. The
figure wears a floor-length dress, an apron, and four rings of beads

around their neck. It also appears to have a moustache, so is wearing clothing that is recognisably female, with facial hair that is male. Various academics have taken a rigid stance: if the dress is female then the figure can't be Odin but must instead be Freyja or his wife Frig. Yet the symbolism is clear. Perhaps in this tiny object we can perceive tenth-century Scandinavian attitudes towards gender as fluid. If the chief of the gods can dress as a woman, and the god of thunder can dress as a woman, could other men?

Other artefacts reinforce the idea that people of one sex could present themselves as another. The hair and clothing of figures found painted on rune stones, engraved in jewellery and woven into tapestries demonstrate gender fluidity in the Viking Age. Hair remains a way of expressing identity today. It is a defining part of a human, something which grows continually through our lives, can be painlessly cut, and painfully torn from the body. Its colour, texture, length, style, and its absence in the case of baldness, not to mention facial and bodily hair, are all signifiers to those around us. As it is today, in Viking society hair was used to express identity.[58] The well-known story of Loki cutting the hair of Sif, Thor's wife, plays upon taboos regarding hair. In Snorri Sturluson's thirteenth-century *Prose Edda,* Sif is described as 'the loveliest of women, with hair of gold'. As a prank, Loki cuts off Sif's golden hair. Thor is so insulted by this that he captures his brother and forces him to have a headdress made of solid gold by the dwarves to replace his wife's hair. And Loki's offence is so severe that he has to pay further compensation still. He ends up providing each of the gods and goddesses with their most precious attributes: Odin gets his magical spear; Thor, his hammer Mjolnir; and Frey his golden boar. That such severe punishment was the result of cutting Sif's hair suggests that to violate a person in this way was unacceptable. A person's hair was part of them; to cut it without permission was equivalent to assault and demanded recompense.

Artistic representations of Viking hair also suggest it carried symbolic meaning. The famous Gotland picture stones, 400 of which date from the fifth to twelfth centuries, provide a visual

record of hairstyles.[59] Those that were erected during the Viking Age show that women most often wore their hair in a ponytail coiled into a knot at the top. Men are usually depicted with short hair, although a third have longer hair in a plait. Many are bearded, but there is an interesting group that appears to subvert these assumptions. Some are shown with a beard but wearing a dress, while one has a beard and a ponytail. The texts, artefacts and images contribute to the evidence that men did subvert gender norms by dressing or wearing their hair in recognisably female ways.

As Viking Age law codes, sagas and religious texts all discuss what should happen if women go about dressed as men, we can assume that women would subvert gender norms in everyday life too. A man divorces his wife, 'on the grounds that she had taken to wearing breeches [. . .] like a masculine woman'. The fact that women are being told not to wear men's clothing implies that enough of them did to require legal structures preventing it.

Back to Birka

Throughout the burials at Birka, artefacts from many thousands of miles away have been discovered. Byzantine fabrics woven with golden threads were buried alongside silks brought from the Far East. Pottery travelled from the Rhineland, while coins from England, Carolingian Gaul and Constantinople reveal a diverse and sophisticated trading network. Burial number Bj 581 was also full of exotic finds, suggesting that the woman interred here had either travelled widely or had come to Birka from elsewhere. It has been argued that she was not of Scandinavian descent herself but had come to Sweden from Slavic lands. The DNA is inconclusive on that, but we know the dead don't bury themselves; the warrior burial she received was created for her by the Swedish community who interred her. They wanted to honour her after death in the most lavish way.

There are some facts we know for certain about this burial. The person in Bj 581 was female. She was buried with weapons, horses

and a gaming set, in a large wooden chamber outside the fortifications of the town. She was seated or enthroned, perhaps even sat astride a horse's saddle, clad in expensive garments woven with silk and silver thread. She is presented in death as wealthy, powerful and involved in warfare in some way. Across the past two centuries, thousands of Viking Age graves have been dug up and their contents labelled 'male' or 'female' depending on the objects found alongside the bones. This one example acts as a reminder that we need to reassess this practice and return to the evidence. Analysis on the DNA of many other bones is now taking place, and more individuals like the Birka Warrior Woman are already emerging.

In November 2019 the reconstructed face of a woman buried at Nordre Kjølen Farm in Solør, Norway, was revealed to the public. Her skeleton indicates that she had been injured by a sword across her forehead, yet this wasn't what killed her. The wound had healed, leaving a scar. She was buried along with a sword, spear, battleaxe and arrows, her head resting on a shield and a bridled horse at the foot of the grave. She was about 18 or 19 years old when she died and 155 centimetres tall. The assemblage could represent her position within a military family, or it could be a reflection of the role she took on in life – namely, as a warrior. The wound is telling, showing that she experienced violence and received injury as a result. Another intriguing burial from Aunvollen in Nord-Trøndelag is also posing new questions. The 20-year-old woman in this burial was laid out on a quilt, with a sword, eight gaming pieces, a comb, scissors and a small box. The combination of traditional 'male' and 'female' finds again suggests we must reassess our preconceptions and see the people of this period as capable of attitudes towards sex and gender that challenge our modern-day assumptions.

The evidence will always remain fragmentary, but these recent discoveries are causing scholars to return to finds from the Viking Age with fresh eyes. Rather than simply interpreting the evidence available to us with techniques inherited from older traditions, steeped in misconceptions, there are now new ways of looking.

Once you seek representations of gender fluidity a fresh angle appears. This is not to say that all Viking women were the shield-maidens of legend, or even that a large number were. Birka Warrior Woman might be an exception. But through the exceptional we can find inspiration, and through her story we are reminded to keep an open mind when we look at the past. It was as complex and contradictory as our present.

It's not just because we can imagine the Birka Warrior Woman fighting with the physical strength and skill of men that her burial is significant. She also shows us a Viking world connected across thousands of miles; a city teeming with ideas and influences; a cosmopolitan, complex and fascinating environment that challenges traditional representations of Vikings. Furthermore, she presents us with a different view of violence in the medieval period. It is important to disentangle the smash-and-grab raiding and pillaging attributed to Viking-age marauders from the military work she may have been involved with at Birka. If she was a leader and able to wield arms, she was likely high-status and highly trained. She may have been part of a troop whose aim was to defend Birka against attack, so it's possible she did not see action through raids or battle further afield.

Her bones show no signs of having engaged in hand-to-hand combat. This is not unusual, as some injuries may not have left their imprint on the skeleton. There also has not been enough analysis conducted on the Birka Warrior bones to determine whether there were characteristic changes to the physique of the individual that would suggest she engaged in warrior activities. Repeated actions, such as drawing a heavy longbow hundreds of times, result in changes to the skeleton.[60] The bones of longbowmen from the fourteenth century show defects to the shoulder blades, wrists and elbows. But no defects like this have yet been determined with regards to the Birka Warrior Woman. Without this evidence it is impossible to say this individual actually took up the weapons she was buried with and used them to fight.

Then there are our modern assumptions about the more gendered aspects of violence. Men involved in military activity are still

pushed towards a certain type of 'masculinity', and violence against women assumes a passivity which reinforces the connections between war being a male pursuit and victimhood being in the realm of the female.[61] The modern truism that 'women and children' are innocent and could not take part in violence remains a deep-rooted assumption. But it is continually subverted today, as it was over a thousand years ago. When men and women exist within structured 'civilisations' and can depend on class mechanisms to maintain the veneer of gender distinction, demarcations of what is expected of a 'man' and a 'woman' can be more easily enforced. But in the challenging environments of Viking Age Scandinavia, in communities where every person's contribution would determine the success and survival of the group, an individual would behave according to need. A ninth-century Scandinavian trading town like Birka would be home to all manner of people from all types of backgrounds. It's likely we'd find women who had faced conflicts and threats, then developed the means to defend themselves in response. There is no single narrative, and the skeleton in grave Bj 581 reminds us not to look for a collective 'woman' of the past, but instead to examine individuals, and what they can tell us about the particular time and place they lived in.

In the same year the Birka Warrior Woman's DNA was revealed, a set of 7,000 clay fragments was uncovered in the Danish trading town of Ribe.[62] Like Birka, this was a coastal Viking settlement

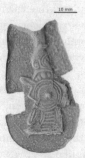

Clay mould used for production of pendants, Ribe, Denmark, ninth century.

where goods, people and ideologies washed in and out on the waves.[63] From this vibrant and cosmopolitan site artefacts would travel the watery motorways of Scandinavia. When pieced together, the thousands of clay remains were discovered to be casts, originally used to produce metal pendants. Mass produced, and an early example of 'fast fashion', the pendants – and the figures and symbols on them – would have been popular. It is interesting then that two of the moulds support the idea of gender fluidity in the Viking world. In one, a bearded man tears at his long hair, which was a gesture usually performed by women, while in another a woman wears a long gown, carrying a shield and a sword. But she is not a warrior, as her long dress and train would make it hard to fight in combat.

It's possible that the woman carrying these weapons represents a Valkyrie. This is the common interpretation of metal figurines, including one discovered in 2013 in Hårby, Denmark, who also wears a dress but wields a sword.

But perhaps the clay fragments, pendants and metal sculptures reference another area of Viking life where women could have subverted gender norms. Viking-era rituals and ceremonies were special occasions, and depictions of these processions can be seen on fragments of woven material discovered in the Oseberg ship. Through reconstructions, the original tapestries appear to show men and women behaving in unconventional ways.[64] A strange figure wears a horned helmet (supporting the idea they were used for ritual rather than battle) while many women bear weapons. Today there are still May Day celebrations, feast days and festivals where members of a community dress in ways that subvert norms. These images suggest that ceremonies during the Viking Age were similarly subversive.

The Birka Warrior Woman and the Ribe 'Valkyries' offer two different views on Viking-age women. On the one hand, there may have been a few notable individuals who took part in battle and were warriors. On the other, women could have taken on male roles and attributes, like weapons, in ritual and ceremonial settings. Both discoveries reinforce the idea that, rather than

simply assign an individual from the past 'male' or 'female', we have to consider cultural context. DNA may determine an XY or XX chromosome configuration, but the way that person lived, dressed, behaved, self-identified and the roles they assumed within their societies are all much harder to reconstruct over a thousand years later. At least now, in part thanks to the Birka Warrior Woman, there are new ways of looking and thinking about gender which are shaping our relationship with the past. With only her bones and grave goods remaining, much of her story has been lost. But advances in technology are beginning to allow these lost women, written out of the historical record for centuries, to speak to us once again.

4

Artists and Patrons

Discovery!

January 1983 – Bayeux, Normandy, France

French officials have a challenge. The Bayeux Tapestry, one of the country's most famous artefacts, is moving to a new museum. It has not been cleaned or restored in decades and is covered in accumulated dirt. How they clean it, where, when and who will get the contract are issues that will be scrutinised by press, experts and onlookers around the globe. Whatever they do they must do it carefully, to protect this unique and delicate medieval survivor.

Across the 35 kilometres of water that separate England from Normandy, in the English capital London, controversial art critic Brian Sewell is penning a damning, yet amusing, piece entitled 'Tapestry and Swimming Pools'.[1] Expressing dismay over a rumour that the most famous embroidery in the world will be dunked in an Olympic swimming pool in Paris, he presents a ludicrous scenario. One hundred local women will be trained to physically hold up the piece for five days and nights to clean the now-filthy fabric.

The unconventional method may be a joke, or a rumour spread as an underhand attempt by a Swiss firm to win the cleaning commission, but the French press quickly jump to the defence. They claim the task is impossible since the enormous swimming pool is 20 metres too short to accommodate the extraordinary medieval

masterpiece. But it still prompts outcry from across the English Channel. Sewell claims the work is 'much more ours than theirs' and others chime in, describing the French as 'inadequate caretakers of a priceless national treasure that should never have departed England'.[2] Like the build-up to war depicted in the Bayeux Tapestry, new battle lines are drawn, and tensions are reaching breaking point.

In Bayeux, a team of conservators is taking the matter very seriously indeed. The mayor has put a firm lid on any discussion of swimming pools, and the people of this small city feel the intense pressure on them to take the very best care of this priceless and fragile artefact. The proceedings are handled with caution, as they wouldn't want anything happening to their most financially rewarding asset. It's worth pointing out that the Bayeux Tapestry should not even carry that name. First, it is an embroidery rather than a tapestry, made of linen and sewn with individual stitches rather than worked on a loom. Second, while it is recorded as being in Bayeux in the fifteenth century, it was most likely made in Canterbury, England. It has had other names in the past, including the Tapestry of Queen Matilda and William's Great Cloth, so there are arguments for it to be renamed again. But were it called, for example the 'Canterbury Embroidery', then this pretty little town in Normandy would lose a substantial part of its tourism income. The mayor is clear: no changes to the name and it stays firmly in Bayeux.

It is an extraordinary medieval survival, depicting the events leading up to the Battle of Hastings of 1066, culminating in William the Conqueror's defeat of King Harold. As the small team of conservators and experts see it laid out for inspection, excitement builds. This is the first opportunity to apply modern scientific methods, scrutinise the front and back of the Bayeux Tapestry, make microscopic observations, take detailed photographs and ensure its preservation through careful conservation. It has been removed from the Hôtel du Doyen, its home for the past forty years, and a custom-made museum is being built inside the destroyed interior of the former Grand Seminary. Here, the 900-year-old linen will

have a safe long-term home, protected behind glass to be show-cased to 400,000 tourists a year – visitors keen to see a treasure adored not just in Normandy, but across the whole of France as well as in England.

First impressions suggest the tapestry is filthy and damaged, and it reeks of insecticide. It's hardly surprising given the rough treatment it has experienced in the past. During the French Revolution it was confiscated as public property and used to cover munition loads.[3] Napoleon moved it to Paris, but it eventually ended up back in Bayeux on a winding contraption which did terrible damage to the final scenes. The biggest threat to its survival came during the Second World War, when Himmler requested its removal to Germany as an example of 'Germanic Art'. The SS-led research group the Ahnenerbe moved it to the Louvre. But a message intercepted by the coding team at Bletchley Park revealed it was to leave for a bunker in Berlin. Had this happened there's no doubt it would have been destroyed or lost, as so many other irreplicable artworks were during the post-war era. When Himmler made his last-ditch attempt to take the Bayeux Tapestry, Allied forces had already stormed the beaches of Normandy and the Louvre was back in French hands. The tapestry was found safe in the museum's basement and returned to Bayeux.

Some 40 years later this team can now see that their first impressions were overly critical; the Bayeux Tapestry is in pretty good condition. It needs a gentle clean, but any thoughts of swimming pools are dismissed entirely. A hand-picked group of experts peer greedily behind the seventeenth-century linen backing, which has been removed for the first time. What secrets might this hidden side reveal?[4] New facts begin to emerge; ten colours of wool were used, there were nine rather than eight sections sewn together, and the embroidery had only been repaired once in the nineteenth century. But one mystery unravels when examined from the back. It relates to the most famous scene on the tapestry: King Harold's death and whether he was shot in the eye with an arrow.

It's an image children know from school, replicated on tea towels, greeting cards and mouse mats. The idea that Harold died

Close up on Harold Godwinson, Bayeux Tapestry (front and back).

from an arrow through the eye has, until recently, been written in our history books as fact.[5] But close examination of the Bayeux Tapestry over the winter of 1982–3 reveals clues that the figure always thought to be Harold – reaching for an arrow that sticks awkwardly out from his helmet – is not the king at all.[6] The Latin inscriptions, which appear above the images and give context of what the scenes present, provide a good starting point for unpicking this myth. Generally, the person mentioned in the text above appears in visual form at the end of the line. If that is the case, the person we know as Harold is not the standing figure with the arrow in the eye, but the individual lying at the end of the scene with a man looming above him about to hack into his leg. Turning to the back of this section of the tapestry, seventeen small holes are revealed, suggesting that at one point this figure too may have had an arrow stitched in his eye.[7] Although the symbolism has been lost or removed, these tiny holes divulge that this man on the ground was also once considered to be King Harold. But was the arrow part of the original design or a later addition? And what about the other character so often mistaken for him? It's only the studious examination of the team of conservators, with just ten days to assess the back of the work, which provides the crucial evidence.[8]

The earliest references to King Harold's death do not mention an arrow at all. The *Anglo-Saxon Chronicle* states simply that he fell and was slain. The most significant text dated to within a few years of the events, 'The Song of the Battle of Hastings', goes into

greater detail, describing how four men hacked and mutilated the king's body, but there's no mention of an arrow. It's a grim read:

> The first of the four, piercing the king's shield and chest with his lance, drenched the ground with a gushing stream of blood. The second with his sword cut off his head below the protection of his helm. The third liquified his entrails with his spear. And the fourth cut off his thigh and carried it some distance off.[9]

The implications are clear: the Normans were victorious not through a fortuitous arrow, but through the strength and skill of the knights.

In later medieval texts an arrow in the eye was symbolically the appropriate death for a perjurer; someone who had broken an oath. Harold is shown earlier in the tapestry swearing on relics, so the arrow has always been interpreted as his just deserts. The right punishment for the crime. A handful of twelfth-century sources mention an arrow, but they could have been employing a bit of artistic license, as a portrayal of what 'should' have happened. The

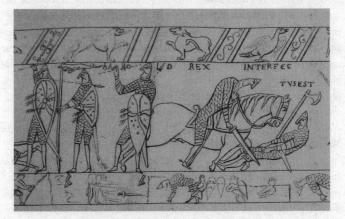

The Bayeux Tapestry, illustrated by Antoine Benoît,
published in 1729 by Bernard de Montfaucon.

selective rewriting of history to shape later moral interpretations of the past is nothing new. Harold met a grizzly death, but the arrow may not have played a part in it. The almost invisible stitches leading to the eye of the figure on the ground may have been added by a later embroiderer with their own agenda.

What's more, the 1982–3 investigations revealed something else. Looking closer at the standing man (previously always assumed to be Harold), there is another line of tiny holes, this time extending from the arrow in his eye. Even more shockingly, the wool of this arrow was nineteenth century, not eleventh. Someone had reworked the design. An earlier drawing made in the 1720s shows not an arrow in the eye, but a lance in the hand. This makes much better sense. The angle of the arrow had always been problematic since it bends awkwardly towards the helmet. One figure in front of him carries a banner while the other holds up his hand, grasping onto a spear. His pose is almost identical to that of the standing individual commonly identified as Harold. The stitches, lost for centuries but revealed in these investigations, prove that the figure is not King Harold but another soldier in the last line of defence for the king. The arrow was once a spear, but the reworked design is how it has been reproduced for over a century. The figure on the floor is in fact the king, wounded in the thigh as the early sources state. If incorrect assumptions have been made about the most famous and reproduced image of the king's death, then it's likely there are other issues that also need readdressing. If we are to look at the Bayeux Tapestry with fresh eyes, it's important to understand how it was created, and to uncover the team of women who made it.

Welcome to Eleventh-Century Normandy

It's a sultry summer morning in July 1077. You have travelled about ten kilometres from the shores of Normandy to the city of Bayeux. The flat landscape shimmers green in the sunlight: the myriad fertile fields, busy villages and modest church spires reflecting the prosperity of the time, with the Viking ravages of the previous

Reconstruction of how the tapestry may have appeared
in the nave of Bayeux Cathedral.

century a distant memory. Arriving at the northern gatehouse you
pass through the extensive fortifications into Normandy's second
city. This main road has been in use for over a millennium, with
the ancient stones reworked in walls and cobbles reminders that
Bayeux was once an important Roman settlement, full of sanctu-
aries to ancient gods.[10] An imposing new edifice rises from the
heart of the town. Castles and cathedrals are spreading like a rash
on both sides of the English Channel, and this sparkling new
church in Bayeux follows their style. It is austere, simple and built
on a huge scale. A pair of sturdy towers flank an archway with
concentric rows of dressed stone. It's a medieval interpretation of
a Roman triumphal arch, celebrating the power of the new Nor-
man world order.

Hundreds of people have congregated outside the cathedral, all
dressed in their finest attire. There are traces of the region's Viking
heritage as soldiers move through the market square kitted out in
full sets of armour, shields in their hands and swords at their sides.
But while their ancestors who came from the Scandinavian north

and settled in Normandy wore the hammer of Thor, these Christianised warriors carry the sign of the cross around their necks. Men wear colourful tunics over breeches, with large woollen cloaks slung across their shoulders. A handful of English men are scattered through the crowd, distinguished from the Normans by their moustaches and hair worn long, rather than shorn up the back of the neck.[11]

Women wear flowing gowns fitted to their figures dyed with woad, madder or dyer's rocket in vibrant shades of red, blue, green and yellow. Some also have fragments of an exotic material – silk – woven into their trimmings. Golden threads shimmer in the stitches of the wealthier ladies, jewels dangling from their neck and headdresses influenced by fashions of the imperial court in Byzantium. Some of the men have returned from campaigns in Sicily, bringing luxury goods and foreign slaves to Bayeux. Every sector of society has been drawn together for a special event – Duke William is coming.

Moving into the nave of the cathedral, you see a vaulted ceiling reaching high on cross-shaped pillars so large that three men would struggle to join hands around the base. The columns are hollow, however, designed to give the impression of bulk. They have been worked up rapidly by masons and stacked drum upon drum with rubble in the core, to create larger spaces with higher roofs than the more modest churches of a few decades prior. This new type of architecture allows for powerful statements in stone to be erected quickly; church and State now govern all aspects of life and a new era has begun. At the head of this new powerhouse is one man – William the Conqueror. He lost the first battle of his reign the previous year, but his many achievements outshine his failures. He has led troops across Europe, smashing through territories from the toe of Italy to the tip of the British Isles. As this legendary figure approaches the steps of the cathedral he appears strong and stern, covered in the regalia of both Duke of Normandy and King of England. With him is his brother Odo, Bishop of Bayeux. He bears himself less like a cleric and more like a warrior, happier wielding a club than a crosier.

Hanging from ropes and stretching around the central space, a roll of fabric runs the full length of the nave. From a distance, the borders suggest the luxurious garments imported along the Silk Road from exotic lands. The paired beasts and birds are familiar motifs that appear on clothes and luxury goods, arriving in the marketplaces of Normandy via the eastern Mediterranean.[12] But closer inspection shows this fabric is not silk, but rather linen with wool embroidery. It bursts with colour, lines of words just visible above hundreds of figures – some on horseback, others on ships, men enthroned and warriors locked in battle. Sweeping an eye across the scenes, it is clear this is not a sacred artwork – no Jesus, Mary and the saints here – but something more of this world. The songs of the Battle of Hastings have been sung in the courts and parroted in the alehouses since that famous day in October 1066 when Norman troops defeated King Harold and his English army, and Duke William seized the throne. Tens of thousands of minute stiches have captured that historic moment, proudly on display in the cathedral at Bayeux.[13]

The piece fits the nave exactly.[14] Depicting a continuous narrative, it starts with the early actions of Harold Godwinson, his forays in Normandy, support for William and tentative oath on relics – these events run down the south side. The action continues; Edward King of England dies and Harold is elected his successor, his coronation overseen by the controversial Bishop Stigand. As the fabric turns the corner and carries on over the entrance to the cathedral, Duke William prepares for war, a tiny cross positioned right above the doorway signifying the halfway mark in the proceedings. Then preparations for battle unfold, with shipbuilding, the forging of weapons and the preparation of troops. Horses and warriors cross the Channel on a sequence of boats, before landing in Pevensey. As the scenes stretch back down the northern side of the nave towards the altar, images of the battle appear. Bodies crash together, decapitated corpses flow into the decorative borders, and finally King Harold falls to his death. Duke William is victorious, now declared King of England and head of a mighty dynasty.

Standing below these images, William clasps his brother in front of the altar cross and the newly minted cathedral is anointed. The events of the embroidery remind all inside the church that this victory has ushered in an age which will bind France and England together for centuries. A group of English female embroiderers has guaranteed these immortal images a central place in the pages of history.[15]

The Women Behind the Bayeux Tapestry

There are few medieval objects that have been so scrupulously studied, yet offer up so many unanswered questions, as the Bayeux Tapestry. Even the question of how it came to be termed a 'tapestry' when it is clearly an embroidery is a mystery. Despite hundreds of books, thousands of articles and numerous studies of the original, debates on central questions continue.[16] Who commissioned it? Who made it? Where was it made? Where was it meant to be displayed? There does seem to be some consensus that it was most likely commissioned by William's brother, Odo of Bayeux, although the potential role of Edward the Confessor's wife Edith is noteworthy, and other suggestions abound too.[17] Odo was made the Earl of Kent by William after the Battle of Hastings, and art-historical evidence points to the main monastery of his kingdom in Canterbury as the most likely place where the ideas and illustrations for the tapestry were developed. It has been robustly argued that the piece was always intended for the nave of Odo's other major bishopric and the anointing of his new cathedral in Bayeux, with the sections of linen carefully measured and plotted so the action falls at designated locations around the space.[18] There is some agreement on these issues. But what about the question of who made it?

Really the Bayeux Tapestry should be described as a 'mistresspiece' rather than a masterpiece, since it was created by a team of female embroiderers.[19] Yet while no one would think of discussing *Starry Night* without mentioning the artist Van Gogh, or the *Mona Lisa* without extensive investigation in the life and times of Leonardo da

Vinci, very few begin discussions of the Bayeux Tapestry thinking about the women who made it. It is an astonishing work of art, full of drama, symbolism, depictions of warfare, daily life, court politics and an emotive cast of eleventh-century individuals.[20]

It is important to consider its sheer size, since it is usually reproduced in squared-off scenes for easier reproduction on T-shirts, greeting cards and tea towels. It runs to nearly 70 metres in length, and like a film reel it is long and thin: only 50 centimetres or so in width. The frieze is a continuous narrative, like a comic strip, with trees or structures breaking up separate sections but not disturbing the flow of the action. Viewers today would recognise the effect of seeing the longships huddled together, riding tumultuous waves, or horses flipped sideways, riders flung from their backs, as cinematic. An extraordinary survivor of what must have been a huge body of textiles that have not made it to the present day, the Bayeux Tapestry provides evidence of an area of medieval art in which women excelled.

The very concept of an artist creating 'art for art's sake' is a relatively modern notion. The expression is first used in the mid-nineteenth century, recorded in the work of French poet and critic Théophile Gautier. It became a bohemian creed repeated by Edgar Allan Poe, John Ruskin and Victorian artists like Dante Gabriel Rossetti.[21] But medieval art was rarely made to that brief. Even through the Renaissance and up to the nineteenth century, most artistic creativity was the work of skilled craftspeople creating the finest examples of useful objects. Instead of a museum or gallery, these artefacts functioned in specific settings, such as a church or a home, and existed as part of design schemes alongside other decoration and articles that performed practical roles. Why some artworks have survived while others haven't can be put largely down to chance, as well as changing tastes, monetary value and historical significance. But when we see a medieval ceremonial comb or a page from an illuminated manuscript in a glass cabinet today, we are seeing it out of context.

Medieval artworks would play roles in sensory or ceremonial environments, where the smell of incense and crushed herbs, the

sight of candles flickering, the sound of chanting and the sensation of cold stone underfoot created moments of drama.[22] Think of the Olympic torch for comparison. By itself in a cabinet it is a beautiful, well-crafted object, designed and made by the premier artisans of the time. But imagine it lit up, carried by the celebrities of the moment, moving into a swelling stadium as fireworks explode overhead, music blasts over speakers and a sea of bodies crushes together in excitement. Artefacts need context to fulfil their intended role.

The Bayeux Tapestry was functional. It may have been unfurled for feast-day celebrations, and alongside it we can imagine wall paintings, stained glass windows, bronze effigies, stone sculptures and gilded chalices. Perhaps it travelled to be revealed in a stately hall or even displayed in advance of battle. The sung or spoken versions of the events of 1066 could have been recited alongside it, creating dramatic moments that brought spectators into the action. Now it is usually cited like a historical text; a fixed document which can be compared with other written accounts as a fact-based version of events. But by considering the women who made it, and the few who appear in it, a different view of the tapestry emerges.

First, an important point: women made the Bayeux Tapestry. Exactly who these women were, where they lived and worked are questions we may never be able to answer. We do know that during the eleventh century, female artists outperformed men in the field of embroidery. Women have excelled at needlework and textile production since antiquity. While the three artistic graces of painting, sculpture and architecture had been dominated by men, the creation of fabrics, from spinning wool to decorating textiles, was largely the realm of women.[23] From the seventh to the tenth century, individual women were praised for their stitching skills. Some are now known as saints, including Eadburga and Ethelreda of Ely.[24] The type of embroideries they created became known as 'opus anglicanum' (English work). These were usually for church vestments – decorative fabrics, woven with silk, gold and jewels – and they were the most desirable luxury goods in Europe. Popes became patrons of these English female artists, and opus anglicanum

vestments are listed in Vatican inventories.[25] William the Conqueror's own chronicler, William of Poitiers, went so far as to write: 'Everyone attests to the great needle-craft of English women in gold embroidery.'[26]

Over the past two centuries women have both pushed against and leaned into the connection of femininity with embroidery. The idea that a woman stitching is a virtuous act has a long history, for while she is still, silent and submissive, she cannot be challenging or corrupted.[27] In the eighteenth century, tenacious women like Mary Wollstonecraft saw the process of embroidering as restrictive. In her *Vindication of the Rights of Women*, she wrote how it 'confines their thoughts to their person', and rejected it in favour of less sedentary activities like gardening, experimental philosophy and literature.[28] But there have also been moves to reclaim fabric as a medium for celebrating female contributions to art. Tracey Emin's famous embroidered tent, *Everyone I Have Ever Slept With* (1995) included 102 appliquéd names stitched around the inside. The quote at the centre – 'With myself, always myself, never forgetting' – not only suggests the piece focuses on Emin's personal battles, but also reiterates Wollstonecraft's suggestion that the process of embroidering is personal, private and performs a role in memorialising.[29]

It is certainly clear from historical references that the women of early medieval England were particularly noted for their skills with a needle, but almost all their extensive output has been lost. While many thousands of fabric fragments have been recovered from early medieval sites and burials as millimetre scraps or eroded onto the surface of metalwork, only two pieces are large and sumptuous enough to give any insight into the skills that would have been required by English embroiderers to make the Bayeux Tapestry.[30] The first, the Maaseik Embroideries, are believed to be the oldest complete pieces of embroidered fabric to survive in Western Europe. They formed parts of a chasuble, the sleeveless cloaks worn by priests. The fragments look rather sorry today, since the silk, pearls and some of the golden threads have been damaged or picked out. But the distinctive colour palette of reds, greens and blues is still clear and the detailed stitched designs

The Maaseik Embroideries, linen ground with silk thread,
most likely ninth century © KIK-IRPA, Brussels.

of birds and beasts present an echo of what must have been very
sophisticated work. They date to the ninth century and appear to
have been made by English women.[31]

Perhaps a more visually impressive precursor to the Bayeux Tap-
estry survives in Durham. The relics of St Cuthbert are a treasure
trove of early medieval high-status artworks. Alongside his famous
gold-and-garnet cross, personal gospel book and ceremonial ivory
comb, a set of embroideries survived intact inside his coffin. Form-
ing part of a stole and maniple – the long strips of material worn
around the neck of a priest and over their arm during mass – they
do not date from the seventh century when Cuthbert died. But
they are still early medieval, made in the tenth century and placed
in the saint's coffin when King Athelstan visited the shrine in 934.[32]
They are worked with gold and silk threads, with the stole depict-
ing prophets from the Old Testament and the maniple the saints
and apostles. Probably made in Winchester, their style and design
mirror manuscript illustrations produced there around that time.

Inscribed on the back of both embroideries is 'Ælfflæd ordered
this to be made for the pious bishop Frithstan'. Ælfflæd was the
second wife of King Edward the Elder (Æthelflæd's brother), and
she instructed them to be made around AD 915 for the Bishop of
Winchester. These Cuthbert Embroideries provide evidence of a

Saints and prophets from St Cuthbert's stole and maniple, Durham Cathedral, early-tenth century.

known and named woman commissioning and possibly creating an expensive and important piece of needlework for a specific patron; a woman who used the holdings of a monastic library as inspiration for design and style. But while these examples recall elements of the Bayeux Tapestry, they also highlight that the 70-metre-long piece of embroidery is an extremely rare survival.

This Woman's Work

Such a demanding project required a single-sex team that could work in close quarters, collaborating over long periods of time. The medieval embroiderers most likely worked together at Barking Abbey to create the tapestry. It had become the second-richest abbey in the country after securing royal patronage from King Edgar in the 970s, and as the king had the right to choose the abbess of Barking himself, a sequence of queens and royal women had held the position, including the wives of Henry I and King Stephen. Finds from the site, including bone combs, coins and

rare coloured glass, suggest this royal relationship greatly enriched the abbey. The nuns at Barking received the finest education available for eleventh-century women, reading biblical studies, ancient law, history, grammar and spelling, and hosted William the Conqueror there while his White Tower was being finished in London. As the abbess received her role and responsibilities directly from the king, the production of the Bayeux Tapestry may have been a gift in turn, used to secure the continued relationship between Barking and the new Norman royal family.

The women – a team of highly trained embroiderers – would have required a good deal of space and resources to create it. The first two sections of the tapestry run to nearly 14 metres – and handling this amount of linen simultaneously is a complicated process. From analysis of the different hands at work on the Bayeux Tapestry it seems that the women worked alongside one another in close proximity, some helping to keep in place the individual sections while others embroidered, with the remaining linen collected together or held on a roller.

While we don't have a full picture of how exactly it was created, a group of women from Leek made a replica in the 1880s, providing some insights into its production. Under the guidance of William Morris's friend, Elizabeth Wardle, a team of at least 37 'shareholders' (women who were associated with her school of art embroidery and dedicated their time to the project) were organised systematically. Elizabeth had her own agenda: she wanted the female artists named and recognised. She sent strips to each of them with instructions to embroider their names below the scenes they had worked on. This was not how the original was made, but like the medieval embroiderers, Elizabeth herself worked alongside members of her family, huddled shoulder to shoulder. The Victorian women realised that the most effective way to complete the project would be to create smaller sections that could then be stitched together. It seems the original embroiderers began to realise a similar thing as they worked on the Bayeux Tapestry.

The standard unit of measuring material in early medieval England was the ell, which is roughly 45 inches or 114 centimetres.[33]

The tapestry is approximately half an ell in height throughout, and the main sections were cut from bolts of linen measuring 24 ells in length then cut in half lengthways. As the embroiderers began working on the first two parts they split this piece of 24 × 1/2 ells of material in two, with the women working on lengths of 12 ells. This is a very large amount of material to manipulate, and it seems that once the women had completed sections one and two they switched to smaller sections of about half the size again. As the tapestry neared completion and the deadline no doubt loomed, the linen was cut into even smaller parts, allowing individuals greater personal control over the material.

It is possible that this was an unusual project and neither commissioners nor embroiderers had worked on anything of this scale before. The changing size of the sections shows they worked out how to stitch as a team most effectively and modified their practices as they went along.[34] The adaptability of the women embroiderers is also clear from the joins between the separate sections. The first two parts are stitched together in a clumsier way, with errors in the alignment of the margins. But as the project progressed the seams became more sophisticated, some appearing almost invisible as the embroidered stitches continued over the break. The planning and coordination between members of the team was becoming increasingly streamlined, and as the embroiderers gained confidence with the project, the quality of their work improved.

What also makes the tapestry exceptional is that, unlike other examples of opus anglicanum, it deals almost exclusively with secular subject matter. Who turned the skills of a group of highly talented women away from the chasubles and copes of bishops, towards recording the death of an English army and the demise of the English kingdom?

Canterbury Connections

The nuns of Barking had regular contact with a group of monks at St Augustine,[35] the most important monastic community in

England and heart of the Canterbury school of art. Its abbot, Scolland, oversaw its monks from 1066 onwards.[36] The communities lived relatively close to one another, and obits for the abbesses are included in surviving documents from the abbey, showing that the monks would pray for their female counterparts.[37]

Scolland had previously been head of the scriptorium at Mont Saint-Michel, and as this island and its distinctive buildings are given prominence on the tapestry, it's very possibly a reference to the fact that he managed the design.[38] There is even a little monk in the margin pointing to the hilltop Norman Abbey, which may be Scolland himself. So the monks could have designed the illustrations, which would then travel from Canterbury to Barking, where the abbess would oversee execution of the sketches onto linen.

Scolland was a well-travelled man and had visited Rome, where he would have seen the Column of Marcus Aurelius, built around AD 180 to commemorate the emperor's victories at battle. There are many similarities between the composition of the great victory friezes on the imperial Roman sculpture and the Bayeux Tapestry, which suggests Scolland may have drawn on it for artistic inspiration,

Bayeux Tapestry, Scolland pointing to the island of Mont Saint-Michel, photographed from Reading reproduction.

perhaps even sketching it while in Rome.[39] Images of troops preparing for battle, travelling by ship and encamping together are common to both, and a scene depicting a woman and child escaping could be a direct copy from the column. One of only three women depicted in the main narrative of the tapestry, the female figure clasps the hand of a young boy as a building burns behind them.

The woman reaches out her other hand towards one of the men holding a torch, as if calling to him. The scene most likely represents the acts of raiding and destruction conducted by Normans along the English coast when they plundered surrounding villages for food and supplies to support the army. In this case the woman and child are victims of war, and this tragic scene shows the vulnerability and suffering that so many across England experienced in the face of the invasion. This tone is at odds with the celebratory mood throughout the rest of the tapestry. But comparison with Marcus Aurelius's column presents another layer of symbolism. In the Roman version of a woman and child escaping, the lady has her breast exposed, with the suggestion of sexual violence

Carving showing a woman being attacked by a warrior, Column of Marcus Aurelius, Rome, c. AD 180 (left). Woman and child running away from a burning building, Bayeux Tapestry, photographed from Reading reproduction (right).

as she shies away from the advances of a fully armed warrior.[40] In the Bayeux image, the woman is dressed and veiled, while the two men are not heavily armed. The differences are subtle, but they disclose the Christian origins of the Bayeux Tapestry. While there is nudity in the margins of the tapestry, all the characters in the main narrative are appropriately dressed according to their status: soldiers in armour, nobility in finery and women veiled and covered.

Yet by recalling the Roman example, the designer may have intended a sense of 'Romanitas' to permeate the tapestry. William is cast throughout as a rightful ruler in the guise of previous Roman Emperors.[41] This might explain a scene that otherwise makes the invading Norman army look destructive and cruel. It conjured up the glory of Rome.[42] The very format of the column may have served as inspiration for Scolland, its unbroken continuous narrative leading him to develop a similar structure. By employing the skills of the renowned English embroiderers now under his command in Canterbury, a different medium was used: not stone but highly prized embroidered fabric.

From Vellum to Wool

Until the eleventh century, Winchester Cathedral and its associated monasteries had been the most influential artistic centre in England, due to support from King Alfred and the subsequent dominance of Wessex over the other kingdoms. But after the turn of the millennium, the Canterbury school rose in prominence.[43] When Scolland moved from Normandy to Kent he set about enriching the abbey there, and enhancing its reputation as a centre for artistic creativity. While many other religious institutions across the country were destroyed and reconfigured along Norman lines, the reputation of Canterbury and its patronage under Scolland meant it wasn't so negatively impacted. Hitler's plans for Oxford serve as a good comparison. While plotting the invasion of Britain as part of Operation Sea Lion in 1940, he hoped to base his new

headquarters at nearby Blenheim Palace and wanted to preserve the university city from destruction by Luftwaffe air raids.[44] Just as the Nazis would see the value in preserving the reputation and history of Oxford for their future, so the Normans harnessed the skilled scribes and talented artists of Canterbury to the service of the new regime.[45]

As abbot of St Augustine's, Scolland would have had access to the many manuscripts produced and housed by the monks in their extensive library, which he could consult when seeking designs, patterns and exemplars for the tapestry. Alongside his experience with the many continental manuscripts under his control while head of the scriptorium in Mont Saint-Michel, he was uniquely placed to develop the sophisticated and esoteric imagery of the tapestry. He also had loyalties on both sides of the Channel and could have intended the finished piece as a gift to Bishop Odo. Not only would it ensure the Earl of Kent continued to financially support his monastery in Canterbury, but it would function as an advert for the artistic skills of the monks at his English monastic house, and the women embroiderers connected to it.[46] Heaving with depictions of cushions, tablecloths, hangings, priestly vestments and the fashionable clothes these women were renowned for producing, it's a sort of portfolio for the artistry of the English monasteries.[47] In its very existence, the tapestry urged England's Norman overlords to consider how the country's educational and creative centres might be put to the service of the new regime, rather than ransacked or dismantled. It was a bid to Odo not to destroy, but to re-employ. The continued outpourings of the Canterbury school after the Conquest, like the wealth of twelfth- and thirteenth-century manuscripts produced there, indicate that, far from destroyed, the institution was bolstered and supported.

Home to the archbishop, the city boasted some of the finest libraries in the country, and St Augustine's Abbey possessed prized manuscripts. The ninth-century Carolingian masterpiece, the Utrecht Psalter, spent at least two centuries in Canterbury from AD 1000. Its lightly inked illustrations were a radical departure for manuscript art. It is a revolution in illumination: instead of

coming before the text or decorating the margins, the images in the Utrecht Psalter wrap around and illustrate each of the psalms. Like the Bayeux Tapestry, this technique recalls comic books; a dramatic interaction between text and image, figures and phrases.

There is no doubt this manuscript influenced the monks in Canterbury. At the beginning of the eleventh century, they made a copy that is now known as the Harley Psalter. The images are very similar, but the English scribes deviated from the black ink of the Carolingian original, and brought blue, red, green and brown wash to their copy. Further developments are made in a version penned after the Norman Conquest known as the Eadwine Psalter.[48] This is even more colourful, with greater solidity to the figures. The fluid and fluttery drapery of the ninth-century drawings has been replaced by more static forms, and the influence of the Romanesque artistic aesthetic is clear in the patterning and linear composition.[49] In this final copy, there are three different translations of the psalms into Latin, and scribes have added words in Old English and Anglo-Norman French in between the lines. Like St Augustine's Abbey itself, the manuscript it produced after the Conquest reflects the blending of old and new, English and Norman influences.

When looking for inspiration for the Bayeux Tapestry, the artists turned to even older manuscripts held at St Augustine's Abbey. A feasting scene showing Odo at a semi-circular table, blessing food and wine during the first meal on landing in Hastings, is based

Eadwine Psalter, folio 108v illustrating psalm 63,
Trinity College, Cambridge, c. AD 1150.

Last Supper illustration, St Augustine Gospel Book, MS. 286, folio 125r,
Corpus Christi College, Cambridge, sixth century (left).
Bishop Odo feasting with his followers on the eve of battle, Bayeux Tapestry,
photographed from Reading reproduction (right).

directly on an image from the St Augustine Gospel Book depicting
Christ at the Last Supper. This manuscript was already legendary
by the time of the Norman Conquest, as it had been brought to
England by the first wave of Roman Christian missionaries at the
end of the sixth century.[50] The archbishop of Canterbury is still
sworn in today by placing his hand on the book, one of the oldest
European manuscripts in existence. English viewers of the Bayeux
Tapestry who had seen Canterbury's most famous manuscript may
well have noticed the parallels between the version on vellum and
that embroidered in wool. The suggestion that Odo was taking the
role of Christ is sycophantic; an attempt by the subjugated to flatter
their subjugator. But the English viewers may have also picked up
on other subtle references to native sources, particularly in the dec-
orative margins. Indeed, it is in these borders that the creativity and
imagination of the female embroiderers is most evident.

On the Edge of the Action

Undeniably, the Bayeux Tapestry is a very macho affair. Alongside
the 623 men, 201 of whom are armed with weapons including

axes, swords, spears, clubs, bows and arrows, there are 37 ships, 35 hunting dogs and 190 horses – the trappings of male knights and warriors. A staggering 88 of these horses are depicted with large penises. There are four men with erections, too, and one flaccid penis is visible in the margin where an individual is being stripped of his chain mail.[51] The largest penis belongs to the fine stallion William is presented with on the eve of battle. The most important man on the tapestry rides the horse with the biggest phallus. The second largest belongs to the horse ridden by King Harold; the implication being that he is a worthy opponent, second only to William himself. Size matters on the Bayeux Tapestry.

When Elizabeth Wardle and the women of Leek produced their copy, the horses' penises were significantly reduced, and the naked men were clothed with little stitched underpants. These changes have been laid at the feet of the priggish Victorian lady embroiderers, but the penises were in fact covered up by the creators of the photographic facsimiles produced at the Victoria and Albert Museum and sent to the embroiderers as templates.[52] And let's not forget that the graphic designs on the original tapestry were stitched by nuns. This Boy's Own subject matter was not out of bounds, and neither were the brutalities of war, death and decapitation. The embroidered penises on the original tapestry remind us not to project current or recent ideas about prudishness or censorship back through the centuries.

As many schoolchildren will have discovered with glee while looking in the margins of the Bayeux Tapestry, there are several sexually implicit scenes. The majority of these feature in abbreviated versions of fables.[53] The naked man running towards a woman who covers her private parts is assumed to be a visual representation of one of Aesop's fables concerning a father raping his daughter. Another set of naked images, showing a woman moving towards a man this time, illustrates the familiar story of a prostitute falling in love with her client. These scenes reflect moments of betrayal in the main narrative, such as when Harold is taken hostage. The scenes below or above mirror and enhance the message of the images in the centre.

Close up on naked man and woman from the margins, Bayeux Tapestry,
photographed from Reading reproduction.

Sex and scandal were as titillating to eleventh-century audiences as they are now. Just as we consume gossip magazines and newspapers reporting on the latest indiscretions of politicians and celebrities, so viewers of the Bayeux Tapestry would have gleaned titbits of gossip from these images. Some of the allusions have become lost to us over the intervening millennium. There is one scene in particular whose significance evades modern eyes; it features one of the three women shown in the main narrative and she is paired with the most explicitly naked man on the tapestry.

The Mystery of Ælfgyva

The very scarcity of female figures naturally makes the three that are included notable. Women are conspicuous by their rarity; the presence of non-presence. There is the woman shown holding onto a child in front of a burning building. We can assume she is not an identifiable individual but a symbol of a group of people: victims of war. No inscription tells us who this woman is, and she features alongside scenes of the construction of the castle at Hastings and images of William and Harold preparing for battle. In the absence of any more information, she appears to be a generalised representation of the women and children who suffered after the invasion.

The other two women in the central part of the Bayeux Tapestry are identified more clearly, either through context or inscriptions. Scholars have argued endlessly over the identity of

the woman in the first image.[54] Her head and body are shrouded in material, with only her face and hands exposed. An inscription above reads: 'Where a certain cleric and Ælfgyva'. She stands inside a building, represented by two columns with dragon heads, and a man reaches into this space to touch her cheek.[55] His pose is unusual, and a naked man in the margin below mirrors his stance exactly with genitals on full display. Another naked man appears before this one, grasping an axe, the weapon perhaps suggesting that threat to life is imminent. If we consider its position on the tapestry, this scene with the mystery woman interrupts the main narrative. William has brought Harold to his palace, where they are shown to be having an animated conversation. Harold gestures to the next scene with his hand, where he will accompany William on his Normandy campaigns. Harold's promises to the Duke are emphasised just before we meet Ælfgyva and the cleric. In the images directly after the Ælfgyva scene, William heads to Mont Saint-Michel accompanied by Harold, who ends up heroically saving two men from quicksand. The scene with the woman occurs after a promise and before a display of loyal service.

For the embroiderers and the intended eleventh-century audience, the significance of Ælfgyva and the monk would have been clear. They would have known who she was and what account or piece of gossip it referred to. But even without knowing the woman's story, we can consider the themes suggested by the scene. Ælfgyva is in an enclosed space that is being entered from outside by a man. A suggestion of sexual liaison or potential violence comes from the naked crouched figure in the margins. Some have seen this as an image of a woman being forgiven for a past sexual encounter, while others have interpreted the scene as showing a woman's private space violated. Is Ælfgyva representative of all Anglo-Saxon women, threatened with rape and the fear of illegitimate children?[56] Either way, the connotations are largely negative and create a sense of foreboding. What is noticeable from our contemporary vantage point, however, is that modern prejudices colour how the scene is interpreted, with one recent historian stating 'the cleric may be making a pass, or slapping the woman

Ælfgyva and a cleric, Bayeux Tapestry, photographed
from Reading reproduction.

for having impure thoughts or for being a witch'.[57] The cliché of
woman as victim, witch or whore is still rife.[58]

Many far-fetched and spurious suggestions have been made as to
the identity of Ælfgyva. Given its popularity as a name in eleventh-
century England, there are no end of possibilities. One theory is
that the scene depicts Harold's sister, whom he has pledged in mar-
riage to William. But this Ælfgyva was already dead by 1066. Other
members of his family have also been proposed, including an imag-
ined daughter, a wife and even his mother. Some claim the woman
is the abbess responsible for the making of the tapestry, and here
she is being given instructions on its creation by a monk. But this
fails to take into consideration the gesture of touching which would
have been inappropriate between a nun and a monk.[59] A relatively
novel suggestion is that the woman is Ælfgyva of Northampton,
who was abbess of Leominster in 1046 and taken as a mistress by
Harold's older brother, Sweyn Godwinson. The enclosure and
habit imply the woman is a nun, but all these suppositions are
loaded with uncertainty. Some names, however, have jumped out
across history and left a greater impression.

Emma as Ælfgyva

Arguments have been put forward that Ælfgyva is the first wife of King Æthelred the Unready, and later queen consort to King Cnut. Born Emma, this powerful woman was called Ælfgyva during her marriage to Æthelred but reverted to her original name in later life. Emma of Normandy is indeed one of the most visually represented early medieval women.[60] Her father was the count of Rouen, an important ruler in Normandy, and this lineage would influence the events leading to the Norman Conquest. As William the Conqueror's great-aunt, she spent a large portion of her life on the French side of the Channel.

It was by controlling the fortunes of her children that she maintained power and influence throughout her life. Her first marriage to Æthelred the Unready (1002–16) was forged to secure relationships between England and Normandy in opposition to Scandinavian forces. She had two sons and a daughter with Æthelred: Edward, who would become King Edward the Confessor; Alfred Ætheling, who was killed in suspicious circumstances; and Goda of England, who married the count of Boulogne. When Danish troops conquered England in 1013 Emma and her family escaped back to her home in Normandy.

In the controversial years between Æthelred's death and Cnut's accession, when invasion from Scandinavia created turmoil over who would succeed the throne, Emma attempted to have her son Edward recognised as heir, even though Æthelred's son from his first marriage, Edmund Ironside, had greater support.[61] But the situation changed when Cnut captured London and destroyed all threats to his reign. Emma agreed to marry Cnut, essentially saving her children's lives, but her sons were sent to be fostered by her brother in Normandy.[62] Her priorities changed overnight, as she now needed to focus on providing the new king with heirs and entrenching herself in the governance of England. She had two children by Cnut, with their daughter, Gunhilda, becoming queen consort of Germany, and their son, Harthacnut, reigning after the

death of his half-brother Harold Harefoot in 1040. Emma's control over her children, willingness to shift allegiance and adaptability to change had a huge influence on eleventh-century English politics. Wife of kings, mother of kings, landholder and game-player, Emma embodies the complexities of the decades leading up to the Battle of Hastings.

Two major recent developments have thrust Emma back into the limelight. First, a copy of the text written in her praise, the *Encomium Emmae Reginae,* was discovered in the Devon Record Office in 2008. It had been languishing in the library of Powderham Castle for 500 years, when the holdings of Breamore Priory were claimed by the Earl of Devon after the Reformation. It then moved to the Record Office in the 1960s, but it took another 45 years for its relevance to come to light. Only one other copy of the text exists, held in the British Library. But the two texts show a major difference: the first version concludes by extolling the virtues of Emma's son with Cnut, Harthacnut, while the second praises her son with Æthelred, Edward the Confessor.[63] Emma was hedging her bets, commissioning two versions of the same text with different outcomes.

The second major development for Emma's legacy was the reconstruction of her skeleton. She had originally been buried in the Old Minster at Winchester alongside Cnut and Harthacnut, with their bones later transferred to the new cathedral, built after the Norman Conquest. During the English Civil War (1642–51) the royal burials were attacked, the bones scattered across the church floor and some hurled through stained-glass windows. Horrified locals placed the skeletons haphazardly into six mortuary chests, which for the past four centuries have overlooked congregations from elevated shelves either side of the high altar. In 2012 a team of osteoarchaeologists from the University of Bristol began to sift through the 1,300 bones to determine whose remains were in these chests.[64] They found evidence for 23 different people, including two young children. Bones belonging to a mature female were scattered between three of the chests, and when reconfigured were found to belong to the same skeleton. As

the only woman named on the chests, and given that she died at the advanced age of 67, it is highly likely these are Emma's bones. Interestingly, jumbled up alongside her were the remains of Archbishop Stigand, who also features on the Bayeux Tapestry and was an influential supporter of Emma during her latter years.[65]

Riding the Tides of Change

The impact of Emma on eleventh-century England can be summed up by looking at two images side by side: one from the tenth-century New Minster Charter showing King Edgar, and the other from the eleventh-century Liber Vitae showing King Cnut and his wife Emma. This was how they were meant to be seen, both books open at these pages on the altar of Winchester Cathedral, in Wessex's heart of power. The earlier image forms the frontispiece for the New Minster Charter, presented by King Edgar in honour of the new Benedictine community in AD 966. This manuscript records royal land grants to the monastery and its imagery captures the dawning of a new age.[66] The Benedictine Reform, which had spread across Europe in the tenth century, was a power grab, with the state supporting one unified set of monks over all other orders.[67] Increasingly, influential rulers saw the opportunity to get behind a puritanical branch of clerics and stamp out the diversity that had emerged among monastic communities. The new Benedictines were a spiritual army in black habits propping up the state powers that funded their institutions. In England, the main players offering their support to King Edgar were Dunstan, Archbishop of Canterbury, Æthelwold, Bishop of Winchester and Oswald, Archbishop of York.[68]

The Benedictine Reform of the tenth century was a spiritual clean-up operation, with secular clerics thrown out – sometimes by force – and replaced with monks. The Crown supported the new church and vice versa.[69] This dynamic is visualised in another contemporary manuscript illumination in the Regularis Concordia. Here, King Edgar sits enthroned in the centre, with Æthelwold

King Edgar sitting between St Æthelwold, Bishop of Winchester
and St Dunstan, Archbishop of Canterbury, Regularis Concordia,
British Library MS Cotton Tiberius Aiii, folio 2v, late-tenth century (left).
Entry into Jerusalem from the Benedictional of St Æthelwold,
British Library Add MS 49598, folio 45v, c. AD 980 (right).

and Dunstan either side and a Benedictine monk beneath them.
All the figures are linked, holding the same scroll representing the
Rule of Saint Benedict. It was a co-dependent relationship. The
New Minster Charter was probably commissioned by Æthelwold,
whose long term as Bishop of Winchester allowed him to enrich
the monastery and develop the Winchester school of illumination.
His own prayer book is the finest surviving example of the exuber-
ant colours, elaborate drapery, linear figures and acanthus designs
that characterise this style.

In the New Minster image King Edgar appears centre stage.
Either side of him, yet smaller in stature, are the Virgin Mary and
Saint Peter. The king is the link between heaven and earth, his
foot crossing the lower-most border and his fingers making con-
tact with the angels that hold Christ in a mandorla above. This is
a powerful piece of propaganda: the monks of Winchester have

the right to the lands listed in the charter through the grace of the king, who receives his position directly from God. It was so effective that some four decades after Edgar, when King Cnut attempted to entrench himself at the heart of the English church, he returned to its imagery for another important Winchester document: the Liber Vitae.[70]

Cnut had taken the throne of England in 1016 after the successful campaigns of his father. King of England, Denmark and Norway, he worked to transform his reputation from that of a brutal invader to legitimate head of church and state. When the frontispiece to the New Minster Liber Vitae (which listed all the individuals who must be remembered and prayed for by the

King Edgar offers the charter to Christ, frontispiece to the New Minster Charter, British Library Cotton Vespasian A. VIII, folio 2v, c. AD 966 (left). King Cnut and Queen Emma offer a cross to Christ, frontispiece New Minster Liber Vitae, British Library Stowe MS 944, folio 6r, c. AD 1031 (right).

community) was developed, the scribes based their version on the earlier image of King Edgar. However, there are some noticeable differences. The illumination records an actual event; the presentation by the new royal couple of a precious cross, which would be displayed on the altar alongside the two books.[71] In a meta narrative, the cross would have appeared in actuality and then in the pages of the manuscript, moving the viewer from real time to the spiritual and eternal. But the other major difference is the inclusion of not one but two primary figures. Cnut is present, his sword piercing the frame in recognition of his military might. But equal to him in stature, and raised a little higher, is Queen Emma.

Her presence here is essential for shoring up his standing in England. They rule alongside one another; although the king is still undoubtedly crowned, Emma receives a veil from heaven. This is a potent symbol, for it recalls the veil of the Virgin Mary, drawing a direct connection between the most important sacred woman and her secular counterpart. The royal couple stand on a mound either side of the altar and peering out of arches beneath them are a sequence of Benedictine monks. Like King Edgar before them, they are propped up and supported by the church. But their styles differ, and while the earlier one is colourful, flamboyant and floriate, the later one mirrors the dramatic pen and ink style of the Canterbury manuscripts. Emma is present at a moment of political change – the shift to a Scandinavian ruler – but also artistic change. The Bayeux Tapestry and the events it records are a direct product of this transitional period, and the influence Emma's actions wielded.

Had Emma never married Cnut, a Danish claim would not have led to the depletion of Harold's forces at Stamford Bridge before the Battle of Hastings. Had Emma not sent her children to be raised in Normandy, then William would not have had such a strong claim to the English throne. Had Emma not shifted allegiance back and forth, the question of Edward's successor would have been clearer, and there may have been other claimants to the throne. Towards the end of her life she was the richest woman in England, holding vast amounts of land in many areas. She didn't

just wield economic power but also political clout, determining the nature of governance throughout the 1030s and 1040s.[72] The eleventh century was a time of constant and rapid change, and Emma's survival was thanks to her strategic ability to turn with the tides.

So, back to the matter at hand. While there is much evidence which points to Emma as Ælfgyva, there is a flaw in the theory. Some later sources suggest that Emma had an affair with the Bishop of Worcester, and it is this scandal which the 'a certain cleric and Ælfgyva' scene references, to remind viewers of the tapestry that Edward the Confessor's mother behaved sinfully.[73] But Ælfgyva is William's great-aunt, and denigrating her reputation would by extension stain him. Once again, we are left with uncertainty. But while it is unlikely to be Emma depicted on the Bayeux Tapestry, we can be sure that few other women had such a direct influence on the episodes it records.

Edith – Queen, Sister, Daughter, Patron?

Emma is a dominating female presence in the events of the late eleventh century, but there's another queen whose influence should not be underestimated. She is also the only woman on the Bayeux Tapestry who can be identified with some confidence. Queen Edith is depicted grieving at the foot of the deathbed of her husband, Edward the Confessor. She weeps into her golden veil and points right. This gesture most likely relates to the election of her brother, Harold, as king in the following scene, and could be a way of indicating that he was Edward's choice for successor on his deathbed. With no offspring of her own, this decision would ultimately have been beneficial to Edith, and the justification for the crown to pass to a member of her family worth emphasising. Like Emma, Edith was wife and sister to kings, but also exerted considerable influence herself.

Echoing Emma's example again, Edith had her name changed when she married.[74] She was originally called Gytha, a nod to the

Queen Edith at the deathbed of her husband, Edward the Confessor, Bayeux Tapestry, photographed from the Reading reproduction.

fact her mother was a Danish noblewoman. Her father was the extremely influential Lord Godwin, who became Earl of Wessex,[75] and her brothers held some of the country's most important positions of authority as Earls of East Anglia, Northumbria, Kent, Sussex, Essex, Surrey and more. She was a well-educated woman and spoke many languages, having grown up at the royal convent in Wilton. The Norman chronicler William of Poitiers described her as 'intelligent as any man . . . a woman in whose bosom there was a school of all the liberal arts'.[76] Her marriage to Edward was politically motivated for, although Edith was not of royal birth, her familial connections would prove useful. And in a strategic move to keep the Godwin family onside, unlike most wives of Saxon kings in the tenth and eleventh centuries Edith was crowned queen in her own right. This coronation led to accusations of nepotism, so much so that in 1051 Edward exerted some damage control, exiling the family to Flanders and sending Edith to a convent. But the Godwin family put on a show of force and returned more powerful than they left. From this point Edith became not just queen but also close adviser to her husband. Her influence increased.

Edith was a patron of the church and of the arts. She gave lands

to the abbey in Abingdon and the see of Wells, and sponsored art-
ists in her role of tending to the king's regal presentation. She
commissioned items of clothing and jewellery, keeping a gold-
smith as one of her tenants. Through her expansive land-holding,
ruthless decision-making and political engineering she overtook
Emma, becoming by the time of the Norman Conquest the rich-
est woman in England and the fourth-richest individual after her
husband, her brother and the Archbishop of Canterbury.

But 1066 was a cruel year for Edith. After her husband King
Edward died on 5 January and Harold became king, she went on
to lose her brother Tostig at the Battle of Stamford Bridge in
September, followed by three more brothers – Leofwine, Gyrth
and Harold himself – at the Battle of Hastings in October. Her
final remaining brother, Wulfnoth, was imprisoned by William
the Conqueror in Normandy, and by Christmas Edith was the
only remaining Godwin in England. Yet despite her vulnerability –
a widow and sister of two kings of England having to accept the
rule of an invader – she thrived under the new Norman regime.
William saw the importance of treating Edward's widow kindly
and while almost all other nobles had their lands and proper-
ties confiscated, Edith is recorded in the Domesday Book as
retaining land in Wessex, Buckinghamshire, East Anglia and the
Midlands.

Like Emma, she knew the importance of writing her own
history, and at the time of the dramatic events of 1066 she
commissioned a book called *The Life of King Edward*.[77] It is a
remarkable piece of self-promotion, for although it relays events
from her husband's life, Edith continually hovers in the back-
ground.[78] The first part deals with her father and brothers,
justifying their actions and reinforcing their influence, while the
second part is hagiography, written to emphasise the sanctity of
her husband. Edith seems to have had a greater hand in the first
part and much of it was composed while her husband was still
alive. It was completed around 1067, when Edith's fortunes had
dramatically transformed, and it provides an incredibly important
source for the wider context of the Bayeux Tapestry. In fact, it has

recently been suggested that Edith may have been the brains behind the embroidery itself.[79]

Edith certainly professed her loyalty to William, paying him tribute from her own wealth and accommodating him in her royal palace at Winchester. The Bayeux Tapestry could be seen as an extension of this support. What's more, Edith had motive, means and opportunity to commission the work. As queen she was head of the female monastic communities in England and would have known of suitable sites where such a project could take place. She had a good understanding of the complex political situation after Hastings and would have wanted both sides – English and Norman – to be represented favourably. This might explain why Harold is shown generously throughout, yet the emphasis remains on the triumph of William. She could have invested her large amounts of personal wealth in the project.

Edith spent most of the latter part of her life in her dowry city of Winchester, where she had access to manuscript art, and at Wilton, where a team of skilled embroiderers could have been developed. She is recorded as having been an excellent embroiderer herself and certainly knew a good deal about working fine fabrics, since she commissioned and oversaw the production of high-status clothing for her husband. She was also witness to scenes depicted on the tapestry and would have had first-hand accounts of the battle in which she lost three brothers – all of whom are memorialised in its stitches. The events of 1066 were incredibly disruptive for English women, many of whom lost male relatives and lived in fear of being forcibly married to Norman incomers.[80] The number of nuns swelled as women sought sanctuary in convents. This would have provided Edith with a growing body of skilled, dedicated embroiderers capable of completing a project as demanding as the Bayeux Tapestry.

The argument is compelling, but once again, it is not possible to say with any certainty that Edith was involved in the creation of the tapestry. True, she is the only identifiable woman stitched onto its scenes, and she had good reason to produce it. But the arguments in favour of Odo as patron remain strong. Ultimately, all we

can confidently deduce is that her influential position means she was capable of such an undertaking, and reminds us that eleventh-century women could be patrons and producers of art. Emma, Edith and the women who embroidered the Bayeux Tapestry played a large but mostly uncredited part in the male-orientated accounts of dukes, kings and battles. Although there are only three women in the main narrative of the tapestry, each of them is representative of the hundreds of others who wielded power and influence. What's more, the images of conquest, triumph and war were brought into existence through the needles of medieval women. We are left with their version of events, and it is one in which women had agency and embroidered their existence onto the canvas of history.

5

Polymaths and Scientists

Discovery!

11 March 1948 – Eibingen Monastery, Wiesbaden, Germany

A brave, frightened women is risking her life in a daring rescue mission. In these post-war years, medieval scholar Margarete Kühn is not dealing with spies and Nazis: instead, she has kidnapped a book. Assisted by her friend Caroline Walsh, an American military spouse, Margarete has secured the manuscript's safe passage across 400 miles, traversing the wildest and most hostile parts of Germany's war-ravaged landscape to a secluded monastery high above the banks of the Rhine.[1] As well as saving the precious reams of vellum, the women are preserving something more important still: the legacy of a twelfth-century saint whose reputation is second to none in Germany. From her childhood as an enclosed nun with just a handful of companions, to her rise on the international stage as a leading scholar, theologian, visionary, musician, linguist, artist and scientist, the remarkable life of Hildegard of Bingen (1098–1179) has been celebrated for centuries.[2] Yet as the aftermath of the Second World War rips through her home in the Rhineland, her written works are destroyed, stolen, hidden and lost. This is a post-war thriller with a medieval twist.

Climbing the cobbled slope alone towards the imposing gates of Eibingen Abbey, Caroline Walsh knows she is doing something extremely dangerous. Her marital connections to the US air force,

along with Margarete's months of preparation, has allowed her to move across the recently partitioned Soviet and American sectors of Germany with 15 kilograms of priceless manuscript concealed on her person. Germany's defeat in the war has resulted in the dramatic division of the country into areas under the control of French, British, Soviet and American troops, with Berlin also divided between the allied powers.

Margarete lives in the American sector of West Berlin, but she travels to the Soviet East for her job working on a huge project to collate all primary German texts from the Romans to AD 1500, called the *Monumenta Germaniae Historica*. Her involvement in the reckless mission to save Hildegard's book will make all future crossings a fraught experience, full of the fear of detection, incarceration or worse; because Margarete has deceived the Russian authorities. Catherine too has risked arrest by bringing the manuscript via train and car to the nuns of Hildegard. But as she watches the abbess of Eibingen clasp the enormous manuscripts to her chest, she knows that Hildegard's work is home. The risk was worth it.

The manuscript is priceless. Known as the *Riesencodex* ('the giant book') because of its size, it is made up of 481 folios of

The *Riesencodex*, collected texts of Hildegard of Bingen, Hessische Landesbibliothek, Wiesbaden, Hs. 2, c. AD 1200.

vellum held together by wooden boards bound in pig leather that measure 45 centimetres by 30 centimetres. Still attached to its spine is a chain, originally used to secure it to the library of the monastery Hildegard founded in Rupertsberg (today called Bingen). The book contains almost all her writings; a rare attempt to create a single version of her 'definitive works' while she was still alive. Many scribes worked for years to collect her visions, music, linguistic writings, homilies, biography and letters. Very few writers even now are so popular in their lifetimes to have such a volume made in their honour.

The manuscript was compiled towards the end of her life, circa 1179, at Rupertsberg. The story of its rescue revolves around a second monastery founded by Hildegard – the site at Eibingen.[3] But many of the texts it contains were originally composed at the monastery where she spent the first decades of her life – Disibodenberg. These three sites form the basis of the 'Hildegard Way' through the heart of the Rhineland, which devoted pilgrims can still travel today to get close to the woman and her works.

The *Riesencodex* had been on the run before. During the Thirty Years War (1618–48) when Swedish troops looted Hildegard's monastery of Rupertsberg, its nuns escaped with the book, carried it across the Rhine and hid it at their sister house of Eibingen. Two hundred years later, when religious establishments in Germany were secularised and their property taken in 1814, the manuscript went on another short trip 35 kilometres along the river to the newly founded State Library of Wiesbaden. Until the start of the Second World War, the *Riesencodex* stayed firmly in and around the Rhineland-Palatine where Hildegard herself spent her 81 years. But under the threat of bombing raids, library director Gustav Struck sent it on a long journey to Dresden, hundreds of miles east, along with a set of eight books that also needed safekeeping. The *Riesencodex* was travelling with another of Hildegard's most precious manuscripts, a priceless copy of her major work *Scivias*, containing illuminations that Hildegard herself had a hand in.[4] An insurance report at the time states that: 'the total value of the manuscripts housed in Dresden should amount to at least five

million Reichsmarks. A replacement is completely impossible since all of them are one-offs.'[5]

Fate was not on the side of Gustav Struck. His assurance from Nazi advisers that Dresden was safer than Wiesbaden was devastatingly inaccurate.[6] In February 1945 the beautiful city was hammered by Allied bombs, killing thousands and flattening buildings. Remarkably, the bank vault containing Hildegard's manuscripts survived, but when officials arrived to examine its holdings they discovered that it had been pillaged. The only manuscript still in the vault was the *Riesencodex*, probably because it was partly hidden and its custom-made metal box was so heavy. In accordance with Soviet instructions to collect first-class artefacts found in Russian-held German territories, the *Riesencodex* became the property of the state.[7] Scholars and Hildegard devotees across the world were anxious that they would never again be able to freely consult her collected works. They needed a plan and Margarete would prove to be the linchpin.

Margarete was not the mastermind behind the plan to save the tome. Hers was the fourth attempt to take Hildegard's work out of Soviet hands. The new director of the Wiesbaden State Library, Franz Götting, had tried every possible legal means of having the manuscript returned, but each was unsuccessful. By 1948 he and Margarete had decided that the *Riesencodex* should be removed from war-torn Dresden by any means and reunited with the community of nuns who continue to sing, read, research and live by Hildegard's example. A plot was forged; Margarete's position on the *Monumenta Germaniae Historica* project in the Soviet sector of Berlin meant she could request access to the manuscript and it would be sent for from Dresden. But this was not just an academic mission for Margarete; it was also personal.

Letters have recently been discovered which show that Margarete wanted to join the nuns at Eibingen.[8] The modern-day monastery can be seen from miles away, its twentieth-century Gothic-style towers looming over a colourful landscape of vineyards, with the Rhine twinkling brightly below. It is a beautiful site and Margarete would have known what comforts awaited her. Not only could

she have pursued her devotion to medieval scholarship in the monastery's enviable library, but she would follow the Benedictine Rule and fill her days with meaningful work.[9] Whether producing wine, creating ceramic art, crafting gold or simply tending to the needs of the many nuns in Eibingen, she would have kept busy. Throughout the day and night her life would be punctuated with the routine of the monastic hours, which she would recite alongside her sisters in the stunning abbey church. Paintings from the famous Beuronese art school would tower above her, presenting iconic, timeless women more reminiscent of Byzantine times than twentieth-century Germany.[10] These would be constant reminders that great things had been achieved by her female forebears.

Becoming a nun at Eibingen must have seemed an attractive idea to the lonely and pious Margarete. Devastated by the death of her brother and bewildered by the changes afflicting wartime Germany, in 1946 she visited the abbey to discuss whether she might become a novice. The nuns, however, were unconvinced she was ready for monastic enclosure. Instead, with Gotting's help they set her a very worldly mission – to use her connections as a medievalist to rescue Hildegard's works. Against all the odds, Margarete persuaded the Soviet authorities to lend her the manuscript to photograph it. Unable to believe her luck, she set about capturing images of the precious manuscript for future generations. And as soon as she had completed the task, she began plotting how to get the book to Eibingen. It weighed the same as a French bulldog and was protected property of the Russian state. The plan with Caroline was hatched and, after a period of nervous preparation and tense execution, the *Riesencodex* was finally making its way to Eibingen. Margarete's one regret was that, after all her efforts, she couldn't be the woman to hand it over. This honour fell to Caroline.

With the goal achieved, however, how would Margarete throw the authorities off the scent? It was Marianne Schrader, a nun at Eibingen, who was to propose something rather underhand. She asked Götting, the library director in Wiesbaden, if he could find a book of the same size and weight as the *Riesencodex*, the idea being that the fake would be returned while the original was held

in Eibingen. Selecting a fifteenth-century printed book of similar dimensions, Götting attached a chain to it and sealed it back in the box in which it had been delivered. It wasn't until Soviet authorities opened it in 1950 that the fraud was detected. The revelation put Margarete in grave danger, and her supporters had to hatch another plan to protect her. She had needed surgery to remove a cancerous eye, so Götting told the furious Soviets that Margarete's poor eyesight meant she mistook the book and returned the wrong one. Götting was unflinching in his support of Margarete, and a compromise was finally agreed. If other valuable books were given to Dresden, Wiesbaden could keep the *Riesencodex*. After a sojourn with the nuns, the manuscript returned to the state library in Wiesbaden, where it still resides today.

Margarete Kühn's involvement in saving the manuscript is little known. She quietly continued to contribute to medieval scholarship and outlived all her colleagues, dying 40 years after these events at the age of 92. Her obituary describes how she lived 'an almost monastic existence', something she clearly craved. She is an unsung hero of the dark post-war chapter of European history, from which numerous artworks and precious documents of the past may never emerge.[11] Thanks to Margarete, this manuscript made it out, but its companion – Hildegard's *Scivias*, complete with the famous illuminations of Hildegard's visions – is still untraceable. Fortunately, reproductions were made of the images before the manuscript was lost, but the original could still be out there, in a private collection or gathering dust in an attic. Perhaps on reading this, someone somewhere might make it public. For now, though, all is not lost. Margarete and Catherine's dedication – their willingness to put their life on the line for Hildegard – has meant her reputation as a medieval wonder woman continues to spread.

Welcome to Twelfth-Century Disibodenberg

Reaching the hilltop monastery of Disibodenberg requires a steep climb through rugged forests. Once you reach the peak, out of

Ruins of the church at the monastic complex of Disibodenberg,
Rhineland-Palatinate, Germany.

breath and aching, a stunning landscape extends below. The undulating horizon pops with waves of colour as red, gold and orange trees, lush green fields and ripe orchards soak up the autumnal sun. The monastery is positioned at a strategic point, where the rivers Nahe and Glan converge and push towards the waterway of the Rhine. The landscape is damp and fertile, perfect for livestock and all types of vegetation. Workshops line the edge of the river, ready to take in materials and send out produce on boats that traverse the thousand kilometres of the Rhine, from the heart of Europe to the North Sea. This site is connected to the vast economic hub of the Holy Roman Empire, with the Imperial Palace of Ingelheim less than 50 kilometres away.[12] Yet this inaccessible peak feels entirely isolated, surrounded only by the riches of the natural world stretching out in every direction. This is a truly special place, and the physically gruelling uphill scramble makes the first impression at the summit even more rewarding.

Turning away from the impressive view, you are greeted by an imposing wall; a stone gatehouse allowing access to what could be mistaken for a fortified medieval town.[13] Walking through it, you see up close the soaring turret you'd only have glimpsed from a distance. It reaches skyward on the newly cleared plateau of the hilltop. The enormous walls rise over three storeys and the church's

stones gleam in the afternoon light, newly cut and freshly laid. The original monastery at Disibodenberg was founded by an Irish saint in the seventh century.[14] Like other Irish missionaries, Disibod drew parallels between the mountainous forest and the deserts of the early hermits; a place entirely disconnected from the temptations of life. 'O wonderous marvel, a hidden form shines forth and rises up in glorious stature to where the living height gives forth mystical truths.'[15] The monastery's fortunes have waxed and waned in the four centuries since its founding, but over the past three decades it has grown significantly, with a shining new complex underway. The man responsible for this rapid growth is Archbishop Ruthard, from the nearby city of Mainz. Wanting to keep the well-located site firmly within the control of the church, in 1105 he relocated a group of Benedictine monks from the city to the hilltop and began an enormous building project. Now, at the start of the 1140s, wooden cranes and rope are used to haul stones and scaffolding leans against partly finished walls, while newly completed rooms still smell of fresh paint.

At the heart of the site, a basilica-style church with a wide-aisled nave and apse at the east end links to a large cloister.[16] Around this sheltered walkway other rooms hide behind wooden doorways. The chapter house, where the Rule of St Benedict is read out loud, and the sacristy, which houses silken vestments and gleaming goblets, huddle together at the far end of the church. Continuing around the cloister, the monks' sleeping and eating quarters are surrounded by kitchens and workshops. Stone gutters channel away rain and muck, while a large cistern provides fresh drinking water. Vegetable gardens and animal enclosures are peppered around the buildings, ensuring the monks have all the food they need. A hospital area tends to the sick, and the intellectual needs of the monks are fed by the well-stocked library and busy scriptorium. But there is a separate section to the north of Disibodenberg: a monastery within a monastery. Beyond the monk's cemetery, another wall encloses a patch of land. A smaller church was built here by earlier canons, to which a kind of annex is attached.

Manuscript illumination showing Hildegard reciting her visions to the monk Volmar, with Richardis behind. Biblioteca Statale, Lucca, Italy, thirteenth century.

Inside this building a woman in her forties is comfortably seated at a writing table, a large wax tablet in one hand and a metal stylus in the other. She is facing a stone wall with a hole in the middle; a piece of fabric hangs over the opening. On the other side of this curtained window sits a monk, roughly the same age as the woman. He is surrounded by scraps of vellum, pots of ink made from oak gall and quill pens carved from the wing feathers of geese.[17] The two speak quietly and enthusiastically through the wall, the woman scraping ideas into wax, the man carefully shaping black letters onto white animal skin. Another woman, young and beautiful, stands listening behind the seated lady. Every so often she leans over and looks at the tablet, contributing a phrase or making a suggestion. The three are engaged in writing a book that will change all their fortunes, particularly that of the older woman who, for three decades, has rarely left this building.

She was given by her parents as an oblate at around the age of eight, perhaps to study scriptures in the noble home of her mentor, Jutta of Sponheim.[18] Since childhood this woman has experienced visions. According to her view of divinity and love flowing through the natural world, the monastery at Disibodenberg is the closest a person can get to experiencing paradise. The

'Living light' (what she calls the divine inspiration she receives) leads her to a corresponding heavenly place in her mind. She describes it as:

> A high mountain, where the flowers and the costly aromatic herbs grow; where a pleasant wind blows, bringing forth their powerful fragrance; where the roses and lilies reveal their shining faces.[19]

On this hilltop she listens to chanting from the church, follows the monastic hours, studies the natural environment around her, soaking up all the knowledge she can. Although her surroundings are paradisical, her day-to-day existence since the age of eight has been harsh, lonely and repetitive: like being sent to boarding school and never leaving.

But things have recently changed. Jutta, who had presided over the group of nuns at Disibodenberg, has died, and the burgeoning female community have declared this woman their new abbess. She is already at loggerheads with the abbot of Disibodenberg over her plans for a new monastic complex in the heart of the industrial Rhineland. The proposed move will address the pressing issue of space: more and more women are coming to join the community at the remote hilltop location, and the building that houses them is cramped and not fit for purpose. The abbot is keen to retain the women, as losing them means losing out on their hefty dowries. But the abbess wants to take her nuns away to larger quarters, and, after all, it's her reputation that is attracting them in the first place. Because this woman – Hildegard – is a visionary.

It is these visions that she is describing to the monk Volmar and her confidant, Richardis. Together they craft her abstract images of searing lights, sapphire figures and star-encrusted skies into a theological work. She describes a view of the divine which is unique: the natural world held in harmony through the female figures of Divine Love and Wisdom, and the church as a mother caring for its child. The fear of being declared heretics is never far

from their thoughts, but together they will write a work that will impress all of Christendom. Hildegard will live a long life – the equivalent of two average lifetimes in the twelfth century – and over the course of these 81 years she will carve her name into history. She will be a confidant to kings, chastiser of emperors and protégé to popes. But right now, this extraordinary, unparalleled medieval woman is about to step off the hilltop at Disibodenberg and onto the world stage.

Who was Hildegard?

Throughout the ages there is perhaps only a handful of people who can be said to have achieved as much as Hildegard.[20] She wrote three major theological works, the first recorded morality play, two scientific treatises, over 300 letters and a large body of music. She even invented her own language – the Lingua Ignota.[21] She founded two monasteries, overseeing their design, construction, funding and daily operations. And she offered counsel to the great minds of the time. Her written work assumes multiple voices: sometimes prophetic and terror-inducing, sometimes gentle and compassionate, sometimes practical and analytical. Her longevity and productivity mean we are left with hundreds of thousands of words, which together present a multifaceted, remarkable, complex woman. While many medieval women's fortunes have risen and fallen, their names lost and their reputations tarnished, Hildegard was always recognised as extraordinary. Today she is more popular than ever, held up by feminists, New Age practitioners, musicians and many more as a medieval wonder.[22]

Her enormous output over the eight decades of her long life means her reputation is rivalled by just a handful of individuals. Perhaps only the polymath Leonardo da Vinci, working three centuries after Hildegard, can compare to her. But as is well known, he rarely finished his projects,[23] while Hildegard did. And those that came after her catalogued, copied, distributed and

protected her completed works. Hildegard broke the mould: she was part of a pan-European intellectual elite that included men and women, and was supported by those around her to rise to fame in a way that many men of her time could only have dreamt of.

Hildegard matters, not just for her own extensive contributions to European theology, science, music and art, but also for what she reveals about the vibrant culture of 'Renaissance' twelfth-century Germany. This was a time of rapid and radical intellectual change, led by developments in science and philosophy. It paved the way for the more famous fifteenth-century Renaissance and the Age of Reason. Considered the start of the High Middle Ages, it was characterised by political, social and economic change.[24] From the reign of Charlemagne in the late eighth to early ninth centuries, monarchs across Europe were consolidating their power and creating centralised states. This continued through the tenth century when Otto the Great took control of the church and extended his influence as Holy Roman Emperor. Building on these shifting forces, the developments of the twelfth century were deeper rooted and longer lasting. The Crusades promoted cross-state diplomacy and collaboration, as kingdoms had to pull together to provide forces for the shared aims of Christendom. As bureaucracy developed across the kingdoms and vernacular languages were increasingly used in written texts there was an evolution in national identities. The rise of universities meant greater engagement with classical texts on law, rhetoric and science. Monastic reform and an increasingly wealthy church established powerhouses of creativity, and closer contact with the Islamic and Byzantine worlds allowed Western scholars access to innovative ideas and new scientific knowledge.[25]

Hildegard lived through this critical period in a politically influential location – the Rhineland-Palatinate, at the heart of the Holy Roman Empire. She witnessed many changes, including the Investiture Controversy, where the papacy undercut the emperor by electing bishops, abbots and the pope. While the Concordat of Worms in 1122 put power firmly back in the hands of secular

rulers, the relationship between church and state became increasingly difficult when the energetic Frederick Barbarossa was pronounced Holy Roman Emperor in 1155. Barbarossa (meaning 'red beard' in Italian) was a singularly gifted medieval ruler, who wanted to restore the Empire to the glory days of Charlemagne. His conquest of Italy and subjugation of the Papacy led to a schism where Barbarossa elected his own anti-popes. The conflicts intensified in the latter years of Hildegard's life when, from 1160, Barbarossa and Pope Alexander III were bitterly opposed to one another. Hildegard felt the terror keenly, as her monastery in Rupertsberg was at the front line of hostilities. She wrote personally to both the emperor and pope, giving advice while daring to criticise the two most powerful men of her time. It was through this role as prophetess to the powerful that she gained the title 'Sibyl of the Rhine'. Like a medieval Cassandra, she wanted influence in what she saw as a pivotal point of moral and social transformation, and she was prepared to shout to be heard.

Illuminations from *Scivias* showing Synagoga protecting Jews and Ecclesia protecting Christians.

And shout she certainly did. In *Scivias* she assumed a prophetic tone to lambast false teachers in the church:

> You, you evil deceivers, who labour to subvert the Catholic faith. You are wavering and soft, and thus cannot avoid the poisonous arrows of human corruption ... And after you pour out your lust in the poisonous seed of fornication, you pretend to pray and falsely assume an air of sanctity, which is more unworthy in my eyes than the stinky mire.[26]

The social turmoil wrought by the Crusades rippled through all parts of twelfth-century life but was particularly destructive for European Jews, with brutal attacks taking place across Europe and the Middle East.[27] Hildegard seems opposed to this violence. She presents Synagoga (who represents the Jews) as a woman holding the prophets in her arms. Synagoga is a counterpart to the female representation of the Christian church, Ecclesia, who is cloaked in gold, and also holds the faithful close to her. This sympathetic representation of Synagoga in *Scivias* demonstrates her opinion that Jews and Christians both contributed to the church, and they should not be persecution by Crusaders. A true medieval activist living through a time of fear, Hildegard was campaigning against immorality and corruption.

Heresy was also on the rise. As a woman who had visions, wrote, preached and held power, the threat of being declared a heretic was ever present. Writing to Pope Eugenius in 1148 she stresses her vulnerability: 'For since I was a child I have never felt secure, not for a single hour.' She continues that 'there is so much divisiveness in people' that she 'has not dared to speak of these things.' This feels like a very modern statement in the current climate of perceived 'cancel culture'. But Hildegard was facing a greater threat than any 'pariah' today; she could be persecuted as a heretic and put to death. She shows great delicacy in being able to navigate the opposing views that swirled around her, while still engaging with the issues of the moment. Some medieval women writers, like Julian of Norwich, escaped the threat of accusation

by remaining in an anchorite's cell and avoiding what was going on in the world. But Hildegard took the role of a prophet and waded into politics head first. She told the pope to act against the 'bear', Emperor Barbarossa: 'You now, the viceroy of Christ, seated on the throne of the church, choose for yourself the better part, that you may be the eagle overcoming the bear!'[28] Bold words for anyone in the twelfth century, let alone a woman.

Hildegard would have felt the impact of this shifting landscape. She represented a class of nobility that was on the decline: the old aristocracy. As the schism made relationships between church and state ever more complex, a new group – the prince-bishops – was emerging. The prince-bishops oversaw the spiritual care of king-doms, but also held all the might and wealth of worldly leaders, something Hildegard lamented repeatedly in her works. Seeing the religious leaders of her time immersed in warfare, corruption and moral vices influenced what she wrote, and formed the basis of later works like *The Play of the Virtues*. In this morality play – the first of its kind to survive – the women in Hildegard's monastery assumed the guise of each virtue, while the only male – the monk Volmar – responded as the Devil. Yet Hildegard's was a real and earthly life too, filled with daily concerns over income, political allegiance, preparing for the future and more. She was spiritual but not detached from the world. And she was surrounded by a cast of men and women from all parts of the political and religious spectrum, who together were producing waves of intellectual and social change.

Her correspondence list is a who's who of the medieval period. She wrote to, and received letters from, some of the shining stars of her generation, including three popes, St Bernard of Clairvaux, Emperor Frederick Barbarossa, King Henry II of England and Queen Eleanor of Aquitaine.[29] Although it was prohibited by the church, she even embarked on a 'book/preaching tour' around Germany, something few women up to the present day could entertain.[30] She was a twelfth-century celebrity. Her book *Scivias* was incredibly popular and widely copied. John of Salisbury, sec-retary to Thomas Becket during the reign of Henry II, wanted to

consult her work because 'Pope Eugenius cherished her with an intimate bond of affection'. He wrote to a scribe abroad asking him if he can find 'the visions and prophecies of the blessed and most famous Hildegard'. Supporting the idea that she was a prophetess, he continued, 'Look carefully too and let me know whether anything was revealed to her at the end of this schism.'[31]

Hildegard's achievements are even more remarkable when we consider that she was blazing a trail as one of the first women visionaries of the medieval period. While others would rise to prominence as mystics in the fourteenth century, during the twelfth century female visionaries were not common.[32] The Second Lateran Council of 1139 made the independence of women in the church more problematic, since the enforced separation of monastic communities led to the strict enclosure of nuns.[33] There was also a clampdown on monastic preaching, which Hildegard would have been bound by. Despite the many threats that constantly circled her, Hildegard was determined in all she did, riding the wheel of fortune through its highs and lows. She didn't shy away from advising and chastising people in power. Her views were both micro- and macrocosmic, short- and long-term. She acted to protect herself and her community of sisters, but also wanted to bring about change on the global stage. But hers was a life of two halves: the first, private, quiet, introspective, and the second, loud, daring and impactful.

Growing into herself

According to both the biography written soon after her death and the wealth of first-hand accounts collected to prove her sainthood, Hildegard was an unusual child whose differences were obvious to her parents from a very young age.[34] One account states that when she was five she asked her nurse if she was able to see anything apart from external objects. Surprised, the nurse replied that she couldn't. Young Hildegard then went on to describe the beautiful calf that was inside one of their pregnant cows, right down to its

markings – 'all white with dark patches on its forehead, feet and back!' The nurse told her mother, who requested to see the calf as soon as it was born. When the animal was just as Hildegard had described they 'saw she had a different character from other people and decided to enclose her in a monastery'.[35]

Given as a tithe to the church by her noble parents while still very young, she was entrusted to a woman five years older than her, with whom she'd share a single room for 24 years.[36] Jutta of Sponheim was the daughter of a count and grew up in a castle, but while most women in her situation would have been a desirable match in marriage, Jutta rejected all suitors and insisted on becoming a nun.[37] She was extremely pious and an ascetic, practising frequent fasting and self-flagellation, praying barefoot for hours in extreme weather, wearing chains and horsehair shirts, and refusing all meat. By the time of her death, aged just 44, her body had been ravaged by these practices, which horrified the young girl she shared a cell with. Hildegard did not want to live a life of deprivation and self-punishment like Jutta. When the nuns of Disibodenberg unanimously chose her as abbess in 1136 she advised them against such practices.

Just five years into her new role, something extraordinary happened. She had experienced visions since she was a toddler but had kept them to herself out of fear that they would be misconstrued. But her visions took on a new complexion in 1141, growing in intensity and intricacy. She describes receiving a 'calling' to tell others about them. Modern doctors and psychiatrists have attempted to determine where Hildegard's visions originated from, what form they took, and whether they indicate underlying medical or mental health issues. Today we look to science for answers, but in the twelfth century the main question asked of a mystic was: are the visions from God or from the devil?

For all mystics, the pressures to prove the divine origins of visions was a pressing concern. If someone cast doubt on the purity of their experiences they could be accused of heresy and face persecution. Hildegard repeatedly stressed that her visions were good and experienced in a waking state, not during a trance. She

described existing in 'the shadow of the living light', but when she entered a vision she felt it physically, 'like a trembling flame, or a cloud stirred by the clear air'.[38] It is highly probable that she was experiencing migraines. What she describes is like the sensations and auras reported by sufferers: 'The heavens opened, and a blinding light of extreme brilliance flowed through my whole brain. And it ignited my heart and all my breast like a fire, not burning but warming.'[39]

Like Julian of Norwich, she returned to her visions again and again in all her works, and alongside extensive descriptions of what she saw, she provided explanations, commentaries and even visual representations. Images from *Scivias*, which Hildegard almost certainly had a hand in, show a proliferation of concentric circles, jagged edges and black spots. Unusually, her illuminations include the use of both gold and silver, the metals creating the effect of 'scotoma' – shimmering and flickering areas of light and dark. The renowned neurologist Oliver Sacks began

Illumination of Hildegard of Bingen's Cosmic Egg from Book I,
Vision III of *Scivias*, twelfth century.

experiencing migraines during early childhood, around the same age as Hildegard did. His description recalls her visions almost exactly, including the range of colours, shapes and composition she included in *Scivias*:

> I was playing in the garden when a brilliant, shimmering light appeared to my left – dazzlingly bright, almost as bright as the sun. It expanded, becoming an enormous shimmering semicircle stretching from the ground to the sky, with sharp zigzagging borders and brilliant blue and orange colours. Then, behind the brightness, came a blindness, an emptiness in my field of vision, and soon I could see almost nothing on my left side. I was terrified – what was happening? My sight returned to normal in a few minutes, but those were the longest minutes I had ever experienced.[40]

The change in nature of Hildegard's visions in her forties unlocked a whole new phase of her life. She recorded that she was 'compelled by a great pressure of pains to make known what I had seen and heard . . . But then my veins and marrow became filled with powers I had lacked in my childhood and youth.'[41] Her whole body was affected by the migraines, and she felt their intensity increase. Could it be that Hildegard was experiencing the menopause?[42] She would have been 43 at this point, which is relatively young to go through menopause today, but was mature for medieval women who rarely lived into their fifties. Current research on the effects of the menopause suggests that the onset of waves of heat, blurred eyesight and increase in the intensity of migraines are all widely shared symptoms.[43] Higher levels of oestradiol (the most abundant oestrogen hormone in post-menopause) could also cause disorientation and even delirium.[44] The timings make sense, and Hildegard could no longer keep these more intense visions to herself. A voice told her to 'cry out therefore and write!' At this point she confided in the monk Volmar, who would become her secretary and closest male confidant, and they began to record her visions.

Sickness or Sanctity?

Hildegard recorded aspects of her visions with scientific precision. She was fascinated by medicine and the human body, penning two thorough treatises on the subjects – *Physica* and *Causae et Curae*. She is considered by many to be the founder of natural sciences in Germany and her remedies are well known today among herbalists and practitioners of alternative medicine.[45] One of the many responsibilities within a monastery was taking care of the sick, and it is likely Hildegard developed many of her cures while working at Disibodenberg's infirmary. She displays a unique understanding of the bodily needs of women, and some of her suggestions are not what we might expect of a nun. For example, she lists the plants that can be ingested to bring about an abortion.[46]

She gives very clear instructions that the woman should take a bath in freshly heated river water and fill it with tansy (a well-known abortifacient), chrysanthemum, mullein and feverfew. The water should cover all the belly. Then she must:

> take rifelbere and one-third as much yarrow, aristologia, and about one-ninth as much yue, and crush this mixture in a mortar. Put it in a little bag and then cook it in wine; add clove and white pepper . . . and honey. Drink this daily both fasting and with meals . . . for five days or fifteen or until the matter is resolved.[47]

While the modern church has developed stringent guidance on abortions in response to advances in medicine, such clear criticism of the process was not expressed in the medieval period. As a healer Hildegard prized the health of the people she assisted above all, and here she is treating a critical situation where a woman may need to 'abort an infant which is a danger to her body'. Even today this view may be seen by some as radical.

Hildegard knew from experience how sickness could affect the female body. She herself suffered not only from migraines but

from other ailments, too. Her ill health is often referenced, both in her own works and in others' accounts.[48] It's been claimed that she used her health complaints to manipulate situations, as she regularly became ill when challenged by others. This was certainly the case when the abbot of Disibodenberg refused to give her a monastery of her own. He later conceded only because he was told that Hildegard, at this point completely paralysed, could die. But she may actually have been experiencing real physical symptoms as a response to periods of intense stress. Compounded by the effects of the menopause during the very active years of her later life, it is likely Hildegard used her own body as a test site, observing what it went through at different times to better help the women under her care.

She certainly advocated keeping healthy in her scientific works, repeatedly stressing the benefits of eating and drinking well. In her letters too, she frequently reminded recipients how important it was to look after the human body, since it took care of the soul. She cautioned against the fasting, scourging and self-deprivation practised by certain monks and nuns like Jutta.[49] Instead, beer is encouraged since it 'positively affects the body when moderately consumed . . . beer fattens the flesh and . . . lends a beautiful colour to the face'. And unlike many of her contemporaries, Hildegard also took a keen interest in the gynaecological and sexual well-being of women.[50] Writing in 1150, she provided the first known description of what a female orgasm feels like:

When a woman is making love with a man, a sense of heat in her brain, which brings with it sensual delight, communicates the taste of that delight during the act and summons forth the emission of the man's seed. And when the seed has fallen into its place, that vehement heat descending from her brain draws the seed to itself and holds it, and soon the woman's sexual organs contract, and all the parts that are ready to open up during the time of menstruation now close, in the same way as a strong man can hold something enclosed in his fist.[51]

It's important to stress that Hildegard never overstepped the bounds of contemporary debate, and her writings were endorsed by the pope himself. Of course, when Hildegard wrote about sex she had in mind the act of procreation. Other twelfth-century authors were writing about female sexuality and gynaecology too, but her discussions of sexuality and gender were broader and more engaged than those of contemporary male writers.[52] Her works were pored over by scholars shortly after her death to support her claim for canonisation, and not one of these male scholars found her to have written about inappropriate subjects.

Her powerful descriptions reveal a surprising lack of censorship exerted on Hildegard by readers and writers of the time. Hildegard was drawing attention to the differences between male and female bodies to stress that they were unique, rather than one being inferior to the other. They also make clear that she understood the essence of female sexual pleasure despite being a professed celibate nun. She had a positive view of sexual activities, seeing in them a necessity and stressing it was better for almost all people's health to be sexually active than not.[53] The first sexual encounter of Adam and Eve, she says, was sweet love-making, but since the Fall it had become increasingly hot and greedy:

> He races swiftly to the woman, and she to him – and she is like a threshing floor pounded by his many strokes and made hot when the grains are thrashed inside her.[54]

Hildegard even argued that a person's temperament was affected by the feelings of the mother and father during intercourse – the more loving and pleasurable the sexual encounter, the happier the child. Her approach to sex reflects a broader agenda that underlines all her work; to provide a female perspective which could be shared and enhanced by the women she lived, worked, prayed and learned alongside. She was putting the focus onto women's experience – something few of her contemporaries did. She even goes so far as to say that, in relation to the act of creation, women

are superior to men: 'Women may be made from man, but no man can be made without a woman.'[55] Whether through medicine, theological texts, images or music, Hildegard was a woman writing for other women.

Feminist Icon?

But can Hildegard be held up as a feminist icon? In her scientific works she positioned men and women not in opposition to one another, but as displaying a wide range of characteristics depending on their natures. She undermined established misogynistic views towards menstruation, stressing instead that it is part of the natural flow of blood in all humans governed by the moon. She also opposed contemporary male authors who consistently reinforced the idea that women are more lustful than men. Her theology emphasises the importance of the female figures of Ecclesia, Synagoga, Love, Wisdom, Eve and the Virgin Mary as the foundations of both the spiritual and universal. While the priesthood is male, she argued that all aspects of the church, and even Christ himself, only exist through the female.[56]

Despite this, there are times where she berates her femininity, as in her very first recorded letter cannily addressed to one of the most influential men of the twelfth century. Bernard of Clairvaux, a preacher and mentor to the pope, heard how she was 'miserable and more than miserable in my womanly existence.'[57] She continued to emphasise the weakness of women in her first major work, *Scivias*, where she perpetuates the Genesis account of how the first woman was created out of Adam. Like Eve, Hildegard remained 'in the fragility of the weaker rib but filled with mystical inspiration'.[58] In presenting these traditional views of gender difference she was playing to a societal norm, creating an unconfrontational space in which her voice could be heard. Filtered through the quill of her male 'secretary' Volmar, there is every chance Hildegard felt the need to self-censor. At the start of her career, she had to describe her experiences, emotions and

Illumination of Hildegard's physical manifestation of Love, from Book I,
Vision I of *The Book of Divine Works*, twelfth century.

ideas in ways that would be acceptable to the male audience that
would scrutinise them.

As she grew in confidence and reputation, however, the num-
ber of references to her weakness as a woman decreased. In her
later theological works, she shifted pronouns regularly. When
describing her visions, she would start by referring to a man 'see-
ing', but the viewpoint would switch in the next sentence to that
of a woman. This blurring of gender appears deliberate; a way of
showing that Divine Love (which she characterises as feminine)
flows through everything regardless of perceived biological sex.
She also visualised central concepts, like the physical manifestation
of Love, as having male, female and animal elements; an old male
bearded head atop a woman, with an eagle on top of that.[59] In the
creative process she wrote how the 'dark sphere' is only filled with
life by 'nourishing it like a mother suckling a child'. She linked
the Latin word 'materia' (matter) with 'mater' (mother), stressing

again how all creation only exists because it is given life through female bodies.

These visions of a universe with men and women co-dependent on one another did not always reflect the reality of Hildegard's existence. She still experienced misogyny. In a letter to Pope Eugenius, she described how her visions had been rejected and criticised by 'many wise men . . . because they come from this poor female figure who was formed in the rib and not taught by philosophers'. In this bold letter Hildegard was asking the pope to challenge his own assumptions of women visionaries. She appeals to the head of the church to behave as an ally and not ignore female voices, visions and views: 'Do not reject these secrets of God, for they are part of that need which is hidden, and which has not yet appeared openly.'[60]

It is impossible to term a medieval woman a 'feminist' since the vocabulary and framework for the term are modern inventions. Hildegard would not have been able to couch her work within feminist approaches because she didn't know of them, but she certainly placed the concerns of females at the heart of all she did. Her public works put the concerns of women in front of the leading male power players of the time and her own example would have proved inspirational to others that followed her. As her reputation grew, so did her worldly influence.

A Sanctuary for Women

When Hildegard began sharing her visions with the monk Volmar after 1141, she also started developing plans for her own monastery. But it wasn't until she was nearly 50 that she became influential enough to push this proposal through and realise her dream of a sanctuary for noble nuns in the heart of the Rhineland. This was achieved thanks to the backing of a pope. Eugenius III was the first pope to come from the Cistercian order (brought to prominence by Bernard of Clairvaux), and he always wore his monastic habit underneath his papal robes. He is described as 'a simple

character, gentle and retiring – not at all, men thought, the material of which Popes are made'.[61] He only took up the position because no one else wanted such a prominent role during an especially dangerous period of political upheaval. Because of the schism in the church, he could not base his papacy in Rome, so moved the pontificate to various locations across Europe. In 1147 he was invited to Trier, close to Hildegard's monastery of Disibodenberg.

News of a female mystic hidden in the hills of the Rhineland reached the pope via the Archbishop of Mainz, and they sent a papal delegation to visit her. Hildegard must have been filled with fearful anticipation as she saw the most important representatives of the church climbing the steep slope towards her, coming to assess whether they had a heretic or a prophet in their midst. She was persuasive. The delegates were so impressed by her that they took the half-finished copy of *Scivias* back with them to Trier. Fortune was on Hildegard's side as Bernard of Clairvaux himself was at the papal court in winter of 1147. Their previous correspondence meant that, when Pope Eugenius read from her work to the court, Bernard was quick to defend Hildegard.[62] She had backing of two of the most influential men in Christendom and had clearly picked her allies carefully. She had broken into the male-dominated world of theology and had papal support to do so.

With the pope's backing for *Scivias*, Hildegard became an international superstar. The female community at Disibodenberg had already expanded, with the number of nuns growing from 12 to 18 in her first two years as abbess.[63] Now women wanted to be near her to follow her example and the small hilltop monastery was inundated with applicants. The monastery was not equipped to accommodate a growing female community, but Abbot Kuno was reluctant for Hildegard to leave. More novices brought more income, and she was the star attraction of Disibodenberg. Wrangling between abbot and abbess continued for some time, but eventually, after the spell of sickness which nearly killed her, Hildegard got her way.

She said the site of her new monastery in the industrial heart of the Rhineland was revealed to her during a vision in which she was instructed to go to the place where the eighth-century bishop-saint, Rupert, had performed his work.[64] Whether divinely inspired or not, it was a tactical choice of location. Now known as Bingen, the site of Rupertsberg was very different in character to the monastery she had grown up in. Rupertsberg was already a thriving town when Hildegard and the nuns arrived. It had a salt road, where traders sold this most valuable commodity, and the market was well connected via trade links to the major cities of Germany and France. The town's infrastructure was sophisticated, run by a court which taxed the community to maintain public amenities like roads and the fortified walls.[65]

Hildegard chose a site to the west of the town, where a ruined chapel and vineyards provided the space for her to realise her vision of a perfect monastery. Construction began in 1150 but it would take years for the buildings to emerge. These were trying times for Hildegard, as she juggled new-found celebrity with the complexities of providing for the 20 noblewomen under her charge. Many of the nuns ended up leaving, while those that stayed resented the shabby surroundings they found themselves in. Hildegard wrote that 'nuns looked at me with dark eyes and said they could not stand the unbearable pressures of discipline and rules'.[66] She had drawn the most affluent noblewomen of the region to her with promises that they would live well. They each brought large dowries and must have been tested by the unending building work and poor living conditions.

The situation worsened when the person closest to her, Richardis, decided to leave. Richardis's brother was Archbishop of Bremen and his high standing meant he managed to secure his sister the desirable position of abbess in Bassum. Hildegard protested the move to an almost dangerous level, drawing on the full potential of her 'personal relationship with God' to condemn the decision angrily in writing to her male superiors. She was certainly not afraid to show the depth of her feelings, particularly towards this specific nun, who had been her constant companion.

Incensed that her beloved was leaving, she wrote this stinging letter to the Archbishop of Mainz in 1151:

> Your curses and your malicious and threatening words are not to be heeded. Your rod and staff have been raised in pride, not in God's service but in the weak presumption of your wicked desires.[67]

The fury of this letter is contrasted by the pitiful grief in the one she then writes when she realises Richardis is really leaving:

> My grief rises up. That grief is obliterating the great confidence and consolation which I had from another human being . . . I loved you for your noble bearing, your wisdom, your purity, your soul and all your life! So much so that many people said, 'What are you doing?'[68]

The passion displayed in Hildegard's letters to Richardis could be read as signs of a deeper, perhaps even romantic, attachment between the two.[69] But it must be remembered that these women had been holed up together for years and had lived cheek-by-jowl in their time at Disibodenberg. Richardis also worked closely with Hildegard to compose and craft her books, acting as an editor of sorts. Theirs was an intense friendship and when Richardis died the very year after leaving Hildegard's side, the sorrow is still tangible in the text Hildegard writes decades later. In her seventies she laments that 'after she withdrew from me into a different region, away from us, she quickly left this worldly life with her honourable name'.[70]

But for the nuns who did stay with Hildegard, things were about to improve significantly. In 1158 she finally secured the backing of the Archbishop of Mainz, and her luxurious monastery was able to expand and thrive. They had a wealth of food and drink, supplied from the surrounding fields and vineyards. She wrote music for her nuns to sing together, which celebrated the power and beauty of women like the Virgin Mary. Her songs are unusual in terms of how much attention they pay to Mary. She is

described as 'Star of the Sea', 'Most Splendid of Gemstones', 'Author of Life', 'Holy Medicine', 'The Bright Matter of the World'. While Eve brought about women's subservience to men, Mary carries them higher:

> Because a woman brought death / A bright Maiden overcame it, / And so the highest blessing / In all of creation / Lies in the form of a woman, / Since God has become man / In a sweet and blessed Virgin.[71]

Her songs were also full of the flavour of the Rhineland, celebrating the surrounding landscape and its cast of local saints. She particularly prized the martyr St Ursula, whose bones – alongside the supposed 11,000 women she died with – had been unearthed in nearby Cologne in 1155.[72] This discovery would have been big news in Hildegard's convent, inspiring her to promote her own agenda of increasing female agency and promoting the history of the Rhineland.

Reliquary containing bones in the Golden Chamber of the Basilica of St Ursula, Cologne, discovered in 1106 and believed to be the legendary 11,000 virgins martyred with the saint.

She made the horror, pain, torture and martyrdom of the female saint a real and vivid experience for the nuns. The potency of lines like 'in the innocence of her girlish ignorance, she does not know what she is saying', would have resonated with them, underlining the common assumption that women were ignorant, weak and insignificant. These songs were as much about the real and the now as they were about the spiritual and the past. The act of singing together, their voices united, about a female saint who moved through their surroundings before them, with the poetic words and transportive music of a saintly woman who sat among them, was a potent act of defiance. Hildegard was creating an atmosphere of empowerment among her nuns in Rupertsberg. Singing together reinforced time and again, throughout the pattern of the monastic hours, the idea of a powerful female legacy tied back to Eve and Mary, through saints like Ursula, up to their present time. The songs Hildegard wrote for her community were designed to inspire, transport and elevate her sisters.

In addition to the numerous songs, her *Play of the Virtues* must have added to the excitement of feast-day celebrations, like an end-of-year school performance. Times were so prosperous that the monastery attracted condemnation by others who felt the nuns were living a little too well. The exuberance of the event is described by a nun called Tengswich from a nearby monastery. She wrote to Hildegard criticising her practices:

> On feast days, your nuns stand in church chanting psalms with unbound hair and for decorative purposes wear long white silk veils which reach down to the ground. On their heads they wear crowns of woven gold . . . and they adorn their fingers with golden rings. And they do this although the first shepherd of the church (St Paul) forbade such things.[73]

Nuns were encouraged to keep their heads shaven, while long uncovered hair was the preserve of the aristocracy. Monastic rules also specifically instructed female religious practitioners not to

wear jewellery and to keep their habits plain and simple. Yet Hildegard's nuns were clearly flouting all these rules. Her reply to Tengswich stated that the women at Rupertsberg were even more worthy of dressing themselves beautifully, since they were virgins and the brides of Christ. She also felt that the balance needed redressing; if male members of the church had all manner of symbolic objects, rich gowns and a hierarchy of paraphernalia, then surely Christian women deserved similar signs of their positions. There was one criticism from Tengswich, however, which Hildegard could not deny: the selection process at Rupertsberg. She says it was not fair that only women of noble birth were admitted to the monastery. Hildegard's response is distinctly classist:

> Which person gathers together their entire herd in one single stable, oxen, asses, sheep and goats, without them diverging? That is why they should also be differentiated between in a monastery.[74]

Hildegard was a nun, a writer, a polymath and a celebrity, but she was also a snob, born and raised among the elite. It was due to having friends in high places that she was able to create a place where learning and the creative arts could flourish. Her wealth and powerful connections ensured her success and that of her monastery in Rupertsberg.

Breaking Boundaries

A musician, linguist, artist, theologian, scientist, adviser, administrator and abbess, Hildegard crossed disciplinary boundaries in search of ways to explore the deeper truths of the universe, which she felt had been revealed to her through her visions. She always insisted that she received her visions through all her senses while fully awake, and it is these descriptions of sight, smell, sound, touch and taste which paint such a vivid picture. For example, when she describes paradise:

Paradise is a pleasant place, flourishing in the fresh greenness of flowers and herbs and the delights of all spices, filled with exquisite perfumes, adorned for the joys of the blessed. It provides the dry earth with fortifying moisture and gives its vital force to the land.[75]

Indeed, colour and especially greenness – 'viriditas' – is at the heart of many of her visions. For Hildegard, it is this verdant green that reveals how the divine essence moves through every part of nature. But she wasn't averse to the melodramatic and horrific, as when she describes the punishments of the soul:

I was made to catch all manner of evil and venomous worms, like scorpions and vipers, which sprayed me all over with their poison till I sickened with weakness . . . What eye can see my wounds and what nostrils can bear the stench of this affliction?[76]

Her writing style is often direct, asking the reader questions: 'What does this mean? How did this happen? How is this?' She also adapts her style depending on what genre of book she is producing. Her visions are steeped in symbolism and storytelling, while her scientific treatises often cover the same ideas but with a practical clarity. Her writing changes with age, and her earlier visions and expositions lack the succinctness of her later ones. Hildegard continued to grow and develop across her long career, and she was careful to differentiate her style and approach from the theologians of her time. The difference in tone could be compared today to that between an academic article and a trade book. Hildegard had not been tutored in a university or trained in the liberal arts as a male scholar would have been. But she had the intellect and skill to express her ideas in distinctive ways that allowed her to communicate effectively.

Her visions were not simply theological to her, but rather a wellspring from which she could draw up other modes of expression, including the visual and the musical. For a mind so

overstimulated and full of original ideas, desperate to describe the indescribable, language could have seemed limiting. Writing to a controversial theologian of the time, Odo of Soissons, she told this learned scholar not to use human constraints and language to define the divine.

> God is full and whole and beyond the beginning of time, and therefore he cannot be divided or analysed by words as a human being can ... Human reasoning has to find God through names and concepts, for human reasoning is by its nature full of names and concepts.[77]

In this vein she also used art and music – the visual and melodic – to express passion, feeling and sensory experiences. Her music is unique, haunting, experimental, extraordinary. Her images fascinate, baffle and assault the eyes with psychedelic colours, shapes and compositions. Hildegard used all the means available through her senses to explore her understanding of existence.[78]

The relationship between what she saw and what she wrote, between text and image, is clear just by looking at the front of this book. It's adapted from the third illustration in Book One of *Scivias*, which Hildegard finished around 1147, just before she left Disibodenberg. The vision begins:

> After this I saw a vast instrument, round and shadowed, in the shape of an egg, small at the top, large in the middle, and narrowed at the bottom; outside it, surrounding its circumference, there was bright fire with, as it were, a shadowy zone under it.[79]

She explains the vision as a representation of the universe in the form of an egg. This ties back to her ideas of the feminine within the divine, since only the female produces eggs, so the universe is made from woman. The ring of fire portrays God's wrath and vengeful defeat of the devil. Male and female are both necessary for creation. Through this image that she received as a vision, she

tries to make the impossible, the invisible and the eternal into something tangible that others could understand. As she was entirely immersed in Christian imagery and concepts, she framed this vision in religious terms. But viewers today may see many different layers of symbolism and meaning in the image.

The same naivety and accessibility of her theological works permeated her other projects. Hildegard emphasised that she learned how to create her incredible music 'without any human instruction, although I had never learnt notation or singing'. Again, the comparison could be made between a musician who studied the subject and dedicated tens of thousands of hours to honing their craft, versus a self-taught virtuoso whose natural flare and originality allows them to create music with a lasting quality. Contemporary writers have described her 'new song' as differing completely from the traditions of the time. In skipping across octaves, jumping from very low notes to very high ones, her music is unlike anything else that survives from the medieval period.[80] Today she is one of the most celebrated early musical composers and the haunting originality of her pieces are as affective now as they were 900 years ago.[81]

Her search for different modes of expression extends to her experiments with language. The Lingua Ignota survives as a glossary of around 1,000 words, but it's not known how Hildegard intended it to be used. The nuns in her monastery may have employed certain words as code, or a spiritually symbolic frame of reference. Many of the words have a distinctly German flavour, blending Latin and vernacular to create something specific to Hildegard and her followers. There are words for spiritual concepts, like 'Aigonz' – God, 'Aieganz' – angel, and 'Sancciuia' – crypt. But there are also more day-to-day words like 'Zizia' – moustache, 'Fluanz' – urine, 'Pusinzia' – snot, and 'Bizioliz' – drunkard. Highbrow or lowbrow, the poetic nature of her invented language runs throughout. As earlier High German poetry worked on alliteration, perhaps Hildegard was creating something similar. Her words have musical and rhythmic qualities, particularly in the final two syllables which produce a bouncy feel when spoken in phrases.

Like her music, her art and her theology, Hildegard's language has intrinsic beauty.

The endless curiosity and expansiveness of Hildegard's mind led her to create her own alphabet, too.[82] There are some similarities with symbols of the zodiac, and while the shapes are clearly influenced by Greek and Roman forms, the combinations are unique. Was she attempting something like Leonardo da Vinci would go on to produce with his mirror writing? Or perhaps again she was creating a script to be used by the nuns in her monastery, emphasising their originality and enhancing their separateness from the rest of the world; a language and an alphabet for use only by the empowered women of Rupertsberg.

In biblical terms, language is a reminder of our earthly constraints.[83] After the flood, a unified humanity all speaking the same language came together to build a tower tall enough to reach heaven. But God was angered by this challenge, so he made it impossible for each to understand the other, meaning the Tower of Babel was left incomplete. Theologically, language represents a flawed tool which limits humanity in its search for the divine. Hildegard may have been striving to create a new divine language that reached the inherent holiness in all things, even snot and urine. Hildegard constantly searched for new ways to express the inexpressible. Without the rhetoric and training of male writers, she developed her own forms of creative expression which sprung from her femininity and her visions. Her passions ran deep, and music, art, visionary literature and scientific treatises were all ways to make sense of the inspiring nature of the universe that she witnessed around her.

To Hildegard and her nuns, the importance of music in particular came to the fore during the very last year of her life. Just six months before her death she found herself locked in battle with members of the church in Mainz. A knight who had been excommunicated had come to her monastery to be absolved. He made his confession, died and the nuns buried him in their cemetery. However, certain churchmen wanted him exhumed as they didn't believe he deserved forgiveness. They ordered the body to be dug

up, but Hildegard refused and erased all evidence of his grave to ensure his remains could not be found.[84] As punishment, she and her nuns were placed under an interdict which brought with it terrible consequences. They could not receive the sacraments or perform acts of worship. But worst of all – they were forbidden from singing.

Now in her eighties, Hildegard did what she had done all her life and fought back, writing that 'whoever imposes silence on the church regarding the singing of God's praise shall not have fellowship with the praise of the angels in heaven.' She battled to the end, writing directly to the archbishop to demand he lift the interdict. Eventually her community's privileges were reinstated and in the final days before her death the nuns of Rupertsberg could once again sing, unified in celebration of the Virgin Mary and the female saints.

Why has Hildegard's name survived down the centuries when those of so many other medieval women have disappeared? Her longevity and productivity had a lot to do with it. If she had died aged 50 she would have left behind only a handful of songs and one book. But the latter part of her life was one of extraordinary creativity and a staggering output of work. She also had friends in the right places. The men and women who surrounded and supported her were some of twelfth-century Europe's biggest players, and her correspondence shows that she was able to play on her reputation to get what she needed. Clearly she was extraordinary in terms of character, intellect and determination, but her most important decision was to commit her ideas to writing. She crafted her own legacy and those around her secured it. By creating the *Riesencodex* at the end of her life, her followers produced a single volume that has protected her vast literary and musical outpourings down the centuries. The manuscript's almost miraculous survival, thanks to Margarete and Caroline in the 1940s, means her voice remains strong, and as women continue to search for inspiring exemplars from the past, her influence continues to grow.

Hildegard in Her World

A second manuscript was sent to safety in Dresden alongside the *Riesencodex*: a thirteenth-century copy of the *Visions* of Elizabeth of Schönau. Roughly 20 years younger than Hildegard, Elizabeth also became famous in her lifetime, even advising nobles in England and France. She started receiving visions while in a trance-like state the year after Hildegard released her book *Scivias*. These were recorded by her brother, an influential member of the German church.[85] Elizabeth knew Hildegard personally and the influence of the older nun is undeniable, both in terms of speaking of her visions and promoting them through writing.[86] However, the women differed in their approach to physical suffering. Elizabeth practised self-mortification and fasting, which drove her to depression and recurrent illness. Hildegard wrote to her encouraging gentler treatment of her body, the mollycoddling tone of her letter revealing a maternal responsibility for the younger woman. Elizabeth's visions were copied and distributed widely as an increasing taste for female mystics spread through Europe. Hildegard was the original and the trailblazer, but she was not the only extraordinary woman of her time.

One of the dangers of writing about truly exceptional individuals like Hildegard is that their extensive body of work can appear an anomaly – the output of a lone genius who existed outside of society. Hildegard wrote so much and had so many valuable things to say in her own right that she takes centre stage in discussions of medieval women. But there are a cast of important, influential and exceptional women around her, and without acknowledging their contributions, it is impossible to truly understand how this one twelfth-century woman could have achieved what she did. These include her personal friends and contributors, like her beloved Richardis, and connections to the Empress, queens, nobility, abbesses and nuns. But there were also other women who were striking out on a kindred path to Hildegard and achieving similar reputations, for example Herrad of Landsberg.

Born when Hildegard was 32, she too was a nun and author,

rising to the position of abbess of the prestigious Mont Sainte-Odile Abbey in Alsace in 1167. With the backing of Emperor Barbarossa her monastery became a centre for reform and offered the most comprehensive education for women at the time.[87] The monastery, which dates back to the seventh century, experienced renewed fame in 2002 when it was reported that 1,100 books had mysteriously gone missing from the locked library.[88] In a crime that would have puzzled Sherlock Holmes, bibliophile burglar Stanislas Grosse had been climbing the abbey walls, creeping through the attic and making his way into the library via a secret door hidden behind a bookcase, after discovering a map of the monastery in the public archives. He cleared the shelves undetected for over two years until he was eventually caught on CCTV. It's hard not to recall the rescue of the *Riesencodex*, and the vulnerability of precious manuscripts, which are still prone to being stolen and lost from records forever.

Illumination from the facsimile copy of Herrad of Landsberg's *Hortus Deliciarum*, made in 1818 before the manuscript was destroyed in 1870.

The only recorded work of Herrad herself has not escaped unharmed. Known as *The Garden of Delights*, it took 30 years to complete, ran to 648 pages with over 300 illustrations, and was a form of encyclopaedia designed to educate and entertain the nuns at her abbey. In it Herrad displayed a wide knowledge of science, philosophy, theology and history.[89] Written mostly in Latin, there are over 1,000 German glosses, demonstrating Herrad's strong command of both languages. The remarkable illustrations bring to life an ambitious and vibrant twelfth-century female religious community, depicting Islamic rulers, Byzantine courts and Indian nobility. While several scribes worked on the huge book, Herrad supervised the whole project and may have been responsible for the illustrations herself.[90] The book also contained self-penned hymns and a vast array of scientific information, displaying a similar range of knowledge to Hildegard.

Herrad began *The Garden of Delights* in 1159, as Hildegard was completing her *Book of the Rewards of Life* – the second of her three major visionary works. Whether or not she knew of Hildegard, Herrad was a brilliant woman in her own right, showing that there was more than one twelfth-century woman challenging the status quo.[91] Tragically the only surviving manuscript of her extraordinarily ambitious work was destroyed during the Franco-Prussian War in 1870. Her words and images were copied by nineteenth-century antiquarians, but if her manuscript had been saved from the ravages of war, as the *Riesencodex* was, then perhaps today her name would be better known.

Hildegard proved that women could learn, write, create and carve out a position of power for themselves, inspiring a devotional following. A nun from Stahleck, Gertrud, was so overwhelmed by her love for Hildegard that she wrote:

> I am at a loss as to what I should say or write to such a unique and beloved mother in Christ, for the power of love has taken from me all knowledge of speech. Indeed, your divine absence has made me drunk on the wine of sorrow.[92]

Her passion ran so deep that she felt 'an aversion not only to dictating a letter, but even to life itself' as she contemplated an existence without Hildegard. The visionary had other devoted fans, like the abbess of Altena, who wrote that she was 'most loved of all women' and lamented Hildegard's lack of reply since, 'I have decided to love you like my own soul.'[93] These letters read like the outpourings of superfans.

Her world was also full of men who supported, honoured and admired her. A letter from Henry Bishop of Liège shows the esteem in which she was held, as he begged her to pray for him: 'Give me your hand as I waver completely and as I take my refuge in you. Make it your concern to watch over me.' The Archbishop of Cologne was desperate for a copy of her works, writing, 'We are unable and unwilling to be without it.' And without the lifelong devotion of the monk Volmar it is unlikely that we would know her name today. He split from his own monastic community to follow Hildegard and was unflinching in his dedication to her. Hildegard lived in a gendered world, but she was celebrated not just as an exceptional woman, but as an exceptional person.

Unfortunately, while Hildegard's reputation was preserved through her completed works collated in the *Reisencodex*, her voice was manipulated and edited just forty years after her death by Gebeno of Eberbach.[94] This writer's monastery was very close to Hildegard's in Rupertsberg, and here he wrote his own bestseller – *Mirror of Future Times*. In long passages he cited Hildegard throughout the work as a prophet, but he removed any context for her words. She is reduced to a chastising, furious sibyl, predicting the apocalypse and providing dire warnings to men of power. His work was even more popular than hers, with 100 manuscript copies surviving to just ten of Hildegard's *Scivias*. So his version of the prophet Hildegard was what readers down the centuries encountered most frequently. The subtlety of her thought, the breadth of her interests, the range of her visions and the empathy that permeates all her work was lost in his text.

Despite making such an impact during her life, and despite the

efforts of numerous scholars, monks and nuns to preserve her creative output and stress her sanctity, her canonisation was rejected time and time again. But while Gebeno is now remembered as a footnote, Hildegard's reputation has only grown as her achievements across the disciplines are increasingly understood and appreciated. She was finally recognised as Saint Hildegard of Bingen and one of only four female Doctors of the Church in 2012.

Although Hildegard is possibly best remembered now for her remarkable achievements in the sciences, linguistics and composition, arguably her greatest achievement was as a theologian. Women were not permitted to write on religious matters. That she developed such a sophisticated and unique religious approach, where God's love is feminine and nurturing and creation was born of divine love, was incredible. She broke the gender barriers, but the encouragement from the men around her suggests we should not only be reviewing our understanding of how women thought and felt in the twelfth century; we should also be turning our attention to the way we view the men of this time. While Hildegard was a woman writing largely for women, throughout her life, from a childhood displaying unusual behaviour, through a middle life plagued with illness, to her role in later years as influential abbess and founder, she was regularly supported by men. Her writings, and their distinctive style, which must have seemed so unusual to male readers trained in theology and the liberal arts, were copied, admired, requested and widely circulated. She did not exist in a vacuum.

A Medieval Marvel

Hildegard's achievements are exceptional by the standards of any era, but perhaps are all the more surprising to twenty-first-century readers, when the environment in which they were performed is so often portrayed as a time of superstition, brutality, and intellectual and cultural impoverishment. Yet her very existence challenges

this view of the period. Hildegard was a product of her time; it is not simply that she was extraordinary, but the world she grew up in was more hospitable to extraordinary women than we might think. Now she has been canonised and recognised as a Doctor of the Church she is being discovered by a global readership, and both she and the time in which she lived can be better understood. [95]

Though she would go on to outlive him by 16 years, Hildegard's frequent periods of illness were of serious concern to her friend and confidant Volmar. His respect and admiration for her are evident in the following account, written during one such period of illness:

Who then will give answers to all who seek to understand their condition? Who will provide fresh interpretations of the Scriptures? Who then will utter songs never heard before and give voice to that unheard language? Who will deliver new and unheard-of sermons on feast days? Who then will give revelations about the spirits of the departed? Who will offer revelations of things past, present and future? Who will expound the nature of creation in all its diversity?[96]

She was loved and celebrated then, and she continues to inspire now. The quality of her writing has stood the test of time. Here she describes her understanding of God:

I am the fiery life of divine substance, I blaze above the beauty of the fields, I shine in the waters, I burn in sun, moon and stars. And I awaken all to life with every wind of the air, as with invisible life that sustains everything. For the air lives in greenness and fecundity. The waters flow as though they are alive. The sun also lives in its own light, and when the moon has waned it is rekindled by the light of the sun and thus lives again; and the stars shine out in their own light as though they are alive.

Mosaic showing the holy trinity illumination from *Scivias*, and
bodily relics of Hildegard in the altar of the St Hildegard in
Rüdesheim (left). Collection of relics displayed in the
nave of St Hildegard in Rüdesheim (right).

Scientists, pagans, humanists and New Age philosophers can all
relate to the essential life-giving qualities described by Hildegard
here. Rather than God the Father as a dominating, intimidating
male presence, Hildegard makes the divine feminine a living,
omnipresent energy subsumed within the natural world. Hers was
a universe full of sound, colour and joy, and her insatiable curios-
ity still bursts out of the page.

Today, Hildegard's relics, rescued from war like the *Reisencodex*,
are held in a golden reliquary at the parish church of Rüdesheim
am Rhine, within sight of the nuns that continue her example at
the abbey of Eibingen. A huge mosaic depicting her famous image
of the Trinity stands over her remains, while the relics of other
saints, preserved after the destruction of her monastery in Ruperts-
berg, stand in the side aisles. I can't help but feel Hildegard would
have been delighted by the magnificent surroundings that were
built to house her remains. Significantly, only her heart and her
tongue have survived the tumultuous centuries of history along
this stretch of the Rhineland. It seems right that that these parts of

6

Spies and Outlaws

Discovery!

October 2018 – Montpellier, Occitanie, France

A small exhibition – 'The Cathars: A Received Idea?' – has opened at the Université Paul-Valéry Montpellier in southern France. Seven centuries earlier, a group of radical Christians thrived in this area. Known as Cathars, they pushed against the power structures of the Church and challenged the primacy of the Papacy, proposing an alternative way of life which included avoiding meat and embracing the idea of two gods (one good and the other evil). And even now, the towns and villages in this region still tie themselves to the Cathars. From Montpellier the exhibition will travel to Nîmes, Beziers and Fanjeaux, right through the heart of the Pays Cathare. It's no great shakes, more an opportunity for students on the university's 'Medieval Worlds' master's course to display their work, and it includes posters, videos, a comic book and a board game. Yet this unassuming exhibition has caused tourism offices, academic lecture theatres and conference rooms across France to erupt in bitter disputes. The newspapers scream with alarmist headlines: 'The Cathars: Did they Really Exist?' The exhibition's reputation spreads as far as America, catching the attention of Chris O'Brien, reporter for the *Los Angeles Times*.[1]

L'Independent run with 'The Exhibition that Dismantles the "Myth" of the Cathars', provocatively doubting the existence of

this persecuted group of heretics, held dear by tens of thousands of inhabitants in the now expanded region of Occitanie. The report suggests that those who cling to the locations, buildings, names and stories of the 'Cathars' believe in a fantasy. The headline is clickbait, but comments below the article reveal concerns among readers. One writes: 'What is this attack on our roots hiding? With all due respect to this disputed historian, we are Cathars and their treasure is within us.'[2] The organiser of the exhibition, Alessia Trivellonie, responds robustly in lengthy interviews:

> This is the story of a secular construction. We now know that the crusade against the Albigenses was launched for political reasons: heresy, widely invented in the Middle Ages, was a pretext used by the pope and the king of France to attack the powerful county of Toulouse.[3]

At the centre of the issue is the ongoing fabrication and commercialisation of Cathar myths. Fact and fiction have become intertwined and separating them out from one another has become tricky work. A huge industry has grown up around the idea of the Cathars. Everything from their castles, their resistance to the Catholic Church and their tragic annihilation in the crusades has been misrepresented, repackaged and sold on.[4] As one scholar notes, 'the distinction between scholarly and popular history is often blurred.'

Studies of medieval Languedoc and the group of heretics based here in the twelfth and thirteenth centuries range from highly detailed archival research to far-fetched conspiracy theories centred on the holy grail and the bloodline of Christ. It's a quagmire of supposition; the use and abuse of historical facts for the benefit of twenty-first century individuals, communities, organisations and institutions. Landowners, tour guides and businesses across the region line their pockets with the money of enthusiastic tourists, desperate to gaze up to where a couple of Cathars scaled the cliffs of Montségur, ostensibly carrying with them the holy grail, or walk the streets of Béziers where tens of thousands died. There's even a sound-and-light experience in Béziers each August called

The Cathars: the Treasure of Béziers. The narration leans into Cathar mythologisation: 'What our region has retained from the tragedy of the Cathars is the taste of rebellion. And the taste of liberty.'

To understand why the Cathar question is so hotly contested we need to go back to the historical divide between northern and southern France. Tensions between the 'haves' and the 'have nots' in France are still bubbling away today, with the 'gilets jaunes' protests against Emmanuel Macron erupting the same year as the Cathars exhibition. High-visibility vests were chosen as the symbol of the protestors as they were readily available and associated with working-class industries. The yellow vests are a movement concerned with economic justice, opposing urban elites and the wealth of the establishment.

Yellow was also the colour associated with the heretics known as Cathars of the Languedoc. In the twelfth century the north and south of France were distinct kingdoms, with different cultures, climates, ideologies and even languages. The so-called Cathar strongholds swept across the south of the country. But in the early thirteenth century, these territories across Languedoc – the region of the language of Oc – were seized by northern nobility, with Paris becoming the heart of France, its values and traditions eroding long-held southern ones.

After trial by inquisition, the Cathars could avoid burning at the stake if they agreed to:

> Carry from now on and forever two yellow crosses on all their clothes except their shirts and one arm [of the cross] shall be two palms long while the other transversal arm shall be a palm and a half long and each shall be three digits wide with one to be worn in front on the chest and the other between the shoulders.

The ten-inch-long yellow crosses represented their outsider status. The yellow vests of 2018 were similarly symbolic, and issues around national identity still rouse passions in France today. In response to the Montpellier exhibition, the tourist office in the heart of

Béziers – the town burned to the ground by crusaders in 1209 – gives this stinging summary: 'To people here, the crusade against the Cathars looks rather like a colonial war. It's something still present and alive in local history.'

And amidst the controversy is a group of medieval women whose extraordinary experiences cast a new light on early thirteenth-century southern France. Their voices are most present in the records – written by male clerics – of inquests into heresy. As the comic book exhibited at the 'Cathars: A Received Idea?' exhibition suggests, these voices may be muffled by the pain of torture, manipulated by inquisitors and mis-recorded by scribes. But the testimonies paint a vivid picture of the challenges the women faced and the dangerous world they inhabited. They lay bare a society where women could be the holders of power, leaders of guerrilla resistance and religious guides. Cathar women were outlaws, spies, rebels and influencers. While their testimonies are flawed and academic wrangling has obscured their words, their existence deserves attention. They reveal a heterogeneous medieval world in which not everyone was in thrall to the church; one characterised by a diversity of beliefs and approaches to social organisation and the role of the individual.

Welcome to Thirteenth-Century Montségur

A newly constructed watchtower perches on a shaft of limestone rock that reaches up towards the sky. It is March 1225 and this fortress atop of a needle of stone has been under siege for the past ten months.[5] Its inhabitants are starving and fear for their lives. A crusading force with as many as 10,000 soldiers waits at their door. But despite the all-too-present danger, a sense of peace has descended for a moment. Behind the three layers of barricades reaching up the cliff towards Montségur, whose very name means 'safe hill' in the local dialect of Occitan, a group of men, women and children wait patiently for the bishop, Guilhabert de Castres, to perform a ritual known as the 'consolamentum'.[6] Whatever the

next hours and days bring, the placing of hands and the saying of prayers will offer comfort, promising these people that, after death, they will be freed from their flawed, imperfect bodies and their souls will return to the divine essence. The fortress at Montségur is described as the 'head and heart' by those within, and the 'Synagogue of Satan' by those on the outside. The siege taking place here is the climax of decades of war and brutality across the towns, cities, villages and countryside of this region of southern France.

At 1,200 metres above sea level, Montségur sits at the highest point in the valley of Ariège along the northern edge of the Pyrenees. To the east of the fortress the ridge rises steadily, but to the west it drops down a sheer cliff face. Nature has made this castle almost impenetrable. The fortifications are just twenty years old, recently rebuilt and strengthened by one of the area's most important lords, Raymond de Péreille.[7] Along with his wife, brother-in-law, and sister, Raymond has created a safe haven for those escaping the Albigensian Crusade; a military campaign originated by Pope Innocent III to eliminate Catharism in Languedoc.[8]

A village has grown within and around the castle walls, with small buildings and houses huddled together on the limestone rocks, and Montségur is the only stronghold in the region that still resists the crusading army. It has already survived four sieges in 12 years, with the leaders of the crusade, Guy and Simon de Montfort, unable to broach its walls. In 1215 the Lateran Council in Rome proclaimed the castle a 'den of heretics' and it became the last refuge for 'faidits' – noblemen and women of the south who were declared heretics for sympathising with the dispossessed. Endowed, strengthened and supported by local noble families, the village has become a sanctuary for Cathars.[9] Now the decision has been made by the crusading knights; the fortress must fall and those within destroyed once and for all.

At the height of the assaults about 500 people shelter inside the castle. One hundred knights protect the barricades and provide the last line of defence against an army of thousands, but the majority

of those inside will not pick up arms and fight. They are self-professed pacifists. The soldiers outside are frustrated. In previous crusades, they have been used to slaughtering all in their path, but things are different at Montségur. As those within defend rather than attack, the crusaders must bide their time. Efforts to cut off the village's food and water supply have not succeeded – local support for the inhabitants is strong and somehow resources are still being smuggled in and out via the sheer cliff face. Basque mercenaries attack the stronghold directly, setting a catapult on the eastern side of the summit and relentlessly flinging boulders against the fortifications. Their strikes are weakening the walls hit by hit, and as more people huddle within the barbican, driven inside by repeated attacks on the huts and caves around the hilltop, the space is becoming impossibly crowded. Sickly men, women and children live with the reek of bodies, excrement and fear. They cannot hold out much longer.

Eventually terms of surrender are agreed and around half of Montségur's 500 inhabitants are allowed to leave, granted surprising leniency in return for compliance. If they give up peacefully, reject their heretical beliefs and offer to testify against those who stay behind, they can leave safely. Yet many choose to remain. They spend the days fasting, praying and receiving the consolamentum, which will prepare their souls for the approach to heaven. On 16 March their bishop leads a procession out through the barbican's gates and down the path towards the crusaders. A huge pyre of wood, built high by the crusaders, has been set alight in a field at the base of the hill. There is no need to subdue or tie up the individuals as, one after another, they walk voluntarily towards the flames.[10]

More than 200 people perish in the fire. Among them is a woman named Esclarmonde, a name that means 'Light of the World' in her native tongue of Occitan. As her hair catches fire and she is overcome by smoke, she is truly alight. But she is not afraid. This is a ritual; this is what she has prepared her starving, emaciated body for. It is her 'endura', her voluntary suicide, her chance to leave behind her sinful body and be received into the

divine.[11] While her flesh will become ashes scattered in the wind, she and the many Cathar women that have gone before her leave behind echoes of their voices. Some are tortured, terrified, regretful. Others are proud, determined, committed. All have their words recorded as evidence of their heresy and the beliefs and practices of those around them.

The chronicles, inquisitorial reports, depositions and documents that survive from early thirteenth-century Languedoc reveal a time and place when certain women aligned themselves with a movement that challenged the papacy and the most powerful families of Europe. They rebelled against Christian knights who had turned away from Arabs in the Holy Land and redirected their fury on their own. Their voices still reverberate across the hills, forests, villages and castles of the Pays de Cathare, where many of them lived in hiding as outlaws, sheltering for safety in caves and huts, launching a guerrilla-style opposition to the destructive forces of the Albigensian Crusade. It is possible to scour the records for their words and their names. We can reconstruct the complex ideological landscape they navigated, and illuminate the social, cultural and political backdrop to their lifetimes. We might find just a glimmer or trace of these women, but they are worth searching for, as the combined evidence helps illuminate a time of dramatic change in thirteenth-century southern France.

'The Church'

One of the most common misconceptions about the medieval period is that every aspect of daily and spiritual life was governed by 'the church'. Generally, this refers to the Catholic Church, its head (the pope in Rome), and its representatives (the archbishops, bishops and priests) maintaining a form of centralised ecclesiastical power across the villages, towns and cities of Western Europe. This understanding of blanket religious control has led to a received version of the Middle Ages in which everyone adhered fully to Christian beliefs; a time when independent thought was

stifled by the all-pervading church, and a period characterised by an atmosphere of fear, superstition and general ignorance.

A text written around 1218 by William of Auxerre, his *Summa Aurea*, is often quoted to distinguish between intellectuals and 'simple people' in medieval religion:

> The oxen are the preachers or prelates . . . the she-asses are said to be simple people, who ought to rely on what is said by their elders. The sense therefore is that the prelates should instruct the simple, and the simple ought to rely on their faith . . . To believe implicitly is to believe that what the church teaches is true.[12]

This division between thinking 'oxen' and simple 'she-asses' has its roots in the Bible – and the connection between ignorance and femininity has its roots in misogyny. Simple people are led like dumb animals by the church in this demeaning generalisation. Certain theologians like William may well have felt that the general population was far less intelligent than he. But is that any different today in terms of academic snobbery? The truth is far more complex.

Yes, the majority of people in the West would have considered themselves to be what we think of today as Catholic. The rhythm of life in cities, towns and villages would have been punctuated by the routine of masses, feast days and ceremonies at the local church. But the levels of devotion and adherence would have varied depending on the community. Some might be devout, but others were lax. Some would fanatically impose religious dogma, others would challenge and undermine it. Some would profess a complete absence of faith.[13] In certain groups, local and ancient tradition may have held greater influence than that of the Catholic Church. Respect for older deities, sacred sites and traditional practices going back generations could have a larger impact on individuals than concepts of God, Jesus, Heaven and Hell. Local variety abounded.

'The church' itself has always been a living organism, trans-

forming year by year in response to new challenges and developments. From the time of Constantine's Council of Nicaea in AD 325, and even before, there has been flux and change on matters central to the very tenets of Christian belief. Was Jesus human or divine? Is the bread really transformed into his body during communion? Is the pope the head of the church? All these issues were debated extensively throughout the medieval period, with those determined orthodox considered on the right side of history, and those that challenged these assumptions condemned as heretics. The church is still an evolving entity today, reacting to events like the rise in birth control and the AIDS crisis. At times it has transformed quickly, while at others the pace of change has seemed painstakingly conservative and reactionary. These varied and complex attitudes to religion offer a different perspective on life across medieval Europe. For us, more importantly, it also puts the notion of 'heresy' into context.

An image reinforced and passed down since the Protestant Reformation is of a medieval church intent on inquisition, torturing and burning. Just think of Monty Python's 'Spanish Inquisition'. This much-circulated idea was popularised from the eighteenth century onwards – it provided a dramatic contrast to the ideas of reason and apparent 'tolerance' of the modern age. It is, of course, a false impression. Religious atrocities, genocide and colonial oppression in the face of opposing beliefs have never abated. The truism persists, however, that the 'medieval' approach was so much worse. *We* are modern and progressive. *They* were ignorant, brutal and cruel. What heresy was, how it manifested and what measures were taken to combat it are localised and specific issues. Rather than see all heretics as somehow bound together in their resistance to the church, and papal responses as coordinated and consistent, each instance should be examined in terms of the local, regional and national impacts of those groups labelled heretical. Are we dealing with one individual stirring up discontent, a family that has passed down unorthodox practices, or an entire region united under a form of alternative religious governance?[14]

'The Heretics'

And so to the Cathars. One of the difficulties surrounding the study of Catharism is that, while from the fourteenth century onwards 'heretics' were deposed and executed by a relatively organised inquisitorial team, in the twelfth and thirteenth centuries there was no such coordination. What's more, the exact nature of the beliefs each individual held is sometimes difficult to determine. Not only are the documents recording them complex and contradictory, but there were a range of different sects all operating around similar locations, so while they are lumped together as heretics, it's possible they held widely divergent beliefs.

From what can be determined, Cathars believed the sacraments the church administered were useless, its clergy corrupt, and its wealth and power ill-gotten.[15] Cathars performed an extreme form of asceticism, not eating meat, avoiding physical and sexual temptations, and rejecting worldly pleasures. But it was their dualist suggestion of a 'good' and 'bad' God that undermined the very foundations of Christian belief. Much ink has been spilt discussing whether the beliefs held by Cathars were influenced by those of Bulgarian heretics known as the Bogomils.[16] They too held dualist beliefs, but as with so many issues in the study of heretics, it remains a subject of debate.

Cathars didn't even use this term for themselves, referring instead to 'good men' and 'good women'. Some scholars still argue that the term 'Cathar' is nothing other than a nineteenth-century invention.[17] In 2013, scholars of medieval heresy met at UCL and the Warburg Institute in London to thrash out the problem of what to call the Cathars, and to debate whether they had even existed.[18] The discussion was a sequence of largely conflicting views, described by one attendee as 'cantankerous'.[19] One branch rejected the term 'Cathar' altogether, suggesting that while it may have been used occasionally by inquisitors, the label was only subsequently consistently imposed by historians attempting to create an image of a movement like the Reformation – an organised and

coordinated attack on the Catholic Church. The other side argued there is evidence from a range of sources that suggests the term is applicable to a group with a distinctive set of beliefs and practices. Both sides accept that there were heretical groups that used different names and rituals varied.

Some historical reports labelled the group 'Albigensians', after the southern French city of Albi. It is not always clear which group of heretics is being recorded, but what united them was an increased feeling that church reform did not go far enough. A feeling of anti-clericalism was bubbling away across Europe. The clergy still married, the church gathered taxes ruthlessly and the papacy was indescribably rich. And so in Languedoc by the 1160s Cathars had organised into a coherent structure and were holding councils, electing bishops and spreading their influence internationally. The papacy's first solution was diplomacy. But no matter how much they negotiated, their advances were rejected. Then in 1198 a new and uncompromising pope, Innocent III, chose a different direction. Just as the death of Thomas Becket had prompted rebellion against Henry II and, centuries later, the assassination of Archduke Franz Ferdinand could be seen as the catalyst for the First World War, here too it was a death that lit the touchpaper which would destroy the Cathars.[20]

In 1208 a papal legate in the Languedoc region called Pierre de Castelnau had been sent by Pope Innocent to root out Cathars. While conducting inquisitions in Provence he became involved in a conflict between the counts of Baux and Toulouse and he died a brutal death. A representative of the pope had been murdered in this religious backwater of southern France. Which side ordered his assassination and why isn't clear, but the pope blamed Raymond of Toulouse for the death of his trusted representative. The Languedoc region, the pope decided, was out of control, riddled with heresy and a danger to all Christendom. He ordered a crusade to destroy Catharism.[21]

The Albigensian Crusade was a turning point in history. As missions to conquer the Holy Land failed and countries found themselves in crippling debt for their fruitless military campaigns,

hordes of knights across Europe craved recompense and purpose. The papacy didn't have a standing army of its own, and Innocent III's appeal for a crusade against Christians in France was a hard sell to the royals and nobles of the West. While they had been roused by Urban II's earlier calls to suppress the 'infidels' and take back the site of Christ's ascension to heaven, turning their swords on fellow Christians on home soil presented an ideological conundrum. That said, the Languedoc region was rich in resources and disorganised in terms of landownership. Eventually, the prospect of grabbing the castles, fields and forests of families across the region was enough incentive to garner the support of a large number of French and English volunteers. Those who joined the forces were also given the promise made to all crusading knights by the pope: 'the goods of the heretics shall be confiscated . . . and remission of sins which we have designated as an indulgence for those who labour for the aid of the Holy Land'.[22] It was a good deal: land, wealth, forgiveness of sins – all without travelling thousands of miles to get it. While historians have been at pains to present the crusade solely as an attempt to quash heresy, it rapidly became a land grab and moved from the realm of religious to secular concerns. But it was 'the church' – Pope Innocent III and the papacy in Rome – stoking the flames.

This wasn't the only time the church used religious concerns to turn on a group of outlaw Christians. The Waldensians were a separate resistance group altogether, but they certainly would have been known to many Cathars. Referred to as 'the poor men of Lyons', they originated after a wealthy merchant, Peter Waldo, gave away all his possessions in 1173.[23] Their followers were largely spread along the Cottian Alps, on the border between France and Italy. The Waldensian territories adjoined those of the Cathars to the west, but from the records, their belief systems were different.[24]

While both rejected the wealth of the papacy and embraced poverty, the Waldensians also rejected pilgrimage as 'just a way of spending money' and said that relics were no different from any other bones. They did allow their followers to eat meat, but more

extreme Waldensians are reported to have suggested the priest-hood was depraved, declared the papacy the anti-Christ, and rejected transubstantiation – the transformation of the bread and wine of the Eucharist into the body and blood of Christ. The easiest way to distinguish Waldensians from Cathars was through their dress and appearance, which is often how systems of belief manifest themselves openly to others. The Waldensians, it seems, expressed their otherness through footwear.[25] They are referred to as 'sandaliati' in inquisition reports, suggesting that the sandals they chose to wear indicated their connection to a heretical group.[26] These micro-communications are often lost to historians and archaeologists looking back on a particular time, but would have been as clear to people then as a goth wearing thick eyeliner or a punk styling their hair today.

While Waldensians and Cathars were punished as heretics, other groups that criticised the papacy were emerging throughout the thirteenth century, with many eventually absorbed as new branches of the church. The Franciscans were founded by St Francis of Assisi in central Italy in 1209 – the same year the pope launched the Albigensian Crusade and 20,000 people were reputedly anni-hilated in the streets of Bézier. It was Innocent III himself who granted Francis the right to found an order that rejected personal property, embraced poverty and encouraged preaching in the streets. Francis adopted the tunic worn by peasants as his order's habit and went about barefoot. In their rejection of papal excess and desire to live in poverty like Jesus, the Franciscans were very similar to the Waldensians. But Francis seems to have proved he was devoted to the church and clergy in a way Peter Waldo couldn't. While the former founded one of the most influential monastic movements within Christianity, the latter was excom-municated and driven into hiding.

What's more, along with the Dominicans, founded in 1216, the Franciscans were authorised by the papacy to conduct the first official church inquisitions. Supported in their efforts to root out heretical beliefs within communities, these two new branches of the church – both openly critical of the papacy – were actively

encouraged to develop systems for gaining confessions. The original intention of inquisitors was to discover if someone held incorrect beliefs due to a flawed education. The Dominicans and Franciscans were seeking to save souls, since their faith declared that people who died with wilfully held incorrect beliefs could not go to heaven. They would argue their intentions were good. But their practices paved the way for the violent inquisitions of the fourteenth and fifteenth centuries, and their approaches to torture and questioning were refined over the 20 years of the Albigensian Crusade on Cathars. The Cathars were the church's guinea pigs, and the resulting testimonies are not always the clear-cut, systematic records of later centuries, but rather the documentation of a trial and error approach. And yet it is only within the reports of these inquisitions we find rare traces of the many women who were intrinsic to Catharism. Their involvement in the church was a major concern to clerics of the time, and they reveal the influential roles that certain women could achieve in this time and place.

Cathars and Female Spirituality

Cathar beliefs deal with that critical question that young people of faith still grapple with today: 'If there is a good and kind God, then why do bad things happen?' The Catholic Church developed concepts of free will, self-determination and the devil to answer these questions, endorsing the idea of a singularly loving and benevolent God. But in dualist thought there are two gods: one that is perfect, pure, ideal and responsible for all things spiritual. Then there is another that is fallible, creates life on earth and is responsible for the material world.[27]

If it is hard to get a handle on Cathars generally, then it is even more so with regards to Cathar women.[28] Accounts are contradictory, with some stating they could hold the very highest roles within communities, while other say there was 'no great tolerance for women'.[29] A roll call of fascinating individuals come and go with passing references in inquisitorial records: Bérengère 'put

aside the sect of the heretics, was reconciled and received a husband'.[30] Fabrissa kept a group of Cathars safe at her castle in Montreal, but was forced to flee from crusaders.[31] Berbeigueira was a believer for 30 years and had to watch as her husband, on his deathbed, expelled all Cathars from their home.[32] From these records, we can be sure that many women were drawn into Catharism. Why was this dangerous sect so appealing to them?

In Cathar beliefs, humans were, by nature, imperfect – fallen angels whose soul and spirit had been given physical form in frail bodies. They believed a person would continue to be reborn in flawed flesh until they could embrace the ascetic practices of abstaining from meat, rejecting sinful acts and receiving the consolamentum before death. Cathars strove for this moment of consolamentum when their souls would be reunited with their angelic form. This was the ritual that comforted the siege victims at Montségur as they waited to meet their death. The body is prepared through fasting and abstinence, and is purified until the final prayers are said alongside the laying on of hands. Both men and women could perform the consolamentum and it was essentially a last rites exercise, designed to purge the human body of sin and suffering. This ritual suggests that Catharism did not focus on individuals, since angels didn't possess distinct natures or genders but were part of the divine essence of the benevolent 'god'. Issues of wealth, background, disability, and of course gender therefore did not concern them. This may have been an incentive to the women who embraced Catharism, since if a person could break the cycle of being born back into flesh, they could cast off their physical forms and return to the essential good spirit.

Because all human flesh was weak and prone to evil, Cathars rejected the idea that Jesus was divine. Why would God put himself in a human vessel? They also reportedly rejected the symbol of the cross. The deposition against one Peter Garcia of Bourguet-Nau says he was overheard making heretical comments during the Good Friday procession. He suggests that instead of uttering 'Behold the wood of the cross', the faithful should instead just say 'Behold, Wood!'[33] While amusing, such statements put Cathars

directly at odds with the Catholic Church. They rejected the Eucharist because the bread:

> Comes from straw, that it passes through the tails of horses, to wit, when the flour is cleaned by a sieve (of horsehair); that, moreover, it passes through the body and comes to a vile end, which, they say, could not happen if God were in it.[34]

Jesus, the cross, the bread of communion; by rejecting these central ideas the Cathars sat well outside the control of the church. They were outlaws rejecting not only the fundamental beliefs of the Catholic faith, but also the taxation, laws and commands of this overriding religious authority.

The issue of gender also clearly set them apart. While the Catholic church could point to any number of passages to show that women should be subservient to men, the Cathars took a different approach to the Bible as a sacred text.[35] At the very beginning of the Book of Genesis there are two passages which have long been seen as incongruous. The first chapter of the creation account stresses that man and woman were created simultaneously, as equals with the same rights to control all the fish, birds and animals. Yet the second chapter describes how Eve was made from Adam's rib, as his partner who must serve him.[36] They may have been written at different times and with different intentions, but the two creation stories at the very opening of the Bible contradict one another. The Genesis account continues, however, along the more divisive line: when God punishes Adam and Eve for eating the fruit of the tree of knowledge, the woman receives a harsh punishment: women would forever experience great pain in childbirth and would be ruled over by their husbands. And so the seeds of misogyny were sown at the very heart of Christianity.

The Cathars, however, read the Bible differently. They argued that everything in it was 'true if it was understood in a mystic sense'. The stories, parables, laws and statements were symbolic of how humanity could cast off evil and strive to ascend into heaven in perfect angelic form. In the twelfth and thirteenth centuries,

reading the Bible was the preserve of the few and was beyond reach for most laypeople. This must have been frustrating to Christians who understood there was a book which contained the secrets of life, morality and how to get to heaven, and yet were denied access to it. Only the 'oxen' could access the wisdom, while the 'she-asses' blindly followed.

Cathars invested in educating their young, regardless of background. As a result, they translated the Bible into the vernacular of southern France, Occitan, so that they could provide access to those who may not have learned enough Latin to understand the Scriptures. And if an individual Cathar, whether male or female, embraced the position of 'perfecti' or 'perfectae' they would receive additional theological training, and had freedom to read and interpret the Bible. Those that chose, or were chosen for, the life of a 'perfect' often took on the responsibilities of fasting and purifying while still very young, but as a result could wield influence. Liberated from the literal instructions on the subservience of women promoted by the church, women could be considered equals of men. Both men and women had to control their flesh and avoid temptation. Both were similarly flawed from conception. Both could lead others in consolamentum. Within the Cathar church women could teach, preach and save.[37] They shared power.

Female 'perfects' were particularly challenging to the Catholic Church. By receiving the consolamentum and living a pure life they believed they had reconciled their soul with their angelic spirit. Therefore, all other humans who have died, including Christ, the Virgin Mary and the saints, were simply fellow angels. As all living beings would be subsumed in the divine essence alongside one another, there was no need to venerate any particular individual. One female perfect is quoted as saying she had 'greater power to liberate than Holy Mary' and that 'the Holy Virgin Mary and Holy Agnes did not have greater merits than any just consoled sinful woman'. The focus on the Holy Spirit, rather than Jesus, was also fundamental to the role of women within Catharism. Unlike Jesus, who was born into a male body, the

Holy Spirit visited everyone equally and was not human in form. With their emphasis on the Spirit rather than the man, Catharism levelled out the sexes in terms of salvation. They rejected Jesus but could get on board with the Holy Spirit.

It's also arguable that a system of belief which took physical suffering and the fallibility of the flesh as its basis would have appealed to women, beset as they are from birth with the challenges of menstruation, pregnancy and the mortal dangers of childbirth. Catharism saw the workings of the womb and the process of procreation as simply perpetuating human beings' sinful time on earth. To be free from this responsibility, free from the prospect of being married off and sexually subservient to male partners, and to have some agency over their bodies and lives would have been tempting. It cannot be underestimated how heavy the burden weighed on medieval women, knowing that from childhood their destiny was to put their lives in danger through childbirth. While most women might be vulnerable to rape, or rejection by a man who had impregnated her therefore rejection by society, Cathar women could lean on their promise to abstain from sex as a means of taking control. About one in 20 women died in childbirth, and many more would have to deal with losing children, physical pain and long-term health issues.[38] To abstain from sexual activity on religious grounds was a safer bet for many, including for nuns, whose populations exploded during the medieval period, and for groups like the Cathars.

While Catharism allowed women a more elevated role than they might have been granted in the northern orthodox regions of France, there were still issues that kept them subservient to men. Because intercourse was considered an evil act that rooted souls to bodies on earth, Cathars were also required to avoid anything positive connected to sex. Just as eggs and meat were tainted with mammalian reproduction so couldn't be eaten, this aversion also extended to pregnant women. There are also some Cathar accounts of the biblical Fall that suggest that the devil seduced souls in the form of a beautiful woman no one could resist.[39] The age-old implication that women could be temptresses was still

present in the Cathar church. But overall it is fair to say that their approach to duality, the fact they perceived all human flesh as flawed, and their inclusive preaching of the Bible were more forgiving towards women than the views of the orthodox church. Women also had equal rights to land ownership in Languedoc and could be found at the head of powerful families across the region, so through their links with Catharism, certain individuals were able to enjoy influence they might not otherwise have gained.[40]

Concubines or Conquerors?

As we turn to the sources in search of individual women, the words of one Cathar scholar seem relevant:

> They were the silent sex in this age of human history and, to find out about them, one has to peer through the eyes of men, themselves not always capable of seeing the truth.[41]

The issue of who records history here is a pressing one. Cathar women were written about by contemporaries who despised and misunderstood them, so sometimes the very least we can determine with any certainty is their names. As inquisition records paint those they interrogate as deviant and sinful, Cathar women are most commonly referenced as 'concubines' to their partners, for example: 'William Raymond of Roqua and Arnauda, his concubine.'[42] As far as the church was concerned, if a woman was not wed through the sacrament of marriage and nevertheless cohabited with a man, she was automatically classed as a concubine. But this misunderstood the nature of Cathar partnerships. Those referred to as 'concubines' by the church would have been recognised as wives by the community. Cathars rejected the sacraments and had their own hierarchy of priests and bishops who would perform the equivalent marriage ceremonies for those men and women who wanted it.

Conversely, many Cathar women were also singled out for their

virginity in testimonies. It seems that by entering into marriage and consummating it, a woman was seen to have left behind her heretical ways. Tying herself to an orthodox man showed she was prepared to enter the Catholic Church, but remaining single and chaste could be a sign she was guilty of heresy. Inquisition reports state: 'Covinens de Fanjeaux abandoned her heresies and took a husband', while 'Bernarda lived three years as a heretic, but afterwards she married and had two children'.[43] In these cases the women were not described as living dissolute lives prior to getting married, but instead were virgins. This undermines suggestions that Cathar women were particularly licentious 'concubines' and instead indicates that most rejected the idea of sex altogether.

This rejection could cause particularly problematic situations for Cathar women coming up against church authorities. In an account of a girl from Rhiems, the abbot of Coggeshall described how a canon in the company of the archbishop saw a young woman walking in a vineyard. He went straight to her and accosted her directly. The girl, under no illusion of what the man wanted, replied: 'If I were to lose my virginity, my body would be corrupted on the instant and I should be damned irredeemably for all eternity.' Saving herself from rape, the girl had instead condemned herself as a heretic. Her desire to remain a virgin signalled her Cathar beliefs, so she and her female mentor were burned at the stake.[44] This questionable moral behaviour by a member of the clergy, supported by the Archbishop of Rhiems, also signals the truth behind the challenges made against the church by 'good Christians'. Some clerics really were behaving in the ways 'heretics' repeatedly decried.

In another charge levelled against Cathar women, papal letters suggested that a more hesitant attitude towards sex, pregnancy and marriage undermined traditional Christian family life. But the genealogy of noble families condemned by inquisitors proves that procreation and the family unit were not rejected outright by Cathars. Passing down beliefs was a family affair, with both fathers and mothers responsible for creating strong bonds down the generations under a feudal system. If the female head of a house, wife

of a landowner or mother of a child was a Cathar, she would pass this faith on to those around her. She had a responsibility to 'save the souls' of those she cared for. Blanche de Laurac, recognised as an important matriarch, brought up many daughters, sons, grand-daughters and grandsons as devoted Cathars. The claim made by the church that Catharism would disintegrate family life is not substantiated. The rejection of sex and the importance of procreation sit side by side, with women able to fill both roles at different times. It seems some Cathar women did lean towards a more pious life where they rejected sex, but many made this choice after the death of their husbands, having already birthed children. It is not a cut and dry situation, with Cathar women occupying a gamut of positions, from mother and wife, to virgins, religious advisers, landowners and resistance leader.

Many Cathars were from noble families in the Languedoc region, but people from all social classes were recorded in the heresy trials. A list from 1209 of Cathar sympathisers in Béziers included four doctors, five hosiers, two blacksmiths, two shoe-makers, a corn-dealer, a tavern-keeper and a woolworker.[45] Woolworkers contributed to one of the most commercialised sectors of the medieval period. Textile production could create income and social mobility for those restricted by serfdom. What's more, as the Bayeux Tapestry embroiderers revealed, weaving was dominated by women. While Cathars lived simple lives of austerity, they still required money for food and materials. Weaving was a popular way of earning it, as attested to in chronicles, depositions and other records. It could be done by women on a small scale in the home.[46] Of course the relationship was not a given, but the connection between the textile industry and Cathars coined the phrase 'weavers into heretics.'[47] It afforded an option for those living outside of societal norms to provide for themselves and their families.

Living as outsiders and outcasts created webs of connections between Cathar communities, but these relationships were often complex and dependant on bonds of loyalty and familial links. In her deposition, Guillemette of Sapiac of Montauban records how she lived with her aunt, who was a heretic. She describes 'dressing

as a heretic' for two years when she was a girl, but then being 'reconciled' to the church and married. Yet she continued to harbour Cathars with her husband:

> They received the heretics Joan of Avignon and her female heretical associates in her house and adored them often . . . Heretics received things from her household whenever they wanted. She believed that heretics were good people.[48]

How do we make sense of Guillemette? She had been a practising heretic for some of her life, recanted at a later stage, but continued to sympathise with and support other heretics. The judgement is made that she will go on a long pilgrimage across France, to Canterbury and finally to Rome and 'wear a cross for seven years'. The complexity of her testimony shows how difficult heresy was to weed out, particularly in communities where it embedded in diverse ways.

Cathar women could be hidden in plain sight, as with Raymonda of Mazerac. The prioress at the Abbey La Lecune, she was reported as a heretic after she questioned the nuns on the Virgin Mary. The deposition states she asked, 'whether the Blessed Virgin had really suckled Jesus physically and suffered giving birth like other women.'[49] This is a complicated testimony. She was a prioress surrounded by nuns, who 'wore the habit of a heretic for four or five years before', according to the document. But it was the nature of her questions on the physical nature of Jesus and Mary which raised the heretical 'red flags' resulting in her inquisition. Her eventual punishment of being made to 'enter a stricter priory' reveals she was allowed to remain within the church and was still considered to be orthodox, despite these questionable beliefs.

Perhaps the most famous female Cathar was Esclarmonde de Foix. She was a member of one of the most important families in the Languedoc, and ruled Foix as regent when her husband died in 1204. Esclarmonde wielded great power during her lifetime. She witnessed documents alongside her brother, like the settlement in March 1198 between the Cistercians of Boulbonne and

the count of Foix, so we know she had enough secular influence to sign charters.[50] She was also responsible, along with Raymond de Péreille, for rebuilding the fortress at Montségur to protect the remaining Cathars from the Albigensian Crusade. While she may not have lived long enough to see its fall during the siege, her actions offered shelter to families that had been driven many hundreds of miles into exile by decades of persecution. But it is her role in Cathar preaching that is most often cited.

She was made a perfect and ran a house for Cathars in Pamiers. In the same city, two years after the death of her husband, Esclarmonde attended a council where representatives of Catholics, Cathars and Waldensians presented their beliefs. It ran for a month and each spokesperson was given a full day to argue their position. To the disdain of the predominantly male council, Esclarmonde was invited to present on Cathar beliefs. She took the stage but was heckled by the Catholic representative, Brother Étienne de Misérichorde: 'Go, Madam, to spin your distaff. It is not appropriate for you to speak in a debate of this kind.'[51] The misogynistic response has enflamed centuries of commentators, who see in Esclarmonde a proto-feminist. Indeed, she has developed legendary status in the Pays Cathare, even though it is difficult to gather facts such as where and when she died. Her involvement in a council and her derogatory treatment by a member of the clergy highlights both the positions to which Cathar women could rise, and the destruction their reputations could suffer at the hands of the orthodox church.

On the Run

It wasn't just reputations that suffered at the hands of the church. The hardship experienced by Cathar women is exemplified in records of the life of Arnaude de Lamothe. By the time of her trial by the Dominican inquisitor Brother Ferrier in 1244, Arnaude was a frail 40-year-old.[52] Her thin frame was the result of decades spent on the run, relying on the generosity of those hiding her

from persecution. She had avoided meat and alcohol since she was a child, eating a vegan diet with a little fish when she could get it. She walked thousands of miles over the course of her life, moving from cave to hut, from forest to barn, constantly changing location to escape crusaders and inquisitors set on hunting her down. Her life was put on this hard course when, in 1208 at the age of seven, she and her sister Peironne met two women in dark clothes at their grand castle in Montauban. Invited by their mother, these women spoke loudly about God and commanded the respect of those in the room. Arnaude recalled how her mother bowed deeply before them three times then asked them to bless her, make her a 'good Christian' and lead her to a 'good end'.

Shortly after the women in dark clothes left, Arnaude's relative Bernard de Lamothe and his companion Raimon Méric (deacon at the church in nearby Villemur) arrived at the castle. They gave long speeches in the great hall and again the women of the house honoured the 'good men' by bowing three times and asking for blessing. This was the last evening Arnaude would spend at her family home. The men had come for her and Peironne. Together, they walked two miles to the home of a woman named Poncia and here, alongside aristocrats, artisans, nobles and peasants, the two girls embraced the teachings of the 'church of God'.[53] Arnaude knew what she was destined for. While at Poncia's home she learned about the life of good Christians, and how receiving consolamentum would bring them salvation after death. In her testimony Arnaude recalled how she was taken to the 'room of the perfects' in front of a group of witnesses. Here she and her sister had to promise to eat no meat, eggs or dairy, to never swear, to live a celibate life and to remain loyal to their beliefs even in the face of death by fire, water or any form. As hands were laid on them Arnaude and Peironne became perfects.

They were still very young so could not yet perform the duties of other perfects, like giving the consolamentum to people on their deathbeds or preaching to the community. Instead, they were kept safe as a rising tide of fear gripped the people of Languedoc. The Albigensian Crusade was on their doorstep. As Deacon Méric

learned of the massacre in Béziers he instructed all the perfects to disperse and find safety away from the eye of the storm. Arnaude and Peironne moved between the homes of sympathisers, staying a day here, a day there, as the forces of Innocent III and the French nobles bore down and took city after city. Sometimes they would find a home to shelter in, but other times they had to hide in damp caves, lighting fires to keep wild animals at bay. They were forced to seek out ever more remote parts of the countryside, travelling as a pair for additional safety. It was required that Cathar women always travel with a female companion, and if one succumbed to illness or death, a new woman had to be found before they could move on. Being on the run was an exceptionally dangerous situation for Arnaude and Peironne to find themselves in. With soldiers out for blood and outlaws taking advantage of chaos, the specific needs of these vegan, celibate, pacifist 'good women' singled them out in homes and bars as heretics. Their vulnerability was clear.

The girls did find refuge from time to time. At Lavaur they stayed a full year at the home of the perfect Azalais. But in May 1211 atrocities were once again close. In the same town, the local castle was attacked. The defence was led by the owner and lady of the castle, Giralda, who commanded the troops and held back Simon de Montfort's forces for two months.[54] When Giralda and her soldiers finally capitulated the punishment was extreme. Sources report that 80 knights were hung, while 400 heretics were burned. Giralda herself was thrown down a well and stoned to death.[55] Her sister, Esclarmonde of Niort, would also gain lasting notoriety in her actions against the crusaders. Along with their third sister, Navarra of Servain, the three women formed the foundations of a familial network which controlled the major estates across the entire Languedoc region.[56]

Avoiding the bloodshed on her doorstep, Arnaude continued to evade capture for two more years until 1213, when she and her sister abandoned their vows as perfects under fear of persecution. But when their mother fell ill, they returned to their Cathar upbringing and turned for help to the 'good women of Linars'. These women were Cathars living like nuns with their own

prioress.[57] Desperate for their mother to be physically and emotionally prepared and then receive the consolamentum, the sisters chose their old ways over the new. For the next 20 years Arnaude once again assumed her role of perfect, living in the homes of other Cathars or hiding in forests with just her 'sociae' (travelling partner) for company. Sympathisers brought her food, but it was a hard life where the threat of torture and inquisition was everpresent. Arnaude had received enough training in rhetoric to deliver sermons in Massac, which was outside the Cathar powerbase of the Languedoc. She was acting as a missionary, carrying the community's beliefs to other areas of France and encouraging the repudiation of the Catholic Church.

An active and important representative of the resistance movement against the Albigensian Crusade, Arnaude was eventually captured in the woods near Saint-Foix in 1243. Threatened with fire, she once again rejected her vows as a perfect and converted to Catholicism just months before she gave her deposition. While her account paints a dramatic picture of women fleeing their enemies, relying on the natural environment and acts of generosity for survival, her recorded testimony is that of a newly converted Catholic. We can hear her voice, but only under duress. Nevertheless, it is clear that Arnaude was a courageous, tenacious and extraordinary thirteenth-century woman.

Heresy Hysteria

In the 1220s, as the Albigensian Crusade raged on in the south, Parisian manuscripts were emerging which presented biblical scenes with allegorical interpretations in contemporary settings. Known as Moralised Bibles, they feature a range of acts considered sinful by the church, including lesbianism and sodomy.[58] They have been described as 'windows opening onto medieval society of the time', but rather than representing reality, it is evident that they were cautionary images, designed to put fear in the hearts of the Parisian nobility that evil was bearing down on them.[59]

Included in the thousands of images are heretics, who are often compared unfavourably to Jews and accused of perverse behaviour. In a representation of Balthazar feasting with the treasures stolen from the temple of Jerusalem, two couples are shown embracing. Labelled 'heretics', the woman looks into a mirror while engaged in a clinch. Opposite, a young monk embraces an

Illuminations from Genesis 3:1-6 in the Moralising Bible, Österreichische Nationalbibliothek, Vienna, MS 2554, folio 2r, c. AD 1220.

Illuminations showing heretical practices in the Moralising Bible, Österreichische Nationalbibliothek, Vienna, MS 1179, folio 165v, early-thirteenth century.

older man. Heretics are painted as bad people, displaying the deadly sins of vanity and lustfulness, but throughout these manuscripts there are many different types of evil and subversive entities. The Moralising Bibles present a thirteenth-century world full of deviance, threats, moral ambiguity and sin.

One representation is particularly distinctive and unusual, depicting a scene of heretics with darkened faces kissing the hind quarters of cats and venerating the creatures. While bizarre to us, the origin of this legend lies in the writings of medieval writer Gautier Map. He described a secret rite performed in darkness, where an enormous black cat was hung by a cord in the middle of a room, and those around it must put their mouths to the animal's anus.[60] Map was suggesting that heretics performed deviant, or even devilish, ceremonies. This accusation was reiterated by Alain of Lille, a French theologian writing at the beginning of the thirteenth century, where he explained the name 'Cathar' came from the word 'chat/cat'. He insinuated that these heretics worshiped the animal as a manifestation of Lucifer. A more convincing reason for the name 'Cathar' may lie in the Greek word 'katarus', which means 'pure'. But Alain bastardised it with his derogatory manipulation.

The Moralised Bibles themselves don't use the term 'cathar', instead referring more generally to 'heretics'. These were the bogeymen of the medieval period; you wouldn't know if a heretic walked among you, or entered your home, but contact with them was a guarantee of death and damnation. Fear of heresy was a growing epidemic in the thirteenth century. This is clear not only from the emergence of the Moralised Bibles, but also through the growing number of trials and inquisitions from 1225 onwards. There is also the suggestion that spies were being used to infiltrate groups of heretics, so feelings of distrust were rife on both sides.

In the mid-1230s, Master Raoul of Narbonne was leading the inquisition in this region and recruited a woman called Marquèse de Prouille as part of his spying efforts. Coming from a local family that was recognised as heretical, Marquèse was easily able to infiltrate Cathar gatherings.[61] Raoul gave her money to supply the

Cathars with food, and under this guise she sent reports back to the inquisitor. He followed up on her information three times, attempting to capture individuals in the act of heretical practice at the homes Marquèse described.[62] But either she was a bad spy, or she was double-bluffing and protecting those she was ordered to betray by giving him incorrect information. He was only able to make one arrest based on her reports, despite handing over large sums for her assistance. He hoped Marquèse would be useful as a spy because of the high status in which women were held within Cathar communities. Her fudging of the mission reiterates the fact that it was hard to determine who could be prosecuted for heresy and who couldn't. That a woman could act as a spy for the inquisition and could simultaneously be embraced by Cathar communities shows the tightrope many walked during these turbulent years.

Nazis, Treasure and Montségur

It's no wonder that Cathar studies remain such a quagmire of controversy. The complex subject has been connected to more than its fair share of erroneous and misleading works, from the Moralised Bibles up to *The Da Vinci Code*. Perhaps most influential was a text published by SS member and historian to the Nazi regime, Otto Rahn. Often cited as the inspiration for Indiana Jones, Rahn is a much-maligned historical figure, but one of his legacies is the glut of publications that connected the Cathars and Montségur to legends of the Holy Grail. His book *Kreuzzug gegen den Gral* (*Crusade Against the Grail*), published in 1933, caught the attention of Heinrich Himmler.

Rahn's ideas were based on those of an esoteric French writer, Joséphin Péladan, founder of France's first occult society – the Cabalistic Order of the Rosicrucian.[63] By 1903 Péladan had proposed that Montségur was 'Montsalvat' – a castle mentioned in the thirteenth-century German text *Parzival*. This medieval romance connects the location to the quest for the Holy Grail,

and Péladan in turn suggested this may have been the 'treasure' two Cathars were seen escaping with during the siege of Montségur.[64] Rahn himself didn't think the Holy Grail was the cup used by Christ at the Last Supper like Péladan, but rather a stone that dropped from heaven to earth along with the fallen angels. In line with Himmler's extended work on Aryan origins, Rahn used the Cathars to further his work on German race theory.[65]

But dogged by the Nazi regime for his open homosexuality, in 1939 Rahn found himself pursued by the Gestapo for desertion. Rahn disappeared that same year and his body was discovered frozen to death in the Austrian mountains on 13 March, just days before the anniversary of the fall of Montségur. His demise was tragic. It has been claimed he was following the example of the Cathars he so admired by undertaking the 'endura', purging his body of impurity, then at the point of starvation walking out into hostile environments to welcome inevitable death, as those who died at Montségur may also have experienced.

In more recent years, *Holy Blood and the Holy Grail* by Michael Baigent, Richard Leigh and Henry Lincoln was published in 1982, inspiring the multi-million-dollar bestselling novel by Dan Brown, *The Da Vinci Code*. It was supposedly based on facts, with the authors heavily relying on a document deposited in the French Bibliotheque Nationale in the late 1960s for their theories, unaware it was a forgery. They created an argument which tied a bloodline of Jesus and Mary Magdalene to a secret sect in the Languedoc region of France. The Cathars were cited as protectors of the grail, holders of a great secret which made them vulnerable to attack by the papacy. The book has since been widely criticised and recognised as an originator of mainstream conspiracy theories, as well as held up as a source of ideological romanticism for the reactionary far right.[66]

But the authors of *Holy Blood and the Holy Grail* do make some relevant points. Understanding the problems of terminology, they state that the terms 'Cathar' and 'Albigensian' were generic names and did not refer to a specific church to rival that of Rome.[67] They also note the political rather than religious motivations for the

Albigensian Crusade, namely that northern nobilities desired the land and wealth of the Languedoc. And pertinently, of the inquisitorial reports on Cathars, they state 'To form a picture of them from such sources is like trying to form a picture of, say, the French Resistance from the reports of the SS and Gestapo.' When searching for 'facts' regarding the Cathars it is hard to work through the agendas of centuries of authors. Whether it is Dominican inquisitors seeking confessions, papal letters justifying the use of armed force against fellow Christians, or modern 'historical detectives' convinced they have uncovered ancient secrets, the texts are not easy to interpret. But through exploring the many women connected to Catharism, we understand a little more fully the experiences of persecution and accusation of heresy.

Wiping out Cathars: Wiping out Women

Heresy is a thought crime, often difficult to discern, and some women in the thirteenth century used this ambiguity to their advantage. They could create centres where they wielded religious and earthly powers, passed on esoteric knowledge to the next generation and preserved local traditions. Rather than a direct threat to the papacy, the behaviour of the 'good Christians' was subversive on a local level. But their attitudes towards the church, central doctrines such as the sacraments, and their elevation of women left them vulnerable to attack.

Delving into the lives of Arnaude, Esclarmonde and Marquèse plunges us into a time and place where families and communities were under threat of extermination. While their testimonies are fragmentary, biased and problematic, the harsh reality of living through heresy trials, trying to evade capture, and protecting ideologies still echoes down the centuries. These women were victims of war, vigilantes, outlaws evading capture, and many were willing to die for their beliefs. We've seen how this time could be reactionary and superstitious, as clerics tortured confessions out of vulnerable victims. Yet despite the attempts to censor and oppress

7

Kings and Diplomats

Discovery!

8 June 1997 – Błonia Park, Kraków, Poland

Pope John Paul II is on familiar ground. He grew up just 50 kilometres south of Kraków in the village of Wadowice, and attended university, became a priest and then a cardinal in the city. One of the most beautiful cities in Europe, it's a busy tourist destination, popular with sightseers and stag-dos alike. Its Old Town was declared the very first UNESCO Heritage site in 1978, thanks in no small part to the pope's involvement.[1] Just a mile and a half from the towers and ancient fortifications of the castle on Wawel Hill (where the den of the dragon Smok nestles beneath layers of architecture from every period) is the enormous open-air park of Błonia. In the summer heat, a million people are gathered together. They wave the yellow and white flags of the Vatican, weep, faint and scream as the head of the Catholic Church appears surrounded by a cube of bulletproof Perspex in his legendary Popemobile. It's a heady, intoxicating and exuberant event. The city's most famous resident is back, and he is treated like a rock star.

He is here to do something he has wanted to do for a long time. He is here to declare a medieval woman a saint. As masses of people listen attentively, he takes the microphone and delivers a sermon:

We must turn to the Hill of Wawel, to the Royal Cathedral, and place ourselves there before the relics of the Queen, the Lady of Wawel. Now the great day of her canonisation has arrived! . . . Hedwig, you have long awaited this solemn day.[2]

The pope is talking directly to a woman who has lain in her grave for 600 years. He has fought passionately and tirelessly for her to receive this 'long-awaited solemn day', his Congregation for Causes of Saints having spent years compiling documents, searching archives and researching her life.[3] To this resident of Kraków she is an icon. As he addresses the jubilant crowds his shoulder is hunched, a result of one of his many brushes with death. He is a frail 77-year-old, but when he speaks of Jadwiga (or Hedwig as she is known outside of Poland) he becomes animated. He insists on standing during his speech, as he does inside his customised car, so people can see him better. One of the most widely travelled rulers in world history, he has visited 129 countries. But alongside travel, his other passion lies in declaring saints.

During his long term as pope, John Paul II beatified 1,340 individuals and declared 483 saints; more than all of the previous popes combined across the last five centuries. He was a serial canoniser, but there was one saint of particularly special importance to him. Throughout his early life he had prayed at Jadwiga's tomb in Kraków Cathedral, worshipped in front of the crucifix she too had knelt before, and gazed in wonder as bones and treasures were raised from her tomb when he was just 19 years old.[4] This ceremony was important, not only to this one man, but to the people of Poland. In his words: 'Many longed to experience this moment and were not able. Years and centuries passed, and it seemed that your canonization was even impossible.'

Jadwiga's very life seems impossible. She was the one and only female 'king' of Poland. In fact, she and her sister Mary, who was declared King of Hungary, are two of the only women in Europe to have held the title of 'Rex' rather than 'Regina'. But Jadwiga has been misunderstood, misrepresented and misused down the centuries. Little known outside of Poland, her position as one of

Europe's only female 'kings' means she is ripe for reassessment by returning to the historical facts, archaeological evidence and physical artefacts of her time. Used as a tool for nationalist agendas, I now want to find the real medieval Jadwiga again, as she is a fascinating example of how much power and influence a woman could wield.

Jadwiga's tomb in Wawel Cathedral has long been a pilgrimage site for those wishing to commemorate her short but important life. As Poland was wiped from the map for more than a century between 1772 and 1918 through partition and absorption into Prussia, Austria and Russia, her tomb became a national rallying point; a place where Poles could remember they had once been an independent and strong nation. Jadwiga mattered in her lifetime, and her existence still holds significance for many Poles today. Despite multiple attempts through the centuries to make her a saint, it was John Paul II who finally ensured her a front-row seat in heaven just two years before the six hundredth anniversary of her death. She was canonised as patron saint of queens and, importantly, of a united Europe. A paragon of chivalry, for those who remember her, she is known as someone who changed the course of history for a great swathe of Central and Eastern Europe.

Welcome to Late-Fourteenth Century Kraków

Noise fills the bustling cobbled streets as, from their respective doorways, a wigmaker and a tailor vie for business, sweet-talking well-to-do Krakowiaks as they navigate the market square.[5] Merchants dress in pale silks, the fabrics beautifully tailored to their bodies. Women's embroidered capes sweep the ground, collecting muck and dirt that will later require painstaking scrubbing by servants. Knights huddle in groups, side-eying those whose tabards display a rival's symbol, while the town executioner cuts a chilling figure dressed from top to toe in red and wielding a hefty sword. The wealthy are dressed in the fashion of the West and would not

look out of place in the glamourous cities of the Holy Roman Emperor in Germany. But moving between the busy market stalls are also people from distant lands; Jews, Muslims, Eastern and Western Christians.

The Rynek – main square – still feels fresh and new in 1399, with most of its buildings dating to the mid-thirteenth century when the city was reconstructed. Just over a century earlier, the city had suffered devastating destruction by Mongols. It has been rebuilt on almost the same blueprint; a phoenix rising from the ashes. However, scorch marks on a few walls betray the fact that further Mongol invasions continued to scar Kraków. Its three kilometres of fortified city walls, seven guarded gates and 46 towers act as a reminder that the city welcomes those who bring it wealth but repels those who are a threat to its prosperity. High-gabled double-storey dwellings line the market square, while more houses squeeze behind them with small yards checkerboarded in between.[6] This is the capital city of Poland, home to its newly founded university and an important member of the Hanseatic League (a powerful organisation of northern trading towns coordinated by German merchants), which brings tradespeople to its streets and ships to its river.

Construction is taking place all around. To the south, the enormous basilica of St Mary's is slowly rising, embryonic towers reaching skyward as masons compete to build higher and higher. To the north, the great Cloth Hall is nearly complete, its Italian facade and rhythmically repeating arches sheltering purveyors of eastern spices, silks, leather and salt fresh out of the nearby Wieliczka mines. A queue has formed outside a large stone building on the edge of the square. The clash of metals and busy noise of negotiation drifts out from its doors. This is the city's Great Weigh House, home to its municipal weighing scales. Here copperworkers from Spisz process their metal, exchanging ore which will go on to Flanders and out to the Black Sea.[7] Great swathes of material are also loaded onto the large scales as tradespeople wait nervously to see how much they can make from their raw produce. The tax officer stands alert, eager to take a share of the

profits and lay down the law, dictating how goods can be sold on. This weighing house is one of the biggest of its kind: the city is a melting pot of trade and influences; a place where Europe meets the Orient. Few cities could rival fourteenth-century Kraków in terms of industry, vibrancy and cosmopolitan culture.

Turning from the economic heart of the city, the powers of church and state tower over the skyline. The rocky outcrop of Wawel Hill rises over 200 metres above the Wisła, Poland's longest river. Under King Casimir III the Great (r. 1333–1370), the last ruler of the Piast dynasty, the court at Wawel was extravagantly expanded. The new Gothic cathedral was enlarged and enriched to witness the marriage of Casimir's granddaughter Elizabeth to the Holy Roman Emperor Charles IV.

Inside this freshly decorated, garishly colourful and exuberantly decorated church a pregnant woman kneels before a crucifix. Maidservants patiently look on, but she is deep in contemplation. The cross she looks up at has travelled the seas to reach Kraków. Like the woman herself, it is both part of the city and yet foreign to it. Jadwiga is still very young – just twenty-five years old – but she has already lived a full and turbulent life. It will soon draw to an untimely close, but at this moment she has achieved a great deal.[8] Through her marriage she has secured Poland's fortunes and brought Christianity to the last pagan corner of Europe. As we look over her shoulder we are peering at a particular moment – one in which a woman could be king, and in which Poland was one of the biggest players on the world stage.

Who is Jadwiga?

As Jadwiga has been declared a saint in one of Europe's most Catholic countries, it can be hard to work through the eulogising and hagiography to find the real woman. Outside of Poland her name is unfamiliar, while inside the country she is sacred property. To most Poles she is the paragon of feminine charm and beauty, a divine creature whose self-sacrifice was the ultimate act of charity

towards the people of Poland. She is depicted on cards, painted as the perfect medieval queen, celebrated in the heady tones reserved for special saints in heaven. But a true picture can only emerge if we return to historical sources, examining the real objects she held and scouring the archaeology of her capital city to set her in the streets and alongside the buildings she visited. Jadwiga needs to emerge into her own world, free from nationalist, imperialist and patriarchal agendas.

Born into the highest echelons of European society, she was the daughter of the king of Hungary and Poland, Louis the Great, and Elizabeth of Bosnia. Though members of the pan-European noble class, both her parents had direct blood ties to Poland. Louis's influential mother, also called Elizabeth, was daughter of the famous Polish king Władysław the Elbow-High. Her other grand-mother was another Polish princess, descended from the Piast dynasty which had ruled Poland for over 400 years. As was com-mon, however, the predominantly Polish Jadwiga was tied through intricate marital links to many ruling families across Europe. She was known as 'Jadwiga of Anjou' because her father was descended from the Capetian line of the French Angevins through his grand-father, Charles Martel. Jadwiga was brought up as part of this dynasty, with its ties to castles, knights, chivalry and courtly love.

In the royal collections of Wawel Cathedral lies a rare and woe-fully understudied item which once belonged to Jadwiga. Her alms purse, an intensely personal possession, reveals much about this woman, as well as the chivalric values of her time. Handbags remain private and important possessions today. Outwardly they can signal one's taste in fashion and design, while inwardly they conceal personal and precious belongings. Designed to carry coins which could be distributed to the poor, the alms purse supports the statements of medieval historians who claimed Jadwiga was invested in providing for those in need. The bag is a fragile object, made of a piece of fabric, folded and sealed with silk bands. The Inventory of Kraków Cathedral of 1563 in the Chapel of Our Lady lists a *kalietka cum reliquis* (pouch with a relic), suggesting there was once part of a saint held inside. The bodily relics are no longer

Front and back of an alms purse, fabric with silk thread, Wawel Cathedral, most likely made in France c. AD 1340.

contained, but the object itself has since assumed sacred qualities through its connection to Jadwiga. We don't even need to look within; the decoration on the outside provides insights into the issues that surrounded and preoccupied her during her lifetime.

Most probably made in France in the mid-fourteenth century, it's a stunning example of opus anglicanum, the medieval tapestry work which first originated in England. The embroiderer has included split, long, short and fishbone stitches, with gold threads throughout. The figures on the purse are dressed in contemporary fashion, the woman depicted on both sides wearing a flowing pink gown with tippet sleeves, gathered up at the front to show she is wealthy enough to afford reams of precious fabric. But it's the subject matter that speaks most clearly of Jadwiga's Angevin roots and connection to courtly love. Across both the front and back images from the tale of Tristan and Iseult are woven.[9] This romance between a Cornish knight and an Irish princess was incredibly popular from the twelfth

century onwards. Sent to retrieve Iseult as wife-to-be to King Mark of Cornwall, Tristan becomes besotted with her when they both ingest a love potion. Iseult marries Mark but continues longing for Tristan. A love triangle emerges, and the young knight and the queen repeatedly deceive Mark in their desperation to be together.[10] While no one has determined which parts of the story are depicted on Jadwiga's purse with certainty, I suggest it conveys a lesser-known scene in which Tristan plays the madman.

Only two manuscripts survive with details of this tale, one in Oxford and one in Berne, but their similarities suggest that it is an episode which was originally included in widely available versions of the romance.[11] Tristan, desperate to see Iseult, travels to England where the king and queen are holed up at Tintagel Castle. He dons a disguise and appears outside, raving and attacking bystanders to suggest he has lost his wits:

> 'Look at the madman! Grrr! Grrr!' The boys and squires began pelting him with sticks, thronging after him through the court as if mad themselves. He turned to them a number of times to see one or another attacking him . . . the king saw him right away.[12]

He's given admission to the castle and then, by playing the fool, persuades the unwitting Mark to let him entertain him. Amused by his antics, the king eventually leaves Tristan alone so he can seek out Iseult. His disguise is seemingly so convincing that he has to provide evidence that he is, in fact, her lover. Tales from their long romance are summarised and eventually, once his faithful hound has bounded up to the real Tristan, Iseult recognises him and falls into his arms.

On one side of the alms purse, a knight grapples with another character while a noblewoman looks on in shock, raising her finger to stop the fight. From above, a bearded man gazes down on the scene. Mad with love, the couple are part of a world turned upside down. The story demonstrates deception in the name of love, from which comes violence and unrest. On the other side of

the purse, two old men with beards lead the noblewoman into the wilderness, depicted by beautifully stylised trees and a variegated sloping hill. The barefooted man holding the woman's arm is most probably the hermit Ogrin, leading Iseult back to her husband once she has realised her life with Tristan, hiding in the woods, is miserable.[13] The other man holds a book, which could represent the letter that King Mark sends to Iseult via the hermit stating that he still loves his wife. This scene takes place at the end of the romance when the love potion between Tristan and Iseult has worn off. This image portrays repentance, Iseult's return to her spouse, and escape from the wilderness back to the safety of court.

The two scenes together are not just there for aesthetic effect; they would have been carefully chosen by the person who commissioned the purse. They present complex messages which were communicable to those who saw it. While modern observers must search backwards through surviving texts and fragmentary manuscripts to reach the original meaning, the medieval contemporaries who saw Jadwiga's purse would have known these stories and intuitively understood the images. Not only does this object show us a Polish ruler imbued with tales of chivalry and courtly love, but the overall message seems to focus on queenly duty. The madness and 'world-turned-upside-down' theme of the first side is a warning about the destructive nature of Tristan and Iseult's adulterous relationship. On the other side a penitent Iseult is led from the terrifying woods, back to the comfort of her husband and her rightful marriage.

It is tempting to read into these images aspects of Jadwiga's own story, since her love life was a central issue mentioned repeatedly by chroniclers at the time. She too loved and lost. She too had to embrace the role of wife to a husband who was not her first love. Her own narrative is woven into the threads of this 600-year-old purse.

Love Versus Duty

Born in Buda, Hungary, Jadwiga was sent to the court in Vienna while still a child, where she lived under the protection of Duke

Leopold III of Austria and was given the very finest education.[14] Her father Louis had negotiated the marriages of his daughters carefully, ensuring when they were still just babies that each was tied to an important European ruler. At the age of five Jadwiga celebrated her 'sponsalia de futuro' or 'provisional marriage' to Leopold's son, William.[15] He was only a few years older at the time. The two children were bound to one another in a lavish ceremony in Hainburg on 15 June 1378. It was a serious event which meant that the couple could legally consummate their marriage as soon as Jadwiga turned 12 without any need for another church ceremony. They were effectively married.

This was a boon for Austria, as Louis had made extensive preparations, treaties and settlements to ensure each of his three daughters became powerful, influential and wealthy rulers after his death. With no sons and an uncertain future, in 1374 Louis signed a treaty with the Polish nobles called the Privilege of Koszyce. The nobility was released from many of its duties, including building and repairing castles, paying tribute, tending to towns and bridges, and even providing hospitality for the king on his travels, on just one condition: that they make one of his three daughters ruler of Poland after his death. Louis's eldest, Catherine, was the first in line, but she died soon after the treaty was signed. The middle sister Mary was then named as heir to Poland, with Jadwiga set to inherit Hungary even though she was still just a child.

All Louis's best laid plans fell apart when he died in 1382. Jadwiga's mother, Elizabeth, had her eldest living daughter Mary declared 'king' of Hungary just days after her father's death. Mary, who was three years older than Jadwiga, was only twelve so her mother effectively seized power, ruling as regent.[16] However, Poland was a different matter. The Polish nobility would only recognise one of Louis's daughters as 'king' on the condition that they live in Poland and marry a man of their choosing.[17] Mary could be king if she moved to Krakow, but Elizabeth would have had to relocate there as well. The queen mother didn't want to be so far from those loyal to her in her court at Buda, so instead she formed a plan.

Louis had intended his uber-kingdom of Hungary and Poland

to remain bound together, but the nobility of each territory wanted no such thing. By seemingly honouring the promise they had made to him, the Polish elite were actually ensuring their independence. Elizabeth had already proclaimed Mary ruler of Hungary and would not relocate to Poland. To keep a tentative grasp on her motherland she sent her other daughter, Jadwiga, in Mary's place, and so the bond with Hungary began to sever.[18] The nine-year-old child who had been shunted between Hungary and Austria was now going to have to live permanently in Poland. Elizabeth delayed Jadwiga's departure, hoping to keep her daughter with her until she was a little older. But civil war and the threat of a usurper to the Polish throne forced her hand. In May 1374, aged just ten, Jadwiga said goodbye to her mother for the last time and entered a foreign land. However, she wasn't only cutting ties with her family. She was also going to lose her intended lover.

It's not surprising that the romantic life of Jadwiga has buried itself so deeply in the Polish imagination. Two of Poland's most influential nineteenth-century painters, Jan Matejko and Wojciech Gerson, both created large canvases showing the moment Jadwiga apparently took up an axe against Dymitr of Goraj, the Grand Court Marshall, in an attempt to be reunited with her lover William. The strength in Jadwiga's face, the anxiety of those around her and the hefty axe all add intensity to the scenes, which show a woman fighting for love in the face of opposition.

Even in the earliest accounts, Jadwiga's love life has all the elements of a tragic romance. As a toddler she's told she will marry William, heir to the Austrian dynasty. At five years old, she takes part in a glorious chivalric ceremony where her eight-year-old fiancé declares he will marry her in front of the most important leaders on the world stage. This was no doubt a terrifying situation for a young girl to find herself in, but the glamour, riches and ritual could not have been lost on her. The knowledge that she would eventually marry this boy dictated her early years. She lived in his court in Vienna, developing into an educated and courtly child, fluent in many languages and educated in matters of church and state.[19] She read romances, in which beautiful princesses fell in

Wojciech Gerson, *Dymitr of Goraj and Jadwiga*, oil on canvas, 1869.

love with powerful knights and pursued an idealised courtly love which morally enriched both parties. But after her father's death everything changed. She could only become King of Poland if she became a resident of Kraków and accepted her advisers' choice of husband. And they had their eyes on someone else.

Having broken ties with Hungary, their ally to the south, the Polish nobles turned their gaze eastward. Here lay the enormous kingdom of Lithuania, which stretched from the Baltic Sea towards Moscow and down to the Black Sea. Lithuania's Grand Duke Jagiełło was already making a reputation for himself as a powerful potential new ally. Creating a bond with Jagiełło would ensure peace on their northern border as well as access to the fertile lands of the kingdom of Rus.[20] He would also allow the noblemen to increase their personal wealth and would act as a deterrent to Austrian influence. But there was a problem; Jagiełło was a pagan. Lithuania was the last part of Europe yet to be Christianised. His advisers were seeking different marriages, perhaps binding the country to Eastern Orthodox Christianity through Sofia of Moscow. But the promise of marriage to a Catholic princess and all the lands she brought with her were

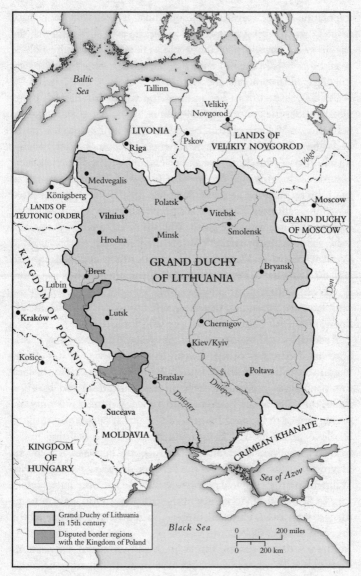

Map of Poland and Lithuania under the rule of Jadwiga and Jagiełło.

temptation enough for the ambitious duke. It would no doubt have helped that Jadwiga was described to Jagiełło as 'so beautiful that she has no equal anywhere in the world'. He agreed with the nobles, would marry Jadwiga and embrace Christianity. She, however, was still engaged to someone else.

Finally released from her mother, the young Jadwiga fell completely under the control of the Polish nobles. Yet she was of course betrothed to William of Austria, and he in turn still wanted to marry her. The canonical account of Jadwiga's life comes from Poland's 'first historian', the chronicler and priest Jan Długosz.[21] In the twelve volumes of his *Annals of the Famous Kingdom of Poland* completed in 1480, he set in stone an account of her life that has been repeated down the centuries.[22] He relates a particular event which would sit comfortably in a romance novel. William raced to Kraków to claim Jadwiga's hand in marriage.[23] While the lords were embarrassed at William's arrival and feared it would impact their negotiations with Jagiełło, Długosz writes that, 'none of the gentlemen had the courage to object to Queen Jadwiga's will'. He continues to empathise with Jadwiga, explaining that she wanted to marry 'one she already knew' rather than 'the unknown, never-seen barbarian'.

According to Długosz, it was the responsibility of the Castle Steward, Dobiesław of Kurozwęki, to keep Jadwiga in her chamber and away from William. But knowing her lover was in the city, the young girl reportedly took an axe and attempted to chop down the gates of the castle in order to reach him. It was only the persuasion of the knight Dymitr of Goraj that apparently stopped her love-driven frenzy. Długosz includes other tantalising information, however, describing a last meeting between the lovers. Having escaped her watch, the teenage Jadwiga reunited with William and the couple danced together one last time in the refectory of St Francis's Monastery in the city.[24] But ultimately Jadwiga turned him away, choosing instead to follow the advice of the decision-makers of Poland.

There is the suggestion that Jadwiga consummated her relationship with William, which would have made their earlier betrothal binding: 'Many people knew that . . . she had for a fortnight shared

her bed with Duke William and that there had been physical con-summation.'[25] Certainly, there were severe consequences, even once William had left Kraków and she had agreed to marry Jagiełło. Długosz is critical of her advisers, stating their decision to choose a 'stranger' and a 'foreign king' rather than 'their own princes', was driven by their greed.[26] Even when the wedding finally took place in January 1386, the early part of their marriage was marred by con-troversy and claims of illicit meetings between Jadwiga and William, until a culprit for the rumours was arrested, tried and given the most severe punishment of having to 'go about like a dog'.[27] The marriage between Jadwiga and Jagiełło would take some time to emerge from the shadow of her broken engagement.

Courtly Love

Jadwiga's romance would have appealed to the medieval imagin-ation and passion for courtly love literature. An ivory casket, made in Paris but held by the cathedral in Wawel, has long been con-nected to Jadwiga and her court. It was found nestled inside a larger reliquary in 1881 and became one of the first objects exhib-ited to the public, with nineteenth-century visitors lining up to view it in the cathedral's treasury on Monday, Wednesday and Friday mornings. But it has been misinterpreted and misunder-stood over the last century and a half. During the Partitions of Poland precious objects in museums and collections were tenu-ously linked to great monarchs of the past, feeding the ever-growing desire for independence and a return to a sovereign Polish state. So Jadwiga's name was mistakenly attached to all manner of medieval objects. This casket, however, does seem to have belonged to her court, and this piece's importance as a product of fourteenth-century France has put it on the world stage as one of the finest examples of medieval chivalric art.

The ivory is deeply carved, with scenes from 'chansons de geste' ('songs of heroic deeds') and Arthurian legend engraved across the front, back, sides and lid. Most surprisingly of all, the original lock

Lock showing the Tower of Love, enamel and silver, from an ivory casket
connected to Jadwiga's court, Wawel Royal Cathedral, probably made in
Paris, second quarter of the fourteenth century.

and metal bindings survive. The keyhole is surrounded by a rare,
illustrated enamel panel, whose imagery pulls together the themes
across the casket – a tower of love guarded by a noblewoman hold-
ing a key, with a knight bowing down before it. This is a celebration
of 'the game of love'; the chivalric knight elevated through his
adoration of a woman. On the casket itself, alongside depictions
of 'Lancelot Crossing the Bridge of Swords' and 'Gawain on the
Dangerous Bed', there are some particularly poignant scenes that
parallel Jadwiga's life. As well as Tristan and Iseult appearing again,
the tragic story of Pyramus and Thisbe is detailed. The tale was
originally featured in Ovid's *Metamorphoses*, but through the thir-
teenth and fourteenth centuries it was retold by troubadours – the
medieval equivalent of touring rock stars, performing shows across
different courts for the entertainment of the nobility.

The inspiration for the story of Romeo and Juliet, 'Pyramus and
Thisbe' recounts the tale of forbidden lovers kept apart by their par-
ents' rivalry. Whispering their love for one another through a crack
in the wall between their adjoining houses, the couple eventually
agree to meet at a grove in secret. Thisbe arrives first and waits

under a mulberry tree. However, a lioness, covered with blood from a recent kill, appears. Scared, Thisbe runs away, leaving her cloak behind. When Pyramus arrives he finds the cloak torn and covered in blood, with lion prints leading away from it. Believing his lover to have been devoured by a wild beast he decides he can't live without her and falls on his sword. Thisbe returns to find him dead and in turn chooses to die, throwing herself on the same blade. The casket shows both the lion with the cloak and the couple's dramatic death, both impaled on a huge sword and Thisbe actively pushing it through her chest. This is an image of the ultimate sacrifice made in the name of love and, alongside the other stories, it reinforces the casket's message that passion must be contained within the framework of moral behaviour and chivalric duty.

Visual representations of what it means to be a good ruler are repeated across the sides and lid of the casket. On the front, Alexander the Great receives wise counsel from Aristotle, reminding the viewer that a good king is an educated one. A scene from the

Ivory carvings from the front of the casket showing episodes from the story of Pyramus and Thisbe.

Hunt of the Unicorn on the left-hand side brings to mind the rule of a female king, as it is only at the lap of a virgin that the magical creature can be subdued. The idea conveyed by this imagery, of Jadwiga as wise and gentle while subduing powerful threats, would not have been lost in a court ruled by a young woman. Whether Jadwiga herself or one of the ladies at her court kept their possessions in this box, they would have understood the symbolism of its images. But it's the complex scene on the lid that speaks most clearly of her connection to the chivalric courtly tradition and the Angevines. Here, two knights lock together at the joust, vying for the favour of the noblewomen looking on.

This is the essence of Western medieval feudal culture: a knightly class supporting the nobility, representing the ruler both in battle and during the displays of prowess on the tilt yard. While fantastical and idealistic, it was a fashionable concept that sought to elevate individuals above the cut and grind of politics, the death and grit of the battlefield, and the machinations of the power hungry to something otherworldly – an ideology based on myth and legend where good conquers evil. Gazing on an object like this would be like losing yourself in a fantasy film today. Jadwiga and her court could imagine themselves morally, intellectually and culturally elevated through such an object. While not necessarily a true reflection of her environment, it allows us to get closer to that with which she filled her imagination.

When Jadwiga's grave was opened in 1949, beautiful damask fabrics were found wrapped around her skeleton. The fourteenth-century clothes she was buried in were woven from silk with decorative patterns that suggest they were made in either Egypt or Spain. Two letters from the pope were also placed inside her coffin, as well as gilded replicas of her orb and sceptre. Those responsible for laying the ruler in ceremony selected objects and clothes that testified not only to Jadwiga's wealth and Kraków's international connections, but also to her status as a lady of high fashion. She was placed in the grave wearing the finest, most luxurious fabrics as a sign of Poland's position on the world stage. But alongside the ivory casket and embroidered alms bag, these fragments of clothing

Carved lid of the casket, with soldiers assaulting the Tower of Love,
scenes from romances, and jousting at the tiltyard.

help create a picture of Jadwiga as the paragon of medieval chivalric
femininity. There was one major difference, however; Jadwiga was
not a queen, like Guinevere or Iseult. She was a king.

King, Not Queen

Jadwiga's coronation took place on 16 October 1384 in Wawel
Cathedral: 'Hedvigis coronatur, in regem Poloniae' – 'Hedwig is
crowned, king of Poland'.[28] Polish law did not recognise succes-
sion in the female line, but Louis's treaty ensured his daughter
would be declared king.[29] The civic unrest that raged in the tur-
bulent years between his death and Jadwiga's ascension to the
throne, during which various people laid claim to the crown of
Poland, meant that drastic action needed to be taken. By naming
her 'king' the nobility were tying her heritage back beyond her
Capetian father, to the earlier Piast rulers.[30] She was not a queen
in deference to anyone; she was sole legitimate ruler. Her seal,
which survives on documents, shows her flanked by angels

enthroned in glory beneath a Gothic canopy, with her coats of arms of Poland and Anjou either side: an undisputed ruler.

This decision to crown her king lay in the hands of the Polish nobility. By the late fourteenth century the concept of the 'corona regni Poloniae' ('the crown of the Polish kingdom') meant that the country was not determined simply as territory ruled by a particular individual. Instead it was a people – with traditions, cultures, language and laws that bound those people together.[31] While the country was ruled by officials, it was the king's duty to preserve the borders of Polish territories and support its people. Louis made this promise at his coronation and reinforced it in the Privilege of Koszyce. He had bound his young daughter to the controlling nobles circling around her in Kraków. She could be king, but she would be under their direct influence.

This is not to say that Jadwiga didn't receive good guidance. She was surrounded by intelligent counsellors who made collective decisions intended to benefit the community of the realm. As a minor, she needed to gradually develop her knowledge of how best to rule and she did this with the support of certain advisers. The major turning point in her reign came just one year after her coronation in 1384, when Jagiełło signed the 'Union of Krevo'. The unassuming little document was only discovered just over a century ago, tucked away from other state records in Kraków Cathedral's archives. This has led to speculation that it is a forgery,[32] but now the rare piece has been accepted as authentic by scholars, and its survival shines a light on the tense arrangements surrounding Jadwiga's marriage.

Jagiełło addresses the document to Jadwiga's mother, Elizabeth, and the Polish delegation. He agrees that, in return for marrying the underage Jadwiga and receiving the title King of Poland 'jure uxoris' (i.e., by right of his wife who already owns the title), he will convert all the pagans of Lithuania to Roman Catholicism and return land gained through war with Poland, along with 45,000 war prisoners. He also offers to pay 200,000 florins to William of Austria for breaking off his engagement with Jadwiga. This was an astonishing amount, as a single florin is equivalent to about 1,000

US dollars today.[33] It suggests that Jagiełło knew Jadwiga was legally bound to William. The controversy surrounding his 'wife grab' was so far-reaching that the pope at first refused to recognise the marriage, concerned that Jadwiga was a bigamist. This document shows how a twelve-year-old girl was essentially purchased by a 35-year-old man for political purposes. But there was still a way for Jadwiga to wield her influence, and leave a lasting legacy. Ultimately it led to Jagiełło's baptism and their marriage in 1386, when he renamed himself Władysław Jagiełło, taking Jadwiga's great-grandfather's name as a sign of his conversion to Christianity.

When Jadwiga married Jagiełło he could not call himself 'king'. Instead, he signed his first charter *dominus et tutor regni Poloniae* ('lord and guardian of the Kingdom of Poland').[34] But by March 1386 Jagiełło was also crowned as king, putting Poland in the rare situation of being a diarchy, ruled by two sovereigns. It is Jagiełło who went on to become an uber-ruler of the enormous joint kingdoms of Poland and Lithuania. It's his name and his victories that epitomise fourteenth-century rule in this part of the world. But until her death, it was Jadwiga's influence that shaped the nation's fortunes. After a difficult start to their marriage, the two kings ruled together, working as a powerful, mutually supportive couple.

She was a feared and respected leader who repeatedly dealt with international conflict and led her army herself. It was the fate of her sister Mary and her mother Elizabeth which forced her to take military action. Events in Hungary were complex as Mary had also been given the title of 'king', but for the Hungarian nobility it sat uncomfortably that 'she' was not a 'he'. They were keen for Mary to rule alongside her betrothed partner Sigismund of Luxembourg, but her ever-meddling mother confused the situation by courting other prospective husbands, including Louis, brother of the king of France. Eventually the situation was resolved through aggression, with Sigismund marching to Buda and demanding his marriage to Mary just months after she'd been promised to Louis. Even still, Mary's crown sat uneasily. In 1385

her throne was captured by Charles III of Naples, who arrived at the Hungarian court with an army.

Charles spared Mary's life, but when his entourage disbanded two months after his coronation, Elizabeth invited the freshly minted King of Hungary to her chambers, where she instructed her 'master of the cupbearers' to stab him. Charles died, leading to Elizabeth's imprisonment in Novigrad Castle, Croatia, along with Mary. She was tried for Charles's murder and found guilty. Sigismund rode to the castle to save his wife and mother-in-law, but when news of his arrival reached Elizabeth's jailers they took matters into their own hands.[35] They strangled her in front of Mary. Jadwiga's sister would never again wield power in Hungary, having ceded all authority to her husband when he regained control of the kingdom. At the age of 24 she fell from her horse, went into premature labour and passed away next to her stillborn son. King in name but little else, Mary was manipulated by those around her and could never rule the way her sister did in Poland.

When news of her mother's murder reached Jadwiga, she marched at the head of her troops to demand the submission of the rebels that had supported Charles. All but one governor accepted her without opposition. She dealt kindly with the people she had subdued, promising that their kingdom – Ruthenia – on the southern Polish border, would never again be separated from the Polish crown. She also made the inhabitants swear to support her husband as well as her, writing to the nobles of Kraków that Jagiełło too was to be recognised as 'their natural lord'.[36] Her diplomacy and negotiation skills were consistently praised by chroniclers. In all her international dealings she was renowned for displaying integrity, a desire to avoid conflict or bloodshed, and a unique ability to win over hostile parties. Travelling across vast areas to meet rulers and reach agreements, she was energetic and bold in her political engagements.

The most threatening presence throughout her reign were the Teutonic Knights. Founded as a military order at the end of the twelfth century, what originally began as an army designed to protect pilgrims, resulted in a powerful state with its borders abutting

Poland. One of their main objectives was the enforced Christian-isation of Lithuania, and many bloody battles were fought across the Polish territories. Finally, through her marriage to Jagiełło, Jadwiga had ensured that Christianity would roll out across the last pagan corner of Europe. But rather than placating them, this frus-trated the Teutonic Knights and they continued their aggression against Jagiełło, whom they considered a heretic. Jadwiga arranged for the Grand Master of the Order to visit her in 1396. After ongoing hostilities regarding claims to land along Poland's north-ern borders, she managed to control the threat of the Teutonic Knights.

While relations remained tense, her mediation skills meant that during her lifetime all-out war was avoided. Just two years after Jadwiga's death, Jagiełło resumed his battles with the Order. This culminated in the famous Battle of Grunwald in 1410; one of the largest and bloodiest battles of the medieval period. The Polish-Lithuanian troops secured victory, leaving the Teutonic Knights virtually annihilated. Jadwiga's diplomacy bought Jagiełło time. Had they engaged in war earlier they would almost certainly have been defeated, but in the intervening years Jagiełło prepared, trained and increased his troops. Without Jadwiga the tables could have been turned and the history of Europe rewritten.

Pious Princess; Clever King

Jadwiga is remembered for her cultured court and her political nous, but of equal – if not greater – significance was her devotion to the Catholic Church. It was a condition of her marriage that Jagiełło accept her faith and then rapidly introduce it throughout his kingdom of Lithuania. He was not always successful in the early years of his campaign, but by the time of his death Catholi-cism was firmly embedded across his kingdom. In Poland Jadwiga took her commitment to church matters seriously.[37] She person-ally funded the repair of older churches, the building of new ones and the establishment of monastic orders throughout the country.

She brought the Slavic Benedictines from Prague to Kraków, founding the Holy Cross Church for them, and also created huge churches for the Carmelites. The church in Poznań still preserves her Anjou coat of arms in its stonework. And in Wawel an object remains that tethers us to Jadwiga and her adopted home city of Kraków: a large wooden crucifix that still hangs in the cathedral.

The scale of this piece is huge – 13 feet high – and it is a remarkable example of Italian Gothic sculpture. Christ's suffering is suggested by the tilt of his head, the bend of his knees as one foot is pinned painfully on top of the other, and even by the veins which protrude from his arms and legs. Christ is emaciated, with finely carved ribs elongating his torso. The contrast of the blackened wood against silver panels incised with floral motifs creates a dramatic effect. The use of red paint to show a stream of blood running down the figure and onto the skull at the base of the cross (symbolising Adam's bones on the mound at Golgotha) enhances

Wooden crucifix, most likely made in Italy in the thirteenth century, Wawel Cathedral.

the visceral nature of this crucifixion. Jesus's actual death on the cross would have been a largely bloodless event since he most likely died from exhaustion and suffocation from the weight of his hanging body. But as theologians in the thirteenth and fourteenth centuries increasingly called on the faithful to suffer like Christ and empathise with his physical pain, ever more contorted and bloody crucifixions emerged. The lines on Jesus's face suggest he is in agony and the overall effect of a very realistic Christ figure would have been enhanced by a wig of human hair placed on the wooden scalp. Standing in front of it, as Jadwiga did regularly, there's an uneasy sense that you are watching a real man at the moment of his death.

Early accounts state that Jadwiga personally ordered this crucifix to be placed in the church, and that she prayed in front of it daily. A proponent of 'Devotio Moderna', she would have meditated on the image of Christ's suffering and projected herself into the moment of his passion as a means of enhancing her piety.[38] The crucifix's significance was not lost on Pope John Paul II either, and in his beatification speech he connects it directly to Jadwiga:

> It is from him, the Christ of Wawel, the black Crucifix to which the people of Krakow come every year on pilgrimage on Good Friday, that you learned, Queen Hedwig, to give your life for the brethren. Your deep wisdom and your intense activity flowed from contemplation, from your personal bond with the Crucified One.

A legend has grown up around the figure, fuelled by early attempts to have Jadwiga declared a saint. The sculpture of Christ was said to talk to 'd'Anjou', telling her to 'do what you see', and sending her visions. This intimate connection between object and owner provides a rare glimpse into the interior life of a medieval ruler.

She showed her support for the church through the donation of other artworks. A stunning little rock crystal cup survives in Dresden Museum, with her coat of arms emblazoned on the base. Dedicated to St Wenceslas, Jadwiga's name runs around the cup's

handle, making it clear to all who saw it that this liturgical item was her donation to the church. The rationale still worn by the bishops of Kraków today was also a gift, commissioned by Jadwiga for her friend and counsellor Jan Radlica. She most probably had it made for her coronation. Covered in pearls, with her arms of Poland and Anjou-Hungary embroidered front and back, an inscription positions her name and that of her father Louis directly over the chest of the bishop.

Early documents state that the Bishop of Poland was given permission to wear the rationale by the pope, so it was not simply an expression of Jadwiga's influence, but also of the papal support for the city of Kraków. It remains a powerful object today, seen as evidence that Kraków once held the prominent position of archbishopric and was home to the pallium. By commissioning this stunning golden pearl-encrusted embroidery, Jadwiga was personally declaring the importance of her city and bolstering its reputation as a hub of Catholicism.

While the rationale remains a potent artefact, Jadwiga's dedication to the city expressed itself most visibly and perhaps most lastingly in a different contribution altogether: the first university in Poland.

Education, Education, Education

Jadwiga was a uniquely educated medieval monarch. Chroniclers documented that she could speak up to seven languages, could certainly read, and most probably could write too. This was by no means a given for medieval rulers, and her husband Jagiełło reportedly could neither read nor write. Her refined education in the Austrian court, and her continued growth under the guidance of Kraków's most learned individuals, are all recorded. Not content to simply be wise herself, Jadwiga determined to secure the intellectual foundations of her country by establishing a university.

Kraków was already a cultured place when Jadwiga moved there in 1384, and her grandfather, Casimir, had gained papal support for founding a university 20 years earlier. But the embryonic

establishment had withered and died. Jadwiga was determined to resuscitate it.[39] She purchased a grand property in the Jewish quarter, called the 'Domus Maius' or 'Great House' due to its size. This imposing fourteenth-century building established a permanent presence within the city and still forms the heart of the university today. As well as securing a central location and bequeathing her personal possessions to the university after her death, Jadwiga also drew together the greatest minds from across the country. Her intention was to develop a system of education which would produce learned clerics who could lead the church in Poland and influence the conversion of her husband's people in Lithuania. It is one of the oldest universities in the world and has produced scholars like Copernicus and Pope John Paul II. However, the university was not named after Jadwiga. Jagiełło oversaw the official opening of the Jagiellonian University just months after her death in 1399. His involvement in its creation was minimal. She dedicated her worldly possessions and energy to it. History has written her name out of her greatest legacy.

Yet a fascinating object survives that indicates quite how intellectually curious and passionate about learning Jadwiga was. The St Florian Psalter, a manuscript measuring roughly 35 centimetres by 25 centimetres and weighing four kilograms, could have been used for personal prayer, but may also have formed the basis for collective worship at court.[40] It is highly likely this book belonged to Jadwiga and was commissioned by the bishop of Kraków, Piotr Wysz Radoliński.[41] The pair had a particularly close relationship, with the bishop acting as her chancellor when she set up court, and later helping her establish the theology department at the university. Trained in law and educated in Prague and Padua, Piotr was her right-hand man.[42] It's highly plausible that he would commission a Polish, Latin and German translation of the psalms for the pleasure of his monarch.

Women feature heavily in the illuminations. In initials throughout the psalter, miniature depictions of women pray or look towards the text. The Angevin coat of arms appears frequently, while on one page an angel carries a pair of enmeshed 'M's.[43] This symbol

Illuminations from the St Florian Psalter showing the monogram associated
with Jadwiga held by angels, folio 53v, most likely made in Krakow,
late-fourteenth century, National Library of Poland, Warszawa.

was also found painted on the walls in the chamber used by Jadwiga at Wawel Castle and seems to have been a shorthand reference to her name, perhaps used in secret communications with the pope. The enigmatic and exuberant images that pepper the first half make this a unique psalter. Supernatural creatures peer out from initials, with some scholars having seen medieval lookalikes of the characters of Yoda and Gandalf in the margins. But alongside curious and, at times, frivolous figures, images related to astrology and science are also woven among the words. Symbols connected to the signs of the zodiac suggest that coded meanings were included to stimulate Jadwiga's intellectual curiosity. That Jadwiga may have held this book, poured over its imagery and attempted to unpick its hidden codes creates the most potent link with her. We can look over her shoulder at the book she once read.

The purse, casket, cross and manuscript are our closest links to the real Jadwiga. They show her love of romance, piety and education, and also that she had a curious and frivolous side. While she has been perceived as a tool or a pawn, manipulated first by the nobles of Kraków and then by her much older husband, the Jadwiga that emerges from examining the items she commissioned and owned reveals a woman forced to grow up very young, and able to achieve cultural, religious and political change while still a teenager.

Enigmatic figures from the St Florian Psalter, folio 18v and folio 37v.

Like her sister before her, Jadwiga's death was connected to childbirth. Childless for over a decade after her marriage to Jagiełło, she finally gave birth to a much-awaited child on 22 June 1399. She was called Elżbieta Bonifacja, honouring an arrangement Jadwiga had made with Pope Boniface. He agreed to be the child's god-father on the condition that Jadwiga named her after him. But mother and daughter only managed three weeks together. First Elżbieta died, followed four days later by her mother, who was just 26 years old. The two were buried together in Wawel Cathedral.

Bones and Treasures

Jadwiga has not slept entirely peacefully inside her tomb in Wawel Cathedral. Her bones were moved from their original burial spot,

and she was exhumed in 1886 and again in 1949. Originally she was placed in the most prominent position within Wawel Cathedral, right next to the main altar.[44] An epithet plaque was raised above the tomb which read *Sidus Polonorum iacet hic, Hedvigis* ('Here lies the star of the Poles, Hedvig'). The plaque also showed Jadwiga and Jagiełło performing their most significant acts: the Christianisation of Lithuania, the foundation of Jagiellonian University and the suppression of the Teutonic Knights.[45] The prominent placing of her burial, on the northern dais of the altar, suggests that even at the time of her death, attempts were being made to establish her as a saint and encourage pilgrims to Kraków to visit her shrine. Her tomb adjoined smaller altars she had set up herself, one of which was dedicated to that most mystical and fashionable of fourteenth-century saints: Bridget of Sweden.[46]

The first exhumation of Jadwiga's bones took place on the 500-year anniversary of the Union of Krevo – the document in which Jagiełło negotiated the terms of their marriage. As the Polish people struggled to find a national identity under the partitions of the eighteenth century, Jadwiga's cult grew, fuelled by artists creating narratives of Poland's historic greatness to stoke a renewed sense of pride. Jan Matejko, as Head of the Academy of Arts, was invited to examine Jadwiga's bones and paint a reconstruction of her. We should see this exhumation as the product of a nationalist agenda, with Jadwiga presented as the personification of Christian ideals and representative of Poland's glorious past.

When her skeleton was measured, it was determined that at 180 centimetres she had been unusually tall for a medieval woman. Despite the height, studies on individual bones, including the collar bone and sternum, concluded that the skeleton was definitely female. Reddish tufts of hair were found on the back of her skull and temples, and analysis of the teeth gave the age at death of around 28, which was not far off from official records. Popular historical accounts probably influenced the analysis, but in the absence of any other cause of death it was noted that the pelvis was high and narrow, which could have led to complications in child-

birth. Matejko created a portrait based on examining Jadwiga's bones himself. His painting looks more like a nineteenth-century queen, rather than fourteenth-century ruler, but the image would become a powerful one.

A tomb monument inside Wawel Cathedral was made to show Jadwiga as the perfect medieval queen, but it remained empty for nearly five decades. In 1949, however, the outspoken and controversial archbishop of Kraków Cardinal Adam Stefan Sapieha began proceedings for Jadwiga's canonisation. This meant she had to be exhumed once again in order to be reburied in her new sarcophagus. During his lifetime Sapieha had seen Poland first gain independence, then occupied and destroyed under the Nazis, and finally absorbed into Soviet Russia. An anti-Semite who was widely condemned for doing nothing to support the Jews during the Holocaust, he trained the future Pope John Paul II. His attempts to elevate Jadwiga from ruler to saint were a nationalist act. But the political landscape changed considerably. That his successor, a young Catholic from war-torn Poland, would achieve this goal some 50 years later testifies to Poland's turbulent history.

Portrait of Jadwiga by Jan Matejko, made after his examination of her skull during her exhumation in 1887.

It also goes some way to explaining why Jadwiga's life has been so actively manipulated and micromanaged by nineteenth- and twentieth-century historians.

Legacy

As much a product of nineteenth and twentieth-century hagiography as a real historical figure of the fourteenth, it is hard to disentangle Jadwiga from legend. When historical individuals are hijacked by later generations for nationalist purposes it can be difficult to reconstruct the world they inhabited. For Jadwiga, it is the material objects she left behind that present the clearest window onto her world. Manipulated from birth, as so many noblewomen were, she emerged into her reign with distinctive qualities and concerns: as an Angevine princess she remained bound to the codes of chivalry, and brought French artworks and romance to her court in Kraków. As a Catholic she emphasised her piety both through personal acts of prayer and through her patronage of church communities. As a ruler forced to assume power at a young age, she managed to command armies, subdue enemies and forge lasting political alliances. As a woman she was well educated and the bequest in her will to Kraków's university indicates that she prized wisdom, learning and knowledge.

In the span of her short life she achieved a great deal. Had she lived longer she may have contributed even more and secured a greater reputation. If she had not needed to secure an heir to the throne, she might not have risked the difficult and dangerous act of childbirth, and perhaps lived longer. But the fact she died due to the pressures felt by many medieval noblewomen should not negate her many achievements. She ruled as a king while still just a girl, and her life changed the course of history.[47] By marrying Jagiełło and working alongside him as joint ruler, she ensured a dynastic relationship between Poland and Lithuania that would last four centuries. She also ensured the conversion of the last pagan country in Europe, and many Lithuanians still hold to that

faith today; it is the country with the highest density of Catholics in all the Baltic states.[48]

It is hard to uncover the real Jadwiga when even during her life she was held to unrealistic standards. As ruler of Poland, she had to be all things to all people. She needed to fit the cast of an ideal medieval princess, paragon of virtue, devoted to Christ. She had to be strong, yet feminine. Educated, but not too clever. Powerful, but not intimidating. It's little surprise that her romance with William is one of the best-known aspects of her life, since it suits modern sensibilities to connect with her heartache and overriding sense of feminine duty. But when we look at the real world around her, and the objects she held dear, a different Jadwiga emerges. The St Florian Psalter, with its enigmatic and whimsical decorations, the purse with its images of romance, and the crucifix she knelt in front of all tell us so much. She was a woman defined by those around her, yet strong enough to emerge as a cultured, educated and insightful individual.

The greatest praise came from those who knew her. Her friend the Bishop Piotr Wysz Radoliński gave a heart-wrenching sermon after her death. Already eulogising the woman as a saint, he described her as:

> a gem of the Kingdom of Poland, an anchor of state's order, an extraordinary jewel, comfort of widows, solace of paupers, help to the oppressed, respect for church officials, escape of priests, strength of peace, and anchor to Lord's laws.

Revealing this 'extraordinary jewel' of a woman through the treasures she left behind seems a fitting way of uncovering the real Jadwiga; a woman who changed the course of history. While her legacy had been written out of the university she founded and the victories that cemented Poland's prominence in fourteenth century Europe, it survives in the artworks she commissioned – a trail of breadcrumbs leading back through time.

8

Entrepreneurs and Influencers

Discovery!

Early 1930s – Southgate House, Chesterfield, England

Colonel William Erdeswick Ignatius Butler-Bowdon wants to play ping-pong in his country mansion.[1] Rummaging for a set of balls in a stuffed cupboard, he finds his progress impeded by dozens of dusty old books. 'I'm going to put the whole bloody lot on the bonfire tomorrow and then we may be able to find ping-pong balls and bats when we want them,'[2] he shouts to his guest. The latter, a curator at the Victoria and Albert Museum, cautions him not to, adding that, 'There may be something of real interest there which you may not at the moment realise.'[3] There most certainly was.

In among the dirt and clutter was a little book, its covers measuring just 21 centimetres by 14 centimetres. The outer binding was clearly medieval – dark parchment pulled tight over wooden boards – and had been nibbled by generations of hungry mice. Inside the cover the crest of Henry Bowdon, resplendent with heron's head and eagle, shows the book had belonged to the family since at least the 1750s. Then another clue on the next page: an inscription reading, 'This Book is of Mountgrace'. Mount Grace Priory in Yorkshire had been home to medieval mystics but was destroyed in the Reformation. The scribe signs his name as Salthouse. It seems whatever was inside the manuscript appealed to Carthusian monks in the north of England in the fifteenth

Eighteenth-century crest of Henry Bowden, inside the cover of *The Book of Margery Kempe*, British Library Add MS 61823, fourteenth century.

century. The monks' handwriting peppers the text: they didn't just read this book; they pored over the words and made notes in the margins for other avid readers.

The book itself is firmly East Anglian. Among the scraps of vellum used to build up the manuscript cover is a letter by one Peter de Monte. He writes to William Bogy of Soham in Cambridgeshire and dates his correspondence 1440. From there it went north to Mountgrace, before heading south again where it's noted in the sixteenth-century records of the London Charterhouse. Here the book was protected by the Catholic Digby family – ancestors of the Butler-Bowdons – before it travelled north one final time to end up in this cupboard in Derbyshire. This family had provided a safe haven for many medieval works of art and literature, including the famous Butler-Bowdon Cope now displayed in the V & A; one of the most outstanding surviving examples of *opus anglicanum*.[4] From this treasure trove of a stately home, another remarkable medieval object was about to emerge.

Freed from its cupboard, the book began a new journey. Under

the care of the V & A scholar who had saved it from the bonfire, the manuscript winged its way to the heart of London. Here an independent female scholar called Hope Emily Allen cast her eyes over it and her breath caught in her throat. This was something truly special. The book centred on the life of a medieval woman who had lived through the turbulent late fourteenth and early fifteenth centuries in East Anglia. Hope Emily Allen, herself a fascinating, intelligent and trailblazing twentieth-century woman, had rediscovered her. The newspapers seized on the story of the unearthed treasure. In 1934, among news of Nazi restrictions and Canadian fires, the manuscript caught the public imagination. The *Evening Standard* described its contents as 'certainly queer, even for a queer age'.[5] But what was this book and who is the queer woman at the heart of it?[6]

Now known as *The Book of Margery Kempe*, since its discovery in the 1930s the text has become something of a superstar in the world of medieval studies; there's even a branch of scholarship known as 'Kempe Studies'. And yet the woman at the heart of this book – Margery – remains relatively unfamiliar to the general public. But this little manuscript provides a window onto one particular corner of the medieval world – the town of King's Lynn in East Anglia, England, during the late-fourteenth and early fifteenth centuries. Margery will be our guide to her hometown and through her we will unpack what life was like for a merchant, mystic and self-professed 'mad' medieval woman. By understanding this extraordinary self-determined, entrepreneurial, outspoken woman from six centuries ago we will see that our modern notions of female agency have far older roots than we might imagine.

Welcome to Medieval King's Lynn

Known as Bishop's Lynn in the early fifteenth century, the town was under the direct command of the Bishop of Norwich. The word 'lynn' possibly refers to the salting pools, whose distinctive smells are the first thing to hit a visitor's senses. At the busy crossroads on the main road into the town, the Romanesque towers of

St Margaret's church loom over the skyline. By the church is the Saturday Market Square, bustling with noise. On either side of the streets winding away from the church, houses with over-hanging gables lean towards each other while shops and inns jostle for space along the cramped road fronts. Horses laden with goods and carts wheel over the cobbles, swerving to avoid the slop and mess thrown from upper windows into the street.

The square is a jumble of people from all classes, with beggars, thieves, sailors and salespeople pressed up against rich merchants and members of the town's various religious communities. Different accents and voices blend as Londoners chat with Dutch traders, and men and women dressed in their weekend best weave between children playing, dogs pissing and vendors shouting.[7] The stalls sell shellfish alongside fine fabrics, butchers quarter meat, while traders flog their latest imported trinkets. The general privy in the corner of the square brings another pungent smell to the air, and the distant clang and crash of ships loading and unloading provides the background noise to the busy scene.

By the front of the minster is the recently completed Trinity Guild Hall; the symbolic centre of Lynn's merchant community. Close to the banks of the River Ouse on which the town has built its wealth, its impressive checkerboard front shines in the sun. Gone

The front of Trinity Guild Hall, King's Lynn, which is much the same as it was when completed in 1428.

are the charred remains of the earlier building, destroyed by fire in 1421, and this new hall is a fabulously rich addition to the town of around 6,000 people.[8] Merchants dressed in the brightest colours and the finest fabrics move through the hall's large oak doors. And beneath its steep arched roof is where we find Margery Kempe.

Born in 1373, she married John Kempe in 1393 and tried her hand at various business ventures through her twenties and thirties. At the age of forty she began the first of many pilgrimages and grew her reputation as a mystic. Her later life was plagued with accusations of heresy and she was even imprisoned, but managed to clear her name. In 1433 she suffered the double loss of her son and father, and around this time started to narrate her *Book*. When we encounter her in 1437, she is registered as a member of the guild, aged 64. She is in her later years, and is wealthy and comfortable. Let's listen to her speak. Her *Book* tells her life as she narrated it, first to her son and then to two other scribes. Although not written down in her own hand, this is the closest we can get to hearing a medieval woman's voice from six centuries ago.

A Real Gateway

Throughout Margery's life, Bishop's Lynn was transforming. The town had exploded from its humble roots in the twelfth century, with ideas and influences pouring into its streets via the wash of the river. By the fifteenth century, wealth among the merchant class increased rapidly as contacts with the Hanseatic League brought more trade to the town. The biggest indicator of the merchants' aspiring pride still standing today is the South Gate.[9] This huge turreted gatehouse went up in 1437, the year Margery was listed as a member of the Trinity Guild.

The mayor and merchants of King's Lynn wanted to impress visitors to the town, as well as provide defences and a convenient way to tax produce coming in and out. They commissioned Robert Hertanger of London to use 200,000 bricks to create a unique structure that would provide a suitably elaborate entrance on the

Photograph from the South Gate, King's Lynn, showing how
the original spring vaulting which began in 1437 was then
completed with a simple barrel vault some 80 years later.

main road into town. It was to have a 20-feet-high arch with a
fan-vaulted ceiling and a grand room above where the mayor
could welcome important guests. There would be extra chambers
for staff and even an indoor toilet.

Unfortunately, Robert was a notorious drunk and he ran out of
money before the building was completed. The South Gate was
topped off with a temporary roof, left unfinished and was nowhere
near as magnificent as the merchants had hoped. They simply put
up with it, decorating the room above and living with the botched
job. A swift fix was ordered by Cardinal Wolsey some 80 years
later, after he'd visited King's Lynn and seen the shabby roof. He
asked local builders to complete it 'as cheaply as possible'. You can
still see where the sophisticated fan vaulting originally meant to
adorn the ceiling has been abandoned and worked over by the
sixteenth-century builders with a simple barrel vault. The South
Gate is a good reminder of how we view the past. We might have
a version that is intended to look complete and authoritative. But
closer inspection reveals imperfections and curiosities that make it all
the more intriguing. The unfinished gatehouse is the warts-and-all
version of the medieval world. And when we look at it from a dif-
ferent angle it presents us with new insights into the past.

Who is Margery Kempe?

The Book of Margery Kempe is a miraculous survivor. Known as 'the first autobiography written in English', there were countless times it could have been lost or destroyed. During Margery's life she was accused of and arrested on charges of heresy, so her mystical and at times bizarre book would have been high on Reformers' 'burn' lists. The book is not a hagiography of a revered saint, but an anomaly; a record of the life of an ordinary married woman, mother to fourteen children. Written in simple and rather crude Middle English, it would not have been preserved for its literary quality. Yet the very simplicity of the writing style is what makes it so interesting. It has not been overworked by scribes fluent in rhetorical and literary devices; it retains a direct quality that speaks to us across time.

If that one manuscript hadn't been passed hand to hand, concealed in collections and hidden in cupboards, we would not have this unique window into the medieval world. We'd have only known about a woman named Margery from seven pages of printed text in the publisher and writer Wynkyn de Worde's *A Shorte Treatyse of Contemplacyon*, produced in London in 1501. His version is just a fraction of what Margery intended to be shared – a life cut down, reordered and transformed. His Margery is a passive listener and quiet contemplative, rather than the larger-than-life roaring and wailing communicator we'll meet.[10]

Thanks to the survival of Butler-Bowdon's manuscript we get a different voice altogether. Written a decade before her death, at the start of Margery's *Book* the voice is determined yet frail, ebullient yet world-weary; a fifty-something woman who wants her life recorded. It opens with the homely words: 'Here begins a short and comforting treatise for sinful wretches, in which they might have great solace and comfort'. She's writing to comfort others. However, Margery quickly makes herself, her life and her experiences the complete focus of the work. She goes on to describe how she has 'for many years has gone astray and always been unstable.' She's

damaged goods, someone who has struggled with her mental and physical health, and has a past life which troubles her.

As the introduction continues she laments how she has been treated, losing all her 'worldly goods', shunned by others and subject to humiliation. She then tells the reader how, while struggling through the birth of her first child, she developed what we would today describe as post-partum psychosis.[11] She records her experiences in the third person as a way of indicating she is narrating past events objectively. Margery says she 'went out of her mind and was bewilderingly vexed and troubled by spirits for half a year, eight weeks and odd days'. She was so affected by the hallucinations it brought about that she had to be restrained day and night. She describes being attacked by demons, and throughout her *Book* Margery constantly fears she is stuck between good and evil; thoughts sent by God and by the devil. Her tormented imaginative world is brought clearly to life.

She recalls her first labour and how, thinking she was going to die, she felt the urge to confess something she 'had never before revealed in her life'. She was so disturbed by the guilt of her sin – compounded by the visions, fever and pain following the difficult birth – that she thought of killing herself many times. She even 'bit her hand so violently that the scar could be seen afterwards for her whole life'. What was the secret that so eroded her conscience? Was it a sexual liaison, that she'd given into temptation, or even that she held heretical thoughts? While we'll never know the nature of that particular secret, the insights revealed by Margery's account of her own life are some of the most personal, painful, human and revealing of all medieval texts. Her voice sounds incredibly modern and many women today can no doubt relate to her experiences and traumas.

If an autobiography as explosive as Margery's hit the shelves today it would cause a stir. She was a well-known, worldly woman of means and influence who was arrested, tried and imprisoned numerous times, and who accuses members of church and state of crimes – including sexual abuse – as punishment for her physical and mental issues. But on closer reading we begin to understand

what is really significant about the *Book*. It's not necessarily the intrigue, but the more mundane details it preserves. Margery is recounting a real life, with all its jagged edges and difficult experiences. It is a gift to historians: jam-packed with incidental information that brings the late-fourteenth and early fifteenth centuries to life. From this one text we learn about the logistics of travel, how business ventures succeeded or failed, the cultural significance of different food and clothing, and what it was like to reach old age – including the caring responsibilities that came with it.

The Book of Margery Kempe doesn't only shed light on the life of one medieval woman. By examining her writing along with the buildings we know she frequented, next to the medieval art we know she saw, against the parades and performances we know she witnessed, and alongside other women of her time, Margery helps to illuminate a rich and complex society. She is the gateway.

Margery: Merchant and Businesswoman

Margery spent nearly all her life in King's Lynn. She came from a wealthy family who wielded considerable local power. Her father, John Brunham, was the town's mayor and a Member of Parliament from 1365 to 1384 – something that would have given Margery both a privileged upbringing and a sense of self-importance. His parliamentary records make for interesting reading, documenting his rise and fall alongside the changing fate of King's Lynn's merchant class.[12] At one point he held many properties alongside what must have been the family home on Fuller's Row. He traded in cloth and corn, bringing in 344 casks of wine through the port in the winter of 1405. He was even involved in a rather daring sea-grab of a ship from Dieppe. But the wheel of fortune that raised him high also brought him low. He was increasingly excluded from local politics until eventually his time as mayor was viewed as the cause of all the town's ills. He is last heard of in 1420, when Margery was in her late forties.

While her father was still in his prime, Margery married another well-connected man – John Kempe of Lynn. [13] John's grandfather was a skinner and merchant, while his father held local office in the town. His father was a very wealthy man whose goods, when seized by the Hanseatic League in 1385, were valued at £300 – the single largest amount in the haul. [14] And like his father, Margery's husband John took on a prestigious role of chamberlain, receiving rents from the townspeople. But it seems Margery did not value her husband's status as much as her own father's. Indeed, she reminds John of this fact in her *Book*, saying: 'He never seemed a likely man to have married her.'

Margery continually reinforces her family credentials to others. When asked by the mayor of Leicester around 1416 to identify herself, she says confidently,

> Sir, I am of Lynn of Norfolk, a good man's daughter of the same Lynn, who had been mayor five times of that worshipful borough and alderman also many years, and I have a good man, also a burgess of that town, Lynn, as my husband.

Margery defines herself through the men in her life, but does so in order to stand her ground. Here she is asserting her lineage, proving herself worthy of his time and attention. She is playing power games.

Margery's *Book* documents her many forays into business. She tries repeatedly to become independently wealthy, moving from one enterprise to another. She wants money and she wants prestige. She would have seen women around her securing the power and reputation she so craved. This is clear from two sets of surviving artworks still on view inside St Margaret's church, in the centre of King's Lynn. The church is the oldest building in the town to survive, with parts dating back to its foundation at the start of the twelfth century. We know Margery was familiar with it, as some of the most dramatic scenes from the *Book* take place either inside the church or in the market square directly opposite. [15]

A small, easy-to-miss carving at the end of one of the medieval pews brings Margery, John and the merchants of Lynn into view.

Pew ends from St Margaret's Church, King's Lynn, showing a merchant on one side and a woman on the other, early-fifteenth century.

On one side is carved the lively, bearded face of a merchant, his expression of concentration emphasised by the frown lines on his forehead. On the other is a woman, her head loosely covered and a swathe of material around her neck. She has wide eyes and a gentle smile plays on her lips. She is not a nun or a noblewoman, as these types of women are depicted with crowns and wimples in other carvings in the church. She is most likely of the merchant class. These two faces, pressed up back-to-back for centuries, allow us to look individuals from the past in the eye. For Margery, they were a reflection of her own reality. These survivors across time bring her world into sharp relief.

Two enormous, stunning brasses have also survived in St Margaret's church. Their unveiling would have caused quite a stir when Margery was a girl. They both depict previous mayors of Lynn, and Margery may have expected that one day her father might have a similar monument to commemorate their family. The first shows Adam de Walsoken and his wife Margaret. At 3 metres by 1.7 metres it is the largest medieval brass to survive anywhere in England. According to the national taxation records of 1332, Adam and Margaret were the wealthiest couple in Lynn at the time.[16] A sign of how close relationships between merchant families were, this Margaret was most likely the daughter of a previous mayor of Lynn herself, so would have brought prestige and influence to the marriage.

Brass Effigies showing Adam and Margaret de Walsoken, St Margaret's
Church, King's Lynn, c. AD 1349.

The couple are shown as equal in height, wearing the finest
fashion of the time, of which the *Book of Margery Kempe* provides
detailed information. Margery laments being regularly insulted for
the showy nature of her dress. She:

> wore gold piping on her headdress, and her hoods were
> dagged [edged] with tippets [narrow strips of clothing]. Her
> cloaks were also dagged and lined with many colours between
> the dags, so that it would be more striking to people's eyes
> and she should be more admired.

If the brass retained any coloured infills we would no doubt be
able to see such details in Margaret's outfit. With a little dog, a
symbol of fidelity, by her feet, she is the more sartorially magnifi-
cent of the two figures.

Beneath the couple, two small scenes show differing sides of
the medieval world; one more rooted in everyday concerns than
the other. On one side, a knight fights with a snail, a surprisingly
common image reflecting 'the world turned upside down',[17] while
on the other a group of people tend to a mill. In their early married

life, Margery and John set up their own horse mill to grind corn, and would have looked forward to the wealth and prestige this could bring them. People would bring their grain and, for a fee, could have it ground into flour to sustain them through the year. But their venture didn't work out. Not only was she stuck with a literal millstone – an expensive item that would have cost Margery and John a large amount – but the book describes how Margery was deceived and swindled by those around her. Mill owners were among the richest people in medieval towns so Margery would have been seriously set back by this. Seeing the couple commemorated in this brass every time she entered the church would have emphasised how life might have been for Margery if her earlier business ventures had brought her success.

The second brass is also huge, at 2.5 metres by 1.5 metres dwarfing almost all others from the medieval period. It depicts the town mayor who preceded Margery's father, Robert Braunche. Its form

Brass Effigies of Robert Braunche, with his wives Leticia and Margaret, St Margaret's Church, King's Lynn, c. AD 1364.

alone – a huge strip of rolled brass – tells us a good deal about the town of King's Lynn in the mid-fourteenth century. There were no mills in England that could roll brass of this size until the sixteenth century, so it must have been imported, probably from Flanders. It testifies to the cross-water links Norfolk had with the Low Countries. King's Lynn, as one of the biggest ports in the country at the time, was like Liverpool in the industrial age. Everything came through its waters – people, produce, art and inspiration.

Here the mayor again defines himself in relation to his wives and his community. His two wives, Leticia and yet another Margaret, are shown either side of him, the three united in eternal polygamy. Below the figures is a fascinating scene, known as 'The Peacock Feast'.[18] It depicts a sumptuous banquet, complete with roasted peacock (a symbol of pride and incorruptibility), the food of love and courage. Only highly distinguished and virtuous ladies were allowed to carry the bird, resplendent with its feathers stuck back onto the roasted carcass and coated in gold leaf. Is this a real feast that Robert gave for King Edward III, the king shown surrounded by musicians at the head of the table? Was one of his wives the woman carrying the bird? While the exact circumstances of the feast cannot be known, it again tells us about the luxury of fourteenth-century King's Lynn.

Robert's second wife Margaret succumbed to illness during an outbreak of plague in 1361, dying before her husband. He had already written his will, leaving all his possessions to her.[19] Had she

Detail from the bottom of Robert's brass effigy, showing 'The Peacock Feast'.

survived him, she would have been one of the richest and most influential people in King's Lynn. Staring at these brasses in middle age, Margery must have felt a sense of jealousy (she admits to being 'hugely envious of her neighbours'), longing for her affluent youth and a desire for recognition. She knew privilege and power were there for the taking, regardless of whether you were a man or a woman. She was striving to secure it.

Margery wanted the finest things in life: food, surroundings, fashion, company. King's Lynn's merchant class would have enjoyed candlelit feasts in rooms decorated with glittering tapestries and exquisite furnishings. While embroidered dresses, painted walls and exotic food have all been lost to the centuries, one object remains that transports us to the world of the rich merchant class. An exceptional golden goblet Margery herself may have drunk from still survives. Despite its name, the King John's Cup has nothing to do with the twelfth-century king. It is, instead, a rare and little-known survivor of seven centuries.[20] In the possession of the mayor of King's Lynn since the sixteenth century, it doesn't seem to have moved far over its long life and still sits in pride of place in a cabinet in the town hall.

King John's Cup, silver and gilt with 31 enamel panels, King's Lynn Town Hall, c. AD 1340.

The King John's Cup is almost as rare a survival as *The Book of Margery Kempe*. It may look like a religious chalice, but the elaborate goblet, weighing nearly two kilograms, displays the most remarkable artistry depicting secular concerns. Where you might expect to see saints and angels on a religious chalice, here beautiful enamel panels show men and women hunting, hawking and shooting. It was most probably made in England, commissioned by a rich merchant in King's Lynn as the ultimate party piece. To pass this goblet around at a feast was a way of displaying wealth and prestige.

All the figures are in fashionable fourteenth-century dress, their clothes drawn tight at the waist. The men have long sleeves, which are held up with a button. They have embroidered collars and their tunics cover their knees. The ladies have long fitted cotehardies – garments that were buttoned down the front and at the sleeves – and tippets. None are wearing headdresses; their hair is worn plaited around their ears. Do these figures show us the characters that surrounded Margery in Lynn? Those handling it may have seen themselves represented.

Enamel panel showing a woman with a hawk in the base of the King John's Cup.

On the lid women outnumber men, and around the cup's rim the artist has alternated between male and female figures. When the cup was finally emptied of wine, a woman with a hawk on her arm revealed herself at the very bottom. We could suppose then that this cup was used in mixed company where men and women were equally respected.[21]

Yet another set of rare survivals from Margery's King's Lynn brings more of her world to life, balancing the exploits of the few with the activities of the many. As well as the Saturday market outside St Margaret's Church, there was another hub of activity to the north of town. Here the Tuesday market took produce fresh from the river and a separate community grew up around it, served by the Chapel of St Nicholas. Rebuilt from a twelfth-century foundation, the church we see today was finished in 1419, when Margery was in her twenties. The two churches competed for worshippers, with Easter Sunday 1426 a bumper event; St Margaret's had 1,600 attendees, while St Nicholas had 1,400.[22] Worshippers brought wealth, so these large numbers would have boosted the churches' coffers and provided revenue that could be invested in decorating the spaces lavishly. Margery was a big supporter of St Margaret's Church, so would have gone to the ceremony in the centre of town. But she also mentions St Nicholas's attempts to acquire a baptismal font in her *Book*.[23] If she – as is likely – visited the building, she may well have spent some time taking in its adornments.

Carved carefully on a stall end in the Chapel of St Nicholas is a magnificent two-masted fighting-and-trading ship set against a starry sky. Ships like these would have come in and out of the busy port day and night. It's incredibly detailed, with the rigging picked out and the heads of little fish emerging from the waves.

The wooden fittings give us insights into the day to day, the fantastical and the funny. There's a master mason working hard at solving a mathematical problem with a set square. In one carving a monkey rides a mule backwards, recreating the notorious 'skimmington ride'. This was a mock parade intended to humiliate individuals considered troublesome within the community, and

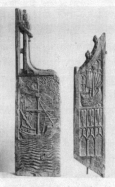

Stall ends depicting two-masted and single-masted fifteenth-century
trading ships, carved from oak, St Nicholas Church, King's Lynn, c. 1419
© Victoria and Albert Museum, London.

named after the wooden spoon that so-called 'unruly' women
used to beat their husbands.[24] It's an event Margery herself may
have seen and enjoyed.

Other carvings show the devil with a boar slung over his back,
an old man sitting peacefully in a shell stroking his beard, and –
particularly odd – a physician working out what enema to insert
in the rectum of a shaggy-haired animal. The human and the nat-
ural worlds are bizarrely bound together. Margery's medieval
world was rich, complex and funny, just like our modern times.
Without knowing the local celebrity or felon the images referred
to, we're most likely missing the joke today. Time erodes nuance.

Amusing and quirky as they are, these carvings also show the
richness of possibility in King's Lynn. Trade and business oppor-
tunities abounded thanks to the tall sailing ships washing in and
out of the river, and like many in her town, Margery was ever on
the lookout for the next entrepreneurial venture that might pro-
vide her with the luxuries she had grown up accustomed to.
Before the mill she had set up a brewery, which also failed. But
these were not the only ways women could achieve wealth and
reputation in the early fifteenth century. With her failed busi-
nesses behind her, Margery turned to a new career path. Celebrities

Misericord depicting the threshing of corn in the middle and
two Blemyae (fantastical figures) who have their faces in their torso
and no heads, carved from oak, made in East Anglia, c. 1415
© Victoria and Albert Museum, London.

like Bridget of Sweden had made a name for themselves inter-
nationally by developing their reputations as mystics. To become
an internationally renowned mystic, however, Margery would
need to give up something extremely important to her: sex.

Sex and Marriage

Despite providing her with money and a good name, Margery's
husband is by no means a main character in her book. When he
does appear, it is to thwart, appease or accompany a strong-willed
Margery. He stands by her despite humiliations and tribulations,
and it is clear that they supported one another. Margery continued
to care for John as they both approached old age, with the physical
and mental deterioration that entailed. In a touching scene, Mar-
gery describes how a 60-year-old John suffered a terrible fall down
the stairs and she nursed him back to health.[25]

They weren't living together at this point, as Margery had taken
her own home in her later years, while John lived nearby alone.

She had gained the independence she clearly craved throughout her early life. It was not unusual in the medieval period for husband and wife to live separately, but as she narrates in her book, some were critical of her choice and felt she should live under the same roof as John. Nevertheless, when his health worsened she moved him into her own home so she could take care of him in his final years. There are poignant details of caring for a loved one as he becomes increasingly 'childish', soiling the bedding and struggling with pain.

Margery does emphasise that John always felt 'tenderness and compassion for her'. They worked together, setting up their joint businesses, and he seems to have supported her financially throughout her entrepreneurial forays and her later, expensive, trips to the Holy Land and across Europe. They also had 14 children together. However, even in the early years of their marriage, when she was about 30 years old, Margery records how she told her husband she no longer wanted to have sex with him; indeed, that Jesus himself had told her not to. In a rather sad and humiliating scene we see the couple celebrating Midsummer Eve in 1413. Her husband asks:

> 'Margery, if there came a man with a sword who would slice off my head unless I should have sex with you as I have done before, tell me the truth from your conscience – for you say you will not lie – whether you would allow my head to be sliced off or allow me to be intimate with you, like in the past?' She replies, 'Truthfully, I would rather see you be slain than that we should turn again to the impurity of sexual activity.'

She goads him further, asking why he won't try to have sex with her, even though they sleep in the same bed. He says: 'He became so afraid when he touched her that he dared not do more.' A far cry from the domineering husband we might expect from a medieval marriage. Margery adds insult to injury, explaining that she still lusts after other men but is sickened by her own husband. Sex

and physical pleasure are a constant theme throughout the book. Margery, unlike many of her mystical contemporaries, thinks, talks and worries about sex all the time.

Some passages in the *Book* display a raw sexuality that is seldom found in medieval texts.[26] Margery describes a man whom she 'loved' approaching her at evensong in church and asking for sex. She is tormented with lust, returning to lie next to her husband that night. She contemplates sleeping with him to satiate her desire but can't bring herself to. She's so enflamed with passion for this other man that she goes to him and offers to sleep with him. But he turns her away saying he wouldn't do it 'for all the wealth in the world'. The passage is sensual and intense, suggesting that the medieval world she inhabited could and would discuss sex in open and revealing ways. After all, she narrated this episode to her own son and at least two other writers.

The intense passion Margery describes as she grapples with her lust for men is transferred onto the vision of Jesus she repeatedly sees. She describes how he 'ravages her soul', calls her his wife, spouse, 'a unique lover', and when she receives his body during communion she will be 'filled with him'. She even wears a ring engraved with the words 'Jesus is my love'.[27] While it may seem surprising today, sexualizing the relationship between Christ and his female devotees was not a new phenomenon. The thirteenth-century *Ancrene Riwle* (the monastic rule for female anchoresses) encouraged women to see Christ as their knight in shining armour, their object of desire, their lover.[28] But Margery's *Book* goes further than any other surviving medieval text in sexualising the relationship between the female protagonist and Jesus.

He is always with her – a replacement for her husband – and this 'beautiful man' brings her the satisfaction she craves. He fills her with ecstasy and passion. She even describes taking part in a wedding ceremony with Jesus, with a guestlist that included Mary, the twelve Apostles and the saints.[29] He insists that they must be intimate with one another, and from this point Margery begins to experience extreme heat brought about through intense physical sensations that sound a lot like orgasms; 'a flame of the fire of love,

marvellously hot and delicious and comforting, not lessening but always increasing.'[30]

Margery hears voices and has companions (Jesus among them) whom only she can see and hear. She also suffers what appear to be fits, where she 'writhed and wrestled with her body'. When she is about to have a seizure she describes her skin changing colour, turning 'purple like lead'.[31] She hears and sees celestial melodies and white lights that flash around her day and night. She even describes being assailed with the repeated vision of men's genitals, paraded in front of her as temptations.[32] Today we might diagnose her as schizophrenic, epileptic (some of her contemporaries suggested this too),[33] or psychotic, but to those around her she was either possessed by the devil, or could possibly provide a direct link to God.[34] It certainly seems many wanted Margery's prayers and intercession: she was paid handsomely for communing with Jesus on other people's behalf. Was Margery exploiting this direct link with Christ to boost her career as a mystic? She goes to great lengths in her *Book* to explain that she is closer to Jesus, Mary and the saints than anyone else. For a wealthy elite concerned with the fate of their souls, Margery's prayers would be a worthwhile investment; something she would play up through her eccentric behaviour, appearance and adventures.

Dressing in virginal white (despite having children), crying in public and refusing her husband sex have all been actions used as evidence of 'queerness' in Margery. It has been suggested that Margery is constantly at odds with the 'normative heterosexual expectations of her community in Lynn'.[35] When her behaviour becomes increasingly extreme, as she dons a hair shirt, fasts on Fridays and asks to travel alone, Margery's husband still stands by her: he 'was always ready when all the others failed'.[36]

Despite demanding a sex ban from her husband, Margery had an impressive 14 children. Whether all made it through childhood or not we do not know. If she pays little attention to her husband in her *Book*, she as good as ignores her many children. We hear of her travelling while pregnant, or how hard a birth had been, but little else. This could be seen as further evidence of her

self-centredness, or as a conscious authorial choice. The latter seems more likely: in omitting any mention of her children she is emulating the style of texts by other mystics, like Hildegard of Bingen. The *Book* truly is 'the Margery show'; her family have little place in it other than to emphasise how much she has suffered in her search for acceptance.

We do know more about one of her children than the others.[37] There is a son who appears to be the 'young man' who first tried to write down his mother's story but made a botched job of it. He moved his young family back to Lynn from his new home in Gdansk, Poland, and must have sat for many hours trying to get his mother's thoughts into some semblance of order.[38] It would fall to other willing male assistants to make sense of Margery's life for the page. As with the other women in this book, in looking for Margery we find a host of supportive men and a cosmopolitan context that challenge our received ideas of the medieval period. But we also find misogyny.

Misogyny and Heresy

Peppered throughout the *Book* are occasions where Margery is criticised, questioned and threatened by men. Margery was only too aware of misogyny. When discussing her ideas on the love of God with Richard Caistor, the local priest, his patronising tone is all too familiar:

> He, lifting up his hands and blessing himself said, 'Bless you! How could a woman occupy one or two hours on the love of God? I shall never eat meat until I know what you can say about our Lord God that will take an hour.'[39]

The reception she receives from men swings from complete support and devotion, through patronising put-downs, to utter derision and hatred. She experiences the spite of one particular man, saying 'the cause of his malice is that she would not obey

him'. She is outspoken, forceful and determined; characteristics that still rub people up the wrong way today. The very real threat of physical violence towards women also runs throughout the *Book*. Margery is sexually assaulted while a being held prisoner, she is grabbed and groped by men, placed in shackles and lives in constant fear of being raped.[40]

Alongside misogyny and fear of violence, Margery suffered at the hands of those who considered her a heretic. The claims laid against her were of particular concern, since this thought crime was rife in the early fifteenth century and, if found guilty, Margery would have been executed. The parish church of St Margaret's in King's Lynn provides a lasting reminder of the increasing persecution of heretics during Margery's lifetime. The first Lollard martyr William Sawtrey – burned at the stake in London in 1401 – was the priest here.[41] Through the late fourteenth and early fifteenth centuries, after John Wycliffe first pronounced his criticisms of the Catholic Church, the movement he is credited with establishing, Lollardy, spread across England. This was exacerbated in towns like Lynn, which had regular contact with the Low Countries and their reform movements. The Lollard movement believed that the church was corrupt, rejected transubstantiation (the turning of the bread and wine into the body and blood of Christ during the Eucharist) and argued the Bible should be available in English.

The face of one of the most outspoken opponents of heresy – bishop of Norwich and one-time overlord of Lynn, Henry Despenser – is carved into the very fabric of Margery's church. He stares out menacingly from the chancel. Known as the 'Fighting Bishop', Henry led an army of men in the Great Schism and against supporters of the Peasant's Revolt. He personally oversaw the execution of the rebel Geoffrey Litster as he was hung, drawn and quartered. Seeing his face carved into her church, Margery would have been reminded that men in positions of power could treat others, particularly those that behaved in unorthodox ways, with extreme brutality.

The Mayor of Leicester is one of the most damning critics in the whole *Book*. He accuses her of being a strumpet, a liar and, most

Misericord showing the coats of arms and head of Bishop Henry Despenser, St Margaret's Church, King's Lynn. The bishop took refuge in the church during town riots in 1377, so the carving likely dates to around this time.

concerningly, a Lollard. The 'Twelve Conclusions of the Lollards' were nailed to the door of Westminster Abbey and St Paul's Cathedral in 1395.[42] Heresy, as a thought crime, was difficult to police and hard to weed out. If found guilty of Lollardy, Margery could have been burned at the stake, like her previous parish priest.[43] She certainly met with one Lollard sympathiser, Philip Repingdon, and her unusual behaviour may have made her vulnerable to those wanting to ascribe it to heresy. On the many occasions she is called upon to defend herself, she's often accused of being a woman who preached. This was forbidden by the church, but the Lollards encouraged women to speak publicly about religious matters. Yet Margery wasn't a Lollard. She frequently asserts that she believes in transubstantiation, and her regular pilgrimages to holy sites and veneration of relics attest to her Catholic faith. But she was an outspoken woman, determined to be heard.

Time and again she is questioned on her faith. Repeatedly she is cleared, notably receiving a letter of support from the Archbishop of Canterbury. While protesting her innocence to the Archbishop of York, the second most important cleric in the country, she does something brazen; she tells him a parable. Here Margery uses humour to assert her power over those who

challenge or demean her. She describes a priest who is lost in the woods. With nowhere to sleep, he lies down in a garden full of blossoming fruit trees. In the night a large bear approaches him, shakes a particularly ripe pear tree, eats all the fruit that drops to the ground, then defecates in the direction of the priest.[44] The next morning, as the cleric dejectedly wanders the streets worrying about why the bear shat on him, he meets a man who explains the event. The priest is the foul bear, gobbling up the sacraments then defecating on the beautiful garden with his worldly greed.

It seems this tale went down very well, with the archbishop declaring it an 'excellent story'. Margery had entertained and delivered a serious moral message about the sins of the clergy through a strange, funny story. She was quite the raconteur, using humour to maintain the upper hand. That Margery could speak of a bear shitting in the woods inside the archbishop's chapel suggests that the scatological was not out of bounds within churches.[45] In fact, images of animals and humans emptying their bowels were often woven into church decoration alongside saints and angels. It also shows that she had the ear of powerful people.

Margery was in contact with the very highest men in the church and was able to defend herself rigorously and learnedly under examination, using her humour and her knowledge of religion. Proving a woman could be well-educated and informed on matters of faith, her command of religious principles was just as strong as many of the men of her time. According to the *Book*, the lawyers of Lincoln even claim 'we've been schooled for years, and yet we're not as competent to answer as you'.[46]

Margery was not afraid to stand her ground in the face of threatening men. When called in front of the Bishop of Worcester she is brought in by his guards.[47] She shocks them all by saying they looked like the devil's men, rather than the bishop's. Worse still, while being questioned by the Archbishop of York, she says, 'I hear tell you are a wicked man.'[48] Somehow she gets away with these brazen comments.[49] Much of the *Book* can be read as Margery's defence against the stain of heresy. Her pilgrimages, her visions and her communications with members of the church and

men in authority all testify to her orthodoxy. By putting her experiences on the page, she's providing a lasting record that could help to clear her name long-term.

Drama and Mysticism

While Margery does not describe herself as a mystic, she dedicates large portions of the book to describing her spiritual visions. She had her first mystical experience while recovering from the agonising birth of her first child. Jesus himself sat on her bed and calmed her before ascending to the heavens. Soon after this Margery starts to hear sounds, including a sweet melody that takes her to paradise. No one else could hear it, but for Margery it was a very real and 'physical' sound. This is when she discovers her gift of spiritual tears. Margery's crying is one of the things most readers of the *Book* remember. She cries everywhere: loudly, passionately and abundantly, usually as a result of great happiness or joy. Margery fully experiences the highs and lows of her emotion.

Viewed with suspicion and intrigue by those around her, her outbursts and behaviour were perceived as 'odd'.[50] Seeing a statue of the Virgin Mary holding her son's dead body, Margery breaks down in tearful sobs, so that she 'might have died'. We can imagine her wailing convulsively in a church, and our modern sense of embarrassment at this drama is mirrored by that of the local priest, who calmly says to her, 'Damsel, Jesus is long since dead'.[51] He is asking why she's crying; why the death of Jesus feels so raw and real to her. But Margery exists in a different time-scape. 'His death is as fresh to me as if he had died this same day,' is her angry retort. Margery is experiencing time from the point of view of a mystic, where biblical past collapses with her present-time surroundings.[52] Her visions have what we might now consider a cinematographic quality, especially when narrating how the events of Christ's death played out before her eyes.[53] She describes seeing 'with her spiritual eye' the road to Calvary: 'And there they bound him to the pillar as tightly as they were able, and they beat him on his fair

white body with rods, with whips, and with scourges.'[54] She is both in the moment and not of the moment.

But when she wails and cries in church she is also performing. The lives of other mystics record similarly public displays of piety and spiritual exuberance, and Margery seems to be aware of the power of her tears, howling and crying to endorse her reputation as a sacred woman. Her love of drama and attention is revealed in one notable scene from the *Book*. A renowned friar comes to give a talk at St Margaret's. A huge crowd has gathered to hear him speak, but he is pre-warned that another local personality, Margery, may start wailing when he does so. She describes how she tried to hold back the tears but they 'burst out with a great cry'.[55] This noise and drama would have echoed around the church and disturbed those trying to listen to the distinguished visitor. The friar tolerated it for a while, but finally banned her from his future talks. In this intriguing scene two performers are both using the church as their stage.[56]

Throughout the *Book* Margery tells us of superstar speakers capable of drawing huge crowds.[57] She also describes the drama of mass (the priest revealing and concealing the crucifix like a piece of performance art) and processions, like that on Palm Sunday, when church rituals were taken out to the streets.[58] And it is likely she was among the audience watching plays performed by touring companies on religious feast days in the streets, with revellers sitting through a whole cycle across a day.

A set of 42 mystery plays dealing with biblical stories, known as the N-Town Cycle, survives from the era.[59] The written texts date from the late-fifteenth century – towards the end of Margery's life. While we can't know for sure whether these were the plays Margery saw in King's Lynn, it does appear they were performed in East Anglia.[60] And one play from the cycle is likely to have made a particular impression on Margery if she did happen to see it: *The Woman Taken in Adultery*. The biblical account is short, describing how no one will throw the first stone at the woman, so Jesus doesn't condemn her either. The medieval version, however, is much longer and puts more words in the woman's mouth.

Margery says in her *Book* that she was every day 'mindful' of that specific biblical story and that she prayed that, as Jesus drove away the adulterous lady's enemies, so he would protect her.[61] The play is a remarkable piece of literature, full of tension, violence and heightened drama. When a woman is discovered in the act of adultery, her lover manages to run away after aggressively wielding a sword at those who have found him. The stage directions help us to imagine the drama and entertainment: 'Here a certain young man shall run out in disarray, with his laces not tied and holding his breeches in his hand.'

While the man escapes, the wife is subjected to a torrent of abuse. She is a 'stinking bitch', a 'whore', a 'harlot' and a 'slut'. But, unusually for the genre, the play changes in tone halfway through. When the woman is dragged before Jesus, the stage directions read that: 'He replies nothing, but always writes on the earth'. Then he gives his famous proclamation: 'Look, which of you that has never committed sin, but are cleaner in life than she, cast stones at her and don't spare her, if so clean of sin you be.' The men all gradually drift off until just Jesus and the woman are left. We can imagine the actors performing in the streets of King's Lynn, working the dynamics of the play to take the audience through the sufferings and ultimate redemption of the woman.

Here Margery's world, and that of the women around her, is reflected in a moralising tale. The woman isn't just a weak, passive victim. She looks death in the eye and accepts she has done wrong, pleading her case and wanting to preserve her life. She is a feisty, individualistic, medieval reimagining of the practically silent woman in the Bible: more fourteenth-century than first-century. She's a rounded, three-dimensional character. In the *Book*, Margery's reflections on her life in Lynn are balanced with tales of the trials she endured while travelling internationally. Leaving her relative comforts back home, her role as a mystic required her to have suffered like Christ. It's through her travels that we learn more about the difficulties facing a medieval self-made woman exploring foreign lands.

Travel and Pilgrimage

The Book of Margery Kempe provides some of the most revealing and thorough surviving descriptions of pilgrimage. We learn of everything from seasickness, delays and robberies on the road, to how groups could fall out with one another and bicker on their travels. Medieval pilgrimage was like our modern-day package holidays. Margery describes unscrupulous guides ripping off vulnerable tourists, paths crammed with other travellers and shabby lodgings. On one occasion she is even forced to sleep on the floor of a barn.

Despite her strong urge to visit the shrines of saints and follow the footsteps of Christ, travel was not easy or pleasurable for Margery. Her unusual behaviour made her a difficult travelling companion, and she often finds herself alone and ostracised abroad:

> Her confessor was displeased because she ate no meat, and so were many of the company. They were also most displeased because she wept so much and was always talking about the love and goodness of our Lord, at table as well as in other places. Therefore, shamefully, they rebuked her and downright chided her and said they would not endure her as her husband did when she was at home in England.[62]

She was treated particularly badly by her companions as she made her way towards Jerusalem. In the *Book* she describes how they didn't just reject her, but put her in danger by slashing her dress above her knee and dressing her in sackcloth to humiliate her. It was treacherous for a woman to travel alone, but by being made an obvious target in this way she was under even great threat. At one point the whole company abandons her and she is left with just one male companion, William Weaver, who is terrified of being attacked. He says, 'I am afraid you shall be taken from me and I shall be beaten up because of you and lose my jacket.'[63] In the same way that women travelling alone today still take precautions, Margery prays for her physical safety, even sleeping with a

maidservant whenever possible to lessen the threat of rape. Pilgrimage was not for the faint-hearted.

Margery would have seen people from all parts of the world moving through the port at Lynn, with some settling permanently. But travel exposed her to an even wider range of cultures and peoples. She describes trying to climb Mount Quarantine, home to a community of monks near Jericho. The climb is hard going and nobody will help her, until a Saracen, 'a good-looking man', leads her up the high mountain.[64] She describes how the Saracens were very kind to her, stating that she 'found all people to be good and gentle to her, except her own compatriots'. There is not a huge amount evidence for racial and religious diversity in the *Book*, but fragments like this suggest that Margery was aware of difference yet largely accepting of it. She also doesn't obviously display prejudice with regards to disability or class. One of her companions to Rome was an Irish man with a broken back, and throughout the book she mixes with lepers, the sick and the poor, as well as royalty and religious leaders.

She met fascinating foreign women on her travels, like the pilgrim returning from Jerusalem with a holy icon in a chest. Margery cannot speak the same language as her, but watches as she shows her painting to others, who honour and worship it.[65] There is also the fine Italian lady, called Margaret Florentine, who travelled with her own entourage of knights and provides safe passage for Margery on her journey to Rome. She meets the same woman again later, when she has given away all her money to paupers, and is shown great kindness, being fed by her at a glamourous table and provided with a hamper and coins.

Margery's description of international travel paints a far more cosmopolitan picture of medieval times than our received ideas of the period might allow for. She traverses thousands of miles of pilgrim routes in her lifetime, rubbing shoulders with fellow travellers, knights, nobles and more from all around the known world. Some are making repeated journeys and exploring the far reaches of Christendom, as she herself does. She doesn't just cross England, but goes to Norway, Poland, across the Middle East,

through France, Spain, Italy and Flanders. She's better-travelled than many of us today, despite being significantly more limited in the forms of transport available to her, the options being horse-back, waggons and by foot. And though she travelled widely, Margery always returned 'home' to King's Lynn.

Margery's Peers

Margery isn't the only author to have emerged from fourteenth-century King's Lynn. A scholar called Nicholas of Lynn wrote an important astronomical work, the *Kalendarium*, referenced by none other than Geoffrey Chaucer. There was also John Cap-grave, an Augustine prior in Lynn who wrote several books that would have been of interest to Margery, including a life of one of her favourite saints, Katherine, and a pilgrim's guide to Rome.[66] But one of the most intriguing of Margery's exact contemporaries is Thomas Hoccleve. He knew of Margery and she of him. There are some passages in his works that seem to be addressed directly to her, particularly in his condemnation of female preachers. He says they should 'sit and spin' rather than gabble on about religion, which 'your intelligence is far too weak to contest'.[67] Margery seems to be replying to Hoccleve in her *Book* when she describes Yorkshire locals yelling at her to 'spin card and wool as other women do'.[68]

Margery, Hoccleve and Capgrave all wrote texts that focus heavily on women's spirituality. Despite this, there are nowhere near as many women mentioned in the *Book* as there are men. Even in the spiritual realm Margery spends far more time talking to Jesus, rather than the Virgin Mary. Could it be that she got on better with men than with women, even in her visions? The *Book* describes good and bad maidservants, some who serve her loyally, and some who abandon her. Margery provides advice and support to widows, nuns and noble ladies, but sometimes these interac-tions go horribly wrong. On one occasion Margery tells a widow she needs to change her confessor, and this does not go down

well.[69] She's thrown out of the house and, in response, gets a 'Doctor of Divinity' to write a cutting letter to the widow explaining she's quite happy never to set foot in her home again. It's a very believable falling-out.

But it is clear that Margery created a powerful impression on the women around her. The Mayor of Leicester says he is worried that she will 'take our wives away from us and lead them off with you'.[70] His comments suggest that Margery's behaviour, as extreme as it may seem at times, was encouraging other women to think of the life of a mystic as one they too could follow. She reaches out to women on the edges of society, and describes wanting to follow Jesus's example by kissing lepers. Her confessor warns her that this is a bad idea, encouraging her instead to kiss sick women. She visits a group of poorly old women, and kisses two 'on the mouth'.[71] When asked by a man if she might help his wife who is also suffering from post-partum psychosis, Margery comforts her and gets her back on the road to recovery.[72]

Perhaps the most noteworthy of her female interactions is with the famous anchorite, Mother Julian of Norwich. The tone of Margery and Julian's books couldn't be more different, with the latter's *Revelations of Divine Love* unfolding gently like a web of contemplation. Her famous phrase, 'all shall be well, all shall be well, and all manner of things shall be well' epitomises what makes Julian's work so special: a consistent quality of patience and calm – Margery's chaotic and, at times, difficult work makes for a striking contrast. But when writing about their meeting, Margery manages to capture Julian's voice. We recognise the anchoress's tone as we know it from *Revelations* in Julian's line, 'He who is always doubting is like a wave on the sea, which is moved and carried about by the wind'.[73] The interaction between two of Norfolk's most famous medieval women shows Margery's ability to record not just what a person said to her, but also capture nuance in the way in which it was said.

Margery did not want to follow in Julian's footsteps and become an anchoress. She found greater inspiration in the superstar spiritualist Bridget of Sweden, who had died in 1373, the year Margery was born. Now one of the patron saints of Europe, Bridget was a

noblewoman in her lifetime, descended from Swedish kings. Like Margery, she was married and had children, but only eight in comparison to Margery's 14. She began seeing visions as a child and, in the famous book of her life, she records experiencing Christ's pain and suffering. There are so many parallels between Margery's and Bridget's books: both travelled widely on pilgrimage, both criticised religious men, both maintained a place in the spotlight and exploit their notoriety.

Margery felt she was in direct competition with Bridget. When she recalls seeing the host and chalice vibrate during mass, Jesus (always chatting away by her side) tells her she is lucky to witness this, adding: 'Brigid never saw me in this way.'[74] Her spiritual peer is never far from view. In Rome, Margery meets one of the saint's maidservants. It would be like talking to a celebrity's confidant today. She wants to know what sort of a person Bridget was, and is told she was kind and smiley.[75] She visits sites connected to Bridget, including the place where she died and the stone where Jesus appeared to her. Margery is touring Rome in the way people take in a Hollywood stars tour today, and Bridget is the main attraction.

Another female mystic mentioned in the book is Marie of Oignies.[76] This thirteenth-century woman's life was a big inspiration for Margery. She too was born into wealth and married young before embracing an ascetic lifestyle, renouncing sex and undertaking gruelling pilgrimages. Marie also wept uncontrollable tears. Margery references several mystics who were unable to control their crying, including the author of the Middle English penitential poem 'The Prick of Conscience' and Elizabeth of Hungary; another thirteenth-century woman. A Bavarian princess, her *Revelations* were translated into Middle English in the 1430s, so she was a hot-off-the-press female mystic.[77] Margery did not exist in a vacuum. She was profoundly influenced by the celebrity mystics of her day and, when her businesses failed, understood that the life of a spiritual woman could bring her wealth and fame. She would be invited to dine with the rich and powerful, could be given gifts and payment for her prayers and her reputation would travel far and wide. The fact that it brought hardship and suffering too was part

of the deal. Like the women Margery cites, the life of an international mystic could bring real rewards, but it came at a price.

Margery Kempe's life mirrors that of her contemporary Joan of Arc in more ways than one. Both got in trouble for their attire – Margery for wearing virginal white, Joan for cross-dressing. Both received holy tears and prophesies, and worried that these came from the devil rather than from God. Both were hounded by the Duke of Bedford and expressed fears of rape and sexual violence. But while Joan was branded a heretic and died at the stake in 1431, Margery lived a long life and died in old age as a wealthy member of the prestigious Trinity Guild in King's Lynn.[78]

Margery's is a rich and textured medieval world, full of people who are compassionate, condescending, cruel, comedic, considerate and caring. She is a difficult woman. But on the whole, her community and the people around her are sympathetic and supportive. She reaches old age, is provided for financially by those around her, and is taken seriously enough for her life to be recorded. And her supporters defend her, even when she is accused of heresy and their own lives are under threat through association.

Her Legacy

We all know someone a bit like Margery. She's loud, opinionated, doggedly determined and self-promoting. She's also vulnerable, self-loathing, troubled and damaged. She wants her story to be recorded and she believes she should be heard. She's a powerful woman – if not always appreciated. When the *Book* was first revealed to the world in 1934, the *Daily Telegraph* described her as 'a wet blanket in any company which was innocently enjoying itself'. Today we're more likely to see Margery as an example of a medieval woman managing her reputation and crafting her brand. In her fifties she transforms from failed middle-class businesswoman to travelling spiritualist.[79] She wears many robes – mother, wife, pilgrim, adventurer, author and adviser.

If her manuscript had never emerged from the dusty cupboard,

we'd only have Wynkyn de Worde's printed version of Margery, in which he makes her a listener and a quiet contemplative, rather than the outspoken woman we know her to be. But thanks to Margery's self-determination and the efforts of Hope Emily Allen, a twentieth-century woman who also bucked the trend, we have access to an invaluable historical resource.

Margery sums up the complexity of her existence within medieval society perfectly:

> Some people said it was a wicked spirit that vexed her; some said it was a sickness; some said she had drunk too much wine; some cursed her; some wished that she were thrown in the harbour; some wished she were put out to sea in a bottomless boat. Others loved and esteemed her.[80]

The Steward of Leicester condemns Margery with these words: 'Either you are a really good woman or else you're a really wicked woman'.[81] But it's impossible to reduce Margery to simply 'good' or 'wicked'. She's like every one of us; contradictory and changeable. Thanks to the survival of her *Book*, after six centuries we are able to see her as fully human.

9

Exceptional and Outcast

'There is no such thing as a single-issue struggle
because we do not live single-issue lives.'[1]

Audre Lorde

Identities Then and Now

This book has focused on a handful of women who high-
light specific themes – diplomacy, artistic production,
warfare, literacy and leadership – at particular moments
throughout the medieval period. Every woman is a complex web
of characteristics. While we cannot always accurately determine
indicators like dress, hair, behaviour and mannerisms, which are
virtually impossible to reconstruct, aspects that others might have
used to define these women – such as their social class, religion,
age, and maternal or marital status – can be drawn out. Sometimes
it is difficult to determine even this much. How much more diffi-
cult it is, therefore, to touch on other facets that they may have felt
were representative of their identities. Questions of gender, sexu-
ality, race and disability are often hard to access from the historical
evidence that survives. But as the discipline of History increas-
ingly opens up to new approaches, and researchers realign their
viewpoints to take these issues into consideration, so a more fully
rounded view of individuals emerges.

Knowing that people of different classes, backgrounds, races, reli-
gions, disabilities, genders and sexual orientations have always been

a part of history allows us to find ourselves in the past. It also serves to level the playing field going forward. It wasn't just rich and powerful men who built the modern world. Women have always been a part of it, as has the full range of human diversity, but we are only now beginning to see what has been hidden in plain sight.

As we come to the close of the book, I want to explore the experiences not of the elite but of the lower classes.[2] There are so many more fascinating areas of study emerging.[3] Recent discoveries are often the results of female academics searching for new ways to find otherwise ignored individuals.[4] By reframing what we are looking for, we can find more people from the medieval period who bring lost narratives to the fore.

The bustling, cosmopolitan and diverse city of London in the second half of the fourteenth century is a particularly rich area for study, since a good deal of written and archaeological evidence survives from this time and place. It had become the country's capital when the royal court relocated from Winchester to Westminster in the twelfth century. A melting pot of people then as now, medieval London was where the super-rich and the impoverished lived cheek by jowl. The city's docks were a source of income and connected merchants, traders and craftspeople with guilds across Europe. By the fourteenth century the population was close to 80,000, with many people having migrated to the city from other parts of the British Isles, France, the Baltic, Italy and Spain.[5] City records, combined with archaeological finds, allow us to get closer to the people of medieval London and observe its population around the time of the Black Death and its aftermath, a pivotal moment in history.

Discovery!

2019 – Museum of London, London, England

Dr Rebecca Redfern is in her usual spot, hunched over a set of bones in the stores of the Museum of London. Increasingly

frustrated by the repeated claims by historians that 'there are no people with black ancestry in the city during certain periods', she's piecing together archaeological evidence for diversity in the medieval city.[6] Arranging a set of bones she knows well, Rebecca is revisiting an excavation that took place between 1986 and 1988 in East Smithfield, near the Tower of London. This site provides a window onto one of the most dramatic and cataclysmic moments in history.[7] It was created to accommodate the victims of the Black Death, the plague that decimated Europe. London was particularly badly affected, with up to 60 per cent of the population wiped out.

The constant movement of people and goods through the medieval city helped to spread the *Yersinia pestis* bacteria, probably via fleas which lived on rats hidden in cargo ships or in containers.[8] Although already present throughout Europe in 1347, the disease was rampant in London by autumn 1348, leading King Edward III to close all ports and shift to emergency governance. For the next two years roughly 300 people died a day, and the depleted population had to deal with the safe burial and disposal of an overwhelming number of bodies. Many continued to be interred in parish churchyards, but two emergency graveyards were sanctioned by the church and crown: one in West Smithfield and another in East Smithfield. The first recorded request for burial at East Smithfield came from a fishmonger called Andrew Cros in 1349, so we know it was a consecrated cemetery by then. The site continued to be used for burial up to the sixteenth century, but the Black Plague pit was only active for about two years, providing a unique context for the human remains found there.

In the 1980s the area was scheduled for redevelopment, so an extensive archaeological excavation took place. About 20,000 square metres of the burial was uncovered, but this was only half of the overall site, the rest remaining underneath existing buildings. When archaeologists opened the graves, it was clear that all the bodies had been treated with the same level of respect. They were laid out carefully in rows, some in wooden coffins, with many fully dressed and even buried with valuables. In total the bones of 634 individuals were excavated, although some had been

partly corroded by chemicals seeping from the vaults of the Royal Mint above. Nearly 40 years after the bones were first discovered, Rebecca is poring over them once again, selecting the ones most suitable for her cutting-edge form of osteoarchaeology.

Forty-one skeletons from the East Smithfield burial ground are chosen for analysis. Rebecca and her team employ a range of techniques, including forensic analysis, facial measurements, macromorphosophic ancestry methods, ancient DNA genome sequencing and stable isotope analysis, which measures the chemicals laid down over time in teeth and bones.[9] These tests are expensive and time-consuming, so this sort of research – and its revolutionary findings – is out of reach for many archaeological excavations. The databases are still in their infancy, but Rebecca is determined to use every technique available to gain an accurate picture of London at the time of the Black Death.

Her results reveal that many of the bones belong to people who had lived in places outside of London, including Wales, Devon, Cornwall and the Western Isles of Scotland. Seventy-one per cent of the skeletons were identified as white European, while 29 per cent were classified as Asian, African or dual heritage. Of these, four women and three men had black African ancestry. One woman had black African/Asian ancestry, but the evidence from her teeth and bones revealed she had grown up in Britain, while others displayed similarly diverse heritages. In the 2021 London census around 60 per cent of the population is recorded as white, with the remaining 40% listed as Asian, black, mixed and other. The results of this study suggest that if you were to walk the streets of medieval London you could expect to encounter a similarly diverse range of people.

One skeleton deserves particular attention.[10] The teeth, which are essential for isotope analysis, have survived well, and other bones confirm that the individual was female. The innovative testing techniques suggest the skeleton was that of a black African woman who had moved to London by the time of the Black Death and died around the age of 40. Like many of the people buried in the East Smithfield cemetery, her bones show evidence

of health issues caused by living in a densely populated urban environment. The effects of unsanitary living conditions, over-crowding and variable food supplies affected the people of London negatively in comparison to rural populations, with increased risks of mortality as well as illness.[11]

The first half of the fourteenth century was a particularly diffi-cult time for England. Environmental issues, including famine and natural disasters, affected much of northern Europe, and the Great Famine of 1315–22 had dramatic and long-lasting impacts.[12] Evi-dence of childhood trauma caused by malnourishment, vitamin deficiencies and infant diseases is clear in many of the East Smith-field bones. The teeth of those who had grown up during times of famine have pitting in their enamel; an echo of physically chal-lenging infanthoods. But the black African female from East Smithfield displays no such evidence of childhood trauma. This suggests she had a healthier diet in infancy. This is a pattern seen across those Black Death victims who had grown up outside of northern Europe, including those who spent their childhoods in Asia and the Mediterranean. By comparison with the wider world, 'the West' was not as affluent as we might assume today.

Yet her bones reveal rotator cuff disease and spinal degener-ation, which would have caused her pain, suggesting she performed repetitive acts and underwent regular physical exertion. She was not alone, as most of the skeletons excavated at East Smithfield had damage to their joints. This black African woman was sub-jected to the same harsh living conditions as many working-class fourteenth-century Londoners, but whether she was enslaved or free, impoverished or wealthy is impossible to determine from the bones alone. We do know that she was not born in the city, and it's likely she travelled a long way to arrive in London.

Migration, Slavery, Race and Religion

Throughout the period covered by this book, it is clear that even seemingly remote locations had contact with people from many

hundreds or even thousands of miles away. As the other women in this book have proved, the medieval period was not as parochial as we may think. Trade brought commodities along roads and water-ways, with silks discovered in Scandinavia and shells from the Indian Ocean in Northumbria. People moved too, through pilgrimage, travel, migration and trafficking. In fact, most residents in medieval urban centres were immigrants or descended from immigrants.[13] Wherever trade took place there would have been vendors, travellers and merchants of different backgrounds, races and religions.

This was certainly the case in towns connected by the Hanseatic League, but during the period of Viking expansion there were also many people moving and being moved from Asia, the Middle East and northern Africa into Europe and vice versa. There is even a reference to Vikings in Newfoundland returning with two Native American children, who may have settled and ultimately entered the gene pool in Iceland.[14] In 2011 a DNA feature (C1e) was identified in the Icelandic population which is not of European or Asian origin, and may have arrived with a Native American woman around the year AD 1000.[15] Enslaved people moved in multiple directions and came from different ethnic backgrounds. While some historians maintain that 'there were no slaves in northern Europe in the late-medieval period, let alone black ones,' this simply was not the case.[16]

Slavery continued after the collapse of Rome, and during the centuries known as the 'Barbarian Invasions' prisoners of war were rounded up and moved, sold or forced into servitude. Thousands of Irish female slaves were taken to Iceland and their DNA integrated with Norwegian men during the original settlement of the ninth and tenth centuries. Caucasian slaves were valued highly in Islamic Spain with women selected to birth children for the Caliphs of Córdoba. St Patrick himself describes his life of slavery, and there is a record of a black African slave being moved via Morocco to Ireland in the ninth century.[17] There is a dip in recorded slavery towards the end of the tenth century, possibly due to the efforts of the Christian church to free individuals as acts of

mercy, but it might be that the terminology simply changed.[18] Throughout most of the later medieval period, slavery was replaced by serfdom, with free labour provided by the poor closer to home, rather than imported from abroad. The Domesday Book records that after the Norman Conquest of 1066 roughly 10 per cent of people were listed under the Latin term 'servus', but whether they were serfs or slaves is uncertain. While the legal basis for slavery disappeared across Europe during the thirteenth century, there was certainly still trade in enslaved people taking place. A Catalonian record of 1410 counted 10,000 African slaves in that area.[19]

Although medieval slavery was less coordinated than the transatlantic slave trade of the seventeenth century onwards, the foundations of racism were laid at this time.[20] It's true that the international nature of the medieval Christian church meant it was a diverse and cosmopolitan entity, and personnel from different backgrounds could move across countries and continents to fill positions where they were required. In seventh-century Canterbury the archbishop was the Greek/Turkish Theodore of Tarsus, while the abbot of the hugely influential St Augustine's was Hadrian, a north African Berber.[21] But for most of the medieval period difference and division was perceived according to religion, ethnicity and race, with state and church stoking xenophobic feeling at various times for economic or political gain.[22] New lines were drawn in 1095 when Pope Urban II called on 'all Christians' to join in a crusade to take back the Holy Land from Muslim control:

A race from the kingdom of the Persians, an accursed race, a race utterly alienated from God, a generation forsooth which has not directed its heart and has not entrusted its spirit to God, has invaded the lands of those Christians and has depopulated them by the sword, pillage and fire.[23]

The Crusades from the eleventh to the thirteenth centuries stoked hostilities between 'them' and 'us'; Christians and non-Christians. The late-medieval church had entrenched itself along racial lines,

encouraging acts of violence against minority groups including Jewish communities, and differentiating Christians from 'Arabs' and 'Moors'. The prejudice and attacks faced by Jews in England is a startling example of this hostility.[24] In the early thirteenth century false accounts of 'blood libels' circulated, where Jews were accused of sacrificing Christian children during their rituals.[25] Incidents were reported in Norwich, Gloucester, Bury St Edmunds, Bristol and Lincoln, with Jews rounded up and killed in response. The worst massacre took place at Clifford's Tower, York, in 1190. After being trapped inside and threatened with death or forced conversion, most of the Jewish families took their own lives. The rest were killed by the mob. Approximately 150 people met their death during the massacre.[26] Anti-Semitic sentiment festered and grew in England until 1290, when it became the first country to forcibly expel all Jews. Christian rhetoric and theological treatises stoked these hatreds.

But the crusades had a globalising effect too, since thousands of Europeans travelled to the East and encountered cultures, civilisations, ideas and people they had not met before. The edges of the known world offered new opportunities for trade and expansion. These links with Arabic and African people were increasingly exploited by merchants along the borders in Eastern Europe, Italy and Spain. The potential for widening global reach was not lost on international rulers either. In the twelfth century Emperor Frederick Barbarossa sought to expand the Holy Roman Empire to encompass all of Christendom and beyond. He introduced imagery of non-white individuals into the visual arts of his court, and representations of black saints, like Maurice, increased as a means of showing the international influence of Christianity with Barbarossa at its head. He drew people from across Europe, Asia and Africa to his court.[27] He favoured Islamic scholars and made peace treaties with the Sultan of Egypt to secure a Christian presence in Jerusalem. Always at loggerheads with the papacy, Barbarossa's tolerance of non-Christians was criticised by the church. Yet the image of a diverse, expansive Holy Roman Empire had a lasting impact on medieval art, thought and state-building.[28]

Painted mural showing Holy Roman Emperor Frederick II, casting himself
in the manner of his predecessor Barbarossa with imperial subjects,
Basilica San Zeno Maggiore, Verona, c. AD 1230.

After Barbarossa's rule, the concept that Christendom encompassed the three known continents continued to be expressed in art. Throughout the Middle Ages, the three magi – Caspar, Melchior and Balthasar – were increasingly depicted as having distinct skin tones in northern European art, with the old and pale Caspar representing Europe; the darker skinned and middle-aged Melchior representing Arabia; and the youngest with the darkest skin, Balthasar, representing Africa. The three wise men from the 'East' differ in age and ethnicity, but are unified in their adoration of the Christ child.

The thirteenth-century Hereford Mappa Mundi shows Jerusalem at the centre of the world, with Europe, Asia and Africa religiously bound together through a network of church buildings. The areas of Africa and the East outside of Christendom are, however, shown populated with strange creatures: headless blemmyes with their faces in their chests or the giant-footed sciapods. Fear of the other was entrenched, and those outside of Christendom in Africa and Asia were considered to be of monstrous races on the periphery of civilisation.

The Black Death led to a turning point in race relations. Blame for the disease was laid at the feet of Jews, Muslims, foreigners, the poor and migrants, with violence erupting against minority

The Adoration of the Magi, from a Book of Hours, most likely made in
Provence, France, c. AD 1480–90, J. Paul Getty Museum, MS. 48, folio 59v.

groups.[29] As workforces were depleted and people moved to find
new work opportunities, population diversity in urban centres
increased, so tensions were stoked. It is against this backdrop of
rapid change that an increasingly negative emphasis on skin colour
emerges in later medieval texts and the visual arts. 'Whiteness'
became equated with saintliness and goodness, while 'blackness'
signified evil.[30] This blatant racism became more and more embed-
ded over the course of the Renaissance through the expansionist
activities of the so-called Age of Discovery. The Portuguese, Span-
ish, French, English and Dutch traded in lives throughout the
sixteenth and seventeenth centuries, and laid the foundations for
prejudices of the modern age. To get a truer sense of London at
this point of change – at the time of the Black Death – is therefore
essential to understanding where more modern prejudices
originated.

How did a black African woman end up in a Black Death burial
site in London? She may have arrived through diplomatic or trade

connections, but the amount of physical labour her body performed suggests that she was working class or in a position of servitude. There are surviving records from the late-medieval period, originally developed for the purposes of taxing 'aliens' in the city, that describe residents of London as coming from countries around the world. These include India, Greece and Scandinavia, and record nearly 500 foreign-born servants. The most prominent settlers were Italian merchants from the major cities of Genoa, Venice and Florence.[31] The Italians, along with other individuals connected to southern Europe, may have been accompanied by black African servants. Italian mercantile cities traded frequently with the Islamic Caliphate, and the woman may have come north from sub-Saharan regions and been sold into servitude in the Mediterranean.

The Sicilian knight Roger de Lyntin is recorded in AD 1259 as searching for his 'Ethiopian slave' who had escaped and was on the run.[32] Black African servants were used as outward displays of wealth and influence; the spoils of international trade with exotic countries. Did the woman buried in East Smithfield arrive with Italian merchants, or did she find another route to London? We cannot know for sure, but her presence, and those of so many others of different backgrounds and ethnicities, remind us that places like medieval London were complex, diverse, cosmopolitan, and experienced many of the issues and divisiveness which comes with that. The city was also a melting pot in terms of gender and sexuality.

Discovery!

1995 – Corporation of London Records Office, London, England

Following the suggestion of fellow medievalist Sheila Lindenbaum, Ruth Mazo Karras is unfurling a roll of vellum containing the Plea and Memoranda for London in the year 1395 – a comprehensive set of records for legal trials held by the mayor of the city.[33] On the second membrane she finds an unexpectedly long entry.

The official versions of these medieval texts, published in the 1920s and 1930s by A. H. Thomas in his *Calendar of Select Pleas and Memoranda of the City of London*, include one simple sentence in place of this lengthy document. Thomas recorded this case as an 'examination of two men charged with immorality, of whom one implicates several persons, male and female, in religious orders.'[34] The authoritative edition of these documents has hidden any references to sexual acts – a sign of contemporary anxieties around sexuality rather than medieval ones. But, as Ruth Mazo Karras discovers, the unedited full entry provides startling new insights into one person's life, their experiences as a sex worker, and the social challenges they faced in terms of sexuality and gender.[35]

The original report talks of both a John Rykener and an Eleanor Rykener. I will refer to them as Eleanor – the name they chose for themselves.[36] On the first Sunday of December 1394, at around 9pm, officers of the city of London claimed they found two men lying together over a stall in Soper Lane, Cheapside, 'doing the most nefarious and ignominious vice.'[37] It was an area associated with prostitution, as the street names Gropecunt and Popkirtle Lane testify.[38] Eleanor and Yorkshireman John Britby were both arrested and brought in front of the Mayor of London, with 'John Rykener, calling [himself] Eleanor, having been detected in woman's clothing.'

Eleanor was arrested for performing a sex act with a man while dressed as a woman. Their testimony went on to describe years of cross-dressing, as well as homosexual and heterosexual encounters with men, women, clerics and nuns, sometimes under the guise of a seamstress or barmaid, and other times dressed as a man. The case reveals aspects of the medieval past in a way that few others can.

The first two decades of our twenty-first century have seen discussion on gender and sexuality taking centre stage both in academia and in public discourse. The transgender rights movement has campaigned for clarification on legal status and protection from discrimination and violence, arguing that trans rights are human rights. While it might seem that these issues are a new phenomenon, gender nonconformity has ancient roots. Sumerian documents from over 4,500 years ago refer to the 'gala' – priests

who tended to the shrines of the goddess Inanna, and were described as neither male nor female.[39] A burial from Prague, dated to the third millennium BC, was discovered to contain a male skeleton dressed in female clothes.[40] The Roman Emperor from AD 218–22, Elagabalus, was referred to by female pronouns and reputedly requested gender reassignment surgery.[41] And the attendant to Empress Theodora, Anastasia the Patrician, fled from court and spent 28 years dressed as a male monk in Egypt.[42]

Like the Birka Warrior Woman, these individuals all presented in ways that challenged societal norms regarding gender. But without any personal written testimonies, determining exactly how they self-identified in terms of sexuality may be impossible today. The only records we have of non-heterosexual behaviour are from legal texts, which documented the interrogation of suspects for acts that subverted societal norms.[43] These are highly biased, using condemnatory language to refer to the individual and their behaviours. The survival of Eleanor's record is extremely rare. In their testimony we gain glimpses into behaviour and actions, how they were perceived at the time, and what they reveal more broadly about gender and sexuality in medieval London.

Transvestite, Transgender, Nonbinary?

Retrospectively applying terms that have only recently been defined to describe individuals from the past is problematic, since they themselves would not have had these frames of reference. Even today, labels and pronouns aren't always adequate to describe the multifaceted nature of identity and sexuality. Trans activist Leslie Feinberg, writing at the end of the 1990s, expresses this from her perspective:

Are you a guy or a girl? I've heard this question all my life. The answer is not so simple, since there are no pronouns in the English language as complex as I am, and I do not want to simplify myself in order to neatly fit one or the other.[44]

But we don't need our terminology to overlap exactly in order to understand that the medieval world wasn't quite as binary as we might imagine. Unlike the female skeleton from Birka or the male remains from Prague, we do have an account of Eleanor's life in their interrogation by the Mayor of London. Just as with the Cathar women, whose testimonies were gathered under pressure and torture, Eleanor's account may have been adapted, changed and exaggerated. Certainly, they delivered their testimony in English, which was then translated into Latin, so elements may have been lost in translation. But the trial record highlights issues of gender and sexuality, and reveals moments of Eleanor's life where they identified as male and other times as female.

Eleanor was arrested for acts of sodomy and prostitution, but it doesn't seem that they were prosecuted for either crime. The legal boundaries are unclear, since sex workers were rarely arrested in fourteenth-century London, and while it was investigated by the church, sodomy was not a common-law crime.[45] Certainly the mayor's court was not fit to hear either case.[46] But Eleanor's testimony implicated a range of people, including members of the clergy, monks and nuns. This suggests that, rather than being concerned with either the prostitution or sodomy, the mayor's court was focused on what Eleanor could tell them about moral corruption by high-status individuals. There is also the implication that Eleanor behaved with dishonesty and deception. They were selling sex to clients while also pretending honest work as an embroiderer and barmaid, not to mention deceiving male clients by dressing as a woman. When John Britby was asked about his involvement, he said he thought he had procured a woman. Eleanor promised to provide a service for John after they had 'agreed a price'. Like all cities, London was a place where trade oiled the economic cogs, so to deceive during a transaction could be considered a crime against the city. There was clearly fear of corruption in all types of negotiations.[47]

Eleanor was trained in prostitution by 'a certain Anna', whose name suggests she was a prostitute from the Low Countries. They were then then taken in by a woman named Elizabeth Brouderer

Interrogation of Eleanor Rykener at the Guildhall, London, 1394–1395, Corporation of London Records Office, Plea and Memoranda Roll A34, m.2.

(her surname a reference to her work as a seamstress). She has been identified as Elizabeth Moring, who in the 1380s was tried for running a brothel and luring girls to prostitute themselves through the offer of apprenticeships in embroidery.[48] Eleanor seems to have been trained in both arts and successfully worked as seamstress and prostitute during the summer of 1394 in Oxford and Beaconsfield. The claims of deception continued as Eleanor described how Elizabeth would first introduce clients to her own daughter Alice 'at night without light'. They are then sent to bed in the dark, but when they woke, Eleanor would be revealed as the woman they had slept with.

The record of the trial includes a list of people Eleanor had sex with and how much they paid, including three scholars in Oxford,

two Franciscans – one of whom gave a gold ring in payment – and six 'foreign men' who paid between twelve pence and two shillings for 'the above-said vice'. Eleanor also states that they had sex with a woman called Joan in Beaconsfield, and with 'many nuns' while dressed as a man. They make no mention of payment for encounters with women, but Eleanor does specify that they 'accommodated priests more readily than other people because they wished to give more [in payment] than others'. This implies that the mayor's court was probing the financial workings of these interactions. There is clearly a political and economic, as well as moral, backdrop to the Eleanor Rykener trial.[49]

King Richard II had only just returned control of London to the mayor, having stripped the city of its civil liberties two years earlier on accusations of misgovernance. And just weeks after Eleanor's case was heard, the 'Twelve Conclusions of the Lollards' were nailed to the doors of Westminster Abbey and St Paul's Cathedral. The third conclusion opposes sodomy among the clergy, so a sense of moral outrage was rife in London. There is a distinctly moralising tone in the pleas entered alongside Eleanor's, with the previous and subsequent accounts requesting support for debt repayments and property ownership, all presented as issues requiring the just hand of the court. These pleas suggest that society was still reeling from the Black Death and the city was in need of reform.[50] It was the duty of the mayor to use a heavy hand to bring about much-needed change.

Three types of social anxiety permeate the trial: fear of women traders, whose numbers had increased after the plague; fear of immoral members of the church; and fear of foreigners or 'aliens'. Eleanor's case should be seen against a backdrop of social unrest, and of complicated financial and political relations between city, mayor and king. Just ten months before the arrest, a curfew of 8pm had been imposed on 'aliens' in the city. It was a response to a rise in violent crime, as described in a writ recorded in the City Letters Book:

Many men have been slain and murdered, by reason of the frequent resort of, and consorting with, common harlots, at

taverns, brewhouses of huksters . . . we do by our command forbid, on command of our Lord the King, and the Mayor and Aldermen of the city of London, that any such women shall go about or lodge in the said city, or in the suburbs thereof, by night or day.[51]

Eleanor was caught with John Britby between 8pm and 9pm, which is perhaps legally more significant than either the sodomy or the prostitution. They had broken curfew, and Britby was an 'alien' from Yorkshire. But the court seemed unsure how to apply these rules to a man dressed as a woman, as no outcome for the case is recorded, which is very unusual. Did the court not know whether to prosecute Eleanor as a woman for prostitution, or as a man for sodomy? Was the trial a means of reflecting the mayor's intention to morally reform the City of London? It has even been suggested that the whole case was a form of political satire, with Eleanor representing King Richard II. The case is complex, but the fact that Eleanor could pass as a woman in different types of employment suggests they were not just cross-dressing, but also performed gendered behaviour.[52]

Eleanor's trial remains the only surviving legal document from late-medieval England to document same-sex intercourse, and throughout the transcript it seems the scribes were struggling to find suitable terms to express the sexual and gendered aspects of the case.[53] There is evidence that women were also cross-dressing as men in late-medieval London, with 13 cases documented between 1450 and 1553.[54] Eleanor was not the only person cross-dressing, although their trial records suggest it was the dishonesty in trading, breaking of curfew with an 'alien' and the immorality of the church members that were of greater concern to the representatives of the city than their gender nonconformity.

Today Eleanor might be described as a sex worker, and as transvestite, transexual or transgender. But none of these terms would have been clear to Eleanor themselves. Prostitution was considered an act performed only by women, and sodomy only by men, while bisexuality and transvestitism are terms that don't appear in

medieval texts. Eleanor would have known they inhabited a marginal and transgressive world, where they subverted societal norms.[55] While aspects of the case remain uncertain, Eleanor Rykener's testimony shines a dim yet important light on attitudes and behaviour among some parts of fourteenth-century London's population. As with the East Smithfield excavation, their trial reveals a city populated by diverse, complicated, fascinating people, and helps to reconstruct a version of the medieval period that has not been flattened or sanitised; one more like the complex societies we live in today.

Final Thoughts

I had not anticipated how much writing this book would change my own perceptions of a period I have dedicated my academic life to. Like so many others, I have been led by generations of historians before me, their contemporary agendas often presented in the guise of empirical truths. I have tried a different, but similarly loaded, approach in this book, putting the spotlight on women. It is no less biased, and is representative of the time in which I am writing. But by re-examining extraordinary women like Hildegard and Margery, casting a new light on over-written females like Æthelflæd and Jadwiga, and using recent discoveries to reconstruct lost individuals like the Loftus Princess and Birka Warrior Woman, the medieval world has taken on a different complexion.

It is an exciting time to be a medievalist and a historian. The digital revolution has transformed how we engage with evidence and conduct international research. Technology and scientific developments allow us to see through layers of soil without picking up a trowel, and reconstruct the faces of people from the past. Access to archives means we can discover the women who walked where we do now. They feel less like distant echoes and more like neighbours who once shared our streets, buildings and landscapes. Every day the internet throws up new discoveries, fresh approaches and challenges to the way we interact with

history. As movements like Black Lives Matter, #MeToo, the fight for transgender rights and an ever-growing number of suppressed voices rise up to capture attention across the world, so we must adjust how we have traditionally engaged with the past.

This is just the start of the conversation. These few women I present to you here are part of a silent majority, with many more voices waiting to be heard. As this book ends, so you can take up the journey of discovery. Go into your local library, visit village museums, read gravestones, walk into churches, explore outlines in fields, search the internet for records, share your findings with others, and open your eyes to the vast body of evidence that history has laid down all around us.

Read texts, look at artworks, examine archaeological finds, draw up statistics or peer through a microscope. It doesn't matter which disciplinary approach you favour, as all subjects have a past, whether it's mathematics, biology, anthropology or art history. Scrutinise how you have been taught, ask questions about what stories you're *not* hearing and push outside of comfort zones in search of less well-trodden paths. We are all responsible for how people in the future will interpret the historic times we are living through. But first, we need to look backward to understand where we are now and create the future we want to see. These medieval women changed the times they lived through and left echoes of their lives for us to uncover centuries later. Every one of us is part of the ever-shifting passage of history. It is our responsibility to think about how we want it recorded and remembered.

Acknowledgements

This book has taken years to write, but even more to percolate, contemplate and ruminate. There are so many who have played a part in its slow evolution. Greatest thanks go to those mentors that started the journey with me and put me on this path. Vincent Gillespie, Heather O'Donoghue, Sally Mapstone and Eddie Jones. Without you I wouldn't have realised my passion for the medieval period. Those at the Centre for Medieval Studies, York, where you fanned the flames and introduced me to the joys of interdisciplinary study. Elizabeth Tyler, Matt Townend, Katy Cubitt, Tim Ayers, Lucy Sackville, Sarah Brown, Nicola MacDonald, Alice Cowen, Sarah Rees-Jones, Julian Richards, Martin Carver, Richard Marks and Christopher Norton. Particular love and thanks to the two women that gave me my academic wings: Jane Hawkes and Mary Garrison.

Colleagues, friends and students have all contributed so much to helping me learn and grow. Those at the Department of History of Art, York; Jeanne Neuchterlein, Michael White, Jason Edwards, Anthony Geraghty, Amanda Lillie, Jo Applin, Megan Boulton and Andrew Wilkinson. You remain the greatest support. Thanks to the Department of History of Art, Warwick University; Jenny Alexander, Louise Bourdua, Rosie Dias, Michael Hatt, Paul Smith, Claire Nicholls, Louise Campbell, Julian Gardner, Michael Rosenthal and Julia Brown. To colleagues from the Departments of History and Archaeology at the University of

Winchester, including Ryan Lavelle, Barbara Yorke, Michael Hicks and Carolyn Esser. And to my past and current home, the University of Oxford. So many thanks to everyone that has helped me on my path. Jonathan Michie, Sandie Byrne, Alison MacDonald, Yasmin Khan, Jonathan Healey, Kristine MacMichael, Mary Acton, Patrick Doorly, Jan Cox, Gill White, Hubert Pragnell, Manya Pagiavla, Oliver Gosling, Tony Buxton, Bryony Leighton, Christina Allen, John Ballam, Elizabeth Gemmill, Tom Buchanan, David Griffiths, Geraldine Johnson, Gervase Rosser, Adrian Stokes, Tara Stubbs, Paul Barnwell, Carly Watson, Hazel Arrandale, Claire Kelly, Claire O'Mahony. To those in my new collegiate home, Harris Manchester College, Linda Hulin, Lesley Smith, Jane Shaw and Kate Wilson. TORCH and all the amazing work you do, especially Victoria McGuiness, Marcus du Sautoy and Oliver Cox. Members of the Bodleian Library and Ashmolean Museum, especially Sarah Holland. Sally Dormer and Bryony Smith at the V&A. And dear friends Peter Frankopan and Martin Kemp – what would I do without you. Rebecca Henderson, how I wish you were still here. Two of my biggest influences are also no longer with us. Cathy Oakes and Angus Hawkins, I owe you everything.

To my DPhil students: you carry the flame onwards, Sez Maxted, Elodie Noel and Melena Meese. To all those students that have taught me, including those from the Berkeley/UNC Summer Schools, Exeter College Programmes, Certificate and Diploma in History of Art, OUDCE and more. To my friends at NSEAD, Michelle Gregson and Rachel Payne. Those at the AHRC who have supported my work and continue as valued colleagues. All the Pantheons and St Paul's Cathedral team. My incredible colleagues at Gloucester History Festival and University of Gloucestershire, especially Sarah Smyth, Sarah Rawlings, Jacqui Grange, Richard Graham, John Lovell, Christian O'Connell, Jason Smith, Candia McKormack, Jo Durrant, Mhairi Smith, Donna Renney, Andrew Armstrong (especially for the help with Æthelflæd) and so many more. Michelle Castelletti and all at the Oxford Festival for the Arts. Emma Griffin and the Royal Historical Society. Colleagues

and friends at the Royal Society of Arts, Thames Landscape Trust, Stained Glass Protection Society, Art History in Schools, Association for Art History, WEA, Climate Coalition and all the organisations I feel so honoured to support. Team Dr J. – the best people – Christy, Margy, Rich, Adele, Rebecca, Robert, Wayne, Angelica, Luna, Andrew, Marky and Kaz. Special love to St Bernard's Convent School, Sister Mary Stevens, Mr Walsh and everyone that inspired me, especially my History and English teachers. Stephanie Boylan, you know you are the reason.

I have had the honour to work with so many amazing teams and individuals in my media work, including Alleycats, Oxford Film and Television, Tin Can Island, HistoryHit, Sky History and colleagues in the BBC. Dan Morelle, thank you always. Special thanks to Mark Bell, Jonty Claypole, Cassian Harrison, Richard Klein, Emma Parkins and Emma Cahusac. Ted White, thanks for discovering me. Mary West, thank you for saving me. Now come the invaluable friends. My St B's lot – I love you forever. Alexa Frost, Melanie Kendry, my tribe – Nina, Dave, Marc and Lou – Cait and Philip Selway, Woodstock friends, you light up my life every day. Alice Roberts, how did I ever cope without you? Waldemar Januszczak, my long-lost brother, and Yumi. Mary Rambaran-Olm, Anne Fletcher, Annie Gray, Hannah Greig, Kate Lister, Cat Jarman, Natalie Pithers, Antonia Wawira, Richard Herring, Catie Wilkins, Alison Daniel, Anita Anand, Iszi Lawrence, Russel Haines, Satwinder Sehmi, Lilley Mitchell, Jóhanna Katrín Friðriksdóttir, Levi Roach, Ella Al-Shamahi, Emma Wells, Hannah Fry, Robin Gibbons, Phil Weir, Lachlan Goudie, Caitlin Green, Danny Wallace, Jenny Colgan, Jonathan Green, Lisa Westcott Wilkins, Emma Dabiri, Jakub Krupa, Patricia Lovett, Averil Cameron, Krissi Murison, James Holland, Francesca Stavrakopoulou, Anne Thériault, Deborah Harkness, Al Murray, Katie Hall and Sarah Churchwell. Bettany Hughes, Mary Beard, Simon Schama, Frank Cottrell-Boyce, Cerys Matthews, David Olusoga, Greg Jenner, Muriel Gray, Emma Baysal, Stewart Lee, Rebecca Rideal, Jonathan Green, Chris Riddell, Amber Butchart, Helen Carr, Chris and Xand van Tulleken, David

Acknowledgements

Aaronovitch, Olivette Otele, Simon Sebag-Montefiore, Anita Rani, Justin Pollard, Kate Williams, Kate Wiles, Gryff Rhys-Jones, Shrabani Basu, Alex von Tunzelmann, Neil Gaiman, Eleanor Parker, Robin Ince, Helen King, Jim Peters, Sona Datta, Mark Gattis, Dan Snow, Lindsey Fitzharris, Philip Pullman, Susie Dent, Ben Garrod, Tony Robinson, Dan Jones, Suzannah Lipscomb, Greg James, Julian Harrison and the British Library, Lucy Worsley, Stephen McGann, Heidi Thomas, Adam Rutherford, Michael Scott, Bendor Grovsenor, Lars Tharp, Andrew Graham-Dixon, Edgar Wright, Giles Kristian, Anna Whitelock, Marc Morris, Jonathan Foyle, Stephanie Merritt, Sue Brunning and the British Museum, Michael Rosen, Paul Carney, Saul David, James and Tom Holland, Bobby Seagull, Jacky Klein, Joanne Harris, Helen Czerski, Fern Riddell, Frank Skinner, Joanna Paul, Frank McDonough, Marina Amaral, Sharon Bennett Connelly, Eleanor Janega, Helen Castor, Jessie Childs, Hallie Rubenhold, Sam Willis, Kate Mosse, The Singh Twins, Adrian Utley, Samira Ahmed, and my travel buddy, Alistair Sooke. I'm sure I've missed some wonderful people, but I feel so honoured to have such incredible people in my life.

David Musgrove gets a special thank you for finding emergency medieval material. Antonia Hoyle for medical advice. Michael Wood for all things Æthelflæd. Steve Sherlock, Terje Gansum, Marianne Moen and many others for personal insights and access to articles. Florence of Northumbria for your tireless work putting medieval women out there. Magdalena Szalewska for all her help with research. My agent and partner through life, Rosemary Scoular. You're incredible. Natalia Lucas, Aoife Rice and Matt Baker too – thank you. To my family. Uncle Eugene, I miss you every day, and my heart remains with Lauren and Marion. Cioc, Uncle A and all the Rozyckis, you are amazing. My Mum, Dad, Tom, Carole, Effie and Maggie, I love you. Dan, Kuba, Kama – my world. Finally, the greatest thanks are due to Lucy Oates, Ana Fletcher, Suzanne Connelly, Tess Henderson, Jessica Patel, Caroline Butler and the team at WH Allen and Penguin Random House. Thank you for trusting me. Thank you for helping me. Thank you for seeing that this book needed to be written.

Endnotes

Preface

[1] Marc Morris, *The Anglo-Saxons: A History of the Beginnings of England* (Hutchinson, 2021), p. 4.

Introduction

[1] On the authenticity of the scarf now displayed in the Houses of Parliament, see Michael Tanner, *The Suffragette Derby* (Robson Press, 2013), pp. 278–9.

[2] Ann Morley and Liz Stanley, *The Life and Death of Emily Wilding Davison* (The Women's Press, 1988), p. 103.

[3] Dianne Atkinson, *Rise up, Women! The Remarkable Lives of the Suffragettes* (Bloomsbury, 2018), p. 255.

[4] Emily Davison, 'The Price of Liberty', *The Suffragette* (5 June 1914), p. 129.

[5] Carolyn Collette, ' "Faire Emelye": Medievalism and the Moral Courage of Emily Wilding Davison', *The Chaucer Review*, Vol. 42, No. 3 (2008), pp. 223–243.

[6] Elizabeth Crawford, *The Women's Suffrage Movement: A Reference Guide 1866–1928* (UCL Press, 2003), p. 159.

[7] Carolyn P. Collette, 'Hidden in Plain Sight: Religion and Medievalism in the British Women's Suffrage Movement', *Religion and Literature*, Vol. 44, No. 3 (2012), pp. 169–75.

8 John Sleight, *One-Way Ticket to Epsom: A Journalist's Enquiry into the Heroic Story of Emily Wilding Davison* (Bridge Studios, 1988), p. 22.

9 Robin Blaetz, *Visions of the Maid: Joan of Arc in American Film and Culture* (University of Virginia Press, 2001), pp. 7–11.

10 Mary Dockray-Miller, 'Why Did the Suffragists Wear Medieval Costumes?', JSTOR Daily (4 March 2020), https://daily.jstor.org/why-did-the-suffragists-wear-medieval-costumes/

11 Liz Stanley and Ann Morley, *The Life and Death of Emily Wilding Davison* (The Women's Press, 1988), p. 10–11.

12 Carly Silver, 'The Amazons were More than a Myth: Archaeological and Written Evidence for the Ancient Warrior Women', *ATI* (29 July 2019), https://allthatsinteresting.com/amazon-women

13 Davison, 'The Price of Liberty', p. 129.

14 *The Morpeth Herald* (20 June 1913).

15 Alexandra Barratt, 'Julian of Norwich and Her Children Today: Editions, Translations and Versions of her Revelations', in eds. Sarah Salih and Denise N. Baker, *Julian of Norwich's Legacy: Medieval Mysticism and Post-Medieval Reception* (Palgrave Macmillan, 2009), pp. 13–29.

16 Fr John Julian, *The Complete Julian of Norwich*, 3rd edition (Paraclete Press, 2011), p. 7.

17 Rowan Williams, *The Anti-Theology of Julian of Norwich,* The 34th Annual Julian Lecture (The Friends of Julian, 2014), p. 1.

18 Avner Shamir, 'Early Reformation Book Burning and Persuasion', *Historisk Tidsskrift*, Vol. 110, No. 2 (2011), pp. 338–57.

19 Denys Turner, ' "Sin is behovely" in Julian of Norwich's *Revelations of Divine Love*', *Modern Theology*, Vol. 20, No. 3 (2004), pp. 407–22.

20 Peter Ackroyd, *The Life of Thomas More* (Anchor Books, 1999), p. 147.

21 Liam Temple, ' "Have We Any Mother Juliana's Among Us?" The Multiple Identities of Julian of Norwich in Restoration England', *British Catholic History*, Vol. 33, No. 3 (2017), pp. 383–400.

22 Peter Lake, 'Anti-Popery: The Structure of a Prejudice', in eds. Richard Cust and Ann Hughes, *Conflict in Early Stuart England:*

Studies in Religion and Politics, 1603–1642 (London, Longman, 1989), pp. 72–106.

23 Leland Royce Harper, 'Attributes of a Deistic God', in *Multiverse Deism: Shifting Perspectives of God and the World* (Rowman and Littlefield, 2020), pp. 47–68.

24 Carter Lindberg, 'Legacies of the Reformation', in ed. Carter Lindberg, *The European Reformation Sourcebook* (Malden, Blackwell Publishing, 2000), p. 261.

25 Martin Luther, *Lectures on Genesis 3:11*, and John Calvin, 'A Sermon of M. John Calvin upon the Epistle of Saint Paul to Titus'. Widely available online.

26 Phillip Alfred Buckner, *Rediscovering the British World* (Calgary University Press, 2005), p. 137.

27 C. Willett Cunnington, *English Women's Clothing in the Nineteenth Century: A Comprehensive Guide with 1,117 Illustrations* (Dover Publications, 1990), p. 20.

28 William Acton, *The Functions and Disorders of the Re-productive Organs in Youth, in Adult Age, and in Advanced Life, considered in their Physiological, Social, and Moral Relations*, 4th edition (John Churchill and Sons, 1865); first published in 1857, held by British Library, shelf mark: 7640.g.8, pp. 113–4. Thanks to Sez Maxted for this reference.

29 Thomas Carlyle, *On Heroes, Hero-worship, & the Heroic in History* (D. Appleton & Co., 1841), p. 34.

30 *Ibid*, p. 15.

31 Diane Watts, *Women, Writing and Religion in England and Beyond: 650–1100* (Studies in Early Medieval History, Bloomsbury, 2019), p. 4.

32 J. C. Chan, 'Medievalists, Recoiling from White Supremacy, Try to Diversify the Field', *The Chronicle of Higher Education* (16 July 2017).

33 Eleanor Ainge Roy, Harriet Sherwood and Nazia Parveen, 'Christchurch attack: Suspect had White-Supremacist Symbols on Weapons', *Guardian* (15 March 2019).

34 Bruce Holsinger, 'Neomedievalism and International Relations', in ed. L. D'Arcens, *The Cambridge Companion to Medievalism* (Cambridge University Press, 2016), pp. 165–179.

35 V. A. Kolve, 'Ganymede/Son of Getron: Medieval Monasticism and the Drama of Same-Sex Desire', *Speculum*, Vol. 73, No. 4 (1998), pp. 1014–1067.

Chapter 1

1 Jessica Fay, 'Wordsworth's Northumbria: Bede, Cuthbert and Northern Medievalism', *The Modern Language Review*, Vol. 111, No. 4 (2016), pp. 917–35.
2 Stephen Sherlock, 'Space and Place: Identifying the Anglo-Saxon Cemeteries in the Tees Valley, North-East England', in eds. Chantal Bielmann and Britany Thomas, *Debating Religious Space and Place in the Early Medieval World* (Sidestone Press, 2018), pp. 93–110.
3 Timothy Darvill, *Prehistoric Britain* (Routledge, 2009), p. 146.
4 B. E. Vyner et al, 'The Street House Wossit: The Excavation of a Late Neolithic and Early Bronze Age Palisaded Ritual Monument at Street House, Loftus, Cleveland', *Proceedings of the Prehistoric Society*, Vol. 54 (Cambridge University Press, 1988), pp. 173–202.
5 Stephen J. Sherlock, 'The Reuse of "Antiquities" in Conversion Period Cemeteries', *Medieval Archaeology*, Vol. 60, No. 2 (2016), pp. 242–65.
6 Robert Christy Totten, *The Bible Significance of East and West; or, Is the Dawn Appearing?* (Palala Press, 2018).
7 Sarah Semple and Howard Williams, 'Landmarks of the Dead: Exploring Anglo-Saxon Mortuary Geographies', in eds. Martyn Clegg Hyer and Gale R. Owen Crocker, *The Material Culture of the Built Environment in the Anglo-Saxon World* (Liverpool University Press, 2015), pp. 137–161.
8 Stephen J. Sherlock, *A Royal Anglo-Saxon Cemetery at Street House, Loftus, North-East Yorkshire*, Tees Archaeology Monograph Series, Vol. 6 (Hartlepool, 2012), p. 114–5.
9 Stephen J. Sherlock and Martin G. Welch, *An Anglo-Saxon Cemetery at Norton, Cleveland*, CBA Research Report 82 (Council for British Archaeology, 1992).

10 Chris Fern, Tania Dickinson and Leslie Webster, *The Stafford-shire Hoard: An Anglo-Saxon Treasure*, Research Report of the Society of Antiquities of London, Vol. 80 (2019), p. 1.

11 David A. Hinton and Robert White, 'A Smith's Hoard from Tattershall Thorpe, Lincolnshire: A Synopsis', *Anglo-Saxon England*, Vol. 22 (1993), pp. 147–66.

12 Richard Abels, 'What Has Weland to Do with Christ? The Franks Casket and the Acculturation of Christianity in Early Anglo-Saxon England', *Speculum*, Vol. 84, No. 3 (2009), pp. 549–81.

13 Patrice Silber, 'Gold and its Significance in *Beowulf*', *Annuale Medievale*, Vol. 18 (1977), pp. 5–19.

14 John Tanke, '*Beowulf*, Good-Luck and God's Will', *Studies in Philology*, Vol. 99, No. 4 (2002), pp. 356–79.

15 Lloyd Laing, 'Romano-British Metalworking and the Anglo-Saxons', in ed. Nick Higham, *Britons in Anglo-Saxon England* (Boydell & Brewer, 2007), pp. 42–56.

16 Alan M. Stahl, 'The Nature of the Sutton Hoo Coin Parcel', in eds. Calvin B. Kendall and Peter S. Wells, *Voyage to the Other World: The Legacy of Sutton Hoo* (University of Minnesota Press, 1992), pp. 3–14.

17 R. Avent and D. Leigh, 'A Study of the Cross-Hatched Gold Foils in Anglo-Saxon Jewellery', *Medieval Archaeology*, Vol. 21 (1977), pp. 1–46.

18 Angus Hector McFadyen, *Aspects of the Production of Early Anglo-Saxon Cloisonné Garnet Jewellery* (Unpublished PhD thesis, Manchester Metropolitan University, 1998), p. 121–145.

19 Sally Crawford, 'Votive Deposition, Religion and the Anglo-Saxon Furnished Burial Ritual', *World Archaeology*, Vol. 36, No. 1 (2004), pp, 87–102.

20 Helen Geake, 'The compleat Anglo-Saxonist: Some New and Neglected Early Anglo-Saxon fish for Andrew Rogerson', in eds. Steven Ashley and Adrian Marsden, *Landscapes and Arte-facts: Studies in East Anglian Archaeology Presented to Andrew Rogerson* (Archaeopress, 2014), pp. 113–122.

21 Janet L. Nelson, 'The Dark Ages', *History Workshop Journal*, Vol. 63, No. 1 (2007), pp. 191–201.

22 Nicholas Perkins, 'Biblical Allusion and Prophetic Authority in Gildas's *De excidio Britanniae*', *The Journal of Medieval Latin*, Vol. 20 (2010), pp. 78–112.

23 Ethan Doyle White, 'The Goddess Frigg: Reassessing an Anglo-Saxon Deity', *Preternature: Critical and Historical Studies on the Preternatural*, Vol. 3, No. 2 (2014), pp. 284-310.

24 Stephen Pollington, 'The Mead-Hall: Fighting and Feasting in Anglo-Saxon Society', *Medieval Warfare*, Vol. 2, No. 5 (2012), pp. 47–52.

25 Sarah Foot, 'The Making of *Angelcynn*: English Identity Before the Norman Conquest', *Transactions of the Royal Historical Society*, Vol. 6 (1996), pp. 25–49.

26 Gregory of Tours, *History of the Franks*, Book 3, chapter 18, ed. Lewis Thorpe (Penguin Classics, 1974).

27 Angela Care Evans, *The Sutton Hoo Ship Burial* (British Museum Press, reprinted 2000), p. 9.

28 Bede, *Ecclesiastical History*, Book II, Chapter 15. All references to Bede are from *Ecclesiastical History of the English People*, trans. L. Shirley-Price, revised edition D. H. Farmer (Penguin Classics, 1990).

29 Ross Cowen, *Milvian Bridge AD 312: Constantine's battle for Empire and Faith* (Osprey, 2016), p. 68.

30 *Gregorii I Papae Registrum Epistolarum*, ed. Paulus Ewald and Ludovicus Hartmann (Weidmann, 1887–91), Monumenta Germaniae Historica (MGH), 123–24, ep.II.35.

31 Bede, *Ecclesiastical History*, Book 1, Chapter 25.

32 Jane Hawkes, 'Stones of the North: Sculpture in Northumbria in the "Age of Bede"', in eds. J. Ashbee and J. Luxford, *Northumberland: Medieval Art and Architecture*, BAA Conference Transactions (Maney Publishing, 2013), pp. 34–53.

33 John P. Blair, *The Church in Anglo-Saxon Society* (Oxford University Press, 2005), p. 61 notes that the first published account states they were found in nearby St Augustine's Abbey.

34 Mary Carruthers, *The Book of Memory: A Study of Memory in Medieval Culture* (Cambridge University Press, 2008), pp. 195–234.

35 Bettany Hughes, *Venus and Aphrodite: History of a Goddess* (Weidenfeld & Nicolson, 2019), p. 7.

36 Robin Couzin, 'Syncretism and Segregation in Early Christian Art', *Studies in Iconography*, Vol. 38 (2017), pp. 18–54.

37 R. A. Markus, 'Gregory the Great's Europe', *Transactions of the Royal Historical Society*, Vol. 31 (1981), pp. 21–36.

38 J. C. Mann, 'The Division of Britain in 197 AD', *Zeitschrift Für Papyrologie Und Epigraphik*, Vol. 119 (1997), pp. 251–254.

39 Sam Lucy, *Burial in Early Medieval England and Wales*, The Society for Medieval Archaeology Monographs, 17 (2002), pp. 1–24.

40 Helen Geake, *The Use of Grave-Goods in Conversion Period England, c. 600–850* (British Archaeological Reports Series, 1997), p. 237.

41 Howard Williams, *Death and Memory in Early Medieval Britain*, (Cambridge University Press, 2006), pp. 100–103.

42 Clare Stancliffe, 'Cuthbert and the Polarity between Pastor and Solitary', in eds. Gerald Bonner, David Rollason and Clare Stancliffe, *St. Cuthbert, his Cult and his Community to AD 1200* (Woodbridge, Boydell & Brewer, 1989), pp. 21-44.

43 Bede, *Prose Life of Saint Cuthbert*, Chapter 9. *The Age of Bede*, trans. J. F. Webb, ed. D. H. Farmer (Penguin Classics, 1998).

44 Helen Appleton, 'The Old English *Durham* and the Cult of Cuthbert', *The Journal of English and Germanic Philology*, Vol. 115, No. 3 (2016), pp. 246–69.

45 Charles C. Rozier, *Writing History in the Community of Saint Cuthbert, 700 AD–1130 AD: From Bede to Symeon of Durham*, (Boydell & Brewer, 2020), pp. 97–142.

46 Bede, *Ecclesiastical History*, Book 2, Chapter 14.

47 John Blair, 'Landscapes of Power and Wealth', in *Building Anglo-Saxon England* (Princeton University Press, 2018), pp. 103–38.

48 Brian Hope-Taylor, *Yeavering: An Anglo-British centre of early Northumbria* (Historic England, 1977), p. 17.

49 Roy Luizza, *Beowulf: A New Verse Translation* (Broadview Press, 1999), p. 311.

50 Bede, *Ecclesiastical History*, Book 4, Chapter 23.

51 R. Daniels, *Anglo-Saxon Hartlepool and the Foundation of English Christianity*, Tees Archaeology Monograph 3 (Oxbow Books, 2007), p. 29.

52 A. Bammesberger, 'A Note on the Whitby Comb Runic Inscription', *Notes and Queries*, Vol. 57, No. 3 (2010), pp. 292–5.

53 G. S. Braddy, 'Deira, Bernicia and the Synod of Whitby', *Cleveland History*, Vol. 87 (2004), pp. 3–13.

54 T. Styles, 'Whitby Revisited: Bede's Explanation of Strenaeshalch', *Nomina*, Vol. 21 (1998), pp. 133–48.

55 Bede, *Ecclesiastical History*, Book 4, Chapter 23.

56 John Blair, *The Church in Anglo-Saxon Society* (Oxford University Press, 2005), p. 212.

57 Sally Crawford, 'Votive Deposition, Religion and the Anglo-Saxon Furnished Burial', *World Archaeology*, Vol. 36, No. 1 (2004), pp. 87–102.

58 Howard Williams, 'Ancient Landscapes and the Dead: The Reuse of Prehistoric and Roman Monuments at early Anglo-Saxon Burial Sites', *Medieval Archaeology*, Vol. 41 (1997), pp. 1–32.

59 Bede, *Ecclesiastical History*, Book 4, Chapter 7.

Chapter 2

1 Ian Randall, 'Queen Cynethryth's "lost" monastery is FOUND', MailOnline (20 August 2021), https://www.dailymail.co.uk/sciencetech/article-9911579/History-Queen-Cynethryth-Mercias-lost-monastery-1-200-years-near-Berkshire-church.html

2 Anna Gannon, *The Iconography of Early Anglo-Saxon Coinage: Sixth to Eighth Centuries* (Oxford University Press, 2003), p. 12.

3 Florence H. R. Scott, 'Cynethryth: Mercia's Forgotten Queen?' *Aelgif-who?* Newsletter No. 1 (2021), https://florencehrs.substack.com/p/cynethryth-mercias-forgotten-queen

4 Christine Rauer, 'Female Hagiography in the Old English Martyrology', in ed. Paul E. Szarmach, *Writing Women Saints in*

Anglo-Saxon England (University of Toronto Press, 2013), pp. 13–29.

5 John Blair, 'Exploring Anglo-Saxon Settlement: In Search of the Origins of the English Village', *Current Archaeology*, Vol. 291 (2014), pp. 12–23.

6 Pauline Stafford, 'Political Women in Mercia, Eighth to Early Tenth Centuries', in ed. Michelle P. Brown and Carol A. Farr, *Mercia: An Anglo-Saxon Kingdom in Europe* (Continuum, 2001), pp. 35–50.

7 Liz James, 'Men, Women, Eunuchs: Gender, Sex and Power', in ed. J. Haldon, *A Social History of Byzantium* (Blackwell, 2009), pp. 31–50, esp. 45–6.

8 Simon Keynes, 'Cynethryth', in eds. M. Lapidge et al, *The Blackwell Encyclopaedia of Anglo-Saxon England* (Blackwell, 1999), p. 133.

9 Frank M. Stenton, *Anglo-Saxon England* (Oxford, Clarendon Press, 1971), p. 223.

10 Norman F. Cantor, *The Civilization of the Middle Ages: a Completely Revised and Expanded Edition of Medieval History, the Life and Death of a Civilization* (HarperCollins, 1993), p. 189.

11 Dorothy Whitelock, *English Historical Documents v. 1 c. 500–1042* (Eyre and Spottiswoode, 1968), pp. 779–80.

12 Alcuin in Dümmler, 1895, no. 61, 62 and 102. Dümmler, Ernst, *Epistolae Karolini aevi, Tomus II*. (Monumenta Germaniae Historica, Epistolarum, Tomus IV) (Weidmann, 1895).

13 Gareth Williams, 'Mercian Coinage and Authority', in eds. Brown and Farr, *Mercia: An Anglo-Saxon Kingdom in Europe*, pp. 210–29.

14 J. R. Maddicott, 'London and Droitwich, c. 650–750: Trade, Industry and the Rise of Mercia', *Anglo-Saxon England*, Vol. 34 (2005), pp. 7–58.

15 Stafford, 'Political Women in Mercia, Eighth to Early Tenth Centuries', pp. 35–50.

16 Damian Tyler, 'An Early Mercian Hegemony: Penda and Overkingship in the Seventh Century', *Midland History*, Vol. 30, No. 1 (2005), pp. 1–19.

17 Philip Grierson and Mark A. S. Blackburn, *Medieval European Coinage* (Cambridge University Press, 1986), pp. 69, 159, 248, 279–80, 576–7, 580.

18 Stafford, 'Political Women in Mercia, Eighth to Early Tenth Centuries', pp. 35–50.

19 John Pickles, *A History of Spaces: Cartographic Reason, Mapping, and the Geo-Coded World* (Taylor & Francis, 2003).

20 Peter Furtado, 'The Histories of Nations and the History of the World', in ed. P. Furtado, *History of Nations: How Their Identities were Forged* (Thames & Hudson, 2014), pp. 10–18.

21 David Dumville, 'The Terminology of Overkingship in Early Anglo-Saxon England', in ed. J. Hines, *The Anglo-Saxons from the Migration period to the Eighth Century. An Ethnographic Perspective* (Boydell & Brewer, 1997), pp. 345–65.

22 Chris Fern and George Speake, 'Helmet Parts, Decorated Silver Sheet, Reeded Strip and Edge Binding', in eds. Chris Fern, Tania Dickinson and Leslie Webster, *The Staffordshire Hoard: An Anglo-Saxon Treasure*, Research Report of the Society of Antiquities in London No. 80 (2019), pp. 70–84.

23 Stephen Pollington, *Tamworth: Capital of the Kingdom of Mercia* (Tamworth Borough Council, 2011), pp. 1–64.

24 Richard Stone, *Tamworth: A History* (Phillimore & Co., 2003), pp. 6–8.

25 Philip Rahtz and Robert Meeson, *An Anglo-Saxon Watermill at Tamworth: Excavations in the Bolebridge Street area of Tamworth, Staffordshire in 1971 and 1978*, CBA Research Report No. 83 (1992), p. 73.

26 Peter Wilcox, *The Gold, the Angel and the Gospel Book* (Lichfield Cathedral, 2011), pp. 16–17.

27 Pamela James, 'The Lichfield Gospels: The Question of Provenance', *Parergon*, Vol. 13, No. 2 (1996), pp. 51–61.

28 Henry Mayr-Harting, *The Coming of Christianity to Anglo-Saxon England* (Pennsylvania State University Press, 1991), p. 89–91.

29 Bede, *Ecclesiastical History*, Book 4, Chapter 3.

30 *Ibid.*

[31] W. Rodwell, 'Lichfield. The Forgotten Cathedral', *Current Archaeology*, Vol. 18, No. 205 (2006), pp. 9–17.

[32] Warwick Rodwell et al, 'The Lichfield Angel: A Spectacular Anglo-Saxon Painted Sculpture', *The Antiquaries Journal*, Vol. 88 (2008), pp. 48–108.

[33] Richard Jewell, 'Classicism of Southumbrian Sculpture', in eds. Brown and Farr, *Mercia: An Anglo-Saxon Kingdom in Europe*, pp. 247–62.

[34] Laura Saetveit Miles, 'The Origin and Development of the Virgin Mary's Book at the Annunciation', *Speculum*, Vol. 89, No. 3 (2014), pp. 632–669.

[35] Janet L. Nelson, 'Carolingian Contacts', in eds. Brown and Farr, *Mercia: An Anglo-Saxon Kingdom in Europe*, pp. 126–146.

[36] Letter from Alcuin to Higbald, Bishop of Lindisfarne. In Dümmler.

[37] Martin Biddle and Birthe Klølbye-Biddle, 'Repton and the Vikings', *Antiquity*, Vol. 66, No. 250 (1992), pp. 36–51.

[38] Jane Roberts, 'Guthlac of Crowland, a Saint for Middle England', *Fursey Occasional Paper*, No. 3 (Norwich, Fursey Pilgrims, 2009), pp. 1–36.

[39] Paolo Squatriti, 'Offa's Dyke Between Nature and Culture', *Environmental History*, Vol. 9, No. 1 (2004), pp. 37–56.

[40] Patricia Healy Wasyliw, *Martyrdom, Murder, and Magic: Child Saints and their Cults in Medieval Europe* (Peter Lang, 2008), p. 78.

[41] Susan J. Ridyard, *The Royal Saints of Anglo-Saxon England: A Study of West Saxon & East Anglian Cults* (Cambridge University Press, 1988), p. 65.

[42] Dawn M. Hadley and Julian D. Richards, 'The Winter Camp of the Viking Great Army, AD 872–3, Torksey, Lincolnshire', *The Antiquaries Journal*, Vol. 96 (2016), pp. 23–67.

[43] Cat Jarman, *River Kings: The Vikings from Scandinavia to the Silk Road* (William Collins, 2021), p. 16.

[44] Martin Biddle and Birthe Kjølbye-Biddle, 'The Repton Stone', *Anglo-Saxon England*, Vol. 14 (1985), pp. 233–92.

45 C. Jarman et al, 'The Viking Great Army in England: new dates from the Repton charnel', *Antiquity*, Vol. 92, No. 361 (2018), pp. 183–199.

46 Richard Abels, 'Royal Succession and the Growth of Political Stability in Ninth-Century Wessex', *The Haskins Society Journal: Studies in Medieval History*, Vol. 12 (2002), pp. 83–97.

47 Gwyn Jones, *A History of the Vikings* (Oxford University Press, 1984), p. 221.

48 David Horspool, *Why Alfred Burned the Cakes* (Profile Books, 2006), p. 2.

49 Lise E. Hull, *Britain's Medieval Castles* (Praeger, 2006), p. xx.

50 Richard Abels, 'Alfred the Great, the *Micel Haeðen Here* and the Viking Threat', in ed. Timothy Reuter, *Alfred the Great*, (Taylor and Francis, 2003), pp. 266–67.

51 Simon Keynes and Michael Lapidge, eds. and trans., *Alfred the Great: Asser's Life of King Alfred and Other Contemporary Sources* (Penguin, 1983), p. 124.

52 Malcolm R. Godden, 'Did King Alfred Write Anything?', *Medium Ævum*, Vol. 76, No. 1 (2007), pp. 1–23.

53 David Pratt, *The Political Thought of King Alfred the Great*, Cambridge Studies in Medieval Life and Thought: Fourth Series. Vol. 67 (Cambridge University Press, 2007), pp. 189–91.

54 Barbara Yorke, 'Alfred the Great: The Most Perfect Man in History?', *History Today*, Vol. 49, No. 10 (1999) pp. 15–17.

55 Edward Freeman, *The History of the Norman Conquest of England: Its Causes and Its Results* (Oxford University Press, 1870), p. 48.

56 Joanne Parker, *'England's Darling': The Victorian Cult of Alfred the Great* (Manchester University Press, 2007), p. ix.

57 Marc Morris, *The Anglo-Saxons: A History of the Beginnings of England* (Hutchinson, 2021), p. 245.

58 Keynes and Lapidge, (eds. & trans.), *Alfred the Great: Asser's Life of King Alfred and Other Contemporary Sources*, chapters 13–15.

59 Simon Keynes, 'England, 700–900', in ed. Rosamond McKitterick, *The New Cambridge Medieval History*, Vol. II (Cambridge University Press, 1995), pp. 18–42.

60 Simon Keynes, 'King Alfred and the Mercians', in eds. M. A. A. Blackburn and D. N. Dumville, *Kings, Currency and Alliances: History and Coinage of Southern England in the Ninth Century* (Boydell Press, 1998), pp. 24–7.

61 Robin Fleming, *Britain after Rome: The Fall and the Rise, 400 to 1070* (Penguin, 2011), pp. 246–8.

62 Maggie Bailey, 'Ælfwynn, Second Lady of the Mercians', in eds. N. J. Higham and D. H. Hill, *Edward the Elder 899–924* (Routledge, 2001), pp. 112–27.

63 Dawn Hadley, *The Vikings in England* (Manchester University Press, 2006), p. 170.

64 *Fragmentary Annals of Ireland*, CELT edition, FA 429, ed. Joan Newlon Radner (Dublin Institute for Advanced Studies, 1978), pp. 169–73.

65 Tim Clarkson, *Æthelflæd, The Lady of the Mercians* (John Donald, 2018).

66 Michael Wood, 'The Annals of Æthelflæd, Lady of the Mercians: Notes Towards an Attempted Reconstruction', publication forthcoming.

67 Pauline Stafford, 'Political Women in Mercia, Eighth to Early Tenth Centuries', pp. 35–50.

68 Carolyn M. Heighway, 'Anglo-Saxon Gloucester to AD 1000', in ed. Margaret L. Gaull, *Studies in Late Anglo-Saxon Settlement* (Oxford University Department for External Studies, 1984), pp. 35–53.

69 Alan Thacker, 'Chester and Gloucester: Early Ecclesiastical Organisation in Two Mercian Burhs', *Northern History*, Vol. 18 (1982), pp. 199–211.

70 Michael Hare, 'The Documentary Evidence for the History of St Oswald's, Gloucester to 1086', in eds. Carolyn Heighway and Richard Bryant, *The Golden Minster: The Anglo-Saxon Minster and Later Medieval Priory of St. Oswald at Gloucester* (CBA Research Report 117, Council for British Archaeology, 1999), pp. 33–45.

71 Marios Costambeys, 'Æthelflæd [Ethelffelda] (d. 918), Ruler of the Mercians', in *Oxford Dictionary of National Biography*, updated regularly online at https://www.oxforddnb.com/

[72] Martin J. Ryan, 'Conquest, Reform and the Making of England', in eds. Nicholas J. Higham and Martin J. Ryan, *The Anglo-Saxon World* (Yale University Press, 2013), pp. 284–322.

[73] See Ian W. Walker, *Mercia and the Making of England* (Stroud, Sutton Publishing, 2000), p. 96.

[74] Thomas M. Charles-Edwards, *Wales and the Britons 350–1064* (Oxford University Press, 2013), pp. 497–510.

Chapter 3

[1] Abigail Bouwman and Frank Rühli, 'Archaeogenetics in evolutionary medicine', *Journal of Molecular Medicine,* Vol. 94, No. 9 (Sept, 2016), pp. 971–77.

[2] Jarunya Samsuwan et al, 'A Method for Extracting DNA from Hard Tissues for Use in Forensic Identification', *Biomedical Reports*, Vol. 9, Issue 5 (September 2018), pp. 433–38.

[3] Charlotte Hedenstierna-Jonson et al, 'A Female Viking Warrior Confirmed by Genomics', *American Journal of Physical Anthropology*, Vol. 164, No. 4 (2017), pp. 853–860.

[4] Neil Price et al, 'Viking warrior women? Reassessing Birka Chamber Grave Bj.581', *Antiquity*, Vol. 93 (2019), pp. 181–98.

[5] Marianne Moen, *Challenging Gender: A Reconsideration of Gender in the Viking Age Using the Mortuary Landscape* (Unpublished PhD thesis, University of Oslo, 2019), p. 2.

[6] Hedenstierna-Jonson et al, 'A Female Viking Warrior Confirmed by Genomics', pp. 853–860.

[7] Lena Holmquist, 'Birka's Defence Works and Harbour – linking one recently ended and one newly begun Research Project', in eds. L. Holmquist, S. Kalmring and C. Hedenstierna-Jonson, *New Aspects on Viking-age Urbanism, c. 750–1100* (Stockholm University, 2016), pp. 35-46.

[8] Charlotte Hedenstierna-Jonson, 'She Came from Another Place: On the Burial of a Young Girl in Birka (Bj 463)', in eds. M. Hem Erikse et al, *Viking Worlds: Things, Spaces and Movement* (Oxbow Books, 2014), pp. 90-101.

9 Martin Ježek, *Archaeology of Touchstones: An Introduction Based on Finds from Birka, Sweden* (Sidestone Press, 2017), p. 7.

10 Fjordor Uspenskij, 'The Baptism of Bones and Prima Signatio in Medieval Scandinavia and Rus', in eds. L. P. Słupecki and J. Morawiec, *Between Paganism and Christianity in the North* (Uniwersytetu Rzeszowskiego, 2009), pp. 9–22.

11 B. Ambrosiani, 'Birka', in eds. S. Brink and N. Price, *The Viking World* (Routledge, 2012), pp 94–100.

12 Bo G. Erikson, *Kungen av Birka: Hjalmar Stolpe arkeolog och etnograf: en bioografi* (Atlantis Publishers, 2015).

13 Martin Carver, 'Burial as Poetry: The Context of Treasure in Anglo-Saxon Graves', in ed. E. M. Tyler, *Treasure in the Medieval West* (York Medieval Press, 2000), pp. 25–40.

14 Nancy L. Wicker, 'Christianisation, Female Infanticide, and the Abundance of Female Burials at Viking-age Birka in Sweden', *Journal of the History of Sexuality*, Vol. 21, No. 2 (2012), pp. 245–62.

15 Mark A. Hall, 'Board Games in Boat Burials: Play in the Performance of Migration and Viking Age Mortuary Practice', *European Journal of Archaeology*, Vol. 19, No. 3 (2016), pp. 439–55.

16 H. Whittaker, 'Game Boards and Gaming Pieces in the Northern European Iron Age', *Nordlit. Tidskrift for kultur og litteratur*, Vol. 24 (2006), pp. 103–12.

17 Marianne Moen, 'Ideas of Continuity: Gender and the Illusion of the Viking Age as Familiar', in eds. Anne Pedersen and Søren M. Sindbæk, *Viking Encounters: Proceedings of the Eighteenth Viking Congress*(Aarhus University Press, 2020), pp. 621–632.

18 David Horspool, *King Alfred: Burnt Cakes and Other Legends* (Harvard University Press, 2006), p. 79.

19 Roberta Frank, 'The Invention of the Viking Horned Helmet', eds. Michael Dallapiazza et al, *International Scandinavian and Medieval Studies in Memory of Gerd Wolfgang Weber* (Hesperides, 2000), pp. 199–208.

20 Magnús Fjalldal, 'The Last Viking Battle', *Scandinavian Studies*, Vol. 83, No. 3 (2015), pp. 317–331.

[21] Roger Manvell and Heinrich Fraenkel, *Heinrich Himmler: The Sinister Life of the Head of the SS and Gestapo* (Skyhorse, 2007), p. 50.

[22] Bill Yenne, *Hitler's Master of the Dark Arts: Himmler's Black Knights and the Occult Origins of the SS*, (Zenith, 2010), p. 134.

[23] Alexandra Service, *Popular Vikings: Constructions of Viking Identity in Twentieth Century Britain* (Unpublished PhD thesis, University of York, 1998), p. 7.

[24] Alice Cowen, *Writing Fire and Sword: The Perception and Representation of Violence in Anglo-Saxon England* (Unpublished PhD thesis, University of York, 2004).

[25] Andrew Wawn, *The Vikings and the Victorians* (D. S. Brewer, 2002) pp. 22–23.

[26] Roberta Frank, 'Viking Atrocity and Skaldic Verse: The Rite of the Blood-eagle', *English Historical Review*, vol. XCIX (1984), pp. 332–43; and Ronald Hutton, *The Pagan Religions of the Ancient British Isles* (Wiley, 1991), p. 282.

[27] Sarah Foot, 'Violence Against Christians? The Vikings and the Church in the Ninth-Century', *Medieval History*, Vol. 1, No. 3 (1991), pp. 3–16.

[28] Sjoerd van Riel, 'Viking Age Combs. Local Products or Objects of Trade?', *Lund Archaeological Review*, Vol. 23 (2017), pp. 163–78.

[29] Judith Jensch, 'Let's Debate Female Viking Warriors Yet Again', Norse and Viking Ramblings (9 September 2017), http://norseandviking.blogspot.com/2017/09/lets-debate-female-viking-warriors-yet.html?m=1

[30] Clare Downham, 'A Context for the Birka Grave Bj 581? Women and Military Leadership in the Tenth Century', in eds. M. Toplak and J. Staecker, *Von Aethelfleda bis Olga. Frauen und Kreigsführung. Die Wikinger Entdecker und Eroberer* (Ullstein Buchverlag, 2019), pp. 151–160.

[31] Joanna Katarzyna Puchalska, '*Vikings* Television Series: When History and Myth Intermingle', *The Polish Journal of the Arts and Culture*, Vol. 15 (2015), pp. 89–105.

[32] Jóhanna Katrín Friðiksdóttir, *Valkyrie: The Women of the Viking World* (Bloomsbury, 2020), pp. 1-19.

[33] L. Mortensen, 'The Marauding Pagan Warrior Woman', in ed. K. A. Pyburn, *Ungendering Civilisation* (Routledge, 2004), pp. 94–117.

[34] Nancy L. Wicker, 'Christianisation, Female Infanticide, and the Abundance of Female Burials at Viking-age Birka in Sweden', *Journal of the History of Sexuality*, Vol. 21, No. 2 (2012), pp. 245–62.

[35] Friðiksdóttir, *Valkyrie*, p. 23.

[36] Ben Raffield, Neil Price and Mark Collard, 'Male-biased Operational Sex Ratios and the Viking Phenomenon: An Evolutionary Anthropological Perspective on Late Iron Age Scandinavian Raiding', *Evolution and Human Behaviour*, Vol. 38, No. 3 (2017), pp. 315–324.

[37] Judith Jensch, *Women in the Viking Age* (Boydell & Brewer, 1991), p. 22.

[38] Kirsten Wolf, 'Transvestitism in the Sagas of the Icelanders', *The 10th International Saga Conference* (University of Trondheim, 1997), pp. 675–84.

[39] From Lee Hollander, *Old Norse Poems* (Columbia University Press, 1936), pp. 57–58.

[40] Friðriksdóttir, *Valkyrie*, p. 6.

[41] Neil Price, *The Viking Way: Magic and the Mind in Late Iron Age Scandinavia* (Oxbow, 2019), p. 192.

[42] *Ibid*, p. 91.

[43] Eldar Heide, 'Spinning Seiðr', in eds. Anders Andrén et al, *Old Norse Religion in Long-Term Perspectives: Origins, Changes, and Interactions* (Nordic Academic Press, 2006), pp. 164–168.

[44] Catrine Jarman et al, 'The Viking Great Army in England: new dates from the Repton Charnel', *Antiquity*, Vol. 92 (2018), pp. 183–99.

[45] T. Sigurðardottir, 'Saga World and Nineteenth-Century Iceland: The Case of Women Farmers', in eds. S. M. Anderson and K. Swenson, *Cold Counsel: Women in Old Norse Literature and Mythology: A Collection of Essays* (Routledge, 2002), pp. 281–93.

[46] Alfred P. Smith, *Warlords and Holy Men* (Edinburgh University Press, 2010), p. 161.

47 S. Sunna Ebenesersdóttir et al, , 'Ancient Genomes from Iceland Reveal the Making of a Human Population', *Science*, Vol. 360, No. 6392 (2018), pp. 1028–1032.

48 Price et al. 'Viking warrior women? Reassessing Birka Chamber Grave Bj.581', pp. 181–98.

49 L. Gardela, 'Warrior-Women in Viking Age Scandinavia? A Preliminary Archaeological Study', *Analecta Archaeological Gicaressoviensia*, Vol. 8 (2013), pp. 276–341, especially p. 293.

50 Per Holck, 'The Oseberg Ship Burial, Norway: New Thoughts on the Skeletons from the Grave Mound', *European Journal of Archaeology*, Vol. 9, No. 2–3 (2006), pp. 185–210.

51 Terje Gansum, 'Role the Bones: From Iron to Steel', *Norwegian Archaeological Review*, Vol. 37, No. 1 (2004), pp. 41–57.

52 *Laxdaela Saga*, Chapter 76.

53 Marianne Moen, 'Ideas of Continuity: Gender and the Illusion of the Viking Age as Familiar', , p. 626.

54 Britt-Mari Näsström, 'Old Norse Religion', in eds. Lisbeth Bredholt Christensen, Olav Hammer and David Warburton, *The Handbook of Religions in Ancient Europe* (Acumen Publishing, 2013), pp. 324–337.

55 The full text is included in Carolyne Larrington (trans.), *The Poetic Edda* (Oxford World's Classics, 1999).

56 Elisabeth Arwill-Nordbladh, 'Negotiating normativities – "Odin from Lejre" as Challenger of Hegemonic Orders', *Danish Journal of Archaeology*, Vol. 2, No. 1 (2013), pp. 87–93.

57 Elisabeth Arwill-Nordbladh, 'Viking Age Hair', *Internet Archaeology*, Vol. 42 (2016), online at http://dx.doi.org/10.11141/ia.42.6.8

58 Eva-Marie Göransson, 'Bilder av kvinnor och kvinnlighet. Genus och kroppspråk under övergången till kristendomen', *Stockholm Studies in Archaeology*, Vol. 18 (1999), pp. 40–42.

59 Sarah Schrader, *Activity, Diet and Social Practice: Addressing Everyday Life in Human Skeletal Remains* (Springer, 2019), pp. 55–126.

60 G. S. Goldstein, *War and Gender: How Gender Shapes the War System and Vice Versa* (Cambridge University Press, 2001), pp. 10–22.

[61] Pieterjan Deckers, Sarah Croix & Søren M Sindbæk, 'Assembling the Full Cast: Ritual Performance, Gender Transgression and Iconographic Innovation in Viking-Age Ribe', *Medieval Archaeology*, Vol. 65, No. 1 (2021), pp. 30–65.

[62] B. Ambrosiani, *Excavations in the Black Earth 1990–1995: Stratigraphy, Birka Studies* 9 (Birka Project, Riksantikvarieämbetet, 2013).

[63] Marianne Vedeler, 'The Textile Interior in the Oseberg Burial Chamber,' in eds. S. Bergerbrant and S.H. Fossøy, *A Stitch in Time. Essays in Honour of Lise Bender Jørgensen*, (Gothenburg University, 2014), pp. 281-301.

Chapter 4

[1] Brian Sewell, 'Tapestry and Swimming Pools', *Art and Artists,* Vol. 196 (1982), p. 28.

[2] Carola Hicks, *The Bayeux Tapestry: The Life Story of a Masterpiece* (Vintage, 2007), p. 299.

[3] David Musgrove and Michael Lewis, 'A Remarkable Survival', in eds. D. Musgrove and M. Lewis, *The Story of the Bayeux Tapestry: Unravelling the Norman Conquest* (Thames & Hudson, 2021), pp. 8–17.

[4] Gale R. Owen-Crocker, 'Behind the Bayeux Tapestry', in eds. M. K. Foys, K. E. Overbey and D. Terkla, *The Bayeux Tapestry: New Interpretations* (Boydell and Brewer, 2009), pp. 119–29.

[5] N. P. Brooks and H. E. Walker, 'The Authority and Interpretation of the Bayeux Tapestry', in ed. R. Gameson, *The Study of the Bayeux Tapestry*, (Boydell and Brewer, 1997), pp. 63–92.

[6] Martin K. Foys, 'Pulling the Arrow Out: The Legend of Harold's Death and the Bayeux Tapestry', in eds. Foys, Overbey and Terkla, *The Bayeux Tapestry: New Interpretations*, pp. 158–75.

[7] David J. Bernstein, 'Victory at Hastings and the Death of Harold', in *The Mystery of the Bayeux Tapestry* (Guild Publishing, 1986), pp. 144–61.

[8] Gabriel Vial, 'The Bayeux Tapestry Embroidery and its Backing Strip', in eds. Pierre Bouet, Brian Levy and François

Nevaux, *The Bayeux Tapestry: Embroidering the Facts of History* (PU Caen, 2004), pp. 83–109.

9 *The Carmen de Hastingae Proelio of Bishop Guy of Amiens*, ed. and trans. Frank Barlow (Oxford University Press, 1999), ll. 544–9.

10 Richard Stillwell, *The Princeton Encyclopaedia of Classical Sites* (Princeton University Press, 2017), p. 124.

11 Hicks, *The Bayeux Tapestry*, p. 5.

12 R. Howard Bloch, *A Needle in the Right Hand of God: The Norman Conquest of 1066 and the Making and Meaning of the Bayeux Tapestry* (Random House, 2006), pp. 137–62.

13 Christopher Norton, 'Viewing the Bayeux Tapestry, Now and Then', *Journal of the British Archaeological Association*, Vol. 172, No. 1 (2019), pp. 52–89.

14 On the use of the ell as the standard measurement in Anglo-Saxon cloth, see G. R. Owen-Crocker, E. Coatsworth and M. Hayward eds., *Encyclopaedia of Dress and Textiles in the British Isles c. 450–1450* (Brill, 2012), pp. 83, 130–2, 189, 316–8, 656.

15 Elizabeth Coatsworth, 'Stitches in Time: Establishing a History of Anglo-Saxon Embroidery', in eds. Monica L. Wright, Robin Netherton and Gale R. Owen-Crocker, *Medieval Clothing and Textiles, No. 1* (Boydell & Brewer, 2005), pp. 1–27.

16 John F. Szabo and Nicholas E. Kuelfer, *The Bayeux Tapestry: A Critically Annotated Bibliography* (Rowman and Littlefield, 2015), p. ix.

17 A. Bridgeford, 'Was Count Eustace II of Boulogne the Patron of the Bayeux Tapestry?', *Journal of Medieval History*, Vol. 25, No. 3 (1999), pp. 155–85.

18 Norton, 'Viewing the Bayeux Tapestry, Now and Then', pp. 52–89.

19 Guerrilla Girls, *The Guerrilla Girls' Bedside Companion to the History of Western Art* (Penguin, 1998), p. 15.

20 Sylvette Lemagnen, 'Preface', in ed. Lucien Musset, *La Tapisserie de Bayeux: Oeuvre d'art et Document Historique*, trans. Richard Rex (Boydell & Brewer, 2005), p. 272.

21 Elizabeth Prettejohn, *Art for Art's Sake: Aestheticism in Victorian Painting* (Paul Mellon Centre for Studies in British Art, 2007), p. 10.

22 Martina Bagnoli et al, *A Feast for the Senses: Art and Experience in Medieval Europe* (Yale University Press, 2016), pp. 17–30.

23 Roger Dunn, 'The Changing Status and Recognition of Fiber Work Within the Realms of the Visual Arts', in ed. Marjorie Agosin, *Stitching Resistance: Women, Creativity and the Fiber Arts* (Solis Press, 2014), pp. 43–54.

24 Charles Reginald Dodwell, *Anglo-Saxon Art: A New Perspective* (Manchester University Press, 1992), pp. 33, 57.

25 Julian Gardner, '*Opus Anglicanum* and its Medieval Patrons', in eds. Clare Browne, Glyn Davies and M. A. Michael, *English Medieval Embroidery: Opus Anglicanum* (Yale University Press, 2021), pp. 49–60.

26 Ralph H. C. Davies and Marjorie Chibnall, eds., *The 'Gesta Guillelmi' of William of Poitiers* (Oxford University Press, 1998), pp. 176–7.

27 Rozsilka Parker, *The Subversive Stitch: Embroidery and the Making of the Feminine* (Women's Press, 1984), p. 11.

28 See Hicks, *The Bayeux Tapestry*, p. 143.

29 Yxta Maya Murray, 'Rape Trauma, The State, and the Art of Tracey Emin', *California Law Review*, Vol. 100, No. 6 (2012), pp. 1631–1710.

30 'The Lexis of Cloth and Clothing in Britain c. 700-1450', Lexis Project, The University of Manchester, 2016-onwards.

31 Mildred Bundy, 'The Anglo-Saxon Embroideries at Maaseik: Their Historical and Art-Historical Context', *Academiae Analecta*, Vol. XLV (1984), pp. 1–84.

32 Jill Ivy, *Embroideries at Durham Cathedral* (Dean and Chapter of Durham, 1997).

33 Mark Chambers, 'How Long is a Launce? Units of Measure for Cloth in Late Medieval Britain', in eds. Robin Netherton and Gale R. Owen-Crocker, *Medieval Clothing and Textiles, 13* (Boydell & Brewer, 2017), pp. 31–66.

34 Gale R. Owen Crocker, 'The Bayeux Tapestry: Invisible Seams and Visible Boundaries', *Anglo-Saxon England*, Vol. 31 (2002), pp. 257–73.

35 Jan Messent, *The Bayeux Tapestry Embroiderer's Story* (Search Press, 1999), pp. 81–2.

36 Howard B. Clarke, 'The Identity of the Designer of the Bayeux Tapestry', *Anglo-Norman Studies*, Vol. 35 (2013), pp. 119–40.

37 Richard Gem, *St Augustine's Abbey* (English Heritage Series, 1997), p. 172.

38 Richard Eales and Richard Sharpe, *Canterbury and the Norman Conquest: Churches, Saints and Scholars, 1066–1109* (A&C Black, 1995), p. 93.

39 Bloch, *A Needle in the Right Hand of God*, p. 148.

40 Sheila Dillon, 'Women on the Columns of Trajan and Marcus Aurelius and the Visual Language of Roman Victory', in eds. Sheila Dillon and Katherine E. Welch, *Representations of War in Ancient Rome* (Cambridge University Press, 2009), pp. 244–71.

41 Gale R. Owen-Crocker, 'Stylistic Variations and Roman Influences in the Bayeux Tapestry', in ed. M. Crafton, *The Bayeux Tapestry Revisited, Peregrinations*, Vol. 2, No. 4 (2009), pp. 1–35.

42 J. D. Anderson, 'The Bayeux Tapestry: A 900-year-old Latin Cartoon', *Classical Journal*, Vol. 81 (1986), pp. 253–7.

43 Eales and Sharpe, *Canterbury and the Norman Conquest*, pp. 95–144.

44 H. Lloyd Goodall, *A Need to Know: The Clandestine History of a CIA Family* (Left Coast Press, 2006), p. 175.

45 Richard Eales and Richard Gameson, 'Books, Culture and the Church in Canterbury Around the Millennium', in eds. R. Eales and R. Gameson, *Vikings, Monks and the Millennium* (Canterbury Archaeological Trust, 2000), pp. 15–40.

46 Julia Crick, 'Conquest and Manuscript Culture', in eds. Laura Ashe and Emily John Ward, *Conquests in Eleventh Century England, 1016, 1066* (Boydell & Brewer, 2020), pp. 123–39.

47 Christopher R. Lakey, '*Res et Significatio*: The Material Sense of Things in the Middle Ages', *Gesta*, Vol. 51 (2012), pp. 1–17.

48 Celia Chazelle, 'Archbishops Ebo and Hincmar of Reims and the Utrecht Psalter', *Speculum*, Vol. 72, No. 4 (1997), pp. 1055–77.

49 Claire Breay and Joanna Story, *Anglo-Saxon Kingdoms: Art, Word, War* (British Library Publishing, 2018), p. 127.

50 Christopher De Hamel, *Meetings with Remarkable Manuscripts* (Allen Lane, 2016), p. 18.

51 George Garnett, 'The Bayeux Tapestry with Knobs On: What do the Tapestry's 93 Penises tell us?', History Extra (14November 2018), https://www.historyextra.com/period/medieval/bayeux-tapestry-penis-why-norman-conquest-battle-hastings-william-conqueror/.

52 Hicks, *The Bayeux Tapestry*, p. 188.

53 Stephen D. White, 'The Fables in the Borders', in eds. Elizabeth Carson Pastan and Stephen D. White, *The Bayeux Tapestry and its Contexts: A Reassessment* (Boydell Press, 2014), pp. 154–82.

54 M. Campbell, 'Ælgyva: the Mysterious Lady of the Bayeux Tapestry', *Annales de Normandie*, Vol. 34 (1984), pp. 127–45.

55 E. Freeman, 'The Identity of Ælgyva in the Bayeux Tapestry', *Annales de Normandie*, Vol. 41 (1991), pp. 117–34.

56 M. Caviness, *Reframing Medieval Art: Differences, Margins, Boundaries* (Tufts University Press, 2001), https://dca.lib.tufts.edu/caviness/abstract.html.

57 'Secrets of the Bayeux Tapestry: Hidden Meanings and Gestures', Guernsey Donkey (18 April 2017), https://guernseydonkey.com/secrets-of-the-bayeux-tapestry-hidden-meanings-gestures/.

58 Pamela Petro, 'The Ælfgyva Syndrome and the Erasure of Women's Stories', *Ms.* (1 March 2001).

59 G. A. Bond, *The Loving Subject: Desire, Eloquence and Power in Romanesque France* (University of Pennsylvania Press, 1995) p. 40.

60 Catherine E. Karkov, *The Ruler Portraits of Anglo-Saxon England* (Boydell Press, 2004), p. 119.

61 Frank Barlow, *Edward the Confessor* (University of California Press, 1984), pp. 30–1.

62 Lois L. Huneycutt, *Matilda of Scotland: A Study in Medieval Queenship* (Boydell Press, 2003), p. 41.

63 Andy Orchard, 'Literary Background to the *Encomium Emmae Reginae*', *Journal of Medieval Latin*, Vol. 11 (2001), pp. 156–83.

64 Will Humphries, 'Emma, the Queen in the Cathedral's Box of Old Bones', *The Times* (16 May 2019).

65 Pauline Stafford, *Unification and Conquest: A Political and Social History of England in the Tenth and Eleventh Centuries* (Oxford University Press, 1989), p. 87.

66 Janina Ramirez, *The Private Lives of Saints: Power, Passion and Politics in Anglo-Saxon England* (W.H. Allen, 2016), pp. 255–86.

67 Catherine Cubitt, 'The Tenth-Century Benedictine Reform in England', *Early Medieval Europe*, Vol. 6, No. 1 (1997), pp. 77–94.

68 Julia Barrow, 'The Ideology of the Tenth-Century English Benedictine "Reform"', in ed. Patricia Skinner, *Challenging the Boundaries of Medieval History: The Legacy of Timothy Reuter* (Brepols, 2009), pp. 141–54.

69 John Blair, *The Church in Anglo-Saxon Society* (Oxford University Press, 2005), pp. 323–6.

70 T. A. Heslop, 'The Production of *de luxe* Manuscripts and the Patronage of King Cnut and Queen Emma', *Anglo-Saxon England*, Vol. 19 (1990), pp. 151–96.

71 Simon Keynes, 'The Liber Vitae of the New Minster, Winchester', in eds. D. Rollason et al, *The Durham Liber Vitae and its Context* (Boydell Press, 2004), pp. 149–64.

72 Pauline Stafford, *Queen Emma and Queen Edith: Queenship and Women's Power in Eleventh Century England* (Wiley, 2001), p. 3.

73 Hicks, *The Bayeux Tapestry*, p. 209.

74 Pauline Stafford, 'Edith, Edward's Wife and Queen', in ed. Richard Mortimer, *Edward the Confessor: The Man and The Legend* (Boydell Press, 2009), pp. 129–38.

75 Alison Weir, *Britain's Royal Families: The Complete Genealogy* (Pimlico, 1996), p. 33.

76 Carola Hicks, *The Bayeux Tapestry*, p. 30.

77 J. L. Grassi, 'The *Vita Ædwardi Regis*: The Hagiographer as Insider', in ed. John Gillingham, *Anglo-Norman Studies: Proceedings of the Battle Conference, Vol. XXVI* (Boydell & Brewer, 2003), pp. 87–102.

78 Frank Barlow, ed, *The Life of King Edward who Rests at Westminster Attributed to a Monk of Saint-Bertin* (Oxford, Clarendon Press, 1992), p. xxix.

79 Carola Hicks, *The Bayeux Tapestry*, pp. 29–32.

80 Pauline Stafford, 'Women in Domesday', *Reading Medieval Studies*, Vol. 15 (1989), pp. 75–94.

Chapter 5

1 Jennifer Bain, 'History of a Book: Hildegard of Bingen's "Riesencodex" and World War II', *Plainsong and Medieval Music*, Vol. 27, No. 2 (2018), pp. 143–70.

2 Fiona Maddocks, *Hildegard of Bingen: The Woman of her Age* (Faber and Faber, 2013), pp. 263–74.

3 Michael Klaper, 'Commentary', in trans. Lora Kruckenberg, *Lieder: Faksmile Riesencodex (Hs.2) der Hessischen Landesbibliothek Wiesbaden, fol. 466-481v*, ed. Lorenz Welker (Hessian State Library, 1998), pp. 23–4.

4 Madeline H. Caviness, 'Hildegard as Designer of the Illustrations of her Works', in eds. C. Burnett and P. Dronke, *Hildegard of Bingen: The Context of Her Thought and Art* (Warburg Institute, 1998), pp. 29–62.

5 Christiane Heinemann, *Der Riesencodex der Hildegard von Bingen. Verschollen - Gefunden - Gerettet. Schicksalswege 1942 bis 1950* (Historische Kommission für Nassau, 2021), p. 27.

6 Jonathan Petropoulos, *Art as Politics in the Third Reich* (University of North Carolina Press, 1996), p. 142.

7 Gregorij Kozlov, 'Die Sowjetischen "Trophänbigaden" – Systematik und Anarchie des Kunstraubs einer Siegermacht', in ed. Hartmann von Uwe, *Kulturgüter im Zweiten Weltkrieg. Verlagerung – Auffindung – Rüchführung* (Koordinierungsstelle für Kulturgutverluste Magdeburg, 2007), pp. 79–104.

8 Heinemann, *Der Riesencodex der Hildegard von Bingen*, p. 50.

9 Wil Derkse, *The Rule of Benedict for Beginners: Spirituality for Daily Life*, trans. Martin Kessler (Liturgical Press, 2003), pp. 2–3.

10 Desiderius Lenz, *The Aesthetic of Beuron and other writings*, trans. John Minahane and John Connolly (Francis Boutle Publishers, 2002) p. 20.

11 Konstantin Akinsha and Grigorii Kozlov, *Beautiful Loot: The Soviet Plunder of Europe's Art Treasures* (Random House USA,1995), pp. ix–xiii.

12 H. Grewe, 'Die Königspfalz in Ingelheim', *Archäologie in Deutschland*, No. 4 (1996), p. 53.

13 Günther Stanzl, 'The Ruins of the Abbey Disibodenberg near Mainz, Germany: Excavation, Conservation and Development of the Site', *Conservation and Management of Archaeological Sites*, Vol. 1 (2000), pp. 21–32.

14 Iris R. Petty, 'Hildegard's Historical Memory: The Lives of Saint Disibod and Saint Rupert as Models of Local Salvation History', *Comitatus: A Journal of Medieval and Renaissance Studies*, Vol. 45 (2014), pp. 133–48.

15 Hildegard of Bingen, 'Antiphon for Saint Disibod', in trans. Mark Atherton, *Hildegard of Bingen: Selected Writings* (Penguin Classics, 2001), p. 35. Hereafter Atherton.

16 Exhibition Catalogue, *Permanent Exhibition Hildegard of Bingen: Her Life and Work* (Museum am Strom, 2014), p. 15.

17 Díaz Hidalgo et al, 'New Insights into Iron-gall Inks through the Use of Historically Accurate Reconstructions', *Heritage Science*, Vol. 6, No. 1 (2018), pp. 1–15.

18 John van Engen, 'Abbess, Mother and Teacher', in ed. Barbara Newman, *Voice of the Living Light: Hildegard of Bingen and Her World* (University of California Press, 1998), pp. 30–51.

19 Hildegard of Bingen, 'Letter to Henry, Bishop of Liège', in Atherton, p. 65.

20 Maria Teresa Brolis, 'Hildegard the Genius', in eds. M. T Brolis, *Stories of Women in the Middle Ages* (McGill-Queen's University Press, 2018), pp. 13–21.

21 Sarah Lynn Higley, *Hildegard of Bingen's Unknown Language: An Edition, Translation, and Discussion* (Palgrave Macmillan, 2007), p. 13.

22 Debra L. Stoudt, 'Elemental Well-Being: Water and its Attributes in Selected Writings of Hildegard of Bingen and Georgius Agricola', in ed. Albrecht Classen, *Bodily and Spiritual Hygiene in Medieval and Early Modern Literature: Explorations of Textual Presentations of Filth and Water*, Journal of Medieval Latin, Vol. 27, No. 1 (2017), pp. 193–220.

23 Martin Kemp, *Leonardo* (Oxford University Press, 2004), p. 6.

24 Susan Wise Bauer, *The History of the Renaissance World: From the Rediscovery of Aristotle to the Conquest of Constantinople* (W. W. Norton, 2013), p. 1.

25 Robert Louis Benson, Giles Constable and Carol Dana Lanham, *Renaissance and Renewal in the Twelfth Century* (Harvard University Press, 1991), p. 471.

26 Hildegard of Bingen, *Scivias*, II. 7, eds. Adelgundis Führkötter and Angela Carlevaris, CCCM 43-43A (Turnholt, 1978), p. 322.

27 C. J. Tyerman, 'Were There Any Crusades in the Twelfth Century?', *The English Historical Review*, Vol. 110, No. 437 (1995), pp. 533–77.

28 Hildegard of Bingen, 'Letter to Pope Eugenius III, 1148–53, Letter 3', in Atherton, p. 66.

29 María Esther Ortiz, 'Símbolo y experiencia visionaria en el Epistolario de Hildegarda de Bingen (1098–1179), *Mirabilia*, Vol. 29 (2019), pp. 70–91.

30 Andra Alexiu, '*Magistra magistrorum*: Hildegard of Bingen as a Polemicist against False Teaching', *Medieval Worlds*, No. 7 (2018), pp. 170–89

31 W. J. Millor and C. N. L. Brooke (ed. and trans.), *The Letters of John of Salisbury, Volume 2: The Later Letters (1163–80)* (Oxford University Press, 1979), p. 224.

32 Elizabeth Ruth Obbard, *Medieval Women Mystics: Gertrude the Great, Angela of Foligno, Brigiitta of Sweden, Julian of Norwich* (New City Press, 2007), pp. 7–15.

33 Julie Hotchin, 'Enclosure and Containment: Jutta and Hildegard at the Abbey of St. Disibod', *Magistra: A Journal of Women Spirituality in History*, Vol. 2, No. 2 (1996), pp. 103–23.

34 Richard Witts, 'How to Make a Saint: On Interpreting Hildegard of Bingen', *Early Music*, Vol. 26, No. 3 (1998), pp. 478–85.

35 Hildegard of Bingen, 'Canonisation Protocol, 14.2', in Atherton, p. 201.

36 Anna Silvas, *Jutta and Hildegard: The Biographical Sources* (Pennsylvania State University Press, 1998), pp. 51–8.

37 Hildegard of Bingen, 'Life of Jutta', in ed. Silvas, *Jutta and Hildegard*, pp. 65–85.

38 Robert Carver, 'Letter to Guibert of Gembloux', in eds. Fiona Bowie and Oliver Davies, *Hildegard of Bingen: An Anthology* (SPCK, 1990), p. 146.

39 Quoted from Andrea Hopkins, *Most Wise and Valiant Ladies* (Collins and Brown, 1997), p. 88.

40 Oliver Sacks, 'Patterns. Migraine: Perspectives on a Headache', *New York Times* (13 February 2008), opinion pages.

41 Theoderich of Echternach, 'Life of Hildegard', Book 2, in Atherton, p. 191.

42 Nu Cindy Chai, B. Lee Peterlin and Anne H. Calhoun, 'Migraine and Oestrogen', *Curr Opin Nerol*, Vol. 27, No. 3 (June 2014), pp. 315–24. My thanks to Antonia Hoyle for this reference.

43 Claire V. Hutchinson, James A Walker and Colin Davidson, 'Oestrogen, Ocular Function and Low-Level Vision: A Review', *Journal of Endocrinology*, Vol. 223, No. 2 (2014), pp. 9–18.

44 José Alberto Avila-Funes et al, 'Association Between High Serum Estradiol Levels and Delirium Among Hospitalised Elderly Women', *Revista de Investigación Clínica*, Vol. 67 (2015), pp. 20–4.

45 Clemens Jöckle, *Encyclopaedia of Saints* (Konecky and Konecky, 2003), p. 204.

46 John M. Riddle, *Eve's Herbs: A History of Contraception and Abortion in the West* (Harvard University Press, 1997), p. 105.

47 Olivia Campbell, 'Abortion Remedies from a Medieval Catholic Nun (!)', JSTOR Daily (13 October, https://daily.jstor.org/abortion-remedies-medieval-catholic-nun/

48 Theoderich of Echternach, 'Life of Hildegard', Book 2, Chapter v, in Atherton.

49 Hildegard of Bingen, 'Letter to Elizabeth of Schönau', in Atherton, p. 79.

50 Joan Cadden, 'It Takes All Kinds: Sexuality and Gender Difference in Hildegard of Bingen's *Book of Compound Medicine*', *Traditio*, Vol. 40 (1984), pp. 149–74.

51 Hildegard of Bingen, *Causae et Curae*, Book 2, ed. Paul Kaiser (Lipsiae, 1903, reproduced by BiblioBazzar, 2009), p. 104.

52 Joan Cadden, 'It Takes All Kinds: Sexuality and Gender Difference in Hildegard of Bingen's *Book of Compound Medicine*', *Traditio*, Vol. 40 (1984), pp. 149-74.

53 Hildegard of Bingen, *Causae et Curae,* Book II, in Atherton, p, 89.

54 Hildegard of Bingen, *Causae et Curae,* Book II, in Atherton, pp, 35–6.

55 Shawn Madigan, *Mystics, Visionaries and Prophets: A Historical Anthology of Women's Spiritual Writings* (Fortress Press, 1998), p. 96.

56 Augustine Thompson, 'Hildegard of Bingen on Gender and the Priesthood', *Church History*, Vol. 63, No. 3 (1994), pp. 349–64.

57 Hildegard of Bingen, 'Letter to Bernard of Clairvaux', in Atherton, p. 3.

58 Hildegard of Bingen, '*Scivias* II, Vision 1', in Atherton, p. 9.

59 Hildegard of Bingen, 'A Vision of Love', from *The Book of Divine Works*, in Atherton, p. 171.

60 Hildegard of Bingen, 'Letter to Pope Eugenius III, 1148, Letter 2', in Atherton, p. 31.

61 John Julius Norwich, *The Popes: A History* (Chatto & Windus, 2011), pp. 149–64.

62 Anne Clark Bartlett, 'Miraculous Literacy and Textual Communities in Hildegard of Bingen's *Scivias*', *Mystics Quarterly*, Vol 18, No. 2 (1992), pp. 43–55.

63 Maddocks, *Hildegard of Bingen*, p. 74.

64 Hildegard of Bingen, 'Songs for Saint Rupert', in Atherton, p. 47.

65 Exhibition Catalogue, *Permanent Exhibition Hildegard of Bingen: Her Life and Work* (Museum am Strom, 2018), p. 47.

66 *Life of Hildegard of Bingen*, Book II, trans. Monika Klaes (Fontes Christiani, 1998), pp. 141–3.
67 Hildegard of Bingen, 'Letter to Heinrich, Archbishop of Mainz, Letter 18R', in Atherton, p. 51.
68 Hildegard of Bingen, 'Letter to Richardis, 1151–2, Letter 64', in Atherton, p. 52.
69 David Randall, 'Intimate Friendship', in eds. D. Randall, *The Concept of Conversation: From Cicero's Sermo to the Grand Siècle's Conversation* (Edinburgh University Press, 2018), pp. 85–121.
70 Exhibition Catalogue, *Permanent Exhibition Hildegard of Bingen: Her Life and Work* (Museum am Strom, 2014), p. 50.
71 Hildegard of Bingen, 'Quia Ergo Femina', in Atherton, p. 118.
72 William Flynn, 'Hildegard (1098–1179) and the Virgin Martyrs of Cologne', in ed. Jane Cartwright, *The Cult of St Ursula and the 11,000 Virgins* (University of Wales Press, 2016), pp. 93–118.
73 'Letter from Tengswich to Hildegard, Letter 52', in eds. Baird and Ehrman, *The Letters of Hildegard of Bingen, Vol. 1* (Oxford University Press, 1994), p. 127.
74 *Ibid*.
75 Hildegard of Bingen, *Scivias*, I, 2, 38, in Atherton.
76 Hildegard of Bingen, *Scivias*, I, 4, in Atherton.
77 Hildegard of Bingen, 'Letter to Odo of Soissons', in Atherton, p. 21.
78 Maria Jose Ortuzar Escudero, 'La Boca y lo Dulce. Algunas reflexiones sobre de la tropologia del gusto en el libro Scivias de Hildegarda de Bingen', *Mirabilia*, Vol. 29 (2019), pp. 70–91
79 Columba Hart and Jane Bishop, trans., *The Ways of the Lord: Hildegard of Bingen* (Harper One, 2005), p. 12.
80 Bruce W. Holsinger, *Music, Body and Desire in Medieval Culture: Hildegard of Bingen to Chaucer* (Stanford University Press, 2001), pp. 87–136.
81 Jennifer Bain, *Hildegard of Bingen and Musical Reception: The Modern Revival of a Medieval Composer* (Cambridge University Press, 2015), pp. 70–100.
82 Medieval Studies Research Blog, 'Letters? I 'ardly know 'er. The Unknown Language (and Letters) of Hildegard of

Bingen', (University of Notre Dame Medieval Institute, October 2015). https://sites.nd.edu/manuscript-studies/2015/10/01/letter-i-ardly-know-er-the-unknown-language-and-letters-of-hildegard-von-bingen/

83 Genesis 11: 1–9.

84 Sabina Flanagan, *Hildegard of Bingen, 1098–1179: A Visionary Life* (Routledge, 1989), p. 11.

85 Elizabeth of Schönau, *The Complete Works* (Pauline Press, 2000), p. 9.

86 Marcelle Thiébaux, trans., 'Benedictine Visionaries in the Rhineland: Hildegard of Bingen (1098–1179), Elisabeth of Schönau (1129-1165)' in eds. M. Thiébaux, *The Writings of Medieval Women* (Garland Library of Medieval Literature, Vol. 14, Series B, 1987), pp. 105–63.

87 Paolo Vitolo, 'The Image of Women and Narrative Strategies in the *Hortus Deliciarum*', in eds. Kari Elisabeth Børresen and Adriana Valerio, *The High Middle Age, The Bible and Women Series* (Society of Biblical Literature, 2015), pp. 327–42.

88 Paul Webster, 'Mystery at the Monastery Ends as CCTV Reveals Chamber of Secrets' Daring Thief', *The Guardian* (19 June 2003).

89 Thérèse McGuire, 'Monastic Artists and Educators in the Middle Ages', *Woman's Art Journal*, Vol. 9, No. 2 (1988), pp. 3–9.

90 Reed Enger, 'Herrad of Landsberg, A French abbess creates the first female-authored encyclopaedia', Obelisk Art History (27 January 2016), https://arthistoryproject.com/artists/herrad-of-landsberg/.

91 Ann Storey, 'A Theophany of the Feminine: Hildegard of Bingen, Elisabeth of Schönau and Herrad of Landsberg', *Woman's Art Journal*, Vol. 19, No. 1 (1998), pp. 16–20.

92 'The Nun Gertrud (of Stahleck), to Hildegard, after 1161, Letter 62', in Atherton, p. 184.

93 'An Abbess of Alterna to Hildegard, before 1173, Letter 49', in Atherton, p. 185.

94 'Gebeno of Eberbach: *The Pentachronon*', in Atherton, p. 193.

95 Nathaniel M. Campbell, 'The Prophetess and the Pope: St. Hildegard of Bingen, Pope Benedict XVI, and Prophetic

Visions of Church Reform', *Postmedieval: A Journal of Medieval Cultural Studies*, Vol. 10, No. 1 (2019), pp. 22–35.

96 Hildegard of Bingen, *Epistula 195*, ed. Lieven van Acker, *Espistolarium. Pars Secunda, XCI–CCLr*, CCCM 91A, (Turnholt, 1993), pp. 443–4.

Chapter 6

1 Chris O'Brien, 'For 800 years they were celebrated as martyrs to their faith. Just one problem: the Cathars may never have existed,' *Los Angeles Times* (31 December 2018).

2 ' "Les Cathares, une idée reçue", l'exposition qui démonte "le mythe" des Cathares', *L'Indépendant* (4 October 2018), https://www.lindependant.fr/2018/10/04/les-cathares-une-idee-recue-lexposition-qui-demonte-le-mythe-des-cathares,4719386.php

3 Vincent Marie, 'Alessia Trivellone: "Réaliser une BD permet à mes étudiants de Master de vulgariser l'Histoire médiévale"', *Cases D'Histoire* (March 2018)

4 Emily McCaffery, 'Imaging the Cathars in Late Twentieth-century Languedoc', *Contemporary European History*, Vol. 11, No. 3 (2002), pp. 409–27.

5 Jonathan Sumption, *The Albigensian Crusade* (Faber and Faber, 1978), p. 237.

6 Zoé Oldenbourg, *Massacre at Montsegur: A History of the Albigensian Crusade* (Phoenix, 2015), p. 340.

7 Claude Lebédel, *Understanding the Tragedy of the Cathars* (Editions Ouest-France, 2011), p. 104.

8 Sumption, *The Albigensian Crusade*, chapter 5.

9 A. Roach, 'The Cathar Economy', *Reading Medieval Studies*, Vol. 12 (1986), pp. 51–71.

10 Michael Costagliola, 'Fires in History: The Cathar Heresy, The Inquisition and Brulology', *Annals of Burns and Fire Disasters*, Vol. 28, No. 3 (2015), pp. 230–4.

11 Costas Tsiamis, Eleni Tounta and Effie Poulakou-Rebelakou, 'The "Endura" of the Cathars' Heresy: Medieval Concept of

Ritual Euthanasia or Suicide?', *Journal of Religion and Health*, Vol. 55, No. 1 (2016), pp. 174–80.

[12] William of Auxerre, *Summa aurea*, ed. Jean Ribaillier, 4 vols (CNRS, 1980–87), iii.XII.3.5 (3,i, 212–3).

[13] Dorothea Weltecke, 'Doubts and the Absence of Faith', in ed. John H. Arnold, *Oxford Handbook of Medieval Christianity* (Oxford University Press, 2014), pp, 357–76.

[14] Peter Biller, 'Intellectuals and the Masses: Oxen and She-asses in the Medieval Church', in ed. Arnold, *The Oxford Handbook of Medieval Christianity*, pp. 323–39.

[15] Stephen O'Shea, *The Perfect Heresy: The Life and Death of the Cathars* (Profile Books, 2000), pp. 17-31.

[16] Malcolm Lambert, *The Cathars* (Blackwell, 1998), p. 31.

[17] R. I. Moore, 'Principles at Stake: The Debate of April 2013 in Retrospect', in ed. Antonio Sennis, *The Cathars in Question* (Boydell & Brewer, 2016), pp. 257–73.

[18] Antonio Sennis, *The Cathars in Question* (Boydell & Brewer, 2016).

[19] Andrew P. Roach, 'Review: Cathars in Questions, ed. Antonio Sennis', *The English Historical Review*, Vol. 133, No. 561 (2016), pp. 396–8.

[20] Claire Taylor, *Heresy, Crusade and Inquisition in Medieval Quercy* (York Medieval Press, 2011), p. 89.

[21] James Wiseman, 'Insight: Suppression of the Cathars', *Archaeology*, Vol. 52, No. 2 (1999), pp. 12–16.

[22] Innocent III, *Inveterata pravitatis hertice (17 Nov 1207)*, from Catherine Léglu, Rebecca Rist and Claire Taylor, *The Cathars and the Albigensian Crusade: A Sourcebook* (Routledge, 2014), 1.1.3.

[23] *La Chanson de la Croisade Contre les Albigeois*, 3 Vols (Les Classiques de l'Histoire de France au Moyen Age, 1931, 1957, 1961), Vol. 1, laisse 68, pp. 164–5. English translation J. Shirley, *The Song of the Cathar Wars: A History of the Albigensian Crusade. William of Tudela and an Anonymous Successor* (Routledge, 1996), p. 41.

[24] Gonzalo Pita, 'Waldensian and Catholic Theologies of History in the XII–XIV Centuries: Part 1', *Journal of the Adventist Theological Society*, Vol. 25, No. 2 (2014), pp. 65–87.

[25] Adam L. Hoose, 'The "Sabotati": The Significance of Early Waldensian Shoes, c. 1184–c. 1300', *Speculum*, Vol. 91, No. 2 (2016), pp. 356–73.

[26] Peter Biller, 'Goodbye to Waldensianism', *Past and Present*, Vol. 192 (2006), pp. 3–33.

[27] Malcolm Barber, *The Cathars: Dualist Heresies in Languedoc in the High Middle Ages* (Routledge, 2017), p. 1.

[28] The only article exclusively concerned with Cathar women is Malcolm Barber's 'Women and Catharism', *Reading Medieval Studies*, Vol. 3 (1977), pp. 45–62.

[29] Emmanuel Le Roy Ladurie, *Montaillou: Cathars and Catholics in a French Village, 1294–1324*, trans. Barbara Bray (Penguin, 1990), p. ix.

[30] Bibliotèque Nationale, *Collection Doat*, Vol. 24, f.126–126v. Hereafter Doat.

[31] *Ibid*, Vol. 23, f.162–80.

[32] *Ibid*, Vol. 24, f.143.

[33] Léglu, Rist and Taylor, *The Cathars and the Albigensian Crusade*, p. 166.

[34] Bernard Gui on the Albigensians, *Inquisitor's Manual* of Bernard Gui [d.1331], early 14th century, translated in J. H. Robinson, *Readings in European History*, (Boston, Ginn, 1905), pp. 381–3.

[35] Jennifer Ward, *Women in Medieval Europe, 1200–1500* (Routledge, 2002), pp. 241–2.

[36] Vladimir Tumanov, 'Mary versus Eve: Paternal Uncertainty and the Christian View of Women', in *Neophilologus*, Vol. 95 (2011), pp. 507–21.

[37] Margaret Schaus, *Women And Gender in Medieval Europe: An Encyclopaedia* (Taylor & Francis, 2006), p. 114.

[38] R. Podd, 'Reconstructing Maternal Mortality in Medieval England: Aristocratic Englishwomen, c. 1236–1503', *Continuity and Change*, Vol. 35, No. 2 (2020), pp. 115–37.

[39] Rene Weis, *The Yellow Cross: The Story of the Last Cathars 1290–1329* (Penguin, 2001), p. 19.

40 Barber, *The Cathars*, p. 43.

41 John Hine Mundy, *Men and Women at Toulouse in the Age of the Cathars* (Pontifical Institute of Medieval Studies, 1990), p. 21.

42 Doat, Vol. 24, pp. 59–60.

43 Bibliotèque de Toulouse, MS 609; *Doat*, Vol. 22, p. 15.

44 Zoé Oldenbourg, *Massacre at Montsegur*, p. 66.

45 Barber, *The Cathars*, p. 71.

46 J. Duvernoy, 'Les Albigeois dans la vie Sociale et Economique de Leur Temps', *Annales de l'Insitul d'Études Occitanes, Actes de Colloque de Toulouse, Années 1964*, pp. 67–8.

47 Lutz Kaelber, 'Weavers into Heretics? The Social Organisation of Early Thirteenth-Century Catharism in Comparative Perspective', *Social Science History*, Vol. 21, No. 1 (1997), pp. 111–37.

48 Doat, Vol. 21, ff. 240r-1v.

49 Doat, Vol. 21, f. 307r.

50 Mundy, *Ibid,* p. 23.

51 Guillaume du Putlaurens, *Chronica*, trans. Jean Duvernoy (CNRS, 1976), p. 49.

52 Anne Brenon, *Les Femmes Cathares* (Perrin, 2004), p. 15.

53 Doat, Vol. 23, ff. 2–49.

54 *Petri Vallium Sarnaci Monachi Hystoria Albigensis*, eds. P. Guébin and E. Lyon, 3 vols (Champion, 1926, 1930, 1939), Vol. 1, para 215, pp. 214-5. English translation W. A. Sibly and M. D. Sibly, *Peter of Les Vaux-de-Cernay: The History of the Albigensian Crusade* (Boydell Press, 1998), p. 111.

55 Barber, *The Cathars*, pp. 43–9.

56 A. Roach, *The Devil's World: Heresy and Society, 1100–1300* (Routledge, 2005), p. 192.

57 Doat, Vol. 23, f. 7v.

58 Katherine H. Tachau, 'God's Compass and Vana Curiositas: Scientific Study in the Old French Bible Moralisée,' *The Art Bulletin*, vol. 80, no. 1, (1998), pp. 7–33.

59 John Lowden, *The Making of the Bibles Moralisées, I; The Manuscripts* (University Park, 2000), p. 9.

60 Gautier Map, *De Nugis Curialium*, eds. M. R. James, C. N. L. Brooke and R. A. B. Mynors (Oxford University Press, 1983), p. 126–7.

61 Barber, 'Women and Catharism', pp. 45–62.

62 Doat, Vol. 23, f. 98–99.

63 John Michael Greer, *The New Encyclopaedia of the Occult* (Llewellyn Worldwide, 2003), p. 365.

64 Juliette Wood, *The Holy Grail: History and Legend* (University of Wales Press, 2012), pp. 74–6.

65 Nicholas Goodrick-Clarke, *The Occult Roots of Nazism: Secret Aryan Cults and Their Influence on Nazi Ideology: The Ariosophists of Austria and Germany, 1890–1935* (The Aquarian Press, 1985), p. 188–9.

66 David Klinghoffer, 'The Da Vinci Protocols: Jews should worry about Dan Brown's success', National Review (5 May 2006), https://www.nationalreview.com/2006/05/da-vinci-proto cols-david-klinghoffer/.

67 Michael Baigent, Richard Leigh and Henry Lincoln, *Holy Blood and the Holy Grail* (Jonathan Cape, 1982), p. 36.

Chapter 7

1 *L'Osservatore Romano*, English Weekly Edition (23 June 1980), pp. 9–12.

2 'Homily of John Paul II, Krakow, 8 June 1997; Holy Mass for the Canonization of Blessed Queen Edwig', *Apostolic Journey of His Holiness John Paul II to Poland (May 31–June 10, 1997)* (Libreria Editrice Vaticana, 1997), published online at https://www.vatican.va/content/john-paul-ii/en/ homilies/1997/documents/hf_jp-ii_hom_19970608_cracovia. html.

3 Felicitas Schmeider, 'Saints Around the Baltic: Some Remarks, Conclusions and Further Questions', in eds. Carsten Selch Jensen et al, *Saints and Sainthood Around the Baltic Sea: Identity, Literacy and Communication in the Middle Ages* (Medieval Institute Publications, 2018, pp. 273–80.

4 George Weigel, *City of Saints: A Pilgrimage to John Paul II's Kra-kow* (Crown Publishing, 2015), pp. 65–88.

5 Alan Lockwood, '"In the Footsteps of Kraków's European Identity." The Rynek Underground Archaeological Exhibit', *The Polish Review*, Vol. 57, No. 4 (2012), pp. 87–99.

6 Marta Marek, *Cracovi, Rekonstrukcje cyfrowe historycznej zabu-dowy Krakowa* (Museum Historycane Miasta, 2013), p. 50.

7 Aldona Garbacz-Klempka and Stansław Rzadkosz, 'Metallurgy in Middle Ages. Raw Materials, Tools and Facilities in Source Materials and Metallographic Research', *Argenti Fodina*, (Ban-ska Štiavnica, 2014), pp. 99–105.

8 Thaddeus V. Gromada, 'Oscar Halecki's Vision of Saint Jadwiga of Anjou', *The Polish Review*, Vol. 44, No. 4 (1999), pp. 433–7.

9 Magdalena Piwocka, *Jałmużniczka*, in ed. M. Piwocka and D. Nowacki *Wawel 1000–2000, vol. I: Katedra krakowska – biskupia, królewska, narodowa* (Muzeum Katedralne na Wawelu, 2000), cat. I/13, pp. 45–6.

10 'Tristan', in N. J. Lacy et. al, *The New Arthurian Encyclopaedia* (Garland Publishing, 1991), pp. 462–3.

11 Samuel N. Rosenberg, 'Les Folies Tristan', in ed. Norris J. Lacy, *Early French Tristan Poems. Volume 1* (D. S. Brewer, 1998), pp. 259–302.

12 *Ibid*, p. 269.

13 James A. Schultz, 'Why do Tristan and Isolde Leave for the Woods? Narrative Motivation and Narrative Coherence in Eil-hart von Oberg and Gottfried von Straβburg', *MLN*, Vol. 102, No. 3 (1987), pp. 586–607.

14 Tadeusz Gromada and Oskar Halecki, *Jadwiga of Anjou and the Rise of East Central Europe* (Social Science Monographs, 1991), p. 69.

15 Robert I. Frost, *The Oxford History of Poland-Lithuania, Volume I: The Making of the Polish-Lithuanian Union, 1385–1567* (Oxford University Press, 2015), p. 8.

16 Pál Engel, *The Realm of St Stephen: A History of Medieval Hun-gary, 895–1526* (I.B. Tauris Publishers, 2001), p. 195.

17 Jerzy Wyrozumski, *Królowa Jadwiga* (Universitas, 2006), p. 76.

18 László Solymosi and Adrienne Körmendi, 'A középkori magyar állam virágzása és bukása, 1301–1506 [The Heyday and Fall of the Medieval Hungarian State, 1301–1526]', in ed. László Solymosi, *Magyarország történeti kronológiája, I: a kezdetektől 1526-ig* [*Historical Chronology of Hungary, Volume I: From the Beginning to 1526*] (Akadémiai Kiadó, 1981), pp. 188–228.

19 Charlotte Kellogg, *Jadwiga: Poland's Great Queen* (Borodino Books, 2018), p. 19.

20 Jerzy Lukowski and Hubert Zawadzki, *A Concise History of Poland* (Cambridge University Press, 2001), p. 42.

21 Norman Davies, *God's Playground: A History of Poland*, (Columbia University Press, 1982), p. 5.

22 Like Pope John Paul II, Długosz was a product of the University of Kraków, and his treatment of Jadwiga was influenced by her reputation within this institution. Paul Knoll, 'Jan Długosz, 1480-1980', *The Polish Review*, Vol. 27, No. 1/2 (1982), pp. 3–28.

23 Anna Brzezińska, 'Jadwiga of Anjou as the Image of a Good Queen in Late Medieval and Early Modern Poland', *The Polish Review*, Vol. 44, No. 4 (1999), pp. 407–18.

24 J. Długosz, *Roczniki czyli Kroniki sławnego Królestwa Polskiego*, Wyndawnictwo Naukowe PWN, 1981, Chapter X, p. 198; R. Bubczyk, *Kariera rodziny Kurozwęckich w XIV wieku* (DiG, 2002), p, 170.

25 *The Annals of Jan Długosz*, an English abridgement by Maurice Michael, with commentary by Paul Smith (IM Publications, 1997), pp. 346–7.

26 J. Długosz, *Roczniki czyli Kroniki sławnego Królestwa Polskiego*, chapters X, X-XI, XI, XI-XII (Wyndawnictwo Naukowe PWN, 1981, 1982, 1985, 2004).

27 Krzysztof Osiński, 'Małżeństwo Jadwigi Andegaweńskiej z Władysławem Jagiełłą w Rocznikach Jana Długosza', *Przegląd Prawniczy Ekonomiczny i Społeczny*, Vol. 2 (2014) pp. 38–48

28 Thaddeus V. Gromada, 'Oscar Halecki's Vision of Saint Jadwiga of Anjou', *The Polish Review*, Vol. 44, No. 4 (1999), p. 434.

29 Robert Frost, *The Oxford History of Poland-Lithuania: Volume 1: The Making of the Polish-Lithuanian Union, 1385–1569* (Oxford History of Early Medieval Europe, 2015), p. 7.

30 Paul Knoll, 'Louis the Great and Casimir of Poland', in eds. S. B. Vardy, Géza Goldschmidr and Leslie S. Domonkos, *Louis the Great, King of Hungary and Poland* (Columbia University Press, 1986), pp. 108–9.

31 Susan Reynolds, *Kingdoms and Communities in Western Europe, 900–1300* (Oxford University Press, 1997), p. 250.

32 Mečislovas Jučas, *Lietuvos ir Lenkijos unija* (Aidai, 2000), p. 110.

33 Oreste Bazzicchi, *Il paradossa francescano tra povertà e societá di mercato* (Effatà Editrice, 2011), p. 98

34 Oscar Halecki, *Jadwiga of Anjou and the Rise of East Central Europe* (Polish Institute of Arts and Sciences of America, 1991), p. 155.

35 John Van Antwerp Fine, *The Late Medieval Balkans: A Critical Survey from the Late Twelfth Century to the Ottoman Conquest* (University of Michigan Press, 1994), pp. 396–7.

36 William Monter, *The Rise of Female Kings in Europe, 1300–1800* (Yale University Press, 2012), p. 74.

37 Roman Maria Zawadzki, 'Poczatki kultu Królowej Jadwigi', in ed. Adam Kubiś, *Jubileusz Sześćsetlecis Wydziału Teologicznego w Krakowie* (Papieska Akademia Teologiczna, 1998), pp. 283–99.

38 Elias H. Füllenbach, *Devotio Moderna (I. Christianity)*, in *Encyclopaedia of the Bible and Its Reception*, Vol. 6 (2013), col. 716–17.

39 Paul W. Knoll, 'Jadwiga and Education', *The Polish Review*, Vol. 44, No. 4 (1999), pp. 419–32.

40 M. Toswell, 'The European Psalms in Translation', in ed. J. Beer, *Companion to Medieval Translation* (Amsterdam University Press, 2019), pp. 13–22.

41 Małgorzata Grzebiennik, 'Psałtez Floriański', published online at https://biblia.wiara.pl/doc/423122.Przeklady-polskie-Psalterz-florianski.

42 Krzysztof Ożóg, 'The Intellectual Circles in Cracow at the Turn of the Fourteenth and Fifteenth Centuries and the Issue

of the Creation of the Sankt Florian Psalter', *Polish Libraries*, Vol. I (2013), pp. 166–85.

43 Ewa Sniezynska-Stolot, *Tajemnice dekoracji Psalterza Florianskiego* (Wyndawnictwo Naukowe PWN, 1992), pp. 10–12.

44 Krzysztof J. Czyżewski, 'Kaplica Władysława Jagieła Króla Polskiego – kilka uwag', in eds. W. Bałus, W. Walanus, M. Walczak, *Artifex Doctus. Studia ofiarowane procesowi Jerzemu Gadomskiemu wsiedemdziesiątą rocznicę urodzin*, Vol. I. (Polska Akademia Umiejętności, 2007), p. 161.

45 Marek Walczak, '"The Jagiellonian Saints": Some Political, National and Ecclesiastical Aspects of Artistic Propaganda in Jagiellonian Poland', in eds. D. Popp and R. Suckale, *Die Jagiellonen. kunst und kultur einer europäischer dynastie an der Wende zur neuzeit*, Wissenschaftliche Beibände zum anzeiger des Germanischen nationalmuseums, Vol. 21 (Germanisches Nationalmuseum Abt. Verlag, 2002), p. 146, figure 10.

46 Marek Walczak, 'Topography of the Royal Necropolis at the Cracow Cathedral in the Middle Ages', in ed. Jirí Roháček, *Epigraphica and Sepulcralia*, Vol. VI (Artefactum, 2015), pp. 67–90.

47 Thaddeus V. Gromada, 'Oscar Halecki's Vision of Saint Jadwiga of Anjou', *The Polish Review*, Vol. 44, No. 4 (1999), 433–7.

48 Department of Statistics to the Government of the Republic of Lithuania, 'Romos katalikų daugiausia' (2009).

Chapter 8

1 Hilton Kelliher, 'The Rediscovery of Margery Kempe: A Footnote', in *The British Library Journal*, Vol. 23, No. 2 (1997), pp. 259–63.

2 John C. Hirsch, 'Hope Emily Allen, the Second Volume of the Book of Margery Kempe, and an Adversary', in *Medieval Feminists Forum: The Journal of the Society for Medieval Feminist Scholarship*, Vol. 31, No. 1 (2001), pp. 11–17.

3 Marea Mitchell, 'Discovering *The Book of Margery Kempe*', in
 eds. Marea Mitchell, *The Book of Margery Kempe: Scholarship,
 Community and Criticism* (Peter Lang, 2005), pp. 1–14.

4 The Butler-Bowden Cope can be viewed in the 'Collections'
 section of the V&A's website by searching 'Butler-Bowden
 cope':https://collections.vam.ac.uk/item/O93441/butler-bowdon-
 cope-cope-unknown/

5 *The Book of Margery Kempe*, trans. Anthony Bale (Oxford World
 Classics, 2015), p. x.

6 Amy Hollywood, 'The Normal, the Queer, and the Middle
 Ages', *Journal of the History of Sexuality*, Vol. 10, No. 2 (2001),
 pp. 173–9, esp. p. 177.

7 KL/C/7/2, fol. 20, ed. Dorothy M. Owen, *The Making of
 King's Lynn: A Documentary Survey* (Oxford University Press,
 1984), p. 264.

8 Margery writes about the fire in Chapter 67.

9 'National Treasure: The South Gate, King's Lynn, Norfolk',
 Society for the Protection of Ancient Buildings (11 December
 2017),https://www.spab.org.uk/news/national-treasure-south-
 gate-king%E2%80%99s-lynn-norfolk

10 'Early printed extracts of Margery Kempe's *Book*', British
 Library collection, available at https://www.bl.uk/collection-
 items/early-printed-extracts-of-margery-kempes-book#

11 See also Phyllis R. Freeman, Carley Rees Bogarad and
 Diane E. Sholomskas, 'Margery Kempe, A New Theory: the
 Inadequacy of Hysteria and Postpartum Psychosis as Diagnos-
 tic Categories', in *History of Psychiatry*, Vol. 1 (1990), pp.
 169–90.

12 L. S. Woodgar, 'B, Robert, of Bishop's Lynn, Norf.', in eds.
 J. S. Roskell, L. Clark, C. Rawcliffe, *The History of Parliament: the
 House of Commons 1386–1421* (Boydell and Brewer, 1993), pub-
 lished online at https://www.historyofparliamentonline.org/vol
 ume/1386-1421/member/brunham-robert.

13 Michael D. Myers, 'A Fictional True-Self: Margery Kempe and
 the Social Reality of the Merchant Elite of King's Lynn', *Albion:*

A Quarterly Journal Concerned with British Studies, Vol. 31, No. 3 (1999), pp. 377–94.

[14] *Ibid*, p. 386.

[15] Margery makes this point herself in Chapter 63.

[16] Stephen Alsford, *The Men Behind the Masque: Office Holding in East Anglian Boroughs 1272–1460*, published online 1998, http://users.trytel.com/tristan/towns/mcontent.html.

[17] Why knights fight with snails is a lasting curiosity of the medieval period. See Sarah J. Biggs, 'Knight v Snail', British Library medieval manuscripts blog (26 September 2013), https://blogs.bl.uk/digitisedmanuscripts/2013/09/knight-v-snail.html

[18] John Page-Phillips and Thurston Dart, 'The Peacock Feast', in *The Galpin Society Journal*, Vol. 6 (1953), pp. 95–8.

[19] Kate Parker, 'Lynn and the Making of a Mystic', in eds. John H. Arnold and Katherine J. Lewis, *A Companion to The Book of Margery Kempe* (D. S. Brewer, 2004), pp. 55–73.

[20] John Cherry, 'King John's Cup', in ed. John McNeill, *King's Lynn and the Fens: Medieval Art, Architecture and Archaeology*, The British Archaeological Association Conference Vol. 31 (2008), pp. 1–16.

[21] *Ibid*.

[22] Charles Tracy, 'The Former Nave and Choir Oak Furnishings, and the West End and South Porch Doors, at the Chapel of St Nicholas, King's Lynn', in ed. McNeil, *King's Lynn and the Fens*, pp. 28–52.

[23] *The Book of Margery Kempe*, Chapter 25.

[24] Stephen Banks, *Informal Justice in England and Wales, 1780–1918* (Boydell Press, 2014), p. 63.

[25] *The Book of Margery Kempe*, Chapter 76.

[26] Virginia Burrus, *The Sex Lives of Saints: An Erotics of Ancient Hagiography* (University of Philadelphia Press, 2004), p. 161.

[27] *The Book of Margery Kempe*, Chapter 31.

[28] Lara Farina, 'Dirty Words: *Ancrene Wisse* and the Sexual Interior', in *Erotic Discourse and Early Religious Writing* (Palgrave Macmillan, 2006), pp. 35–61.

[29] *The Book of Margery Kempe*, Chapter 35.

[30] *Ibid*, Chapter 35.

31 *Ibid*, Chapter 57.

32 *Ibid*, Chapter 58.

33 *Ibid*, Chapter 44.

34 Marlys Craun, 'Personal accounts: The story of Margery Kempe', *Psychiatric Services*, Vol. 56 (2005), pp. 655–6.

35 Carolyn Dinshaw, *Getting Medieval: Sexualities and Communities, Pre and Post-Modern* (Duke University Press, 1999), p. 147.

36 Isabel Davies, 'Men and Margery: Negotiating Medieval Patriarchy', in eds. John H. Arnold and K. J. Lewis, *A Companion to the Book of Margery Kempe* (Boydell & Brewer, 2004), pp. 35–54.

37 Sebastian Sobecki, ' "The Writyng of this Tretys": Margery Kempe's Son and the Authorship of Her Book', *Studies in the Age of Chaucer*, Vol. 37 (2015), pp. 257–83.

38 *The Book of Margery Kempe,* Book 2, Chapter 1.

39 Taken from Marea Mitchell, *The Book of Margery Kempe: Scholarship, Community and Criticism* (Peter Lang Publishing, 2005), p. x.

40 *The Book of Margery Kempe*, Chapter 52.

41 John H. Arnold, 'Margery's Trials: Heresy, Lollardy and Dissent', in eds. Arnold and Lewis, *A Companion to The Book of Margery Kempe*, pp. 35–54.

42 Claire Cross, *Church and People: England, 1450–1660*, (Blackwell, 1999), p. 1.

43 Edward Powell, *Kingship, Law and Society: Criminal Justice in the Reign of Henry V* (Oxford University Press, 1989), pp. 141–67.

44 *The Book of Margery Kempe*, Chapter 52.

45 Paul Hardwick, *English Medieval Misericords: The Margins of Meaning*, (Boydell & Brewer, 2011), p. 110.

46 *The Book of Margery Kempe*, Chapter 55.

47 Sarah Rees Jones, ' "A Peler of Holy Church"; Margery Kempe and the Bishops', in ed. Jocelyn Wogan-Browne et al, *Medieval Women: Texts and Contexts in Late Medieval Britain, Essays for Felicity Riddy* (Turnhout, 2000), pp. 377–91.

48 *The Book of Margery Kempe*, Chapter 52.

49 *Ibid*, Chapter 45.

50 Carolyn Dinshaw, *How Soon is Now? Medieval Texts, Amateur Readers and the Queerness of Time* (Duke University Press, 2012), p. 105.

51 *The Book of Margery Kempe*, Chapter 60.

52 Michel de Certeau, *The Mystic Fable, Vol. 1: The Sixteenth and Seventeenth Centuries*, trans. Michael B. Smith (University of Chicago Press, 1992), p. 11.

53 *The Book of Margery Kempe*, Chapter 80.

54 *Ibid*, Chapter 79.

55 *Ibid*, Chapter 61.

56 James Charles Cummings, *Contextual Studies of the Dramatic Records in the Area Around the Wash, c.1350–1550* (Unpublished PhD Thesis, University of Leeds, 2001), pp. 80–192.

57 E.g. the Augustinian Friar in King's Lynn, Chapter 68.

58 *The Book of Margery Kempe*, Chapter 78.

59 Sue Niebrzydowski, 'Secular Woman and Late-Medieval Marian Drama', *The Yearbook of English Studies*, Vol. 43 (2013), pp. 121–139.

60 Claire Sponsler, *Drama and Resistance: Bodies, Goods and Theatricality in Late Medieval England* (University of Minnesota Press, 1997), pp. 136–60.

61 *The Book of Margery Kempe*, Chapter 27.

62 Chapter 26.

63 Chapter 27.

64 Chapter 30.

65 Chapter 30.

66 Karen Winstead, *John Capgrave's Fifteenth Century* (University of Philadelphia Press, 2004), pp. 1–18.

67 David Aers, *Community, Gender and Individual Identity: English Writing 1360–1430* (Routledge, 1988), p. 97.

68 *The Book of Margery Kempe*, Chapter 53.

69 *Ibid*, Chapter 18.

70 *Ibid*, Chapter 48.

71 *Ibid*, Chapter 74.

72 *Ibid*, Chapter 75.

73 *Ibid*, Chapter 18.

74 *Ibid*, Chapter 20.
75 *Ibid*, Chapter 39.
76 *Ibid*, Chapter 62.
77 Alexandra Barratt, 'Margery Kempe and the King's Daughter of Hungary', in ed. Sandra J. McEntire, *Margery Kempe: A Book of Essays* (Routledge, 1992), pp. 189–201.
78 Anthony Bale, 'Introduction', in *The Book of Margery Kempe* (Oxford University Press, 2015), pp. ix-xxxv.
79 Tara Williams, 'Manipulating Mary: Maternal, Sexual and Textual Authority in *The Book of Margery Kempe*', in *Modern Philology*, Vol. 107, No. 4 (2010), pp. 528–55.
80 *The Book of Margery Kempe*, Chapter 28.
81 *Ibid*, Chapter 47.

Chapter 9

1 Audre Lorde, *Sister Outsider: Essays and speeches by Audre Lorde* (Crossing Press, 2007), p. 138.
2 Charles Tilly, *Coercion, Capital, and European States: A.D. 900–1900* (Blackwell, 1992), p. ix.
3 Barbara Hanawalt, 'Golden Ages for the History of Medieval English Women', in ed. S. Mosher Stuart, *Women in Medieval History and Historiography* (University of Pennsylvania Press, 1987), pp. 1–24.
4 T. R. Turner et al, 'Participation, Representation, and Shared Experiences of Women Scholars in Biological Anthropology', *American Journal in Physical Anthropology*, Vol. 165 (2018), pp. 126–57.
5 J. Lutkin, 'Settled or Fleeting? London's Medieval Immigrant Community Revisited', in eds. M. Allen and M. Davies, *Medieval Merchants and Money: Essays in Honour of James L. Bolton* (Institute for Historical Research, 2016), pp. 137–50.
6 Rebecca Redfern and Joseph T. Hefner, ' "Officially Absent but Actually Present": Bioarchaeological Evidence for Population Diversity in London during the Black Death, 1348–50AD', in eds. L. Madeleine, L. Mant and Alyson Jaagumägi Holland,

Bioarchaeology of Marginalized People (Academic Press, 2019), pp. 69–114.

[7] Ian Grainger et al, *The Black Death Cemetery, East Smithfield, London, MoLAS Monograph Series, Vol. 43* (Museum of London Archaeology, 2008), p. 5.

[8] K. R. Dean et al, 'Human Ectoparasites and the Spread of Plague in Europe during the Second Pandemic', *Proceedings of the National Academy of Sciences*, Vol. 115, No. 6 (2018), pp. 1304–9.

[9] Mark Jobling and Andrew Millard, 'Isotopic and Genetic Evidence for Migration in Medieval England', in eds. Mark Ormrod, Joanna Story and Elizabeth Tyler, *Migrants in Medieval England: c.500–c.1500* (Proceedings of the British Academy, 229, 2020), pp. 19–64.

[10] Bonnie Greer, 'Magical Blackness', *In Search of Black History* (Audible Original Podcast, 2019).

[11] Brittany S. Walter and Sharon N. DeWitte, 'Urban and Rural Mortality and Survival in Medieval England', *Annals of Human Biology*, Vol. 44, No. 4 (2017), pp. 338–48.

[12] E. Kendall et al, 'Mobility, Mortality and the Middle Ages: Identification of Migrant Individuals in a Fourteenth-century Black Death Cemetery Population', *American Journal of Physical Anthropology*, Vol. 150, No. 2 (2013), pp. 210–22.

[13] Sarah Rees-Jones, 'English Towns in the Later Middle Ages: The Rules and Realities of Population Mobility', in eds. Ormrod, Story and Tyler, *Migrants in Medieval England*, pp. 265–303.

[14] Geraldine Heng, *The Invention of Race in the European Middle Ages* (Cambridge University Press, 2018), p. 269.

[15] Sigríður Sunna Ebenesersdóttir et al, 'A New Subclade of mtDNA Haplogroup C1 Found in Icelanders: Evidence of Pre-Columbian Contact?', *American Journal of Physical Anthropology*, Vol. 144 (2011), pp. 92–9.

[16] P. Spufford, *Power and Profit: The Merchant in Medieval Europe* (Thames & Hudson, 2002), p. 339 (quoted from R. Redfern and J. T. Hefner).

17 M. Ray, 'A Black Slave on the Run in Thirteenth-century England', *Nottingham Medieval Studies*, Vol. 51 (2007), pp. 111–19.

18 Robert Bartlett, *England under the Norman and Angevin Kings: 1075–1225* (Oxford University Press 2000), pp. 317–19

19 R. Fossier, 'Europe's Second Wind', in ed. R. Fossier, *The Cambridge Illustrated History of the Middle Ages: 1250–1520*, 3 vols. (Cambridge University Press, 1986), p. 423.

20 Geraldine Heng, 'The Invention of Race in the European Middle Ages I: Race Studies, Modernity and the Middle Ages I', *Literature Compass*, Vol. 8, No. 5 (2011), pp. 315–31.

21 Bernhard Bischoff and Michael Lapidge, *Biblical Commentaries from the Canterbury School of Theodore and Hadrian* (Cambridge University Press, 1994), p. 172.

22 Robert Bartlett, 'Medieval and Modern Concepts of Race and Ethnicity', *Journal of Medieval and Early Modern Studies*, Vol. 31, No. 1 (2001), pp. 39–56.

23 Robert the Monk's record of Urban's speech, in Dana C. Munro, 'Urban and the Crusaders', *Translations and Reprints from the Original Sources of European History*, Vol 1:2, (University of Pennsylvania, 1895), pp. 5–8.

24 Robert C. Stacey, 'Anti-Semitism and the Medieval English State', in eds. J. R. Madicott and D. M. Palliser, *The Medieval State: Essays Presented to James Campbell* (Hambledon, 2000), pp. 163–77.

25 S. Zeitlin, 'The Blood Accusation', *Vigilae Christianae*, Vol. 50, No. 2 (1996), pp. 117–24.

26 B. Dobson, *The Jews of Medieval York and the Massacre of March 1190* (Borthwick Institute Publications, 2002), p. 5.

27 Jeff Bowersox, 'Emperor Frederick II Rules over a Cosmopolitan Empire (ca. 1230s)', Black Central Europe Project, https://blackcentraleurope.com/sources/1000-1500/emperor-frederick-ii-rules-over-a-cosmopolitan-empire-1230s/

28 John Freed, *Frederick Barbarossa: The Prince and the Myth* (Yale University Press, 2016), pp. 370–4.

29 David Nirenberg, *Communities of Violence: Persecution of Minorities in the Middle Ages* (Princeton University Press, 2015), pp. 231–50.

30 K. J. P. Lowe, 'The Stereotyping of Black Africans in Renaissance Europe', in eds. T. F. Earle and K. J. P. Lowe, *Black Africans in Renaissance Europe* (Cambridge University Press, 2010), pp. 17–47.

31 F. Guidi-Bruscoli, 'London and its Merchants in the Italian Archives, 1380–1530', in eds. M. Allen and M. Davies, *Medieval Merchants and Money: Essays in Honour of James L. Bolton* (Institute for Historical Research, 2016), pp. 113–36.

32 M. Ray, 'A Black Slave on the Run in Thirteenth-century England', pp. 111–9.

33 Ruth M. Karras and David L. Boyd, 'The Interrogation of a Male Transvestite Prostitute in Fourteenth-Century London', *The GLQ Archive*, Vol. 1 (1995), pp. 459–65.

34 A. H. Thomas, *Calendar of Select Please and Memoranda of the City of London: A.D. 1381–1412*, 3 Vols (Cambridge University Press, 1924–32), p. 228.

35 R. M. Karras and D. L. Boyd, ' "Ut cum muliere": A Male Transvestite Prostitute in Fourteenth Century London', in ed. L. Fradenburg and C. Freccero, *Premodern Sexualities* (Routledge, 1996), pp. 99–116.

36 Jeremy Goldberg, 'John Rykener, Richard II and the Governance of London', *Leeds Studies in English*, Vol. 45 (2014), pp. 49–70.

37 Corporation of London Records Office, Plea and Memoranda Roll A34, m.2 (1395)

38 D. J. Keene and V. Harding, *Historical Gazetteer of London Before the Great Fire, Vol. 1, Cheapside* (Chadwyck-Healey, 1987), pp. 645–810.

39 Piotr Steinkeller, *Third-millennium legal and administrative texts in the Iraq Museum* (Eisenbrauns, 1992), p. 37.

40 Chris Johnstone, 'Grave of Stone Age "Gender Bender" Found in Prague', *Česká Pozice* (20 November 2011).

41 Eric Varner, 'Transcending Gender: Assimilation, Identity and Roman Imperial portraits', in ed. Ann Arbor, *Memoirs of the American Academy in Rome,* Vol. 7 (University of Michigan Press, 2008), pp. 200–1.

42 Randy P. Conner et al, *Cassell's Encyclopaedia of Queer Myth, Symbol, and Spirit: Gay, Lesbian, Bisexual, and Transgender Lore* (Cassell, 1997), p. 57.

43 Judith M. Bennett, 'Lesbian-like and the Social History of Lesbianisms', *Journal of the History of Sexuality*, Vol. 9, No. 1/2 (2000), pp. 1–24.

44 Leslie Fienberg, *Transgender Warriors* (Random House, 1996), p. ix.

45 P. Johnson and R. Vanderbeck, *Law, Religion and Homosexuality* (Routledge, 2014), p. 31.

46 Jeremy Goldberg, 'John Rykener, Richard II, and the Governance of London', *Leeds Studies in English*, Vol. 45 (2014), pp. 49–70.

47 Gervase Rosser, 'Crafts, Guilds and the Negotiation of Work in the Medieval Town', *Past and Present*, Vol. 154 (1997), pp. 3–37.

48 F. Rexroth, *Deviance and Power in Late Medieval London*, trans. P. E. Selwyn (Cambridge University Press, 2007), p. 269–71.

49 Ruth M. Karras and Tom Linkinen, 'John/Eleanor Rykener Revisited', in eds. L. E. Doggett and D. E. O'Sullivan, *Founding Feminisms in Medieval Studies*, (D. S. Brewer, 2016), pp. 114–24.

50 J. Hatcher, 'England in the Aftermath of the Black Death', *Past and Present*, Vol. 144 (1994), pp. 3–35.

51 *Memorials of London and London Life*, ed. Henry Thomas Riley (Longmans, Green and Co., 1868), pp. 534–5, quoted from Goldberg, 'John Rykener, Richard II, and the Governance of London', p. 65.

52 Cordelia Beattie, 'Gender and Femininity in Medieval England', in ed. N. F. Partner, *Writing Medieval History* (Bloomsbury Academic, 2005), pp. 155–7.

53 H. Janin, *Medieval Justice: Cases and Laws in France, England and Germany, 500–1500* (McFarland, 2004), p. 118.

54 Judith M. Bennett and Shannon McSheffrey, 'Early, Erotic and Alien: Women Dressed as Men in Late Medieval London', *History Workshop Journal* 77 (2014), pp. 1–25.

55 J. A. Schultz, *Courtly Love, the Love of Courtliness, and the History of Sexuality* (University of Chicago Press, 2006), p. xv.

Picture Credits

p. 77 English Heritage Images/Historic England Photo Library © Historic England

p. 79 Modified from Jarman et al. 2018: fig 1; published by Cambridge University Press

p. 85 © Ashmolean Museum/Bridgeman Images; © The Trustees of the British Museum

p. 99 Ola Myrin, The Swedish History Museum/SHM (CC BY)

p. 103 Christer Åhlin, The Swedish History Museum/SHM (CC BY)

p. 104 The Swedish History Museum/SHM (CC BY); Price et al. (2018), copyright Þórhallur Þráinsson

p. 106 Licensed under CC BY-SA 4.0 (Author: Goran tek-en); Werner Forman Archive/Bridgeman Images

p. 107 © Manchester Art Gallery/Bridgeman Images

p. 113 Sören Hallgren, The Swedish History Museum/SHM (CC BY)

p. 122 The Print Collector/Alamy Stock Photo; Nationalmuseet – The National Museum of Denmark, licensed under CC BY-SA 2.0

p. 127 Pieterjan Deckers, Søren Sindbæk, Aleks Pluskowski and The Society for Medieval Archaeology

p. 134 Bridgeman Images; © Région Normandie – Inventaire général – Pascal Corbierre

p. 135 The History Collection/Alamy Stock Photo

p. 137 © MailOnline - Leo Delauncey

p. 144 © KIK-IRPA, Brussels

p. 145 © Chapter of Durham Cathedral

p. 149 Alinari/Bridgeman Images

p. 152 Creative Commons Public Domain image

p. 153 The Parker Library, Corpus Christi College, Cambridge

p. 161 Creative Commons Public Domain Image (Author: Mike Christie); British Library, licensed under CC0 1.0 Universal (CC0 1.0) Public Domain Dedication

p. 162 © British Library Board. All Rights Reserved/Bridgeman Images; British Library, Creative Commons Public Domain Image

Picture Credits

Bibliography

I have included an extensive Bibliography as I would like this book to act as a resource for anyone wanting to research further. This book is just the start of many more potential investigations, so by providing you with the many works I consulted, you will be able to do your own digging.

PRIMARY SOURCES

'An Abbess of Alterna to Hildegard, before 1173, Letter 49', in trans. Mark Atherton, *Hildegard of Bingen: Selected Writings*. Penguin Classics, 2001. pp. 35. Hereafter Atherton.

'Gebeno of Eberbach: *The Pentachronon*', in Atherton, p. 193.

'Letter from Tengswich to Hildegard, Letter 52', in eds. Joseph L. Baird and Radd K. Ehrman, *The Letters of Hildegard of Bingen, Vol. 1*. Oxford University Press, 1994. p. 127.

'The Nun Gertrud (of Stahleck), to Hildegard, after 1161, Letter 62', in Atherton, p. 184.

Bale, Anthony, intro and trans., *The Book of Margery Kempe*. Oxford University Press, 2015.

Elizabeth of Schönau, *The Complete Works*. Pauline Press, 2000.

Gregory of Tours, *The History of the Franks*, Book 3, ed. Lewis Thorpe (Penguin Classics, 1974).

Hildegard of Bingen, 'A Vision of Love', from *The Book of Divine Works*, I, 1, in Atherton, p. 171.

——'Antiphon for Saint Disibod', in Atherton, pp. 35.

——'Letter to Bernard of Clairvaux', in Atherton, p. 3.

——'Letter to Elizabeth of Schönau', in Atherton, p. 79.

——'Letter to Heinrich, Archbishop of Mainz, Letter 18R', in Atherton, p. 51.

——'Letter to Henry, Bishop of Liège', in Atherton, p. 65.

——'Letter to Pope Eugenius III, 1148, Letter 2', in Atherton, p. 31.

——'Letter to Pope Eugenius III, 1148–53, Letter 3', in Atherton, p. 66.

——'Letter to Richardis, 1151–2, Letter 64', in Atherton, p. 52.

——'Life of Jutta', in ed. Anna Silvas, *Jutta and Hildegard: The Biographical Sources*. Pennsylvania State University Press, 1998. pp. 65–85.

——'Quia Ergo Femina', in Atherton, p. 118.

——*Causae et Curae*, Book 2, ed. Paul Kaiser. Leipzig, 1903.

——*Epistula 195*, ed. Lieven van Acker, *Espistolarium. Pars Secunda, XCI-CCLr*, CCCM 91A. Turnholt, 1993.

——*Espistolarium. Pars Secunda*, ed. Lieven van Acker, *XCI–CCLr*, CCCM 91A. Turnholt, 1993.

——*Scivias*, eds. Adelgundis Führkötter and Angela Carlevaris, CCCM 43–43A. Turnholt, 1978.

'Homily of John Paul II, Krakow, 8 June 1997; Holy Mass for the Canonization of Blessed Queen Edwig', in *Apostolic Journey of His Holiness John Paul II to Poland (May 31–June 10, 1997)*, Libreria Editrice Vaticana, 1997.

La Chanson de la Croisade Contre les Albigeois, 3 Vols. Les Classiques de l'Histoire de France au Moyen Age, 1931, 1957, 1961.

Life of Hildegard of Bingen, Book II, trans. Monika Klaes. Fontes Christiani, 1998.

Map, Gautier, *De Nugis Curialium*, eds. M. R. James, C. N. L. Brooke and R. A. B. Mynors (Oxford University Press, 1983), p. 126–7.

Museum am Strom, *Permanent Exhibition: Hildegard of Bingen: Her Life and Work*. Exhibition catalogue. Museum am Strom.

Petri Vallium Sarnaci Monachi Hystoria Albigensis, eds. P. Guébin and E. Lyon, 3 vols., (Champion, 1926, 1930, 1939), Vol. 1, para 215,

pp. 214-5. English translation W. A. Sibly and M. D. Sibly, *Peter of Les Vaux-de-Cernay: The History of the Albigensian Crusade* (Boydell Press, 1998), p. 111.

Sacks, Oliver, 'Patterns. Migraine: Perspectives on a Headache', *New York Times*, 13 February 2008, Opinion Pages.

Sewell, Brian, 'Tapestry and Swimming Pools', *Art and Artists*, Vol. 196. 1982. p. 28.

The Annals of Jan Długosz, English abridgement by Maurice Michael, commentary by Paul Smith. IM Publications, 1997. pp. 346–7.

The Carmen de Hastingae Proelio of Bishop Guy of Amiens, ed. and trans. Frank Barlow. Oxford, 1999.

The Letters of John of Salisbury. Volume 2. The Later Letters (1163–80), ed. and trans. W. J. Millor and C. N. L. Brooke. Clarendon Press, 1979.

Theoderich of Echternach, 'Life of Hildegard, Book 2', in Atherton, p. 191.

William of Auxerre, *Summa aurea*, ed. Jean Ribaillier, 4 vols. CNRS, 1980–87.

SECONDARY SOURCES

Abels, Richard, 'Alfred the Great, the *Micel Haeðen Here* and the Viking Threat', in ed. Timothy Reuter, *Alfred the Great*. Studies in Early Medieval Britain, Routledge, 2003. pp. 266–7.

——'Royal Succession and the Growth of Political Stability in Ninth-Century Wessex', *The Haskins Society Journal: Studies in Medieval History*, Vol. 12 (2002). pp. 83–97.

——'What Has Weland to Do with Christ? The Franks Casket and the Acculturation of Christianity in Early Anglo-Saxon England', *Speculum*, Vol. 84, No. 3 (2009), pp. 549–81.

Aers, David, *Community, Gender and Individual Identity: English Writing 1360–1430*. Routledge, 1988.

Agosin, Marjorie, *Stitching Resistance: Women, Creativity and Fiber Arts*. Solis Press, 2014.

Akinsha, Konstantin and Kozlov, Grigorii, *Beautiful Loot: The Soviet Plunder of Europe's Art Treasures*. New York, 1995.

Alexiu, Andra, '*Magistra magistrorum:* Hildegard of Bingen as a Polemicist against False Teaching', *Medieval Worlds*, No. 7 (2018). pp. 170–89.

Allen, M. and Davies, M., *Medieval Merchants and Money: Essays in Honour of James L. Bolton.* Institute for Historical Research, 2016.

Alter, Robert, *The Five Books of Moses.* W. W. Norton & Company, 2004.

Ambrosiani, B., 'Birka', in eds. S. Brink and N. Price, *The Viking World.* Routledge, 2012. pp. 94–100.

——*Excavations in the Black Earth 1990–1995: Stratigraphy, 1. Part One: The Site and the Shore. Part Two: The Bronze Caster's Workshop, Birka Studies* 9 (2013).

Anderson, J. D., 'The Bayeux Tapestry: A 900-year-old Latin Cartoon', *Classical Journal*, Vol. 81 (1986). pp. 253–7.

Anderson, S. M. and Swenson, K., *Cold Counsel: Women in Old Norse Literature and Mythology: A Collection of Essays.* New York, 2002.

Andrén, Anders et al, *Old Norse Religion in Long-Term Perspectives: Origins, Changes, and Interactions.* Nordic Academic Press, 2006.

Appleby, Jo et al, 'The Scoliosis of Richard III, last Plantagenet King of England: Diagnosis and Clinical Significance', *The Lancet*, Vol. 383, No. 9932 (2014). p. 1944.

Appleton, Helen, 'The Old English *Durham* and the Cult of Cuthbert', *The Journal of English and Germanic Philology*, Vol. 115, No. 3 (2016). pp. 246–69.

Arnold, John H., 'Margery's Trials: Heresy, Lollardy and Dissent', in eds. John H. Arnold and Katherine J. Lewis, *A Companion to The Book of Margery Kempe.* D. S. Brewer, 2004). pp. 75–94.

Arwill-Nordbladh, Elisabeth, 'Negotiating Normativities – "Odin from Lejre" as Challenger of Hegemonic Orders', *Danish Journal of Archaeology*, Vol. 2, No. 1 (2013). pp. 87–93.

——'Viking Age Hair', *Internet Archaeology*, Vol. 42 (2016).

Ashe, Laura and Ward, Emily John, *Conquests in Eleventh Century England, 1016, 1066.* Boydell & Brewer, 2020.

Avent., R., and Leigh, D., 'A Study of the Cross-Hatched Gold Foils in Anglo-Saxon Jewellery', *Medieval Archaeology*, Vol. 21 (1977), pp. 1–46.

Avila-Funes, José Alberto et al, 'Association Between High Serum Estradiol Levels and Delirium Among Hospitalised Elderly Women', *Revista de Investigación Clínica*, Vol. 67 (2015). pp. 20–4.

Bagnoli, Martina et al, *A Feast for the Senses: Art and Experience in Medieval Europe*. Yale University Press, 2016.

Baigent, Michael, Leigh, Richard and Lincoln, Henry, *Holy Blood and the Holy Grail*. London, 1982.

Bailey, Maggie, 'Ælfwynn, Second Lady of the Mercians', in eds. N. J. Higham and D. H. Hill, *Edward the Elder 899–924*. Routledge, 2001. pp. 112–27.

Bain, Jennifer, *Hildegard of Bingen and Musical Reception: The Modern Revival of a Medieval Composer*. Cambridge University Press, 2015.

——'History of a Book: Hildegard of Bingen's "Riesencodex" and World War II', *Plainsong and Medieval Music*, Vol. 27, No. 2 (2018). pp. 143–70.

Bammesberger, A., 'A Note on the Whitby Comb Runic Inscription', *Notes and Queries*, Vol. 57, No. 3 (2010), pp. 292–5.

Bandstra, Barry L., *Reading the Old Testament: An Introduction to the Hebrew Bible*. Wadworth Publishing, 2008.

Barber, Malcolm, *The Cathars: Dualist Heresies in Languedoc in the High Middle Ages*. Routledge, 2017.

——'Women and Catharism', *Reading Medieval Studies*, Vol. 3 (1977). pp. 45–62.

Barlow, Frank, *Edward the Confessor*. University of California Press, 1984.

Barlow, Frank, ed., *The Life of King Edward who Rests at Westminster Attributed to a Monk of Saint-Bertin*. Clarendon Press, 1992.

Barrow, Julia, 'The Ideology of the Tenth-Century English Benedictine "Reform"', in ed. Patricia Skinner, *Challenging the Boundaries of Medieval History: The Legacy of Timothy Reuter*. Brepols, 2009. pp. 141–54.

Bartlett, Anne Clark, 'Miraculous Literacy and Textual Communities in Hildegard of Bingen's *Scivias*', *Mystics Quarterly*, Vol 18, No. 2 (1992). pp. 43–55.

Bartlett, Robert, *England under the Norman and Angevin Kings: 1075–1225*. Oxford, 2000.

——'Medieval and Modern Concepts of Race and Ethnicity', *Journal of Medieval and Early Modern Studies*, Vol. 31, No. 1 (2001). pp. 39–56.

Bauer, Susan Wise, *The History of the Renaissance World: From the Rediscovery of Aristotle to the Conquest of Constantinople*. W. W. Norton & Company, 2013.

Bazzicchi, Oreste, *Il paradossa francescano tra povertà e societá di mercato*. Effatà Editrice, 2011.

Beattie, Cordelia, 'Gender and Femininity in Medieval England', in ed. N. F. Partner, *Writing Medieval History*. Bloomsbury Academic, 2005. pp. 155–7.

Bennett, Judith M., 'Lesbian-like and the Social History of Lesbianisms', *Journal of the History of Sexuality*. Vol. 9, No. 1/2 (2000). pp. 1–24.

Bennett, Judith M. and McSheffrey, Shannon, 'Early, Erotic and Alien: Women Dressed as Men in Late Medieval London', *History Workshop Journal*. Vol. 77 (2014). pp. 1–25.

Benson, Robert Louis, Constable, Giles, and Lanham, Carol Dana, *Renaissance and Renewal in the Twelfth Century*. Harvard University Press, 1991.

Bernstein, David J. *The Mystery of the Bayeux Tapestry*. Guild Publishing, 1986.

Biddle, Martin and Klølbye-Biddle, Birthe, 'Repton and the Vikings', *Antiquity*, Vol. 66, No. 250 (1992). pp. 36–51.

——'The Repton Stone', *Anglo-Saxon England*, Vol. 14 (1985). pp. 233–92.

Biller, Peter, 'Goodbye to Waldensianism', *Past and Present*, Vol. 192 (2006). pp. 3–33.

——'Intellectuals and the Masses: Oxen and She-asses in the Medieval church', in ed. John H. Arnold, *The Oxford Handbook of Medieval Christianity*. Oxford University Press, 2014. pp. 323–39.

Bischoff, Bernhard and Lapidge, Michael, *Biblical Commentaries from the Canterbury School of Theodore and Hadrian*. Cambridge University Press, 1994.

Blackburn, M. A. A. and Dumville, D. N., *Kings, Currency and Alliances: History and Coinage of Southern England in the Ninth Century*. Boydell Press, 1998.

Blair, John, 'Exploring Anglo-Saxon Settlement: In Search of the Origins of the English Village', *Current Archaeology*, Vol. 291 (2014). pp. 12–23.

——'Landscapes of Power and Wealth', in *Building Anglo-Saxon England* (Princeton University Press, 2018), pp. 103–38.

——*The Church in Anglo-Saxon Society*. Oxford University Press, 2005.

Bloch, R. Howard, *A Needle in the Right Hand of God: The Norman Conquest of 1066 and the Making and Meaning of the Bayeux Tapestry*. Random House, 2006.

Bond, G. A., *The Loving Subject: Desire, Eloquence and Power in Romanesque France*. University of Pennsylvania Press, 1995.

Bonner, Gerald, Rollason, David and Stancliffe, Clare, eds., *St. Cuthbert, his Cult and his Community to AD 1200*. Boydell & Brewer, 1989.

Børresen, Kari Elisabeth and Valerio, Adriana, *The High Middle Age, The Bible and Women Series*. Society of Biblical Literature, 2015.

Bouet, Pierre, Levy, Brian and Nevaux, François, *The Bayeux Tapestry: Embroidering the Facts of History*. PU Caen, 2004.

Bouwman, Abigail and Rühli, Frank, 'Archaeogenetics in evolutionary medicine', *Journal of Molecular Medicine*, Vol. 94, Issue 9 (2016). pp. 971–7.

Bowersox, Jeff, 'Emperor Frederick II Rules over a Cosmopolitan Empire (ca. 1230s)', Black Central Europe Project. https://black-centraleurope.com/sources/1000-1500/emperor-frederick-ii-rules-over-a-cosmopolitan-empire-1230s/.

Bowie, Fiona and Davies, Oliver, eds., *Hildegard of Bingen: An Anthology*. SPCK, 1990.

Braddy, G. S., 'Deira, Bernicia and the Synod of Whitby', *Cleveland History*, Vol. 87 (2004). pp. 3–13.

Breay, Claire and Story, Joanna, *Anglo-Saxon Kingdoms: Art, Word, War*. British Library Publishing, 2018.

Brenon, Anne, *Les Femmes Cathares*. Perrin, 2004.

Bridgeford, A., 'Was Count Eustace II of Boulogne the Patron of the Bayeux Tapestry?', *Journal of Medieval History*, Vol. 25, No. 3 (1999). pp. 155–85.

Brink, S. and Price, N., *The Viking World*. Routledge, 2012.

Brolis, Maria Teresa, *Stories of Women in the Middle Ages*. McGill-Queen's University Press, 2018.

Brooks, N. P., and Walker, H. E., 'The Authority and Interpretation of the Bayeux Tapestry', in ed. R. Gameson, *The Study of the Bayeux Tapestry*, 1997. pp. 63–92.

Brzezińska, Anna, 'Jadwiga of Anjou as the Image of a Good Queen in Late Medieval and Early Modern Poland', *The Polish Review*, Vol. 44, No. 4 (1999), pp. 407–18.

Bubczyk, Robert, *Kariera rodziny Kurozwęckich w XIV wieku*. Wydawnictwo DiG, 2002.

Bundy, Mildred, 'The Anglo-Saxon Embroideries at Maaseik: Their Historical and Art-Historical Context', *Academiae Analecta*, Vol. XLV (1984). pp. 1–84.

Burrus, Virginia, *The Sex Lives of Saints: An Erotics of Ancient Hagiography*. University of Philadelphia Press, 2004.

Cadden, Joan, 'It Takes All Kinds: Sexuality and Gender Difference in Hildegard of Bingen's *Book of Compound Medicine*', *Traditio*, Vol. 40 (1984). pp. 149–74.

Campbell, M., 'Ælfgyva: the Mysterious Lady of the Bayeux Tapestry', *Annales de Normandie*, Vol. 34 (1984). pp. 127–45.

Campbell, Nathaniel M., 'The Prophetess and the Pope: St. Hildegard of Bingen, Pope Benedict XVI, and Prophetic Visions of Church Reform', *Postmedieval: A Journal of Medieval Cultural Studies*, Vol. 10, No. 1 (2019). pp. 22–35.

Campbell, Olivia, 'Abortion Remedies from a Medieval Catholic Nun', JSTOR Daily, 13 October 2021. https://daily.jstor.org/abortion-remedies-medieval-catholic-nun/.

Cantor, Norman F., *The Civilization of the Middle Ages: A Completely Revised and Expanded Edition of Medieval History, the Life and Death of a Civilization*. Harper Collins, 1993.

Carruthers, Mary, *The Book of Memory: A Study of Memory in Medieval Culture*. Cambridge University Press, 2008.

Cartwright, Jane, *The Cult of St Ursula and the 11000 Virgins*. University of Wales Press, 2016.

Carver, Martin, 'Burial as Poetry: The Context of Treasure in Anglo-Saxon Graves', in ed. E. M. Tyler, *Treasure in the Medieval West*. York Medieval Press, 2000. pp. 25–40.

——*Sutton Hoo: Burial Ground of Kings?*. British Museum Press, 2000.

Caviness, M., *Reframing Medieval Art: Differences, Margins, Boundaries*. Tufts University, 2001.

Certeau, Michel de, *The Mystic Fable, Vol. 1: The Sixteenth and Seventeenth Centuries*, trans. Michael B. Smith. University of Chicago Press, 1992.

Chai, Nu Cindy, Peterlin, B. Lee and Calhoun, Anne H., 'Migraine and Oestrogen', *Curr Opin Nerol*. Vol. 27, No. 3 (2014). pp. 315–24.

Chambers, Mark, 'How Long is a Launce? Units of Measure for Cloth in Late Medieval Britain', in eds. Robin Netherton and Gale R. Owen-Crocker, *Medieval Clothing and Textiles, 13*. Boydell & Brewer, 2017. pp. 31–66.

Charles-Edwards, Thomas M., *Wales and the Britons 350–1064*. Oxford University Press, 2013.

Chazelle, Celia, 'Archbishops Ebo and Hincmar of Reims and the Utrecht Psalter', *Speculum*, Vol. 72, No. 4 (1997). pp. 1055–77.

Cherry, John, 'King John's Cup', in ed. John McNeil, *King's Lynn and the Fens: Medieval Art, Architecture and Archaeology, The British Archaeological Association Conference*, Vol. 31 (2008). pp. 1–16.

Chris, Catling, 'Buried in a Royal Bed: Street House Anglo-Saxon Cemetery', *Current Archaeology*, Issue 281 (2013). pp. 20–7.

Christensen, Lisbeth Bredholt, Hammer, Olav and Warburton, David, *The Handbook of Religions in Ancient Europe*. Acumen Publishing, 2013.

Clarke, Howard B., 'The Identity of the Designer of the Bayeux Tapestry', *Anglo-Norman Studies*, Vol. 35 (2013). pp. 119–40.

Clarkson, Tim, *Æthelflæd, The Lady of the Mercians*. Birlinn, 2018.

Coatsworth, Elizabeth, 'Stitches in Time: Establishing a History of Anglo-Saxon Embroidery', in eds. Monica L. Wright, Robin

Netherton and Gale R. Owen-Crocker, *Medieval Clothing and Textiles*, *No. 1*. Boydell & Brewer, 2005. pp. 1–27.

Conner, Randy P. et al, *Cassell's Encyclopaedia of Queer Myth, Symbol, and Spirit: Gay, Lesbian, Bisexual, and Transgender Lore*. Cassell, 1997.

Costagliola, Michael, 'Fires in History: The Cathar Heresy, The Inquisition and Brulology', *Annals of Burns and Fire Disasters*, Vol. 28, No. 3 (2015). pp. 230–4.

Costambeys, Marios, 'Æthelflæd [Ethelffelda] (d. 918), Ruler of the Mercians', in *Oxford Dictionary of National Biography*, Vol. 1. Oxford University Press, 2004.

Couzin, Robin, 'Syncretism and Segregation in Early Christian Art', *Studies in Iconography*, Vol. 38 (2017), pp. 18–54.

Cowen, Alice, *Writing Fire and Sword: The Perception and Representation of Violence in Anglo-Saxon England*. Unpublished PhD thesis, University of York, 2004.

Cowen, Ross, *Milvian Bridge AD 312: Constantine's battle for Empire and Faith*. Osprey Publishing, 2016.

Craun, Marlys, 'Personal accounts: The Story of Margery Kempe', *Psychiatric Services*, Vol. 56 (2005). pp. 655–6.

Crawford, Sally, 'Votive Deposition, Religion and the Anglo-Saxon Furnished Burial Ritual', *World Archaeology*, Vol. 36, No. 1 (2004). pp. 87–102.

Crick, Julia, 'Conquest and Manuscript Culture', in eds. Laura Ashe and Emily John Ward, *Conquests in Eleventh Century England, 1016, 1066*. Boydell & Brewer, 2020. pp. 123–39.

Cross, Claire, *Church and People: England, 1450–1660*, Blackwell, 1999.

Cubitt, Catherine, 'The Tenth-Century Benedictine Reform in England', *Early Medieval Europe*, Vol. 6, No. 1 (1997). pp. 77–94.

Dallapiazza, Michael et al, *International Scandinavian and Medieval Studies in Memory of Gerd Wolfgang Weber*. Hesperides, 2000.

Daniels, R., *Anglo-Saxon Hartlepool and the Foundation of English Christianity*. Tees Archaeology Monograph 3. Oxbow Books, 2007.

Darvill, Timothy, *Prehistoric Britain*. Routledge, 2009.

Davies, Norman, *God's Playground: A History of Poland*. Columbia University Press, 1982.

Davies, Ralph H. C. and Chibnall, Marjorie, eds., *The 'Gesta Guillelmi' of William of Poitiers*. Oxford, 1998.

De Hamel, Christopher, *Meetings with Remarkable Manuscripts*. Allen Lane, 2016.

Dean, K. R. et al, 'Human Ectoparasites and the Spread of Plague in Europe during the Second Pandemic', *Proceedings of the National Academy of Sciences*, Vol. 115, No. 6 (2018). pp. 1304–9.

Deckers, Pieterjan, Croix, Sarah and Sindbæk, Søren M., 'Assembling the Full Cast: Ritual Performance, Gender Transgression and Iconographic Innovation in Viking-Age Ribe', *Medieval Archaeology*, Vol. 65, No. 1 (2021). pp. 30–65.

Department of Statistics to the Government of the Republic of Lithuania, 'Romos katalikų daugiausia', 2009.

Derkse, Wil, *The Rule of Benedict for Beginners: Spirituality for Daily Life*, trans. Martin Kessler. Liturgical Press, 2003.

Dillon, Sheila, 'Women on the Columns of Trajan and Marcus Aurelius and the Visual Language of Roman Victory', in eds. Sheila Dillon and Katherine E. Welch, *Representations of War in Ancient Rome*. Cambridge University Press, 2009. pp. 244–71.

Dinshaw, Carolyn, *Getting Medieval: Sexualities and Communities, Pre and Post-Modern*. Duke University Press, 1999.

——*How Soon is Now? Medieval Texts, Amateur Readers and the Queerness of Time*. Duke University Press, 2012.

Długosz, J., *Roczniki czyli Kroniki sławnego Królestwa Polskiego*, Chapter X, X-XI, XI, XI-XII. Polish Scientific Publishers PWN, 1981, 1982, 1985, 2004.

Dobson, B., *The Jews of Medieval York and the Massacre of March 1190*. Borthwick Institute Publications, 2002.

Dodwell, Charles Reginald, *Anglo-Saxon Art: A New Perspective*. Manchester University Press, 1982.

Doggett, L. E. and O'Sullivan, D. E., *Founding Feminisms in Medieval Studies*. D. S. Brewer, 2016.

Downham, Clare, 'A Context for the Birka Grave Bj 581? Women and Military Leadership in the Tenth Century', in eds.

M. Toplak and J. Staecker, *Von Aethelfleda bis Olga. Frauen und Kreigsführung. Die Wikinger Entdecker und Eroberer*. Ullstein Buchverlag, 2019. pp. 151–60.

Doyle White, Ethan, 'The Goddess Frigg: Reassessing an Anglo-Saxon Deity', *Preternature: Critical and Historical Studies on the Preternatural*, Vol. 3, No. 2 (2014). pp. 284–310

Dumville, David, 'The Terminology of Overkingship in Early Anglo-Saxon England', in ed. J. Hines, *The Anglo-Saxons from the Migration Period to the Eighth Century. An Ethnographic Perspective*. Boydell & Brewer, 1997. pp. 345–65.

Dunn, Roger, 'The Changing Status and Recognition of Fiber Work Within the Realms of the Visual Arts', in ed. Marjorie Agosin, *Stitching Resistance: Women, Creativity and Fiber Arts*. Solis Press, 2014. pp. 43–54.

Duvernoy, J., 'Les Albigeois dans la vie Sociale et Economique de Leur Temps', *Annales de l'Insitul d'Études Occitanes, Actes de Colloque de Toulouse, Années 1964*. pp. 67–8.

Eales, Richard and Gameson, Richard, 'Books, Culture and the Church in Canterbury Around the Millennium', in eds. R. Eales and R. Gameson, *Vikings, Monks and the Millennium*. Canterbury Archaeological Trust, 2000. pp. 15–40.

Eales, Richard and Sharpe, Richard, *Canterbury and the Norman Conquest: Churches, Saints and Scholars, 1066–1109*. A&C Black, 1995.

Earle, T. F. and Lowe, K. J. P., *Black Africans in Renaissance Europe*. Cambridge University Press, 2010.

Ebenesersdóttir, Sigríður Sunna et al, 'A New Subclade of mtDNA Haplogroup C1 Found in Icelanders: Evidence of Pre-Columbian Contact?', *American Journal of Physical Anthropology*, Vol. 144 (2011). pp. 92–9.

Ebenesersdóttir, S. Sunna et al, 'Ancient Genomes from Iceland Reveal the Making of a Human Population', *Science*, Vol. 360, No. 6392 (2018). pp. 1028–32.

Engel, Pál, *The Realm of St Stephen: A History of Medieval Hungary, 895–1526*. I. B. Tauris Publishers, 2001. p. 195.

Engen, John van, 'Abbess, Mother and Teacher', in ed. Barbara Newman, *Voice of the Living Light: Hildegard of Bingen and Her World*. University of California Press, 1998. pp. 30–51.

Enger, Reed, 'Herrad of Landsberg, A French abbess creates the first female-authored Encyclopaedia', Obelisk Art History, 27 January 2016. https://arthistoryproject.com/artists/herrad-of -landsberg/.

Erikson, Bo G., *Kungen av Birka: Hjalmar Stolpe arkeolog och etnograf: en biografi*. Atlantis Publishers, 2015.

Escudero, Maria Jose Ortuzar, 'La Boca y lo Dulce. Algunas reflexiones sobre la tropologia del gusto en el libro Scivias de Hildegarda de Bingen', *Mirabilia*, Vol. 29 (2019). pp. 70–91.

Fanning, Steven, 'Bede, *Imperium*, and the Bretwaldas', *Speculum*, Vol. 66 (1991). pp. 1–26.

Fay, Jessica, 'Wordsworth's Northumbria: Bede, Cuthbert and Northern Medievalism', *The Modern Language Review*, Vol. III, No. 4 (2016). pp. 917–35.

Fern, Chris and Speake, George, 'Helmet Parts, Decorated Silver Sheet, Reeded Strip and Edge Binding', in eds. Chris Fern, Tania Dickinson and Leslie Webster, *The Staffordshire Hoard: An Anglo-Saxon Treasure*, Research Report of the Society of Antiquities in London, No. 80 (2019). pp. 70–84.

Fienberg, Leslie, *Transgender Warriors*. Random House, 1996.

Fjalldal, Magnús, 'The Last Viking Battle', *Scandinavian Studies*, Vol. 83, No. 3 (2015). pp. 317–31.

Flanagan, Sabina, *Hildegard of Bingen, 1098–1179: A Visionary Life*. Routledge, 1989.

Fleming, Robin, *Britain after Rome: The Fall and the Rise, 400 to 1070*. Penguin, 2011.

Flynn, William, 'Hildegard (1098–1179) and the Virgin Martyrs of Cologne', in ed. Jane Cartwright, *The Cult of St Ursula and the 11000 Virgins*. University of Wales Press, 2016. pp. 93–118.

Foot, Sarah, 'The Making of *Angelcynn:* English Identity Before the Norman Conquest', *Transactions of the Royal Historical Society*, Vol. 6 (1996), pp. 25–49.

——'Violence Against Christians? The Vikings and the church in the Ninth-Century', *Medieval History*, Vol. 1, No. 3 (1991). pp. 3–16.

Fossier, R., *The Cambridge Illustrated History of the Middle Ages: 1250–1520*, 3 vols. Cambridge, 1986.

Foys, Martin K., 'Pulling the Arrow Out: The Legend of Harold's Death and the Bayeux Tapestry', in eds. Martin K. Foys, Karen E. Overbey and Dan Terkla, *The Bayeux Tapestry: New Interpretations*. Boydell Press, 2009. pp. 158–75.

Fradenburg, L. and Freccero, C., *Premodern Sexualities*. Routledge, 1996.

Frank, Roberta, 'The Invention of the Viking Horned Helmet', in eds. Michael Dallapiazza et al, *International Scandinavian and Medieval Studies in Memory of Gerd Wolfgang Weber*. Hesperides, 2000. pp. 199–208.

Frank, Roberta, 'Viking Atrocity and Skaldic Verse: The Rite of the Blood-eagle', *English Historical Review*, Vol. XCIX (1984). pp. 332–43.

Freed, John, *Frederick Barbarossa: The Prince and the Myth*. Yale University Press, 2016.

Freeman, E., 'The Identity of Ælfgyva in the Bayeux Tapestry', *Annales de Normandie*, Vol. 41 (1991). pp. 117–34.

Freeman, Edward, *The History of the Norman Conquest of England*, 5 vols. Clarendon Press for Macmillan and Company, 1867–79.

Freeman, Phyllis R., Rees Bogarad, Carley and Sholomskas, Diane E., 'Margery Kempe, A New Theory: The Inadequacy of Hysteria and Postpartum Psychosis as Diagnostic Categories', *History of Psychiatry*, Vol. 1 (1990). pp. 169–90.

Friðiksdóttir, Jóhanna Katrín, *Valkyrie: The Women of the Viking World*. Bloomsbury, 2020.

Frost, Robert I., *The Oxford History of Poland-Lithuania, Volume I: The Making of the Polish-Lithuanian Union, 1385–1569*. Oxford University Press, 2015.

Füllenbach, Elias H., 'Devotio Moderna (I. Christianity)', *Encyclopaedia of the Bible and Its Reception*, Vol. 6 (2013). cols. 716–17.

Furtado, Peter, *History of Nations: How Their Identities were Forged*. Thames & Hudson, 2014.

Gameson, R., *The Study of the Bayeux Tapestry*. Boydell Press, 1997.

Gameson, Richard, 'English Manuscript Art in the Late Eleventh Century', in eds. R. Eales and R. Sharpe, *Canterbury and the Norman Conquest: Churches, Saints and Scholars, 1066–1109*. Continuum, 1995. pp. 95–144.

Gannon, Anna, *The Iconography of Early Anglo-Saxon Coinage: Sixth to Eighth Centuries*. Oxford University Press, 2003.

Gansum, Terje, 'Role the Bones: From Iron to Steel', *Norwegian Archaeological Review*, Vol. 37, No. 1 (2004). pp. 41–57.

Garbacz-Klempka, Aldona, and Rzadkosz, Stansław, 'Metallurgy in Middle Ages. Raw Materials, Tools and Facilities in Source Materials and Metallographic Research', *Argenti Fodina* (2014), pp. 99–105.

Gardela, L., 'Warrior-Women in Viking Age Scandinavia? A Preliminary Archaeological Study', in *Analecta Archaeological Gicaressoviensia*, Vol. 8 (2013). pp. 276–341.

Gardner, Julian, '*Opus Anglicanum* and its Medieval Patrons', in eds. Clare Browne, Glyn Davies and M. A. Michael, *English Medieval Embroidery: Opus Anglicanum*. Yale University Press, 2021. pp. 49–60.

Garnett, George, 'The Bayeux Tapestry with Knobs On: What do the Tapestry's 93 Penises tell us?', History Extra, 14 November 2018. https://www.historyextra.com/period/medieval/bayeux-tapestry-penis-why-norman-conquest-battle-hastings-william-conqueror/.

Geake, Helen, 'The Compleat Anglo-Saxonist: Some New and Neglected Early Anglo-Saxon Fish for Andrew Rogerson', in eds. Steven Ashley and Adrian Marsden, *Landscapes and Artefacts: Studies in East Anglian Archaeology Presented to Andrew Rogerson*. Archaeopress, 2014. pp. 113–22.

——*The Use of Grave-Goods in Conversion Period England, c. 600–850*. British Archaeological Reports Series, 1997.

Gem, Richard, *St Augustine's Abbey*. English Heritage Series, 1997.

Godden, Malcolm R., 'Did King Alfred Write Anything?', *Medium Ævum*, Vol. 76, No. 1 (2007). pp. 1–23.

Goldberg, Jeremy, 'John Rykener, Richard II and the Governance of London', *Leeds Studies in English*, Vol. 45 (2014). pp. 49–70.

Goldstein, G. S., *War and Gender: How Gender Shapes the War System and Vice Versa*. Cambridge University Press, 2001.

Goodrick-Clarke, Nicholas, *The Occult Roots of Nazism: Secret Aryan Cults and Their Influence on Nazi Ideology: The Ariosophists of Austria and Germany, 1890–1935*. The Aquarian Press, 1985.

Göransson, Eva-Marie, 'Bilder av kvinnor och kvinnlighet. Genus och kroppspråk under övergången till kristendomen', *Stockholm Studies in Archaeology*, Vol. 18 (1999). pp. 40–2.

Grainger, Ian et al, *The Black Death Cemetery, East Smithfield, London, MoLAS Monograph Series, Vol. 43*. Museum of London Archaeology, 2008.

Grassi, J. L., 'The *Vita Ædwardi Regis*: The Hagiographer as Insider', in ed. John Gillingham, *Anglo-Norman Studies: Proceedings of the Battle Conference, Vol. XXVI*. Boydell & Brewer, 2003. pp. 87–102.

Greer, Bonnie, 'Magical Blackness', *In Search of Black History*. Audible Original Podcast, 2019.

Greer, John Michael, *The New Encyclopaedia of the Occult*. Llewellyn Worldwide, 2003.

Gregorii I Papae Registrum Epistolarum, eds. Paulus Ewald and Ludovicus Hartmann. Weidmann, 1887–91.

Grewe, H., 'Die Königspfalz in Ingelheim', *Archäologie in Deutschland*, No. 4. Wissenschaftliche Buchgesellschaft, 1996.

Grierson, Philip and Blackburn, Mark A. S., *Medieval European Coinage*. Cambridge University Press, 1986.

Gromada, Tadeusz and Halecki, Oskar, *Jadwiga of Anjou and the Rise of East Central Europe*. Social Science Monographs, 1991.

Gromada, Thaddeus V., 'Oscar Halecki's Vision of Saint Jadwiga of Anjou', *The Polish Review*, Vol. 44, No. 4 (1999), pp. 433–7.

Grzebiennik, Małgorzata, 'Psałterz Floriański', in ed. Stanisław Skórka, *Historia Książki i Bibliotek*. 2003. https://biblia.wiara.pl/doc/423122.Przeklady-polskie-Psalterz-florianski.

Guerrilla Girls, *The Guerrilla Girls' Bedside Companion to the History of Western Art*. Penguin, 1998.

Guest, Gerald B., *Bible Moralisée Codex Vindobonensis 2554 Vienna*, Oesterreichische Nationalbibliothek. Harvey and Miller, 1995.

Guidi-Bruscoli, F., 'London and its Merchants in the Italian Archives, 1380–1530', in eds. M. Allen and M. Davies, *Medieval Merchants and Money: Essays in Honour of James L. Bolton*. Institute for Historical Research, 2016. pp. 113–36.

Hadley, Dawn, *The Vikings in England*. Manchester University Press, 2006.

Hadley, Dawn M. and Richards, Julian D., 'The Winter Camp of the Viking Great Army, AD 872–3, Torksey, Lincolnshire', *The Antiquaries Journal*, Vol. 96 (2016). pp. 23–67.

Haldon, J., *A Social History of Byzantium*. Blackwell, 2009.

Halecki, Oscar, *Jadwiga of Anjou and the Rise of East Central Europe*. Polish Institute of Arts and Sciences of America, 1991.

Hall, Mark A., 'Board Games in Boat Burials: Play in the Performance of Migration and Viking Age Mortuary Practice', *European Journal of Archaeology*, Vol. 19, No. 3 (2016). pp. 439–55.

Hanawalt, Barbara, 'Golden Ages for the History of Medieval English Women', in ed. S. Mosher Stuart, *Women in Medieval History and Historiography*. University of Pennsylvania Press, 1987. pp. 1–24.

Hardwick, Paul, *English Medieval Misericords: The Margins of Meaning*. Boydell & Brewer, 2011.

Hare, Michael, 'The Documentary Evidence for the History of St Oswald's, Gloucester to 1086', in eds. Carolyn Heighway and Richard Bryant, *The Golden Minster: The Anglo-Saxon Minster and Later Medieval Priory of St. Oswald at Gloucester*. CBA Research Report 117, Council for British Archaeology, 1999. pp. 33–45.

Hart, Columba and Bishop, Jane, trans., *The Ways of the Lord: Hildegard of Bingen*. Harper One, 2005.

Hatcher, J., 'England in the Aftermath of the Black Death', *Past and Present*, Vol. 144 (1994). pp. 3–35.

Hawkes, Jane, 'Stones of the North: Sculpture in Northumbria in the "Age of Bede"', in eds. J. Ashbee and J. Luxford, *Northumberland: Medieval Art and Architecture*. BAA Conference Transactions, Maney Publishing, 2013. pp. 34–53.

Healy Wasyliw, Patricia, *Martyrdom, Murder, and Magic: Child Saints and their Cults in Medieval Europe*. Peter Lang, 2008.

Hedenstierna-Jonson, Charlotte, 'She Came from Another Place: On the Burial of a Young Girl in Birka (Bj 463)', in ed. M. Hem Erikse et al, *Viking Worlds: Things, Spaces and Movement*. Oxbow Books, 2014. pp. 90–101.

Hedenstierna-Jonson, Charlotte et al, 'A Female Viking Warrior Confirmed by Genomics', *American Journal of Physical Anthropology*, Vol. 164, No. 4 (2017). pp. 853–60.

Heide, Eldar, 'Spinning Seiðr', in eds. Anders Andrén et al, *Old Norse Religion in Long-Term Perspectives: Origins, Changes, and Interactions*. Nordic Academic Press, 2006. pp. 164–8.

Heighway, Carolyn M., 'Anglo-Saxon Gloucester to AD 1000', in ed. Margaret L. Gaull, *Studies in Late Anglo-Saxon Settlement*. Oxford University Department for External Studies, 1984. pp. 35–53.

Heinemann, Christiane, *Der Riesencodex der Hildegard von Bingen. Verschollen – Gefunden – Gerettet. Schicksalswege 1942 bis 1950*. Historische Kommission für Nassau, Wiesbaden, 2021.

Helgason, A. et al, 'mtDNA and the Origin of the Icelanders: Deciphering Signals of Recent Population History', in *American Journal of Human Genetics*, Vol. 66, No. 3 (2000). pp. 999–1016.

Heng, Geraldine, 'The Invention of Race in the European Middle Ages I: Race Studies, Modernity and the Middle Ages 1', *Literature Compass*, Vol. 8, No. 5 (2011). pp. 315–31.

——*The Invention of Race in the European Middle Ages*. Cambridge University Press, 2018.

Heslop, T. A., 'The Production of *de luxe* Manuscripts and the Patronage of King Cnut and Queen Emma', *Anglo-Saxon England*, Vol. 19 (1990). pp. 151–96.

Hicks, Carola, *The Bayeux Tapestry: The Life Story of a Masterpiece*. Vintage Books, 2007.

Hidalgo, Díaz et al, 'New Insights into Iron-gall Inks through the Use of Historically Accurate Reconstructions', *Heritage Science*, Vol. 6, No. 1 (2018). pp. 1–15.

Higley, Sarah Lynn, *Hildegard of Bingen's Unknown Language: An Edition, Translation, and Discussion*. Palgrave Macmillan, 2007.

Hine Mundy, John, *Men and Women at Toulouse in the Age of the Cathars*. Pontifical Institute of Mediaeval Studies, 1990.

Hinton, David A. and White, Robert, 'A Smith's Hoard from Tattershall Thorpe, Lincolnshire: A Synopsis', *Anglo-Saxon England*, Vol. 22 (1993), pp. 147–66.

Hirsch, John C., 'Hope Emily Allen, the Second Volume of the Book of Margery Kempe, and an Adversary', in *Medieval Feminists Forum: The Journal of the Society for Medieval Feminist Scholarship*, Vol. 31, No. 1 (2001). pp. 11–17.

Holck, Per, 'The Oseberg Ship Burial, Norway: New Thoughts on the Skeletons from the Grave Mound', *European Journal of Archaeology*, Vol. 9, No. 2–3 (2006). pp. 185–210.

Hollander, Lee, *Old Norse Poems*. Columbia University Press, 1936.

Hollywood, Amy, 'The Normal, the Queer, and the Middle Ages', *Journal of the History of Sexuality*, Vol. 10, No. 2 (2001). pp. 173–9.

Holmquist, Lena, 'Birka's Defence Works and Harbour – linking one recently ended and one newly begun Research Project', in eds. L. Holmquist, S. Kalmring and C. Hedenstierna-Jonson, *New Aspects on Viking-age Urbanism, c. 750–1100*. Stockholm University Press, 2016. pp. 35–46.

Holsinger, Bruce W., *Music, Body and Desire in Medieval Culture: Hildegard of Bingen to Chaucer*. Stanford University Press, 2001.

'Homily of John Paul II, Krakow, 8 June 1997; Holy Mass for the Canonization of Blessed Queen Edwig', in *Apostolic Journey of His Holiness John Paul II to Poland (May 31–June 10, 1997)*. Libreria Editrice Vaticana, 1997. https://www.vatican.va/content/john-paul-ii/en/homilies/1997/documents/hf_jp-ii_hom_19970608_cracovia.html.

Hoose, Adam L., 'The "Sabotati": The Significance of Early Waldensian Shoes, c. 1184–c. 1300', *Speculum*, Vol. 91, No. 2 (2016). pp. 356–73.

Hope-Taylor, Brian, *Yeavering: An Anglo-British Centre of Early Northumbria*. H.M. Stationery Office, 1977.

Hopkins, Andrea, *Most Wise and Valiant Ladies*. Collins & Brown, 1997.

Horspool, David, *Why Alfred Burned the Cakes*. Profile Books, 2006.

Hotchin, Julie, 'Enclosure and Containment: Jutta and Hildegard at the Abbey of St. Disibod', *Magistra: A Journal of Women Spirituality in History*, Vol. 2, No. 2 (1996). pp. 103–23.

Hughes, Bettany, *Venus and Aphrodite: History of a Goddess*. Weidenfeld & Nicolson, 2019.

Hull, Lise E., *Britain's Medieval Castles*. Praeger, 2006.

Humphries, Will, 'Emma, the Queen in the Cathedral's Box of Old Bones', *The Times*, 16 May 2019.

Huneycutt, Lois L., *Matilda of Scotland: A Study in Medieval Queenship*. Boydell Press, 2003.

Hutchinson, Claire V., Walker, James A. and Davidson, Colin, 'Oestrogen, Ocular Function and Low-Level Vision: A Review', *Journal of Endocrinology*, Vol. 223, No. 2 (2014). pp. 9–18.

Hutton, Ronald, *The Pagan Religions of the Ancient British Isles*. Blackwell, 1991.

Ivy, Jill, *Embroideries at Durham Cathedral*. Dean and Chapter of Durham, 1997.

James, Liz, 'Men, Women, Eunuchs: Gender, Sex and Power', in ed. J. Haldon, *A Social History of Byzantium*. Blackwell, 2009. pp. 31–50.

James, Pamela, 'The Lichfield Gospels: The Question of Provenance', *Parergon*, Vol. 13, No. 2 (1996). pp. 51–61.

Janin, H., *Medieval Justice: Cases and Laws in France, England and Germany, 500–1500*. McFarland, 2004.

Jarman, C. et al, 'The Viking Great Army in England: new dates from the Repton charnel', *Antiquity*, Vol. 92, No. 361 (2018). pp. 183–99.

Jarman, Cat, *River Kings: The Vikings from Scandinavia to the Silk Road*. William Collins, 2021.

Jesch, Judith, 'Let's Debate Female Viking Warriors Yet Again', Norse and Viking Ramblings, 9 September 2017. http://norse-andviking.blogspot.com/2017/09/lets-debate-female-viking-warriors-yet.html?m=1.

——*Women in the Viking Age*. Boydell Press, 1991.

Jewell, Richard, 'Classicism of Southumbrian Sculpture', in Michelle P. Brown and Carol A. Farr, *Mercia: An Anglo-Saxon Kingdom in Europe*. Continuum, 2001. pp. 247–62.

Ježek, Martin, *Archaeology of Touchstones: An Introduction Based on Finds from Birka, Sweden*. Sidestone Press, 2017.

Jobling, Mark and Millard, Andrew, 'Isotopic and Genetic Evidence for Migration in Medieval England', in eds. Mark Ormrod, Joanna Story and Elizabeth Tyler, *Migrants in Medieval England: c.500–c.1500*. Proceedings of the British Academy, 229 (2020). pp. 19–64.

Jöckle, Clemens, *Encyclopaedia of Saints*. Konecky and Konecky, 2003.

Johnson, P. and Vanderbeck, R., *Law, Religion and Homosexuality*. Routledge, 2014.

Johnstone, Chris, 'Grave of Stone Age "Gender Bender" Found in Prague', *Česká Pozice*, 20 November 2011.

Jones, Gwyn, *A History of the Vikings*. Oxford University Press, 1984.

Jučas, Mečislovas, *Lietuvos ir Lenkijos unija* (Aidai, 2000).

Kaelber, Lutz, 'Weavers into Heretics? The Social Organisation of Early Thirteenth-Century Catharism in Comparative Perspective', *Social Science History*, Vol. 21, No. 1 (1997). pp. 111–37.

Karkov, Catherine E., *The Ruler Portraits of Anglo-Saxon England*. Boydell Press, 2004.

Karras, R. M. and Boyd, D. L., ' "Ut cum muliere." A Male Transvestite Prostitute in Fourteenth Century London', in eds. L. Fradenburg and C. Freccero, *Premodern Sexualities*. Routledge, 1996. pp. 99–116.

Karras, Ruth M. and Boyd, David L., 'The Interrogation of a Male Transvestite Prostitute in Fourteenth-Century London', *The GLQ Archive*. Vol. 1 (1995). pp. 459–65.

Karras, Ruth Mazo and Linkinen, Tom, 'John/Eleanor Rykener Revisited', in eds. L. E. Doggett and D. E. O'Sullivan, *Founding Feminisms in Medieval Studies*. D. S. Brewer, 2016. pp. 114–24.

Keene, D. J. and Harding, V., *Historical Gazetteer of London Before the Great Fire, Vol. 1, Cheapside*. Chadwyck-Healey, 1987..

Kelliher, Hilton, 'The Rediscovery of Margery Kempe: A Footnote', *The British Library Journal*, Vol. 23, No. 2 (1997). pp. 259–63.

Kellogg, Charlotte, *Jadwiga: Poland's Great Queen*. Borodino Books, 2018.

Kemp, Martin, *Leonardo*. Oxford University Press, 2004.

Kendall, E. et al, 'Mobility, Mortality and the Middle Ages: Identification of Migrant Individuals in a Fourteenth-century Black Death Cemetery Population', *American Journal of Physical Anthropology*, Vol. 150, No. 2 (2013). pp. 210–22.

Keynes, Simon, 'Cynethryth' in eds. M. Lapidge et al, *The Blackwell Encyclopaedia of Anglo-Saxon England*. Blackwell, 1999. p. 133.

——'England, 700–900', in ed. Rosamond McKitterick, *The New Cambridge Medieval History*, Vol. II. Cambridge University Press, 1995. pp. 18–42.

——'King Alfred and the Mercians', in eds. M. A. A. Blackburn and D. N. Dumville, *Kings, Currency and Alliances: History and Coinage of Southern England in the Ninth Century*. Boydell Press, 1998. pp. 24–7.

——'The Liber Vitae of the New Minster, Winchester', in eds. D. Rollason et al., *The Durham Liber Vitae and its Context*. Boydell Press, 2004. pp.149–64.

Keynes, Simon and Lapidge, Michael, eds. and trans., *Alfred the Great. Asser's Life of King Alfred and Other Contemporary Sources*. Penguin, 1983.

Klaper, Michael, 'Commentary', in trans. Lora Kruckenberg, *Lieder: Faksmile Riesencodex (Hs.2) der Hessischen Landesbibliothek Wiesbaden, fol. 466–481v*, ed. Lorenz Welker. Reichert Verlag, 1998. pp. 23–4.

Klinghoffer, David, 'The Da Vinci Protocols: Jews should worry about Dan Brown's success', National Review, 5 May 2006. https://www.nationalreview.com/2006/05/da-vinci-proto cols-david-klinghoffer/.

Knoll, Paul, 'Jan Długosz, 1480–1980', The Polish Review, Vol. 27, No. 1/2 (1982), pp. 3–28.

Knoll, Paul, 'Louis the Great and Casimir of Poland', in eds. S. B. Vardy, Géza Goldschmidr and Leslie S. Domonkos, Louis the Great, King of Hungary and Poland, East European Mono-graphs, 1986. pp. 108–9.

Knoll, Paul W., 'Jadwiga and Education', The Polish Review, Vol. 44, No. 4 (1999). pp. 419–32.

Gregorij Kozlov, 'Die Sowjetischen "Trophänbigaden" – Systematik und Anarchie des Kunstraubs einer Siegermacht', in ed. Hartmann von Uwe, Kulturgüter im Zweiten Weltkrieg. Verlagerung – Auffindung – Rüchführung (Koordinierungsstelle für Kulturgutverluste Magde-burg, 2007), pp. 79–104.

L'Osservatore Romano, English Weekly Edition, 23 June 1980, pp. 9–12.

Lacy, N. J. et al, 'Tristan', The New Arthurian Encyclopaedia. Gar-land Publishing, 1991. pp. 462–3.

Laing, Lloyd, 'Romano-British Metalworking and the Anglo-Saxons', in ed. Nick Higham, Britons in Anglo-Saxon England. Boydell & Brewer, 2007. pp. 42–56.

Lakey, Christopher R., 'Res et Significatio: The Material Sense of Things in the Middle Ages', Gesta, Vol. 51 (2012). pp. 1–17.

Lambert, Malcolm, The Cathars. Blackwell, 1998.

Larrington, Carolyne, trans., The Poetic Edda. Oxford World's Classics, 1999.

Le Roy Ladurie, Emmanuel, Montaillou: Cathars and Catholics in a French Village, 1294–1324, trans. Barbara Bray. Penguin, 1990.

Lebédel, Claude, Understanding the Tragedy of the Cathars. Editions Ouest-France, 2011.

Léglu, Catherine, Rist, Rebecca and Taylor, Claire, The Cathars and the Albigensian Crusade: A Sourcebook. Routledge, 2014.

Lemagnen, Sylvette, 'Preface', in ed. Lucien Musset, *La Tapisserie de Bayeux: Oeuvre d'art et Document Historique*, trans. Richard Rex. Boydell & Brewer, 2005. p. 272.

Lenz, Desiderius, *The Aesthetic of Beuron and Other Writings*, trans. John Minahane and John Connolly. Francis Boutle Publishers, 2002.

Lloyd Goodall, H., *A Need to Know: The Clandestine History of a CIA Family*. Left Coast Press, 2006.

Lockwood, Alan, '"In the Footsteps of Kraków's European Identity." The Rynek Underground Archaeological Exhibit', *The Polish Review*, Vol. 57, No. 4 (2012), pp. 87–99.

Lorde, Audre, *Sister Outsider: Essays and Speeches by Audre Lorde*. Crossing Press, 2007.

Lowden, John, *The Making of the Bibles Moralisées, I, The Manuscripts*. University Park, 2000.

Lowe, K. J. P., 'The Stereotyping of Black Africans in Renaissance Europe', in eds. T. F. Earle and K. J. P. Lowe, *Black Africans in Renaissance Europe*. Cambridge University Press, 2010. pp. 17–47.

Lucy, Sam, *Burial in Early Medieval England and Wales*, The Society for Medieval Archaeology Monographs, 17 (2002). pp. 1–24.

Luizza, Roy, *Beowulf: A New Verse Translation*. Broadview Press, 1999.

Lukowski, Jerzy and Zawadzki, Hubert, *A Concise History of Poland*. Cambridge University Press, 2001.

Lutkin, J., 'Settled or Fleeting? London's Medieval Immigrant Community Revisited', in eds. M. Allen and M. Davies, *Medieval Merchants and Money: Essays in Honour of James L. Bolton*. Institute for Historical Research, 2016. pp. 137–50.

Maddicott, J. R., 'London and Droitwich, *c.* 650–750: Trade, Industry and the Rise of Mercia', *Anglo-Saxon England*, Vol. 34 (2005). pp. 7–58.

Maddocks, Fiona, *Hildegard of Bingen: The Woman of her Age*. Faber and Faber, 2013.

Madigan, Shawn, *Mystics, Visionaries and Prophets: A Historical Anthology of Women's Spiritual Writings*. Augsburg Fortress, 1998.

Mann, J. C., 'The Division of Britain in 197 AD', *Zeitschrift Für Papyrologie Und Epigraphik*, Vol. 119 (1997), pp. 251–4.

Manvell, Roger and Fraenkel, Heinrich, *Heinrich Himmler: The Sinister Life of the Head of the SS and Gestapo*. Skyhorse, 2007.

Marek, Marta, *Rekonstrukcje cyfrowe historycznej zabudowy Krakowa*. Muzeum Historyczne Miasta Krakowa, 2013.

Markus, R. A., 'Gregory the Great's Europe', *Transactions of the Royal Historical Society*, Vol. 31 (1981), pp. 21–36.

Mayr-Harting, Henry, *The Coming of Christianity to Anglo-Saxon England*. Pennsylvania State University Press, 1991.

McCaffery, Emily, 'Imaging the Cathars in Late Twentieth-century Languedoc', *Contemporary European History*, Vol. 11, No. 3 (2002). pp. 409–27.

McFadyen, Angus Hector, *Aspects of the Production of Early Anglo-Saxon Cloisonné Garnet Jewellery*. Unpublished PhD thesis, Manchester Metropolitan University, 1998.

McGuire, Thérèse, 'Monastic Artists and Educators in the Middle Ages', *Woman's Art Journal*, Vol. 9, No. 2 (1988). pp. 3–9.

McKitterick, Rosamond, *The New Cambridge Medieval History*, Vol. II. Cambridge University Press, 1995.

Merlo, Grado Giovanni, 'Christian Experience of Religious Non-conformism', in ed. John H. Arnold, *Oxford Handbook of Medieval Christianity*. Oxford University Press, 2014. pp. 436–56.

Messent, Jan, *The Bayeux Tapestry Embroiderer's Story*. Madeira Threads Ltd, 1999.

Mitchell, Marea, *The Book of Margery Kempe: Scholarship, Community and Criticism*. Peter Lang, 2005.

Moen, Marianne, *Challenging Gender: A Reconsideration of Gender in the Viking Age Using the Mortuary Landscape*. Unpublished PhD thesis, University of Oslo, 2019.

——'Ideas of Continuity: Gender and the Illusion of the Viking Age as Familiar', in eds. Anne Pedersen and Søren M. Sindbæk, *Viking Encounters: Proceedings of the Eighteenth Viking Congress*. Aarhus University Press, 2020. pp. 621–32.

Monter, William, *The Rise of Female Kings in Europe, 1300–1800*. Yale University Press, 2012).

Moore, R. I., 'Principles at Stake: The Debate of April 2013 in Retrospect', in ed. Antonio Sennis, *The Cathars in Question*. Boydell & Brewer, 2016.

Moore, Robert I., *Heretics! Resistances and Repression in the Medieval West*. Belin, 2017.

Morris, Marc, *The Anglo-Saxons: A History of the Beginnings of England*. Penguin Random House, 2021.

Mortensen, L., 'The Marauding Pagan Warrior Woman', in ed. K. A. Pyburn, *Ungendering Civilisation*. Routledge, 2004. pp. 94–117.

Munro, Dana C., *Translations and Reprints from the Original Sources of European History*, Vol 1:2. University of Pennsylvania Press, 1895.

Murray, Yxta Maya, 'Rape Trauma, The State, and the Art of Tracey Emin', *California Law Review*, Vol. 100, No. 6 (2012). pp. 1631–710.

Musgrove, David and Lewis, Michael, *The Story of the Bayeux Tapestry: Unravelling the Norman Conquest*. Thames & Hudson, 2021.

Musset, Lucien, *La Tapisserie de Bayeux: Oeuvre d'art et Document Historique*, trans. Richard Rex. Boydell & Brewer, 2005.

Myers, Michael D., 'A Fictional True-Self: Margery Kempe and the Social Reality of the Merchant Elite of King's Lynn', *Albion: A Quarterly Journal Concerned with British Studies*, Vol. 31, No. 3 (1999). pp. 377–94.

Näsström, Britt-Mari, 'Old Norse Religion', in eds. Lisbeth Bredholt Christensen, Olav Hammer and David Warburton, *The Handbook of Religions in Ancient Europe*. Acumen Publishing, 2013. pp. 324–37.

Nelson, Janet L., 'Carolingian Contacts', in eds. Michelle P. Brown and Carol A. Farr, *Mercia: An Anglo-Saxon Kingdom in Europe*. Continuum, 2001. pp. 126–46.

——'The Dark Ages', *History Workshop Journal*, No. 63 (2007), pp. 191–201.

Newman, Barbara, *Voice of the Living Light: Hildegard of Bingen and Her World*. University of California Press, 1998.

Nirenberg, David, *Communities of Violence: Persecution of Minorities in the Middle Ages*. Princeton University Press, 2015. pp. 231–50.

Norton, Christopher, 'Viewing the Bayeux Tapestry, Now and Then', *Journal of the British Archaeological Association*, Vol. 172, No. 1 (2019). pp. 52–89.

Norwich, John Julius, *The Popes: A History*. Chatto & Windus, 2011.

O'Shea, Stephen, *The Perfect Heresy: The Revolutionary Life and Death of the Medieval Cathars*. Profile Books, 2001.

Obbard, Elizabeth Ruth, *Medieval Women Mystics: Gertrude the Great, Angela of Foligno, Brigiitta of Sweden, Julian of Norwich*. New City Press, 2007.

Oldenbourg, Zoe, *Massacre at Montsegur: A History of the Albigensian Crusade*. Phoenix, 2006.

Orchard, Andy, 'Literary Background to the *Encomium Emmae Reginae*', *Journal of Medieval Latin*, Vol. 11 (2001). pp. 156–83.

Ortiz, María Esther, 'Símbolo y experiencia visionaria en el Epistolario de Hildegarda de Bingen (1098–1179), *Mirabilia*, Vol. 29 (2019). pp. 70–91.

Osiński, Krzysztofm, 'Małżeństwo Jadwigi Andegaweńskiej z Władysławem Jagiełłą w Rocznikach Jana Długosza', *Przegląd Prawniczy Ekonomiczny i Społeczny*, Vol. 2 (2014). pp. 38–48

Owen-Crocker, Gale R., 'The Bayeux Tapestry: Invisible Seams and Visible Boundaries', *Anglo-Saxon England*, Vol. 31 (2002). pp. 257–73.

Owen-Crocker, Gale R., 'Behind the Bayeux Tapestry', in eds. M. K. Foys, K. E. Overbey and D. Terkla, *The Bayeux Tapestry: New Interpretations*. Boydell Press, 2009. pp. 119–29.

——'Stylistic Variations and Roman Influences in the Bayeux Tapestry', in ed. M. Crafton, *The Bayeux Tapestry Revisited, Peregrinations*, Vol. 2, No. 4 (2009). pp. 1–35.

——*The Bayeux Tapestry: Collected Papers*. Routledge, 2012.

Owen-Crocker, Gale R., Coatsworth, Elizabeth and Hayward, M., *Encyclopaedia of Dress and Textiles in the British Isles c. 450–1450*. Brill, 2012.

Ożóg, Krzysztof, 'The Intellectual Circles in Cracow at the Turn of the Fourteenth and Fifteenth Centuries and the Issue of the Creation of the Sankt Florian Psalter', *Polish Libraries*, Vol. 1 (2013), pp. 166–85.

Page-Phillips, John and Dart, Thurston, 'The Peacock Feast', in *The Galpin Society Journal*, Vol. 6 (1953). pp. 95–8.

Parker, Joanne, *'England's Darling': The Victorian Cult of Alfred the Great*. Manchester University Press, 2007.

Parker, Kate, 'Lynn and the Making of a Mystic', in eds. John H. Arnold and Katherine J. Lewis, *A Companion to The Book of Margery Kempe*, D. S. Brewer, 2004. pp. 55–73.

Parker, Rozsilka, *The Subversive Stitch: Embroidery and the Making of the Feminine*. The Women's Press, 1984.

Partner, N. F., *Writing Medieval History*. Bloomsbury Academic, 2005.

Pastan, Elizabeth Carson, 'The Material Context of the Bayeux Embroidery: Manufacture, Display and Literary References', in eds. Elizabeth Carson Pastan and Stephen D. White, *The Bayeux Tapestry and its Contexts: A Reassessment*. Boydell Press, 2014. pp. 9–32.

Perkins, Nicholas, 'Biblical Allusion and Prophetic Authority in Gildas's *De excidio Britanniae*', *The Journal of Medieval Latin*, Vol. 20 (2010), pp. 78–112.

Petro, Pamela, 'The Ælgvva Syndrome and the Erasure of Women's Stories', *Ms.*, 1 March 2001.

Petroff, Elizabeth Alvilda, *Medieval Women's Visionary Literature*. Oxford University Press, 1986.

Petropoulos, Jonathan, *Art as Politics in the Third Reich*. University of North Carolina Press, 1996.

Petty, Iris R., 'Hildegard's Historical Memory: The Lives of Saint Disibod and Saint Rupert as Models of Local Salvation History', *Comitatus: A Journal of Medieval and Renaissance Studies*, Vol. 45 (2014). pp. 133–48.

Phillips, Matthew, 'Urban Conflict and Legal Strategy in Medieval England: The Case of Bishop's Lynn, 1346–50', *Urban History*, Vol. 42, No. 3 (2015). pp. 365–80.

Pickles, John, *A History of Spaces: Cartographic Reason, Mapping, and the Geo-Coded World*. Taylor & Francis, 2003.

Pickvance, Christopher, 'Medieval Domed Chests in Kent: A Contribution to a National and International Study', *Regional Furniture*, Vol. 26 (2012). pp. 105–47.

Pita, Gonzalo, 'Waldensian and Catholic Theologies of History in the XII–XIV Centuries: Part 1', *Journal of the Adventist Theological Society*, Vol. 25, No. 2 (2014). pp. 65–87.

Piwocka, Magdalena, *Jałmużniczka*, in eds. M. Piwocka, D. Nowacki, *Wawel 1000–2000, Vol. I: Katedra krakowska – biskupia, królewska, narodowa*. Muzeum Katedralne na Wawelu, maj-wrzesień, 2000., pp. 45–6.

Pollington, Stephen, *Tamworth: Capital of the Kingdom of Mercia*. Tamworth Borough Council, 2011.

——'The Mead-Hall: Fighting and Feasting in Anglo-Saxon Society', *Medieval Warfare*, Vol. 2, No. 5 (2012), pp. 47–52.

Powell, Edward, *Kingship, Law and Society: Criminal Justice in the Reign of Henry V*. Oxford University Press, 1989.

Pratt, David, *The Political Thought of King Alfred the Great*. Cambridge University Press, 2007.

Prettejohn, Elizabeth, *Art for Art's Sake: Aestheticism in Victorian Painting*. Paul Mellon Centre for Studies in British Art, 2007.

Price, Neil, *The Viking Way: Magic and the Mind in Late Iron Age Scandinavia*. Oxbow, 2019.

Price, Neil et al, 'Viking warrior women? Reassessing Birka Chamber Grave Bj.581', *Antiquity*, Vol. 93 (2019). pp. 181–98.

Puchalska, Joanna Katarzyna, '*Vikings* Television Series: When History and Myth Intermingle', *The Polish Journal of the Arts and Culture*, Vol. 15 (2015). pp. 89–105.

Pyburn, K. A., *Ungendering Civilisation*. Routledge, 2004.

Radner, Joan Newlon, *Fragmentary Annals of Ireland*, CELT edition, FA 429, Dublin Institute for Advanced Studies, 1978.

Raffield, Ben et al, 'Ingroup Identification, Identity Fusion and the Formation of Viking Warbands', in *World Archaeology*, Vol. 48, No. 1 (2016). pp. 35–50.

Raffield, Ben, Price, Neil and Collard, Mark, 'Male-biased Operational Sex Ratios and the Viking Phenomenon: An Evolutionary Anthropological Perspective on Late Iron Age

Scandinavian Raiding', in *Evolution and Human Behaviour*, Vol. 38, No. 3 (2016). pp. 315–24.

Rahtz, Philip and Meeson, Robert, *An Anglo-Saxon Watermill at Tamworth: Excavations in the Bolebridge Street area of Tamworth, Staffordshire in 1971 and 1978*, CBA Research Report No 83, 1992.

Ramirez, Janina, *The Private Lives of Saints: Power, Passion and Politics in Anglo-Saxon England*. W. H. Allen, 2016.

Randall, David, *The Concept of Conversation: From Cicero's Sermo to the Grand Siècle's Conversation*. Edinburgh University Press, 2018.

Rauer, Christine, 'Female Hagiography in the Old English Martyrology', in ed. Paul E. Szarmach, *Writing Women Saints in Anglo-Saxon England*. University of Toronto Press, 2013. pp. 13–29.

Ray, M., 'A Black Slave on the Run in Thirteenth-century England', *Nottingham Medieval Studies*, Vol. 51 (2007). pp. 111–19.

Redfern, Rebecca and Hefner, Joseph T., ' "Officially Absent but Actually Present": Bioarchaeological Evidence for Population Diversity in London during the Black Death, 1348–50 AD', in eds. Madeleine L. Mant and Alyson Jaagumägi Holland, *Bioarchaeology of Marginalized People*. Academic Press, 2019. pp. 69–114.

Rees Jones, Sarah, ' "A Peler of Holy church"; Margery Kempe and the Bishops', in eds. Jocelyn Wogan-Browne et al, *Medieval Women: Texts and Contexts in Late Medieval Britain, Essays for Felicity Riddy*. Turnhout, 2000. pp. 377–91.

——'English Towns in the Later Middle Ages: The Rules and Realities of Population Mobility', in eds. Mark Ormrod, Joanna Story and Elizabeth Tyler, *Migrants in Medieval England: c.500–c.1500*. Proceedings of the British Academy, 229 (2020). pp. 265–303.

Rexroth, F., *Deviance and Power in Late Medieval London*, trans. P. E. Selwyn. Cambridge University Press, 2007.

Reynolds, Susan, *Kingdoms and Communities in Western Europe, 900–1300*. Oxford University Press, 1997.

Riddle, John M., *Eve's Herbs: A History of Contraception and Abortion in the West*. Harvard University Press, 1997.

Ridyard, Susan J., *The Royal Saints of Anglo-Saxon England: A Study of West Saxon & East Anglian Cults*. Cambridge University Press, 1988.

Rieder, Paula M., 'The Uses and Misuses of Misogyny: A Critical Historiography of the Language of Medieval Women's Oppression', in *Historical Reflections*, Vol. 38, No. 1 (2012). pp. 1–18.

Riel, Sjoerd van, 'Viking Age Combs. Local Products or Objects of Trade?' *Lund Archaeological Review*, Vol. 23 (2017). pp. 163–78.

Roach, A., 'The Cathar Economy', *Reading Medieval Studies*, Vol. 12 (1986). pp. 51–71.

——*The Devil's World: Heresy and Society, 1100–1300*. Routledge, 2005.

Roach, Andrew P., 'Review: Cathars in Questions, ed. Antonio Sennis', *The English Historical Review*, Vol. 133, No. 561 (2016). pp. 396–8.

Roberts, Jane, 'Guthlac of Crowland, a Saint for Middle England', *Fursey Occasional Paper*, No. 3. Fursey Pilgrims, 2009. pp. 1–36.

Rodwell, W., 'Lichfield. The Forgotten Cathedral', *Current Archaeology*, Vol. 18, No. 205 (2006). pp. 9–17.

Rodwell, Warwick et al, 'The Lichfield Angel: A Spectacular Anglo-Saxon Painted Sculpture', *The Antiquaries Journal*, Vol. 88 (2008). pp. 48–108.

Rose, Martial, *Dramatic Images: The Roof Bosses of Norwich Cathedral in Relation to the Drama of the Middle Ages*. Gryfones Joy Press, 2007.

Rosenberg, Samuel N., 'Les Folies Tristan', in ed. Norris J. Lacy, *Early French Tristan Poems. Volume 1*. D. S. Brewer, 1998. pp. 259–302.

Rosser, Gervase, 'Crafts, Guilds and the Negotiation of Work in the Medieval Town', *Past and Present*, Vol. 154 (1997). pp. 3–37.

Rozier, Charles C., *Writing History in the Community of Saint Cuthbert, 700 AD–1130 AD: From Bede to Symeon of Durham*, Boydell & Brewer, 2020.

Ryan, Martin J., 'Conquest, Reform and the Making of England', in eds. Nicholas J. Higham and Martin J. Ryan, *The Anglo-Saxon World*. Yale University Press, 2013. pp. 284–322.

Saetveit Miles, Laura, 'The Origin and Development of the Virgin Mary's Book at the Annunciation', *Speculum*, Vol. 89, No. 3 (2014). pp. 632–69.

Samsuwan, Jarunya et al, 'A Method for Extracting DNA from Hard Tissues for Use in Forensic Identification', *Biomedical Reports*, Vol 9, Issue 5 (2018). pp. 433–38.

Schaus, Margaret, *Women and Gender in Medieval Europe: An Encyclopaedia*. Taylor & Francis, 2006.

Schmeider, Felicitas, 'Saints Around the Baltic: Some Remarks, Conclusions and Further Questions', in eds. Carsten Selch Jensen et al, *Saints and Sainthood Around the Baltic Sea: Identity, Literacy and Communication in the Middle Ages*, Medieval Institute Publications, 2018. pp. 273–80.

Schrader, Sarah, *Activity, Diet and Social Practice*. Springer, 2019.

Schultz, J. A., *Courtly Love, the Love of Courtliness, and the History of Sexuality*. University of Chicago Press, 2006.

Schultz, James A., 'Why do Tristan and Isolde Leave for the Woods? Narrative Motivation and Narrative Coherence in Eilhart von Oberg and Gottfried von Straβburg', *MLN*, Vol. 102, No. 3 (1987), pp. 586–607.

Scott, Florence H. R., 'Cynethryth: Mercia's Forgotten Queen?', *Aelgif-who?* Newsletter No. 1 (2021). https://florencehrs.substack.com/p/cynethryth-mercias-forgotten-queen.

Semple, Sarah and Williams, Howard, 'Landmarks of the Dead: Exploring Anglo-Saxon Mortuary Geographies', in eds. Martyn Clegg Hyer and Gale R. Owen Crocker, *The Material Culture of the Built Environment in the Anglo-Saxon World*. Liverpool University Press, 2015. pp. 137–61.

Sennis, Antonio, *The Cathars in Question*. Boydell & Brewer, 2016.

Service, Alexandra, *Popular Vikings: Constructions of Viking Identity in Twentieth-Century Britain*. Unpublished PhD thesis, University of York, 1998.

Sherlock, Stephen J., *A Royal Anglo-Saxon Cemetery at Street House, Loftus, North-East Yorkshire*, Tees Archaeology Monograph Series, Vol. 6. Tees Archaeology, 2012. p. 114–15.

——'Space and Place: Identifying the Anglo-Saxon Cemeteries in the Tees Valley, North-East England', in eds. Chantal Bielmann and Britany Thomas, *Debating Religious Space and Place in the Early Medieval World*. Sidestone Press, 2018. pp. 93–110.

——'The Reuse of "Antiquities" in Conversion Period Cemeteries', *Medieval Archaeology*, Vol. 60, No. 2 (2016), pp. 242–65.

Sherlock, Stephen J., and Welch, Martin G., *An Anglo-Saxon Cemetery at Norton, Cleveland*, CBA Research Report 82. Council for British Archaeology, 1992.

Shirley, J., *The Song of the Cathar Wars. A History of the Albigensian Crusade. William of Tudela and an Anonymous Successor*. Scolar Press, 1996.

Sibly, W. A. and Sibly, M. D., *Peter of Les Vaux-de-Cernay: The History of the Albigensian Crusade*. Boydell Press, 1998.

Sigurðardottir, T., 'Saga World and Nineteenth-Century Iceland: The Case of Women Farmers', in eds. S. M. Anderson and K. Swenson, *Cold Counsel: Women in Old Norse Literature and Mythology: A Collection of Essays*. Routledge, 2002. pp. 281–93.

Silber, Patrice, 'Gold and its Significance in *Beowulf*', *Annuale Medievale*, Vol. 18 (1977). pp. 5–19.

Silvas, Anna, *Jutta and Hildegard: The Biographical Sources*. Pennsylvania State University Press, 1998.

Simpson, Gavin, 'The Pine Standard Chest in St Margaret's church, King's Lynn, and the Social and Economic Significance of the Type', in ed. John McNeil, *King's Lynn and the Fens: Medieval Art, Architecture and Archaeology, The British Archaeological Association Conference*, Vol. 31 (2008). pp. 53–65.

Skinner, Patricia, *Challenging the Boundaries of Medieval History: The Legacy of Timothy Reuter*. Brepols, 2009.

Smith, Alfred P., *Warlords and Holy Men*. Edinburgh University Press, 2010.

Sniezynska-Stolot, Ewa, *Tajemnice dekoracji Psalterza Florianskiego*. Polish Scientific Publishers PWN, 1992.

Sobecki, Sebastian, '"The Writyng of this Tretys": Margery Kempe's Son and the Authorship of Her Book', in *Studies in the Age of Chaucer*, Vol. 37 (2015). pp. 257–83.

Solymosi, László and Körmendi, Adrienne, 'A középkori magyar állam virágzása és bukása, 1301–1506 [The Heyday and Fall of the Medieval Hungarian State, 1301–1526]', in ed. László Solymosi, *Magyarország történeti kronológiája, I: a kezdetektől 1526-ig* [Historical Chronology of Hungary, Volume I: From the Beginning to 1526], Akadémiai Kiadó, 1981. pp. 188–228.

Spufford, P., *Power and Profit: The Merchant in Medieval Europe*. Thames & Hudson, 2002.

Squatriti, Paolo, 'Offa's Dyke Between Nature and Culture', *Environmental History*, Vol. 9, No. 1 (2004). pp. 37–56.

St Clair Feilden, H., *A Short Constitutional History of England*. BiblioBazaar, 2009.

Stacey, Robert C., 'Anti-Semitism and the Medieval English State', in eds. J. R. Madicott and D. M. Palliser, *The Medieval State: Essays Presented to James Campbell*. Hambledon, 2000. pp. 163–77.

Stafford, Pauline, 'Edith, Edward's Wife and Queen', in ed. Richard Mortimer, *Edward the Confessor: The Man and The Legend*. Boydell Press, 2009. pp. 129–38.

——'Political Women in Mercia, Eighth to Early Tenth Centuries', in eds. Michelle P. Brown and Carol A. Farr, *Mercia: An Anglo-Saxon Kingdom in Europe*. Continuum, 2001. pp. 35–50.

——*Queen Emma and Queen Edith: Queenship and Women's Power in Eleventh Century England*. Wiley, 2001.

——*Unification and Conquest: A Political and Social History of England in the Tenth and Eleventh Centuries*. Hodder Education, 1989.

——'Women in Domesday', *Reading Medieval Studies*, Vol. 15 (1989). pp. 75–94.

Stahl, Alan M., 'The Nature of the Sutton Hoo Coin Parcel', in eds. Calvin B. Kendall and Peter S. Wells, *Voyage to the Other World: The Legacy of Sutton Hoo*. University of Minnesota Press, 1992. pp. 3–14.

Stanzl, Günther, 'The Ruins of the Abbey Disibodenberg near Mainz, Germany: Excavation, Conservation and Development of the Site', *Conservation and Management of Archaeological Sites*, Vol. 1 (2000). pp. 21–32.

Steinkeller, Piotr, *Third-millennium legal and administrative texts in the Iraq Museum*. Eisenbrauns, 1992.

Stenton, Frank M., *Anglo-Saxon England*. Clarendon Press, 1971.

Stillwell, Richard, *The Princeton Encyclopaedia of Classical Sites*. Princeton University Press, 2017.

Stone, Richard, *Tamworth: A History*. Phillimore & Co., 2003.

Storey, Ann, 'A Theophany of the Feminine: Hildegard of Bingen, Elisabeth of Schönau and Herrad of Landsberg', *Woman's Art Journal*, Vol. 19, No. 1 (1998). pp. 16–20.

Stoudt, Debra L., 'Elemental Well-Being: Water and its Attributes in Selected Writings of Hildegard of Bingen and Georgius Agricola', in ed. Albrecht Classen, *Bodily and Spiritual Hygiene in Medieval and Early Modern Literature: Explorations of Textual Presentations of Filth and Water*, *Journal of Medieval Latin*, Vol. 27, No. 1 (2017). pp. 193–220.

Stuart, S. Mosher, *Women in Medieval History and Historiography*. University of Pennsylvania Press, 1987.

Styles, T., 'Whitby Revisited: Bede's Explanation of Strenaeshalch', *Nomina*, Vol. 21 (1998), pp. 133–48.

Sumption, Jonathan, *The Albigensian Crusade*. Faber and Faber, 1978.

Szabo, John F. and Kuelfer, Nicholas E., *The Bayeux Tapestry: A Critically Annotated Bibliography*. Rowman and Littlefield, 2015.

Szarmach, Paul E., *Writing Women Saints in Anglo-Saxon England*. University of Toronto Press, 2013.

Tachau, Katherine H., 'God's Compass and Vana Curiositas: Scientific Study in the Old French Bible Moralisée', in ed. John T. Paoletti, *The Art Bulletin*, Vol. 80, No. 1, (1998). pp.7–33.

Tanke, John, '*Beowulf*, Good-Luck and God's Will', *Studies in Philology*, Vol. 99, No. 4 (2002), pp. 356–79.

Taylor, Claire, *Heresy, Crusade and Inquisition in Medieval Quercy*. York Medieval Press, 2011.

Thacker, Alan, 'Chester and Gloucester: Early Ecclesiastical Organisation in Two Mercian Burhs', *Northern History*, Vol. 18 (1982). pp. 199–211.

Thiébaux, Marcelle, trans., 'Benedictine Visionaries in the Rhineland: Hildegard of Bingen (1098–1179), Elisabeth of Schönau (1129–1165)', in *The Writings of Medieval Women*, Garland Library of Medieval Literature, Vol. 14, Series B (1987). pp. 105–163.

Thomas, A. H., *Calendar of Select Please and Memoranda of the City of London: A.D. 1381–1412, 3 Vols.* Cambridge University Press, 1924–32.

Thompson, Augustine, 'Hildegard of Bingen on Gender and the Priesthood', *Church History*, Vol. 63, No. 3 (1994). pp. 349–64.

Tilly, Charles, *Coercion, Capital, and European States: A.D. 900–1900. Studies in Social Discontinuity.* Blackwell, 1992.

Toswell, M., 'The European Psalms in Translation', in ed. J. Beer, *Companion to Medieval Translation.* Amsterdam University Press, 2019. pp. 13–22.

Totten, Robert Christy, *The Bible Significance of East and West; or, Is the Dawn Appearing?.* Palala Press, 2018.

Tracy, Charles, 'The Former Nave and Choir Oak Furnishings, and the West End and South Porch Doors, at the Chapel of St Nicholas, King's Lynn', in ed. John McNeil, *King's Lynn and the Fens: Medieval Art, Architecture and Archaeology, The British Archaeological Association Conference*, Vol. 31 (2008). pp. 28–52.

Trivellone, Alessia, *L'hérétique imaginé: Hétérodoxie et iconographie dans l'Occident médiéval, de l'époque carolingienne à l'Inquisition.* Brepols, 2009.

Tsiamis, Costas, Tounta, Eleni and Poulakou-Rebelakou, Effie, 'The "Endura" of the Cathars' Heresy: Medieval Concept of Ritual Euthanasia or Suicide?', *Journal of Religion and Health*, Vol. 55, No. 1 (2016). pp. 174–80.

Tumanov, Vladimir, 'Mary versus Eve: Paternal Uncertainty and the Christian View of Women', *Neophilologus*, Vol. 95 (2011). pp. 507–21.

Turner, T. R. et al, 'Participation, Representation, and Shared Experiences of Women Scholars in Biological Anthropology',

American Journal in Physical Anthropology, Vol. 165 (2018). pp. 126–57.

Tyerman, C. J., 'Were There Any Crusades in the Twelfth Century?', *The English Historical Review*, Vol. 110, No. 437 (1995). pp. 533–77.

Tyler, Damian, 'An Early Mercian Hegemony: Penda and Overkingship in the Seventh Century', *Midland History*, Vol. 30, No. 1 (2005). pp. 1–19.

Tyler, E. M., *Treasure in the Medieval West*. York Medieval Press, 2000

Uspenskij, Fjordor, 'The Baptism of Bones and Prima Signatio in Medieval Scandinavia and Rus', in eds. L. P. Słupecki and J. Morawiec, *Between Paganism and Christianity in the North*. Uniwersytetu Rzeszowskiego, 2009. pp. 9–22.

Van Antwerp Fine, John, *The Late Medieval Balkans: A Critical Survey from the Late Twelfth Century to the Ottoman Conquest*. University of Michigan Press, 1994. pp. 396–7.

Varner, Eric, 'Transcending Gender: Assimilation, Identity and Roman Imperial portraits', in eds. Sinclair Bell and Inge Lyse Hansen, *Memoirs of the American Academy in Rome*, *Vol. 7*. University of Michigan Press, 2008. pp. 200–1.

Vedeler, M., *The Oseberg Tapestries*. Scandinavian Academic, 2019.
——'The Textile Interior in the Oseberg Burial Chamber', in eds. S. Bergerbrant and S.H. Fossøy, *A Stitch in Time. Essays in Honour of Lise Bender Jørgensen*. Gothenburg University, 2014. pp. 281-301.

Vial, Gabriel, 'The Bayeux Tapestry Embroidery and its Backing Strip', in eds. Pierre Bouet, Brian Levy and François Nevaux, *The Bayeux Tapestry: Embroidering the Facts of History*. Caen, 2004. pp. 83–109.

Viegas, Jennifer, 'Bejeweled Anglo-Saxon Burial Suggests Cult at Loftus', *Discovery News*, 11 April 2008.

Vitolo, Paolo, 'The Image of Women and Narrative Strategies in the *Hortus Deliciarum*', in eds. Kari Elisabeth Børresen and Adriana Valerio, *The High Middle Age, The Bible and Women Series*. Society of Biblical Literature, 2015. pp. 327–42.

Vyner, B. E., 'The excavation of a Neolithic cairn at Street House, Loftus, Cleveland', *Proceedings of the Prehistoric Society*, Vol. 50 (1984). pp. 151–96.

Vyner, B. E. et al, 'The Street House Wossit: The Excavation of a Late Neolithic and Early Bronze Age Palisaded Ritual Monument at Street House, Loftus, Cleveland', *Proceedings of the Prehistoric Society*, Vol. 54 (1988), pp. 173–202.

Walker, Ian W., *Mercia and the Making of England*. Sutton Publishing, 2000.

Walter, Brittany S. and DeWitte, Sharon N., 'Urban and Rural Mortality and Survival in Medieval England', *Annals of Human Biology*, Vol. 44, No. 4 (2017). pp. 338–48.

Ward, Jennifer, *Women in Medieval Europe, 1200–1500*. Routledge, 2002.

Wawn, Andrew, *The Vikings and the Victorians*. D.S. Brewer, 2002.

Webster, Paul, 'Mystery at the Monastery Ends as CCTV Reveals Chamber of Secrets' Daring Thief', *Guardian*, 19 June 2003.

Weigel, George, *City of Saints: A Pilgrimage to John Paul II's Krakow*. Crown Publishing, 2015. pp. 65–88.

Weir, Alison, *Britain's Royal Families: The Complete Genealogy*. Vintage, 1996.

Weis, Rene, *The Yellow Cross: The Story of the Last Cathars 1290–1329*. Penguin, 2001.

Weltecke, Dorothea, 'Doubts and the Absence of Faith', in ed. John H. Arnold, *Oxford Handbook of Medieval Christianity*. Oxford University Press, 2014. pp. 357–76.

White, Stephen D., 'The Fables in the Borders', in eds. Elizabeth Carson Pastan and Stephen D. White, *The Bayeux Tapestry and its Contexts: A Reassessment*. Boydell Press, 2014. pp. 154–82.

Whitelock, Dorothy, *English Historical Documents v. 1 c. 500–1042*. Eyre & Spottiswoode, 1968.

Whittaker, H., 'Game Boards and Gaming Pieces in the Northern European Iron Age', *Nordlit. Tidskrift for kultur og litteratur*, Vol. 24 (2006). pp. 103–12.

Wicker, Nancy L., 'Christianisation, Female Infanticide, and the Abundance of Female Burials at Viking-age Birka in Sweden',

Journal of the History of Sexuality, Vol. 21, No. 2 (2012). pp. 245–62.

Wilcox, Peter, *The Gold, the Angel and the Gospel Book*. Lichfield Cathedral, 2011.

Williams, Gareth, 'Mercian Coinage and Authority', in eds. Michelle P. Brown and Carole A. Farr, *Mercia: An Anglo-Saxon Kingdom in Europe*. Continuum, 2001. pp. 210–29.

Williams, Howard, 'Ancient Landscapes and the Dead: The Reuse of Prehistoric and Roman Monuments at early Anglo-Saxon Burial Sites', *Medieval Archaeology*, Vol. 41 (1997). pp. 1–32.

——*Death and Memory in Early Medieval Britain*. Cambridge University Press, 2006.

——'Engendered Bodies and Objects of Memory in Final Phase Graves', in eds. Jo Buckberry and Annia Cherryson, *Studies in Funerary Archaeology, Volume 4: Burial in Later Anglo-Saxon England, c. 650–1100 AD*. Oxbow Books, 2010. pp. 26–37.

Williams, Tara, 'Manipulating Mary: Maternal, Sexual and Textual Authority in *The Book of Margery Kempe*', *Modern Philology*, Vol. 107, No. 4 (2010). pp. 528–55.

Wiseman, James, 'Insight: Suppression of the Cathars', *Archaeology*, Vol. 52, No. 2 (1999). pp. 12–16.

Witts, Richard, 'How to Make a Saint: On Interpreting Hildegard of Bingen', *Early Music*, Vol. 26, No. 3 (1998). pp. 478–85.

Wolf, Kirsten, 'Transvestitism in the Sagas of the Icelanders', *The 10th International Saga Conference*. University of Trondheim, 1997. pp. 675–84.

Wood, Juliette, *The Holy Grail: History and Legend*. University of Wales Press, 2012.

Woodgar, L. S., 'B, Robert, of Bishop's Lynn, Norf.', in eds. J. S. Roskell, L. Clark, C. Rawcliffe, *The History of Parliament: the House of Commons 1386–1421*. Boydell and Brewer, 1993. https://www.historyofparliamentonline.org/volume/1386-1421/member/brunham-robert.

Wyrozumski, Jerzy, *Królowa Jadwiga*. Universitas, 2006.

Yenne, Bill, *Hitler's Master of the Dark Arts: Himmler's Black Knights and the Occult Origins of the SS*. Zenith, 2010.

Yorke, Barbara, 'Alfred the Great: The Most Perfect Man in History?', *History Today*, Vol. 49, No. 10 (1999). pp. 15–17.

——'"The Weight of Necklaces": Some Insights into the Wearing of Women's Jewellery from Middle Saxon Written Sources', in eds. Stuart Brookes, Sue Harrington and Andrew Reynolds, *Studies in Early Anglo-Saxon Art and Archaeology: Papers in Honor of Martin G. Welch*. Archaeopress, 2011. pp. 106–11.

Zawadzki, Roman Maria, 'Poczatki kultu Królowej Jadwigi', in ed. Adam Kubiś, *Jubileusz Sześćsetlecis Wydziału Teologicznego w Krakowie.*, Papieska Akademia Teologiczna, 1998. pp. 283–99.

Zeitlin, S., 'The Blood Accusation', *Vigilae Christianae*, Vol. 50, No. 2 (1996). pp. 117–24.

Zerner, Monique, *Inventer hérésie? Discours polémiques et pouvoirs avant l'inquisition*. Centre d'Etudes Médiévales, 1998.

Index

Note: page numbers in **bold** refer to photographs.

Index